The Underwater Photographer
Digital and Traditional Techniques

This book is dedicated to Colin Bateman.
An enquiring student
A talented photographer
And a dear friend

The Underwater Photographer

Digital and Traditional Techniques

Third Edition

Martin Edge

ELSEVIER

AMSTERDAM • BOSTON • HEIDELBERG • LONDON • NEW YORK • OXFORD
PARIS • SAN DIEGO • SAN FRANCISCO • SINGAPORE • SYDNEY • TOKYO
Focal Press is an imprint of Elsevier

Focal Press is an imprint of Elsevier
Linacre House, Jordan Hill, Oxford OX2 8DP
30 Corporate Drive, Suite 400, Burlington, MA 01803, USA

First edition 1996
Second edition 1999
Third edition 2006

British Library Cataloguing in Publication Data
A catalogue record for this book is available from the British Library

Library of Congress Cataloguing in Publication Data
A catalogue record for this book is available from the Library
of Congress

ISBN–13: 978-0-2405-1988-3
ISBN–10: 0-2405-1988-4

For information on all Focal Press publications
visit our web site at http://www.focalpress.com

Typeset by Charon Tec Ltd, Chennai, India
www.charontec.com
Printed and bound in Italy

06 07 08 09 10 10 9 8 7 6 5 4 3 2 1

Contents

Foreword

The previous two editions of *The Underwater Photographer* have earned Martin Edge an international reputation as an excellent tutor of a subject which is multi-faceted and often difficult to explain simply yet comprehensively.

This latest edition, whilst carrying on the successful formula, is really a major new working and should quickly establish itself as both a comprehensive reference manual and a continual source of inspiration.

Martin's approach is very personal and his book is littered with decades of experience imparted to help the reader not only produce better photographs, but also to understand why, without the feeling of being a slave to the learning process.

There is no doubt that the advent of digital photography has revolutionised underwater photography and now accounts for the majority of shots being taken underwater. The exciting capability of digital cameras has opened up underwater photography to a whole new audience and Martin's teachings apply equally well to this new technology.

In a fast-changing world capable of producing instant results it still pays to understand the basics in order to maximise the quality of your shots. *The Underwater Photographer* provides all the technical knowledge you need but more importantly gives you the benefit of Martin's considerable practical experience.

This is a very comprehensive book which you can either immerse yourself in from cover to cover or dip into randomly to solve a problem or seek inspiration but, above all, learn from someone who is both passionate and knowledgeable as well as being a good teacher.

Peter Rowlands
PR Productions
Editor/Publisher, Underwater Photography magazine
<u>*www.uwpmag.com*</u>

About the book

The book is split into five parts:

1. The basics and beyond
2. The digital revolution
3. Using SLR cameras and compact digitals underwater
4. The mindset
5. The big four.

The basics and beyond considers the basic theory and principles of underwater photography, including popular lenses, problems when using zoom lenses, and how to dive and select subjects whilst protecting the reef.

The digital revolution covers digital issues relevant to the underwater photographer, including ideas on how to use the LCD screen, reading histograms and much more.

Using SLR cameras and compact digitals underwater examines the use of exposure modes, metering patterns, focusing techniques, exposure compensation and TTL flash issues.

The mindset is at the heart of the book, and describes my entire philosophy on how to approach underwater photography. It includes the TC system (Think and Consider), which has been re-written to take advantage of digital capture.

The big four discusses the four particular topics that, over the years, I have found to dominate the quest for knowledge of enthusiasts. They are composition, lighting, close-up and macro, and wide-angle. There is an in-depth chapter on each of these.

Introduction

I discovered underwater photography in the early 1980s, and immediately became addicted. I was not especially interested in the variety of equipment available at that time; I was too distracted by the wonderful images on display in scuba magazines and books, and at BSOUP (British Society of Underwater Photography) meetings in London.

There was a clear distinction between the best and the rest, and I was determined to find out why. How were the best photographers able to obtain such superior pictures to those obtained by enthusiasts using the same equipment in the same location and on occasions shooting the same subject? I was also influenced by three American photographers; Howard Hall, and Jim and Cathy Church. At BSOUP, dive trade shows and seminars, I had the opportunity to question some of the best underwater photographers at that time. My questions tended to revolve around topics such as imagination, patience and visualisation – topics not easy to explain.

My persistence paid off, and over a period of time I gained a valuable insight from these conversations. Using my own interpretations of words, I began to label what I had discovered and set out to apply this knowledge to my own underwater photography. In a short time (months as opposed to years), I developed my skills and abilities significantly.

Others would question me about my own techniques, and I found a way to communicate topics that were less to do with equipment, *f*-stops and shutter speeds and more to do with how to think and apply ideas underwater. These questions led to articles, which inevitably led to underwater photography courses and workshops for individuals or small groups, with tuition structured for both beginners and the experienced (see www. edgeunderwaterphotography.com for details). In the early 1990s the idea of writing a book came to mind, and since that time my efforts by and large have been directed towards helping others to develop their own underwater photography. I am proud to say that many of them have surpassed my own ability.

The Underwater Photographer was first published in 1996. It has been translated into other languages, updated with a second edition, and reprinted more times than I can remember. In these previous updates I refreshed the photographs, but the knowledge I had learnt and documented many years ago stayed the same.

The digital revolution has now changed everything that has gone before and nowhere more than in underwater photography has digital had such a profound effect. There are those who are learning to scuba dive simply to participate in underwater photography. Divers without any previous inclination whatsoever are purchasing their first digital cameras and underwater housing. It has also had an enormous effect on teaching underwater photography to others. Now, the digital camera and the way in which we use it have taken on a significant and unique advantage over its film predecessor. Think about it! Digital is immediate; we are able to see what we have taken in an instant. Hundreds of photos can be taken on every dive, and memory cards can be used over and over again. An idea can be scrutinised and perfected, compositions can be altered and exposures corrected – all before returning to the dive boat. If we are to improve to the best of our ability, we need to use these advantages whilst underwater at the time.

This book has been completely rewritten to take advantage of what digital has to offer to the underwater photographer. All of the images have been replaced. Whilst the uses of film cameras are discussed, this is from an SLR perspective and not for the Nikonos, Sea & Sea or other amphibious cameras so common in previous books of this genre.

A certain amount of basic knowledge is assumed of the reader. This book is not a beginner's guide to digital photography, and neither is it an instruction book on how to use imaging programs such as Adobe Photoshop. What it does contain is a clear insight into how quality and award-winning underwater photographs are taken. So, dip into it for whatever may interest you in any particular place at any particular time. I hope you enjoy it, and have fun improving your underwater photographs.

Martin Edge

Acknowledgements

This book has taken eighteen months out of my life. Without the support and enthusiasm of others, it would never have been possible. First and foremost I would like to thank my wife Sylvia, whose love, faith and support in me is never-ending. This book and all our workshops abroad would never happen but for you. Thank you Sylv, I love you lots. Thanks also to my son and daughter, Katie and Jamie: thanks for your help with text, Katie, you are now an official 'computer minx'.

I would also like to thank: Mark Walker for his digital advice in the early stages of my own 'D' learning; Ken Sullivan for his inventions and support over so many years; Ian Turner for the original text; Judith Young for her help with the final text; Shannon Conway for his support both above and below the waves (not to mention those 'roll-ups') Mark Hardy – you have spent so much of my money but I'm grateful you did; Alan and Heather Hammond from Alan James Photography; Jenny, Rob, Geoff and Liz from Cameras Underwater; Steve Warren and all the guys at Ocean Optics – thank you all for your support over the years; Peter Rowlands for his help and wisdom when I need advice; Dan Beecham for Chapter 19 on digital compacts; Mike Davidge and Julian Macielinski for additional photographs; Alex Mustard for Chapter 21 on filters and ideas on all things digital – you are a breath of fresh air to all underwater photographers; thank you for sharing your ideas with us; Robert White Photographic in Bournemouth; Stuart Culley for ideas on colour management; Laura Chappell at Bournemouth Oceanarium; Chris and Dave Beale at AWC; Paul Williams and Bob from Phoenix Imaging; David and all the team at Jessops, Bournemouth; Carol Day for her typing skills; Norrie Phillips; Philip Andrews for his help with the glossary; Karen Ranger and Bob Wrobel for their studio skills; Hilary Lee and Derek from Divequest for the meticulous planning and organisation of our tropical photo workshops; the staff from the Trouville Hotel in Bournemouth; Lorraine Bateman for her friendship, wisdom and advice; Emma Baxter and the team at Focal Press; the contributors from www.wetpixel.com and www. digideep.com; and all my friends at BSOUP.

I also extend my thanks to all those who have attended my photo courses – without your thirst for knowledge I would have little to teach and write about.

Photographic information

All of the photographs have been taken using a combination of both film and digital cameras over the last five years.

Film cameras and lenses: I use Nikon SLR cameras including the Nikon F90x and currently the Nikon F100. My popular lenses are:

- wide-angle – the Nikon 16-mm full-frame fisheye; Nikon 17-mm to 35-mm zoom with a +4 dioptre (this lens has replaced my 20-mm and 28-mm)
- close-up and macro – Nikon 60-mm macro; Nikon 105-mm macro; Nikon 200-mm macro.

Housings: I use Subal housings and ports for all my film work. My housings have been fitted to accommodate a flash shoe on all four corners, together with a tripod socket on each base plate. I find the facility to attach a flash gun quickly to a particular corner to be a real advantage. Certain bespoke ports have been made for me by Ken Sullivan of Photo Ocean Products and engineer Andrew Hirst. I use Subal fisheye dome ports for all of my fisheye work, with the addition of a port extender on the fisheye port and flat port when using my Nikon 17-mm to 35-mm zoom and my Nikon 200-mm macro lens.

Digital: I added a Nikon digital D100 SLR camera and Subal digital housing to my tool bag in 2002. I have added two additional lenses for digital work: a Nikon 10.5-mm fisheye and a Nikon 12-mm to 24-mm lens for wide-angle. I continue to use my 60-mm, 105-mm and 200-mm macro with my digital camera.

Flash guns: The majority of my film images were taken with Sea and Sea flash guns, particularly the Sea & Sea YS 30s and two YS 120s for wide-angle fisheye work. For certain macro applications, i.e. greater than life size, I use an Edge/Sullivan ring flash Mk 111.

My current choice of flash guns for digital is Inon Z220s units for both wide-angle, and close-up. For macro applications, I use either my Inon Z220 flashgun or my original Edge/Sullivan ring flash Mk1. This prototype RF, whilst underpowered for low ISO films like Fuji Velvia, is excellent for digital work.

Flash arms: I have used a number of types over the years, but now favour flash arms made by Ultralight for their strength, light

weight and flexibility. An excellent addition to my wide-angle work has been the Ultralight buoyancy arms, which have significantly reduced the strain in my elbow joints and made wide-angle work easier and more enjoyable.

Accessories: I use a Nikon +4 close-up dioptre on my 105-mm lens and, on occasions, a tele-converter on either the 105-mm or 200-mm lens to gain increased magnification with film cameras.

Film stock: My choice of transparency film stock for both wide-angle and close-up continues to favour Elite Chrome Extra Colour 100 ISO film, Ektachrome E100 VS (very saturated) and, on occasions, Fuji Velvia.

Other digital cameras: I have taken every opportunity to try other digital cameras and housings, in particular the Nikon D70, Canon D10 and D20 with housings from Nexus and Sea & Sea, Aquatica and Ikelite, and, more recently, the Nikon D2x. My choice of a compact digital is the excellent Olympus 5050, closely followed by its more recent models, the 5060 and 7070, in their own Olympus housing.

Do I still use film? The answer is yes, but only in certain circumstances. Digital is now my first choice. With over twenty-five years' experience, I still find it a considerable advantage to have the benefits of the LCD review with me when I shoot. As confident as I am with my use of film, I can never anticipate the precise result.

In circumstances when I anticipate shooting moving subjects into the direction of the sunlight or a bright surface with a combination of flash and ambient light, I continue to choose film over digital because of my own digital camera limitation of recording pleasing highlights on the sensor. This limitation has much to do with the slow shutter sync speed of 180th second with a flash. Using a digital SLR like the Nikon D70 or D2x I would have less of a concern, as the shutter sync speed is considerably faster.

As I write this page, the long awaited update – the Nikon D200 – has just been released. Whilst there are no camera housings on the market for it at this time, early reviews are encouraging. I, for one, expect to be using the D200 (without any desire for a film backup) by the summer of 2006.

To the reader

When choosing the photographs for this book I was often torn between many aspects, all of equal importance and none relevant without the others. For these reasons, I have included a detailed summary of how each was taken. They do not belong in one chapter but in all of them, so I would encourage you to view them in their entirety.

1 Basics refresher – traditional techniques

I have assumed that you, the reader, have an understanding of various aspects of photography and how it may differ underwater. The basics of aperture, shutter speeds, depths of field etc. are fundamentals of which you must have a grasp if you intend to develop yourself as a photographer. Here is a short refresher, although the more experienced among you may, of course, wish to skip this section.

Shutter speeds

Shutter speed controls the length of time that the film in your camera is exposed to the light. The faster the shutter speed, the less time the light entering the lens has to strike the film or digital sensor. The result is a sharper picture. The slower the shutter speed the longer the light has to strike, resulting in pictures that are less sharp.

Shutter speeds are expressed in fractions of a second: 1/30, 1/60, 1/125, 1/250 and so on. The fraction doubles between one speed and the next, indicating that the shutter is remaining open twice as long. Altering the shutter speed can do two things:

1. Stop action. The faster the shutter speed, the more quickly the action of the situation can be 'frozen in time'. 1/125 s will freeze the movement of most fish and other marine life; however, agile creatures such as dolphins and seals usually require a speed of 1/250 s to freeze their movement. For still-life and wide-angle images, 1/60 s is usually adequate for most situations.

2. Control the natural light source. As you manipulate the shutter speed, you increase or decrease the amount of natural light that is allowed to enter the camera.

Do remember that shutter speed does not affect flash exposure; nor does it have any control over depth of field.

The technique of slow shutter and rear curtain synchronisation underwater photography has become very popular. The general concept is to use slow shutter speeds to create artistic blur and a feeling of movement. There's more about this elsewhere in this book (see Rear curtain synchronisation, in Chapter 43).

Synchronisation speed

When a flashgun is used with a camera there is a shutter speed that must not be exceeded, so that the flash and the camera can synchronise with each other. Most film SLRs have a sync speed of at least 1/250 s. This means that a flash can be triggered at any shutter speed between 30 s and 1/250 s. The latest digital SLRs from Nikon and Canon have an increased flash sync speed of 1/500 s.

Apertures

The aperture is the opening in the camera lens, and is often referred to as an *f*-stop or a stop. While the shutter speed controls the speed at which light enters the camera, the aperture regulates the quantity of that same light. The value of *f*-stops is normally shown as *f*22, *f*16, *f*11, *f*8, *f*5.6, *f*4, *f*2.8.

Each higher number allows half as much light into the camera as the lower number immediately preceding it – so an *f*-stop of *f*22 lets in half as much light as one of *f*16, while *f*16 allows in twice as much light as *f*22 but only half as much as *f*11, and so on.

Remember, the higher the *f*-numbers the smaller the aperture. On most film camera lenses, the highest *f*-stop is either *f*32 or *f*22, depending on the lens. The lowest *f*-stop is around *f*2.5, again depending on the lens.

Beginners to photography are often confused by other terms, such as 'closing the aperture'. This simply means selecting a higher *f*-number to reduce the light.

Changing the aperture of a camera does three things:

1. It controls the natural light source entering the camera
2. It regulates the distance the flash is from the subject
3. It determines the amount of depth of field in the picture.

Depth of field

Depth of field is the zone of acceptable sharpness in front of the camera at any focused distance. When a lens is focused on a

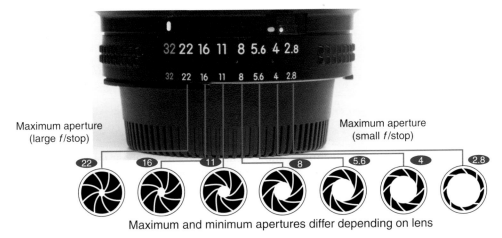

Maximum aperture (large f/stop)

Maximum aperture (small f/stop)

Maximum and minimum apertures differ depending on lens

Note: The smaller the f-number (e.g. f1.4, f2 etc.), the larger is the aperture, thus allowing more light reaching the film to compensate for the duration of the shutter curtain travelling time

Figure 1.1
Each consecutive f-stop lets in half as much light as the preceding f-stop.

Figure 1.2
Depth of field.

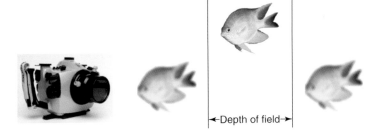

←Depth of field→

particular point, that point is determined to be the 'point of sharpest focus'. There is a distance both in front of and behind that point which is described as providing 'acceptable focus'; this distance is usually one-third in front of the point of focus and two-thirds behind the point (depending on the lens used and the focused distance). The smallest aperture – e.g. f22 – provides the greatest depth of field, while the widest aperture – e.g. f2.8 – provides the narrowest depth of field.

Lens to subject distance
The shorter the distance between the lens and the subject, the smaller the depth of field. On the other hand, the greater the distance, the greater the depth of field becomes.

Lens focal length

Wide-angle lenses
Lenses with short focal lengths (lower numbers) offer the greatest depth of field and a larger picture area. A 16-mm fisheye lens

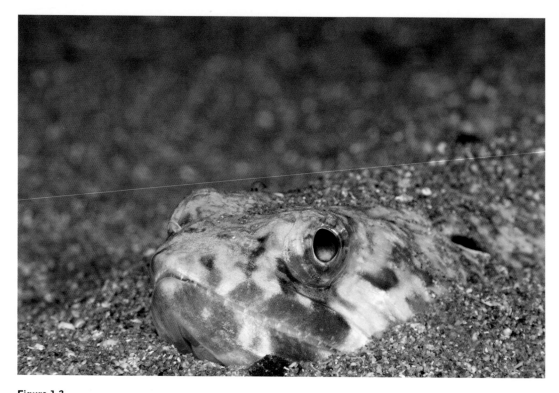

Figure 1.3
Depth of field has captured this lizard fish in sharp focus. The area just behind the head is out of focus. Even though the amount of depth of field is the same with other macro lenses focused at the same magnification, the characteristic of the out-of-focus blur appearance is different. This effect is regularly used by topside wildlife photographers to enable their subjects to stand out against the background.

 Nikon D100, 200-mm macro lens, Subal housing, single Sea & Sea YS120 flash gun on manual full power, 1/180 second shutter at f16.

has a huge picture area and huge depth of field. These attributes make it an ideal lens to shoot seascapes, wrecks and scenes with potential for a wide field of view. Other popular wide-angle lenses or adapters for underwater photography are:

- 10.5-mm fisheye
- 12-mm–24-mm wide-angle zoom
- 17-mm–35-mm wide-angle zoom
- 18-mm–35-mm wide-angle zoom
- 20-mm wide-angle.

Macro lenses
Lenses with longer focal lengths (higher numbers) have a much reduced picture area and provide a smaller depth of field. A Nikon 105-mm lens has a narrow picture area resulting in reduced depth of field. However, this makes it ideal for small creatures and for fish portraits, which can fill the entire picture frame. These lenses are known as macro lenses, and are completely the opposite to

wide-angle lenses. Other popular macro lenses, as well as the 105-mm, are:

- 50-mm macro
- 60-mm macro
- 90-mm macro
- 100-mm macro
- 200-mm macro
- 70-mm–180-mm macro zoom.

Refer to Chapter 5 for further information on preferable lenses.

Effective aperture
When using macro lenses in the 60-mm or 105-mm ranges, the optics within the lens casing move further from the film plain in the camera. The consequence of this is the display in your SLR camera of an effective aperture or f-stop. An effective f-stop is a higher number than the highest f-stop marked on the barrel of your lens and displayed in the LCD monitor on all film and digital SLR cameras. I have known some who are new to underwater photography to become quite panic-stricken when they see the f numbers of $f45$ or $f64$ displayed. This is quite normal when working with macro lenses close to the subject at high magnification.

2 Colour loss, light and particulates

The behaviour of light underwater is unlike the behaviour of light on land. For a start, the density of water is 800 times that of air. Such is the density of water, in fact, that people compare a picture taken in 0.5 m of water with a picture on land taken at 800 m away. As soon as light enters the water it also interacts with suspended particles, resulting in a loss of both colour and contrast.

It often comes as a huge shock for non-divers to discover that colour also decreases with the depth of water. Particulates and water molecules react with the light entering the sea, and it immediately begins to be absorbed. Red goes first, then orange and yellow, until only green and blue are left. So rapid is the loss of red that within half a metre of the surface those red swimming shorts are muted and dull! Even in the best imaginable visibility, particulates are suspended in the water column. In a typical tropical diving destination with good visibility, these particulates tend to reflect and scatter light as they move through the water. You can reduce their effects, but never eliminate them entirely.

Beginners to underwater photography often forget that *horizontal* distance also reduces light. If you are 7 m deep and 2 m from your subject, the total light path is actually equivalent to 9 m.

It is also important for the underwater photographer to recognise that the conditions on the surface of the water have an effect on how light passes through the water. Calm seas generally allow more light to pass through, whilst a choppy sea reflects more light.

Figure 2.1

The filtration effects of colour according to depth.

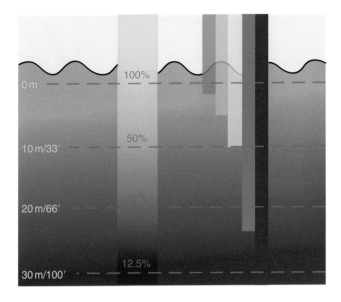

Figure 2.2

The behaviour of natural light underwater.

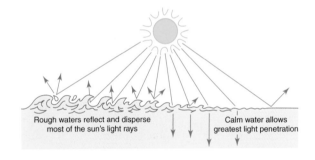

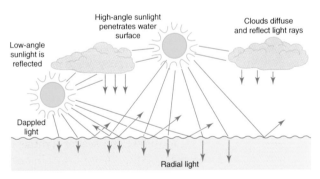

The position of the sun in the sky and the time of day also have an effect on the amount and quality of light entering the water. When the sun is high in the sky over a flat calm sea, most of the sun's rays pass through the surface. As the sun arcs closer to the horizon, the light loss due to the angle of reflection against the water surface increases dramatically. The light that does penetrate at these times is usually soft and diffused, and I find it the most

Figure 2.3

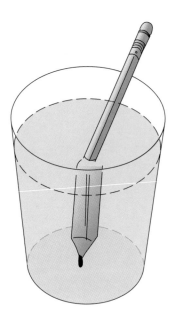

inspiring and magical time of day to take natural light photos underwater – although if you want to take pictures when the sun is high in the sky, the best lighting conditions are between 1000 and 1400 hours.

You will find a great deal more on this subject in Chapters 21 and 41.

Exercise: Refraction

Put on your mask, hold your camera in front of you and submerge. You will notice that, underwater, your camera appears larger and closer to you than it really is. This effect is called *refraction*, and is the difference between the behaviour of light rays in air and in water. Place a pencil in a glass of water, and you will see it bend at the join between the air and the water. The measurement of this 'bending' of light as it enters a medium (i.e. water) from another of different density (i.e. air) is known as the index of refraction. The refractive index of water is one and a third (133 per cent) more than that of air, which is why objects viewed underwater appear to be one-third bigger than their actual size. This not only fools the eye of the photographer; it also fools the camera lens!

3 Getting close physically

Throughout this book you will read and be reminded of the fact that the reduction of the length of the column of water between the lens and the subject is paramount. This point cannot be emphasised enough if you intend to minimise the problems of colour loss, diffusion, refraction and backscatter.

The choice of lenses makes it possible to reduce the column of water because of their close focusing properties. Macro lenses achieve considerable magnification and focus very close to underwater subjects. Wide-angle lenses can focus extremely closely, whilst their wide angle of view is able to take more subjects into the viewfinder.

Beginners to underwater photography often fail to get close to a subject, and as a result many take the picture from too far away. Not only does the subject look tiny in the finished picture, but the distance involved also reduces the effectiveness of flash, resulting in poor colour, saturation and sharpness. There is no point in blaming the camera, the flash gun and the make of film, or the quality of the digital camera and its number of megapixels. Getting as close as physically possible is often all it needs to produce a marked improvement in results, as long as you can do this with due consideration for the underwater environment – a subject covered in detail in Chapter 7.

Certain subjects will not always allow you to get close and reduce the length of the column of water. If this happens, just do your best in the circumstances.

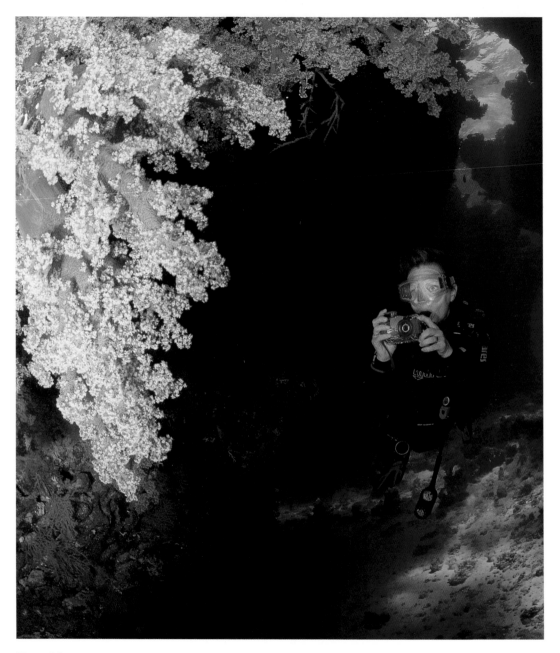

Figure 3.1
Getting as close as possible, physically, is often all it needs to produce a marked improvement in results, as long as you can do this with due consideration for the environment. No matter which camera system you have, get close and fill the frame. When you think you are close enough, then get closer. Olympus 5050 in Olympus housing with wide-angle adaptor and Ikelite 125 flash gun.

The best tip for any underwater photographer who is struggling to achieve pleasing results is: Get close to the subject and fill the frame. When you think you're close, then get closer!

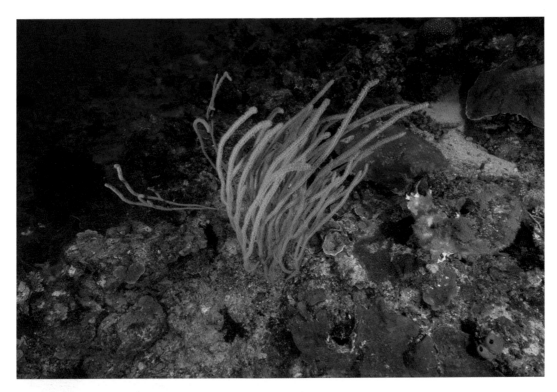

Figure 3.2
A photographer from another dive boat took a similar shot on a reef near to Bunaken Island, Manado, Sulawesi. I was swimming behind him but held back to observe his technique. He took several shots, varied the angle but never got any closer to his subject. He was using a wide angle lens behind a dome port on an Ikelite housing and was shooting between 2 and 3 metres away. I decided to copy his technique, angle of view and his distance away from the whip corals. This was my result. You can see that it is much too far away to be effective. It's a very flat, two dimensional image with little impact. The colour and sharpness are reduced because of the 2–3 metre distance from my camera to the subject.

Figure 3.3

I took more shots but this time much closer to the whip corals. On the seaward side of the reef I was able to get below the whips and shoot upwards capturing the blue water background with the whips framed against the unlit reef wall in a vertical compositional format. The opportunity looked promising, the main fact being that this colony of whips were easy accessible without fear of harming the reef. I examined my LCD monitor and noticed that I had clipped the branches on the left hand side. My wide angle zoom lens was at its widest focal length of 12 mm so I backed off an additional 0.3 metre so I could include the entire colony. My total camera to subject distance was just less than a metre. Figures 3.2 and 3.3 not only emphasise the importance of getting close to the subject but reiterates the topic of Chapter 4 – shooting up on subjects, not down!

Nikon D100 Digital SLR in a Subal housing. Nikon 12 mm–24 mm lens. 60th second at F11. Two Inon Z220 flash guns on manual full power. White balance set to Cloudy. Taken on RAW and converted to jpg in Photoshop CS.

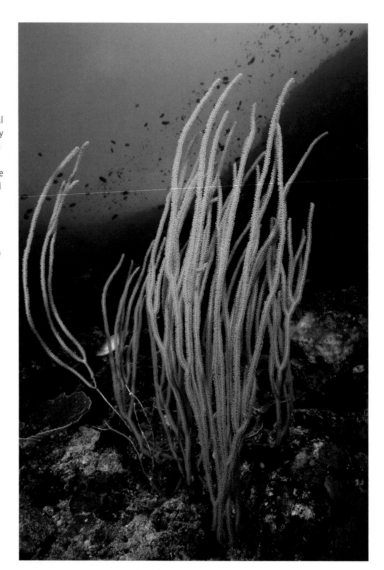

4 Shooting up

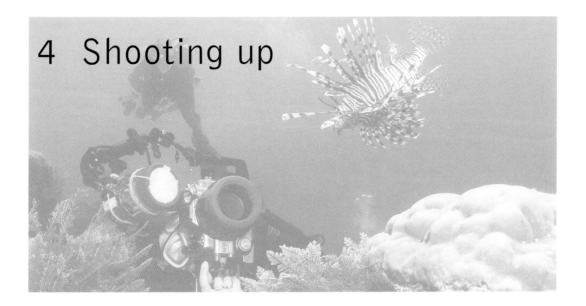

Get below a subject and shoot up towards the surface. Don't shoot down! That is the one technique above all others that can instantly and dramatically improve your underwater photographs!

The way in which people dive compounds the problem and encourages negative and unflattering downward camera angles. Basically, you strike a horizontal pose and fin from point A to point B. This is the most natural and comfortable position, and allows your eyes to look in front and slightly downwards, and capture subjects which are often below eye level.

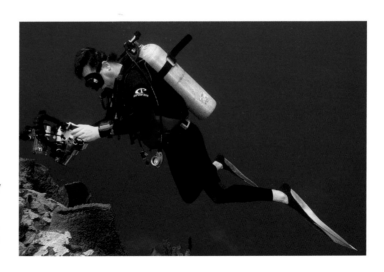

Figure 4.1
It is so easy for a beginner to shoot down on a subject. It is the most common fault. Whilst diving, our body position compounds the problem. Finning horizontally, it is normal to look down, so when we begin to use a camera we unknowingly maintain this angle of view.

When using an underwater camera, you need to avoid the flat, downward camera angle adopted by virtue of your body position that naturally occurs when diving. With just a tilt of the camera angle, you can turn a mundane 'snap' of the underwater world into a striking image. To do this, however, you need to understand your body position whilst underwater!

Check out a selection of your own images to see whether you have a tendency towards these particular 'faults':

- Are you continually photographing subjects surrounded by unflattering rocks, sand and reef?
- Is your shot a birds-eye view of the subject?
- Are the unflattering 'backgrounds' often brighter and more reflective than your intended subject?
- Do your pictures appear flat and two-dimensional or frequently lack a 'sense of depth'?
- Are you in the habit of shooting subjects at downward angles?

On land, people don't use downward angles to photograph a child, a domestic pet or another animal; they crouch down so they are at eye level. Neither do they shoot down on to the heads of friends or family when taking a portrait. The same principles apply underwater . . . except that your body is in a different position, and that's what you need to be aware of.

Kicking the habit

Some suggestions to get you into the habit of shooting up, not down, include the following:

- Remind yourself constantly to 'shoot up'
- Attach a 'shoot up' sticker to your film or digital housing
- Look for subjects growing proud of the reef, which can be approached from below
- Practise approaching fish from below and shoot upwards
- When photographing bottom-dwelling subjects such as crocodile fish, make every effort to adopt an eye-level approach.

By adopting these upward attitudes and angles on subjects, you not only achieve better separation against the background and a sense of depth but also the subject gains a greater sense of prominence in the picture frame. Placing the subject on the proverbial pedestal, above the eyes of the viewer, will afford it greater attention!

Several exceptions to this general concept are discussed elsewhere in this book.

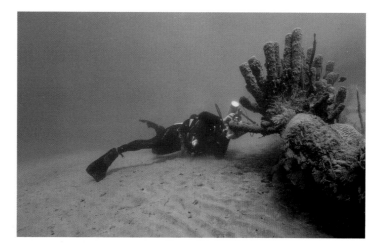

Figure 4.2
Consider the position of this photographer. If you cannot recall ever adopting this upward angle, then perhaps you have not been shooting up effectively. The wide positions of the legs encourage a stable position and allow the elbows to brace the camera, thereby aiding composition. With digital cameras, it also makes it much easier to view the LCD screen with limited movement of the housing. Taking up a bodily position like this underwater is unfamiliar and will feel uncomfortable at first, but with a little practice it becomes second nature. Contact with sand and rubble is acceptable; with the living reef is not.

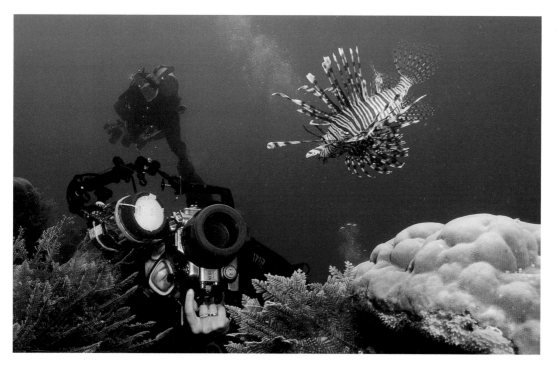

Figure 4.3
Ideally positioned below the subject, shooting upwards into a blue mid-water background.

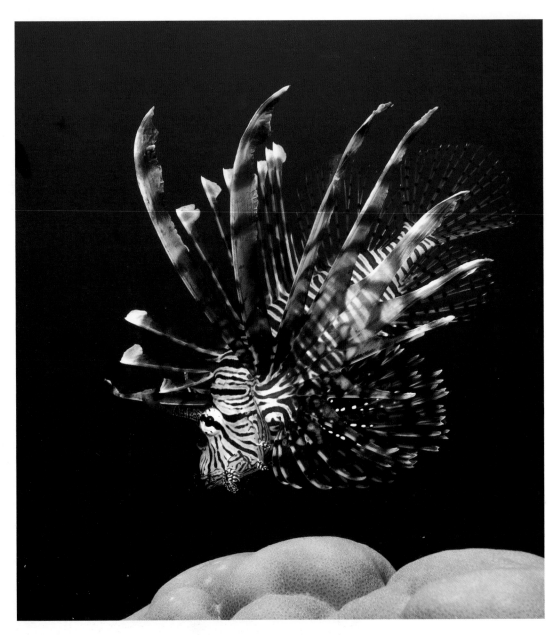

Figure 4.4
I too photographed this particular lion fish using an Olympus 5060 in its own housing, with an Ikelite DS125 flash, 1/125 s at *f*6. Notice how the fish is so prominent against its blue background. I used the coral in the bottom half to balance the composition. In Photoshop CS, I made a slight adjustment to the contrast and colour saturation. I applied the un-sharp mask filter to an amount setting of 110.

Figures 4.5 and 4.6
Compare these two shots of the same goby, one taken at eye level and one looking directly down from a bird's-eye view. Although they both display good negative space, most readers will feel more connected to the view at eye level than the one looking down.

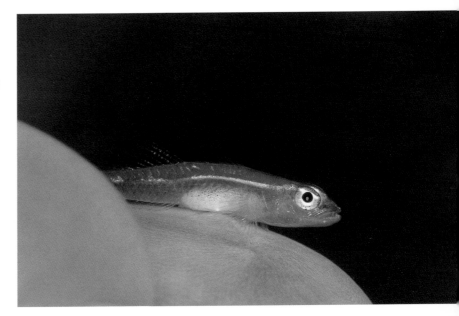

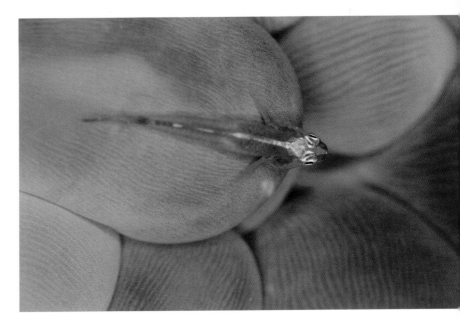

5 Preferable lenses and lens law

There is a plethora of photography books on the basics and the anatomy of camera lenses. I intend to concentrate on which lenses to use underwater and why. Throughout the book I am assuming that most, if not all, readers have a basic understanding of underwater photography, so that I don't have to reiterate the elementary principles and can 'drill down' to the real issues.

Two categories of lenses for underwater photography

There are lenses ideal for wide-angle and others for close-up and macro. Whether a built-in lens on a digital compact camera or interchangeable lenses suitable for film or digital SLR cameras, they are used in a different way underwater.

Underwater there is one particular factor that does not affect the land photographer: the water clarity and thus visibility. This significantly influences the choice and use of lenses.

In underwater photography it is vitally important to reduce the length of the column of water between the lens and the subject. The choice of lenses in underwater photography is directly related to achieving this aim – reducing the column of water.

Wide-angle lenses are capable of focusing very closely on the subject; they also have a wide field of view that can capture an expanse of seascape. This is one reason why wide-angle underwater photography is so popular, because it allows you to bring the beauty of a reef, for example, to life. This can be achieved at close range and, because you are shooting through a small column

Figure 5.1
Popular wide-angle lenses from
Nikon: the 16-mm fisheye, the
10.5-mm DX digital fisheye and
12 mm–24 mm DX wide-angle digital
zoom lens.

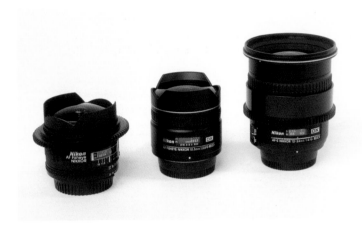

Figure 5.2
Wide-angle Canon EF-S
10-mm–22-mm zoom. Reproduced
courtesy of Canon UK.

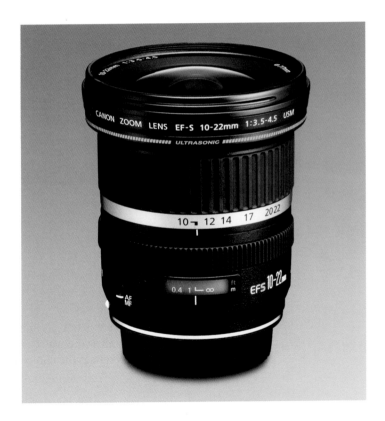

of water, the flashguns can bring out the true colour and sharp detail of each subject.

The other distinct advantage of using wide-angle lenses underwater is the increase in depth of field. The wider the lens, the greater is the depth of field. With a 16-mm fisheye lens, for instance, the

Figure 5.3
Canon EF-S 60-mm macro lens.
Reproduced courtesy of Canon UK.

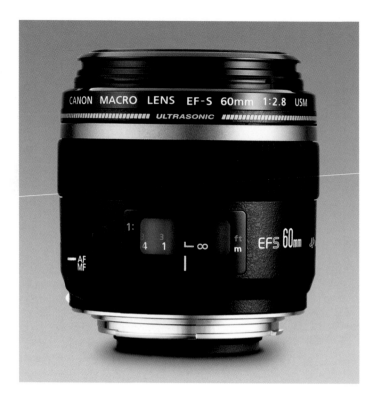

depth of field is so great that it is not unrealistic to pre-set focus at 1 m, safe in the knowledge that everything from 0.7 m to infinity will be sharp.

Macro lenses are also capable of focusing close to subjects but have a narrow angle of view, which makes them ideal for fish and small marine life.

Digital lens law

The most important difference between film and digital cameras is the reduced size of the digital sensor compared to a 35-mm transparency. When using a digital SLR, the angle of view seen by the camera sensor is less than would be seen across a 35-mm frame using film. This effect gives a magnification of around 1.5× or 1.6×. For example, using a Nikon 60-mm macro lens on a Nikon DSLR with a magnification factor of 1.5× provides a focal length of 90 mm. The 60-mm macro has a reproduction ratio of 1 : 1, also known as life-size. When used on a DSLR, the magnification factor is also multiplied by 1.5×, resulting in a magnification factor of 1.5 × life-size (one and a half). This is

Figure 5.4
Canon 100-mm EF macro lens.
Reproduced courtesy of Canon UK.

a great advantage for macro underwater photography as, for instance, a Nikon 200-mm macro lens becomes a 300-mm macro with a reproduction ration of $1.5 \times$ life-size – useful for shy macro subjects. Lenses of these focal lengths – 50-mm macro, 60-mm macro, 100-mm macro, 105-mm macro, 70-mm–180-mm macro zoom – continue to be popular for both film and digital capture.

The downside is that the wide-angle lenses so essential for underwater photography are increased by the same amount. A 16-mm fisheye becomes a 24-mm, a 17-mm–35-mm zoom lens becomes a 26-mm–53-mm zoom, etc.

New lenses for the DSLRs: wide-angle

Nikon, Canon, Sigma, Tamron and Tokina have designed lenses with a true wide-angle capability.

Nikon has released the 12-mm–24-mm F4 G ED-IF AF-S DX zoom. With the $1.5 \times$ magnification on Nikon SLRs, this lens is the equivalent of 18-mm–36-mm on film. The ever popular Nikon 16-mm full-frame fisheye now has a digital equivalent in the Nikon 10.5-mm fisheye. Nikon lenses also fit the Fuji Finepix Pro digital SLR cameras, which have incorporated the Nikon bayonet fit into their own design.

The Canon equivalent is the EF-S 10-mm–22-mm zoom. Canon DSLRs have a magnification factor of $1.6 \times$, which provides a 16-mm–35-mm coverage – ideal for underwater wide-angles.

Tokina has released the AT-X 124 AF PRO DX zoom, which fits both Canon and Nikon DSLRs. Its angle of view is in the region of 18 mm or 19 mm on digital at its widest, depending on the size of the camera's image sensor.

Figure 5.5
Sigma 10-mm–20-mm zoom lens.
Reproduced courtesy of Sigma UK.

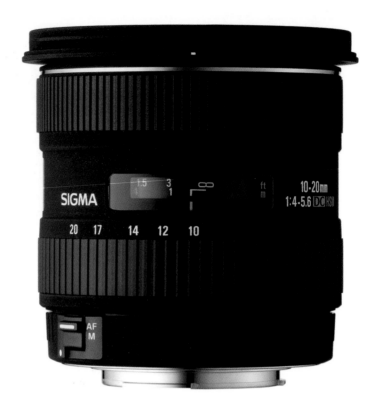

Sigma's equivalent is the 12-mm–24-mm F4.5-5.6 EX DG aspherical HSM lens.

Further information

Reviews on most popular lenses for both film and digital cameras can be found at www.naturfotograf.com, www.dpreview.com and www.wetpixel.com.

Websites of lens manufacturers mentioned above are as follows:

www.canon.com

www.nikon.com

www.sigma-imaging-uk.com

www.Tamron.com

www.Tokina.com.

You can read more about lenses in Chapters 42 and 43.

6 The trouble with zooms

With the increase in sales of SLR cameras in housings, both film and digital, zoom lenses have become more and more popular. The advantages of zoom lenses are obvious when compared to fixed focal length lenses, in that one single lens offers a range of focal lengths.

In the past, zoom lenses never quite produced the quality of performance demanded by the discerning underwater photographer. The popular choices for underwater use were the Nikon 24-mm–50-mm, Nikon 35-mm–70-mm and the Sigma 24-mm–70-mm lenses. They were neither a true wide-angle nor macro lenses, but a general-purpose option. With various lengths of extension they could be used behind dome ports with gears to control the zooming facilities. The fixed focal lenses capable of producing the quality required were (and still are) the Nikon, Canon, Sigma and Tamron equivalents to the 20-mm and 24-mm prime lens and the 60-mm macro and 105-mm macro.

Recent years have seen the introduction of true wide-angle zoom lenses, in particular the Nikon 18-mm–35-mm and the excellent (but pricey) Nikon 17-mm–35-mm zooms. Lens design has advanced, and these two models have been inspirational for many photographers. I myself have been using the Nikon 17-mm–35-mm lens since 2000, while my Nikon 20-mm, 24-mm, 28-mm and 35-mm lenses have been gathering dust!

Disadvantages of zooms

Zoom lenses have their shortcomings, and one disadvantage in particular. This has nothing to do with design, specification, or even the age-old debate on which is best – zoom or prime.

Figure 6.1
The excellent Nikon 17-mm–35-mm zoom lens.

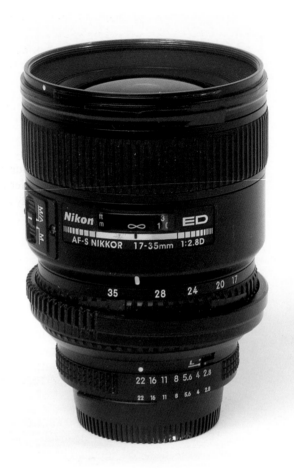

During the 1990s, I noticed a trend with a number of my underwater photography students. Their medium wide-angle (24-mm to 35-mm range) pictures were well exposed with good composition, but the focus did not appear as sharp as expected. The subjects were filling the frame, but the colour saturation also seemed drab. Over a period of months, I noticed similar results with other photographers. They were using reliable film and flashguns with accurate TTL, their close-up and macro work was very proficient, and their technique was good. So what was causing the problem?

Get physically close to your subject

I then had the opportunity of diving with a number of them on a photo trip, and the reason became obvious. Using the popular zoom lenses in the 24-mm to 80-mm range, they had become accustomed to using the zoom to get optically close instead of getting *physically* close to the subject. This had caused all the

problems! All their kit was up to the job, but the photographers were simply too far from their subjects to get colour, sharpness and quality. This was compounded by the versatility of the zoom lens in making the subject fill the viewfinder.

Once the problem was obvious, it was easy to rectify. However, the trend still exists among many other underwater photographers, who have not yet been made aware of it as one reason why their pictures are not as good as they could be. So get in close wherever possible: don't rely on your lenses to do it for you. Get into the habit of setting your zoom lens to its widest focal length as you enter the water. Get as close to your chosen subject as you physically can, and only zoom in when you need to fill the frame! If you are unaware of the cause of the problem, it can cause much frustration.

I advocate the use of wide-angle zooms, because their quality and versatility is outstanding. I would never be without my 12-mm– 24-mm digital lens and my 17-mm–35-mm lens when I choose to use film.

Further information

Reviews on most popular lenses for both film and digital cameras can be found at www.naturfotograf.com, www.dpreview.com and www.wetpixel.com.

7 The environment

The environment and its protection is, quite rightly, high on everyone's agenda these days. This includes concern for the seas, their myriads of species and the coral reefs. Many codes of conduct and environmental articles about photo diving also emphasise the need to avoid touching the reef as much as possible, and to take care with 'this and that'. Rarely do they tell you how you should achieve this in practice. It is not easy to get cameras and flash guns close in to the reef to photograph small subjects.

I lead many groups of underwater photographers to all parts of the world, and my groups have frequently been praised for the manner in which they approach their underwater photography. Here are some of my own tips for obtaining good shots without damaging the reef – tips that I would like to share with you. Some of the following may be 'old hat', but have protected many an underwater environment and made many friends around the world.

Subject accessibility

Around three-quarters of the subjects who live on, in or very close to the reef cannot be photographed, even by very experienced photographers, by virtue of their inaccessibility. There are two choices to get round this:

1. Shoot the subject from a distance whilst hovering above or to the side of the reef. Although this is unlikely to produce underwater photos of quality, it is an option, and may allow you to record a subject for the first time.

Figure 7.1
I took this photograph to illustrate the inaccessibility of a subject. This was the only angle I could achieve on the seahorse without the risk of damage to the sea fan. I was hovering in mid-water and had difficulty trying to focus. You can see that the subject is turned away, poorly composed, with distracting out-of-focus branches in the foreground. There was no solution to this except to move on and look for a more productive opportunity.

2. Dismiss the possibility of taking this particular shot in favour of finding a subject you can approach, get close to and photograph safely without any risk to the environment.

Conscientious underwater photographers do this all the time. Being shown numerous photogenic subjects by the dive guide is not necessarily a direct route to a successful photographic outcome. Let's take the example of a pigmy seahorse. On a muck dive in Sulawesi, my group was led to at least five individual locations for pigmy sea horses of all shapes, colours and sizes. All were very small to the human eye; however only one particular location appeared to be safely accessible so that we could approach, settle gently on the black volcanic sand, position the flashguns and take photos. Many of the other pigmies were surrounded by good negative space, they were more colourful and would have offered much better opportunities had we been able to access an area close to them without lying on the reef. We simply couldn't do that; we couldn't get in to shoot them, so we rejected the idea and visited the other, more accessible site.

More accessible areas for better photography

Maintaining good buoyancy and hovering a metre or so above the reef may allow a snapshot to be taken of just about any reef creature. However, very rarely will this produce anything more than just a snap. In fact, it is often impossible to get a decent shot from this position. If you cannot get a position on a subject without a struggle, simply reject the idea and search for subjects you can approach. The following areas should offer much greater potential:

- Areas where the reef gives way to coral rubble or sand
- Areas on the overhang where a flat reef may drop off vertically

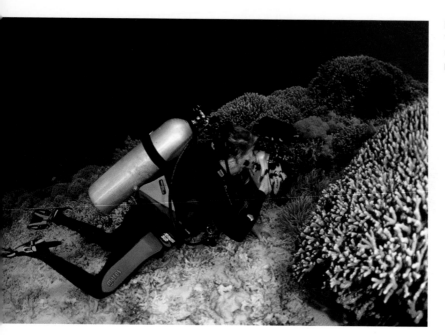

Figure 7.2
Where sand and coral rubble meets the reef is often productive for the photographer.

- Areas that are devoid of living corals but play host to small blennies, gobies and suchlike
- Areas of black volcanic sand, popularised by 'muck diving' photography, host an incredible amount of accessible marine life.

A flat reef of pristine quality, however beautiful it may look, can be totally unproductive as a photo dive if the only position the underwater photographer can adopt is one of hovering while pointing the camera downwards at a bird's-eye view angle. On the other hand, formations of brain coral, which host subjects like Christmas tree worms, small fish and other still life, can provide a great deal of interest and also be easily accessible. An area of sand around the base of the formation can be used to settle and frame the subjects, providing this is done carefully and skilfully, avoiding disturbing the bottom and inadvertently coating the corals with clouds of sand.

If there is a subject you are desperate to photograph but the only way to position yourself is by hovering above or around the reef, then it is much easier shooting wide-angle than using a close-up or macro lens. These types of pictures, however, require the disciplines of time, patience, buoyancy control and solid camera handling.

The gentle touch!

The two-finger technique is something which I encourage in other photographers, and I have found it is appreciated by resorts and dive-guides everywhere. It is simply the practice of making

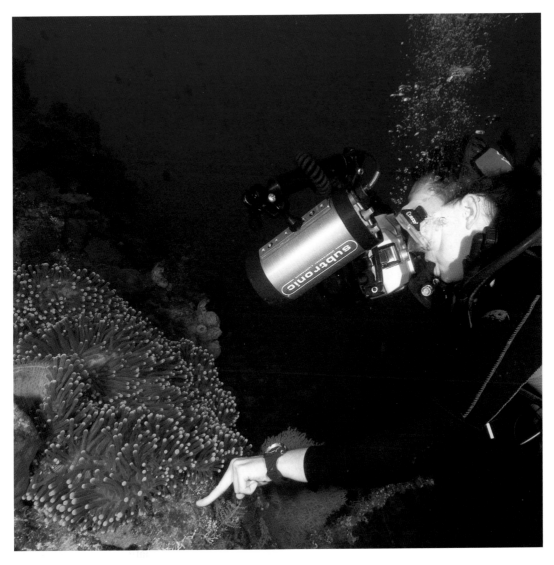

Figure 7.3
The two-finger technique is an excellent way to steady yourself at close range with the minimum of effort required to stay still. It is also easy to exit the area by pushing away with one or two fingers, rather than trying to use a finning action.

acceptable contact with portions of the reef consisting of non-living rocks or sandy areas. It has to be done carefully, however. If you have good buoyancy control and a correctly configured and balanced camera set-up, you can hold the housing in your right hand whilst using two fingers of your left hand to lightly steady yourself on non-living rocks, not the living reef. This is an excellent way in which to get close but without the risk of making contact. With practice, you will be able to steady yourself at close range with the minimum of effort required to stay still. When the picture opportunity is ended, then lightly pushing away from the reef with one or two fingers is all that's necessary.

Avoid collisions

Most collisions occur when people move away from the reef in an undisciplined way. They may be excited over what they've just shot, itching to check the digital LCD, and simply lose concentration for a moment. Forgetting about your fins can bring on that 'sinking' feeling in your stomach, when you are aware that your fins have caught on something and you know it's the reef before you even turn to look. If you do find yourself in that position, stop finning! Use the air in your lungs or your BC to lift you clear of the reef. Whenever you move in to take a picture close to the reef, just take a second to consider how you intend to make your exit. If you feel any doubt that you cannot get in to shoot it, then stop! Back off and find something you can shoot comfortably.

Flash hand-held techniques

More damage is caused by fins inadvertently kicking the corals than by any other camera-related carelessness. As a result, I no longer advocate the use of hand-held flash techniques in any underwater photography conducted on or close to the reef.

Holding the housing in one hand and the flash in the other, you immediately have less control over your buoyancy. While this is fine for open-water photography, it can cause problems closer to the reef. Versatile flash arms have been available for a number of years, and these can replicate most hand held positions. With two hands on the housing, or using one hand and the two-finger technique, you'll be more aware of your stability.

Underwater camera set-ups

Macro and close-up facilities with frames and prongs (e.g. on Nikonos and Sea & Sea cameras) have never helped reef conservation. If you do want to continue using such cameras for close-up and macro, you may like to consider upgrading to a housed system. With the advent of digital, there are many second-hand film SLR systems on the market at outstanding value. You will find it much easier, and with SLR macro lenses the flexibility it gives you for photographing smaller subjects is excellent.

The 105-mm macro lens has a longer working distance to subjects than does the 60-mm macro. At life size with a 60-mm lens and depending on the length of the 60-mm port, minimum focus need be no more than a few centimetres from the subjects. If you have a penchant for small, shy subjects, invest in a 105-mm macro lens.

My favourite lighting set-up for macro is the ring flash. Unobtrusive to fish, and reef-friendly in nature, it makes it much easier to shoot macro using the two-finger technique in and around the reef.

Figure 7.4
A wide-angle photographer displays excellent buoyancy control whilst shooting sponges in Dominica. Notice that he has two hands holding the housing, whilst his flash is connected by a long flash arm.

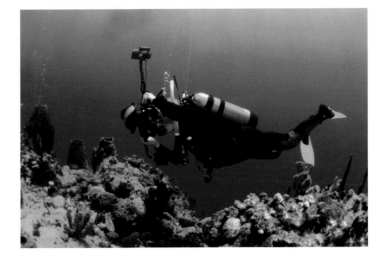

Flash arms are often too long for close-up and macro work, so strip down to the bare essentials. Use only the smallest flash arm to do the job. If there are items attached to the housing and not required for the task, then remove them. This will minimise the chance of inadvertent contact with corals and allow you to get closer. The ergonomic balance of your rig will improve, which will make picture-taking easier all round.

Give Subal elbow the elbow!

Ever heard of Subal elbow? Some of you may know it as Nexus or Seacam elbow. It occurs in the right or left elbow, and is caused by the weight and strain of your camera rig over a period of time. By reducing the length of your flash arms, you reduce the weight of your rig – and in turn this will reduce elbow strain.

Buoyancy arms

I have two sections of ultralight buoyancy arms for both my close-up and wide-angle lighting systems. They consist of sections of buoyant arms which counterbalance the negative weight of the camera housing. Not only does this help to eliminate Subal elbow; it also provides a better balanced camera system for both close-up and wide-angle use.

Touching, poking and moving

Prodding the nudibranch to 'help' it climb a little higher up the finger coral to get a better background, persuading the scorpion fish to look your way with a light poke of a flash arm or cajoling a puffer fish into a crevice is unnecessary; there are plenty of other opportunities. Let us all stop doing it, and encourage others to do the same!

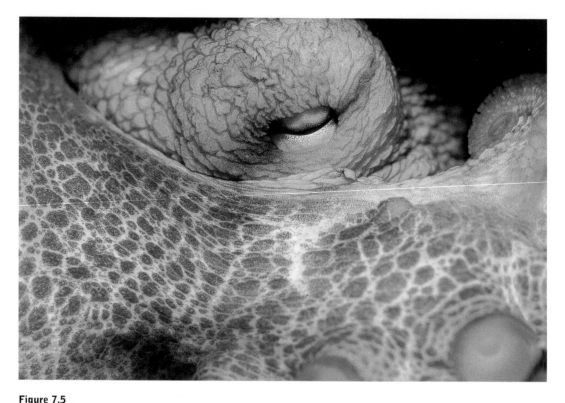

Figure 7.5
I was with two other photographers when we found this octopus in the waters around Bonaire. We limited ourselves to two shots each.

Nikon F90x, 105-mm macro lens, Subal housing, ring-flash on TTL, Kodak VS, 1/250#s at *f*16. Captain Don's Habitat, Bonaire.

Just too many shots

There comes a time when a seahorse, octopus or perhaps a puffer fish has been exposed to the flashgun going off just once too often. No-one can be prescriptive about this, but we all have a sense of when enough is enough. Next time you feel this, indicate to your buddy or the dive guide that you want to move on to something else.

Buoyancy

One-on-one buoyancy refreshers

These can be conducted by a dive guide at any resort in the world. For the underwater photographer who may have been out of the water for some time, a formal refresher is an ideal way to build technique and confidence all at the same time.

Some resorts advise trimming your buoyancy on a check-out dive with your normal camera equipment. Others will encourage a

Figure 7.6
On this occasion, the opportunity allowed me to get close to the subject, position my flash guns and concentrate without the concern of being too close to the reef.

buoyancy check without your camera. Whatever the case, the majority of camera set-ups tend to be negatively buoyant and you need to fine-tune yourself whilst carrying the equipment you intend to use on a photo trip.

Your weight is paramount
Dive tanks differ in size and weight from one resort to another, so adjust and trim your weight accordingly on each photo trip. You will know when your buoyancy is correct, as you should be neutrally buoyant at your 3-m decompression stop at the end of

the dive. I recommend a pouched zip-up weight belt for underwater photographers diving on a coral reef. This allows weight to be removed or added quickly and efficiently for those photo dives when you want to reduce or increase weight for different depths. Leg weights should not be used on a reef. If you have a problem with your legs floating, then an adjustment to your tank and or your weight belt is usually the answer.

Position of bottle and buoyancy control
It's a generally held view that, if you fix your tank so that the strap of the buoyancy control (BC) is towards the lower half of the tank, then your legs will tend to float more when hovering or swimming in the horizontal. It's trial and error with each person, but it works for me – so give it a try!

Dangling hose and gauges

Make sure that nothing is hanging below your body when swimming or hovering horizontally. There are numerous types of clip to fasten depth gauge, BC straps and other equipment out of harm's way.

Towards a better underwater environment

There is an infinite number of photo opportunities, but many are simply unphotographable by virtue of the subject's location in, on or around the reef. Make an assessment. If it looks problematic, then forget it and continue your search. You will find the same species in another photographer-friendly situation, perhaps not during that dive or at the same location, but you will find the opportunities. When you do, take advantage and enjoy the experience. You will be content in the knowledge that you have behaved with integrity and at the same time done your bit for the environment of the reef and the life around it.

Note

8 Image quality, megapixels and sensors

One question regarding digital imaging crops up over and over again. It concerns the number of megapixels in a camera, and many underwater digital photographers are continuously monitoring the recent releases of digital SLRs and the smaller consumer compacts. Not so long ago, a six-megapixel (MP) camera was the ultimate. That figure soon rose to eight megapixels, and the latest Nikon D2x and its Canon counterpart, the EOS-1DS Mark 11, now boast twelve and sixteen megapixels respectively.

Image quality is not just about the amount of megapixels; it also depends on other factors, such as the quality of the camera's sensor, its dynamic range and its ability to reduce digital noise.

Megapixels are more about size than quality. If you are printing photographs up to A4 (210×297 mm) or A3 (297×420 mm) size, you will not see any difference between a six- and an eight-megapixel camera. However, if you begin to print much larger images, then the extra pixel count starts to be significant. The number of pixels in a camera mainly affects the size of a print, and not the quality of the image.

Sensors

Digital camera sensors are not all the same. Whilst two sensors may both have eight megapixels and may be CMOS in type, they will differ from camera model to model. Digital image quality is also related to other factors, such as tonal range, noise reduction and (most important to the underwater photographer) the ability to deal with highlights. One major objective of digital camera manufacturers has been to enable a digital sensor to deal with

highlights in the same way that film is able to capture them. Improvements in highlight capture have been substantial in recent Nikon and Canon models, while the latest digital from Fuji, the Finepix S3 Pro, has a unique sensor. It has twelve megapixels, but uses the additional six megapixels to build a more accurate tonal range, particularly in the highlights. The Nikon D2x SLR camera clearly illustrates that highlights in the form of underwater sunbursts can be comparable with those achieved with film because of the advancement of sensor technology.

So do your homework when thinking of buying a new SLR. Check reviews which comment on the qualities of such things as tonal range, colour range, noise reduction and the ability to capture detail in the highlights.

Further information

Chapters 19 and 20 provide further information regarding digital compact and SLR cameras.

Websites that may help include:

Canon EOS-1DS Mark 11
www.dpreview.com/articles/canoneos1dsmkii
www.wetpixel.com/i.php/full/subal-cd1d-housing-for-canon-1d-1ds-mk-ii/

Nikon 2DX
www.wetpixel.com/i.php/full/nikon-d2x-and-subal-nd2-review

Fuji Fine Pix S3 Pro
www.dpreview.com/reviews/fujifilms3pro
www.wetpixel.com/i.php/full/fuji-s3-pro-10-stop-dynamic-range

9 Memory cards

A memory card is the recording medium whereby digital image data are electronically stored. Memory cards are effectively the equivalent of digital film. The starter card that comes with most digital cameras hardly holds any photographs at all; it is fine to test whether the camera is working properly when you first buy it, but you will soon require at least one extra card.

There are several types of memory cards available, including Compact Flash, Memory Stick, Secure Digital, Smart Media and xD-Picture Card. Memory cards are rated at different speeds.

You can record more images on a memory card using lower resolution than at higher ones. Cards come in various sizes, from sixteen megabytes to eight gigabytes. A sixteen-megabyte card, for example, holds anything from a few to more than 150 images, depending on the file size and compression settings.

Handle a memory card carefully according to the manufacturer's instructions. Insert it into your camera or memory card reader in the correct direction, and never force it. Remember always to turn off your camera before inserting or removing a memory card. Never shut the camera off or remove a card when a photo is being written (saved) to it!

Removable cards

If you take lots of pictures, buy a digital camera that accepts high-capacity removable memory cards. Before you buy a high-capacity card, make sure it's compatible with your camera by checking the manual or contacting the manufacturer.

Figure 9.1a
Whilst the 256-MB compact flash card is suitable for JPEGs, it is too small for RAW files.

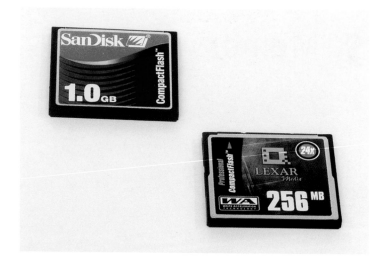

Figure 9.1b
The high-capacity 8-GB card.

At least two memory cards, each of at least one gigabyte in size, are recommended. The advantages of having two one-gigabyte or two-gigabyte cards is that if you should lose or damage one, there will be less shots lost on these cards than on a four- or eight-gigabyte card. You can't download or change a card mid-shoot, which is why a 500-megabyte card is too small when shooting RAW format with SLRs. With the advent of digital cameras that can produce both a RAW and JPEG files at the same time, many photographers are updating to two- and four-gigabyte cards.

Finally, avoid Micro Drive storage cards; they are yesterday's technology, fragile and unreliable. A buddy of mine dropped one from no more than a metre in height, and it completely failed.

10 File types: RAW vs JPEG and TIFF

There is a great deal of discussion regarding whether to shoot JPEG or RAW. It's not confined to underwater photography, and appears to have come about for two main reasons:

1. Digital enthusiasts see the RAW format as the professional approach to photography. This is borne out by current trends, digital photography magazines, Internet news groups and such like. The ethos among professional photographers, both land and underwater, appears to be 'shoot RAW'.
2. All digital SLRs and the vast majority of compact digitals have a RAW capture facility. The higher-end models provide the user with the choice to shoot a RAW plus a JPEG at the same time.

RAW stores every piece of data the camera has recorded from the sensor. It's become a bit of a cliché, but think of a RAW file as a digital negative that has yet to be processed in the digital darkroom. At first glance, a RAW image appears to be the best option for many photographers. It offers exceptional flexibility:

- Numerous aspects of the original data captured at the time the exposure was made can be adjusted
- You can fine-tune by adjusting the white balance, exposure, hue, contrast, colour and much more without impairing the image at all
- It really helps underwater photographers to address all the challenges relating to exposure, colour and the blue water cast.

JPEG is the most commonly used format there is. One advantage is that JPEGs can be compressed, so a large image can be

squeezed into a small portion of memory. The highest-quality JPEG file settings produce quality of a standard that is indistinguishable from other types of file such as a TIFF. However, if you want to enlarge a JPEG print to the size of a large poster, then it may not provide the quality unless you are using cameras of eight megapixels and above. For almost everything else, JPEG is a worthwhile option. If you get the exposure and white balance wrong in the camera, adjustments can still be made in Photoshop, but not with the same degree of control and flexibility as RAW! When you shoot high-quality JPEG, the technology inside the camera effectively processes the file for you. The result is a finished image that can be burnt to disc or printed out at home.

With *RAW plus JPEG*, innovations in digital camera technology now allow you to have your cake and eat it. Digital cameras that shoot a RAW plus a JPEG file create two picture files for each shot. Take care to select white balance accurately, and be critical regarding exposure (use the histogram to fine-tune). As a result, you have an efficient way of viewing your pictures and printing, emailing or submitting them to publishers, for instance. If you need to adjust the exposure or you think you have a great image that can be used for publication or a competition, you simply dig out the RAW copy and convert it as normal.

TIFF

TIFF files should not be overlooked in this file vs file debate. Not all digital cameras will offer TIFF as an option; however, when they do you have another comparison to make between TIFF and JPEG. TIFF files will always be of higher quality than JPEGs. The main problem with TIFF is that it creates a large file size, which will cause your camera to slow down when trying to write your images to the memory card. This delay can hinder attempts to shoot action pictures, for example. If the highest possible quality is your objective, then RAW format is a better choice than TIFF, because it is much more versatile and smaller.

Figure 10.1 (Opposite page)
This shot was taken in Dominica. Although I shoot RAW for all my underwater work, on this occasion I shot JPEG. I have blown this image up to 12 × 8 inches and compared it to other close-up shots taken with RAW and then converted to TIFF in computer. I cannot tell any difference between the two. I cloned some backscatter from the top portion of the frame and cropped the composition to eliminate a piece of unwanted, very reflective background. This has taught me to evaluate the LCD more closely whilst underwater. I could have corrected these weaknesses at the time if I had looked more closely at the mistake I made.

In conclusion . . .

If you enjoy the digital imaging experience and have the time and motivation to spend on the computer, then RAW is without doubt one of the most innovative and flexible concepts to emerge from the digital revolution. On the other hand, if you have a load of RAW images from your photo/dive trips and have a problem in finding the time to 'process' them, then you should consider the JPEG option or RAW plus JPEG.

One thing is for certain … do everything possible to get the photograph as precise as you can in camera – exposure, composition, sharpness. It makes it so much easier to choose which pictures to retain and process, and which to delete.

My own choice is to shoot RAW underwater. I rarely expose more than five or six ideas on a given dive, then edit mercilessly. When I need to spend time in front of a computer, I use Photoshop CS RAW converter. However, I am now starting to see excellent, colour saturated, sharp JPEGs from the recent DSLR releases from Canon, the EOS-1DS Mark 11, and the Nikon 2Dx. They are producing JPEGs far superior to my own RAW conversions from a Nikon D100. These latest cameras are reducing the time that photographers have to sit in front of a computer, so there may soon come a time when I myself will be shooting high-quality JPEGs!

11 Digital ISO and noise

ISO settings

An advantage of the digital camera's ISO setting is that it can be altered to suit the photographic circumstances. With film, when the light gets poor you load a faster film (such as 400 or 800 ISO) which is more sensitive to light. With digital all these options are built in to the camera, so if the light gets poor you can always increase the ISO setting. Most digital cameras now have a minimum ISO of 100. This can be a definite advantage when you are diving a wreck in 30 m of water and you lose the sunlight behind clouds. It's then impossible to light the entire wreck with flash, but the natural light becomes too low for a decent exposure. An option is to open the shutter speed, but the trade-off is sharpness when hand-holding. The downside to setting a higher ISO is that the pictures may suffer from noise. Noise is like the grain you get from high-speed films.

'Noise'

The higher you set the ISO on digital cameras, the more 'noise' becomes visible. Noise manifests itself by the presence of colour speckles where there should be none – so instead of a blue-water background you may notice faint pink, purple and other colour speckles in the otherwise blue water. The same phenomenon can also occur when shooting close-ups with a black background at high digital ISO settings.

One of the major differences between a compact digital camera and a digital single lens reflex (DSLR) is that the former may

produce images with a lot of noise when using high ISOs and/or long exposure times, while the latter is practically noise-free. Just what is noise, and how can it be eliminated or minimized?

Causes of noise

A higher ISO amplifies the signal received from digital light photons. Amplify the signal and you amplify the background electrical noise that is present in any electrical system. In low light there is not enough light for a proper exposure, and the longer the image sensor is allowed to collect the light, the more background electrical noise it also collects. A larger image sensor means that the photo site can be larger, giving it a larger light-gathering capacity. It is therefore able to generate a larger signal-to-noise ratio. That's why a digital camera with six million pixels crammed into a smaller image sensor has more noise (especially at high ISOs) than a does a six megapixel digital camera using the much larger image sensor.

There are a number of things to remember about noise:

- Long exposures can introduce noise
- A higher ISO introduces noise, so try to use the lowest setting possible
- Digital SLRs are practically noise free.

In-camera reduction of noise

Manufacturers have incorporated noise reduction algorithms into their software when either slow shutter speeds are used or the ISO setting is increased. Depending on the digital camera make and model and the algorithm quality, these work to a certain extent.

Practically noise-free digital SLRs

Digital SLR images are virtually noise-free because they have a larger image sensor than do digital compacts. With a larger image sensor, each pixel can be larger and each photo site can be slightly further apart from its neighbour. This extra distance is often enough to prevent signal leakage from one photocell onto another – hence much less noise!

Until recently noise was a fact of life in consumer compact digital cameras, but manufacturers have made enormous in-roads to reduce issues like noise and shutter lag. Don't be put off going digital, but check the reviews on your intended camera purchase before you do.

Further information

There is further information on digital noise in Chapter 19.

12 Resolution

Resolution is a measurement of the output quality of an image, usually in terms of pixels, dots, or lines per inch. The terminology varies according to the intended output device.

Pixels per inch – ppi – is a measurement of image resolution which defines the size an image will print. An image that is 1600 by 1200 pixels at 300 ppi will print at a size of 5.3 × 4.0 inches, or it could be printed at 180 ppi for a printed size of 8.89 × 6.67 inches. The higher the ppi value, the better quality print you will get – but only up to a point. 300 ppi is generally considered the point of diminishing returns when it comes to inkjet printing of digital photos.

Dots per inch – *dpi* – is often used interchangeably with ppi, causing a lot of confusion. Dots per inch refers to the resolution of a printing device, defining how many dots of ink are placed on the page when the image is printed; dpi does not correspond directly with ppi because a printer may put down several dots to reproduce one pixel. The higher a printer's dpi, the smoother your printed image will appear, provided you have a suitable amount of image resolution. Today's photo-quality ink jet printers have a dpi resolution in the thousands (1200–4800 dpi). They will give you acceptable-quality photo prints of images with 140–200 ppi resolution, and high-quality prints of images with 200–300 ppi resolution.

Often images are referred to as high resolution (hi-res) or low resolution (low-res). High resolution is an image intended for print, generally having 300 dots per inch or more. Low resolution

refers to images only intended for screen display, generally having 100 pixels per inch or less.

Camera manufacturers often refer to two different types of resolution when listing product specification – optical resolution, and interpolated or digital resolution.

Interpolation is a process where the software adds new pixels to an image based on the colour values of the surrounding pixels. Interpolation is used when an image is un-sampled to increase its resolution. Re-sampling through interpolation is not ideal, and can result in a blurry image.

Optical resolution is often listed along with the interpolated resolution in referring to camera specifications. The optical resolution is the true measurement of what can be captured, while the interpolated resolution should be disregarded as a purchasing factor.

13 Digital white balance

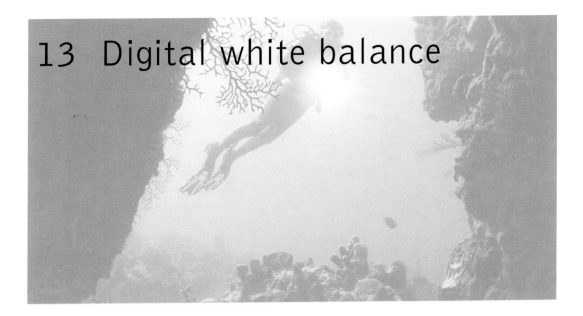

With film cameras, you have to change film in order to correct for colour casts during the moment of taking the photograph. Digital cameras have built-in white balance settings, making life so much easier. The colour of light underwater has different characteristics from the light on land. The deeper you go, the more light is diffused – so at 30 m deep, just blue light remains. For natural colouration it's usual to select a custom white balance setting before shooting. Options differ from camera to camera, but the usual ones are: auto, direct sunlight, fluorescent, incandescent, flash, cloudy, shade and preset (also known as custom white balance).

Auto white balance

Many underwater photographers set 'Auto' and then adjust the white balance to suit their taste in a RAW converter or Photoshop. Personally, I find that the blue water colour produced by auto white balance is quite unappealing.

Custom white balance

Most digital cameras allow you to preset your own personalised white balance. Methods vary from camera to camera, but the idea is to take a grey card underwater, and meter the reflected light falling on the card. To do this, you hold it in front of the camera and follow your camera's instructions to set custom white balance. You may think this is pointless, because you can easily alter

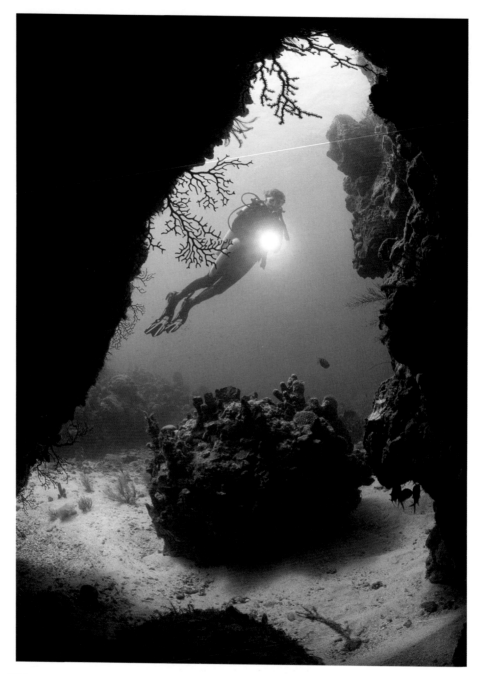

Figure 13.1

Whilst I took this cave-diver image on a RAW setting of cloudy, I much preferred the natural tones provided by the white balance colour picker in Photoshop CS RAW converter (which looks like an eye-dropper). To sample an area of the image, click the colour picker on a neutral tone such as sand or rocks. This will often produce a pleasing white balance snapshot, but take care with flash-lit photos as the colour picker can produce horrendous colour casts. Also consider setting 'preset' custom white balance in your camera during the dive. I encourage you try all these different methods for yourself.

Nikon D100 and 10.5-mm fisheye in Subal housing, 1/180 s at ƒ8, ISO 200, cloudy WB setting, two Inon Z220 flash guns attached to the housing but turned off.

Figure 13.2
Four examples of white balance options in Photoshop's CS RAW converter.

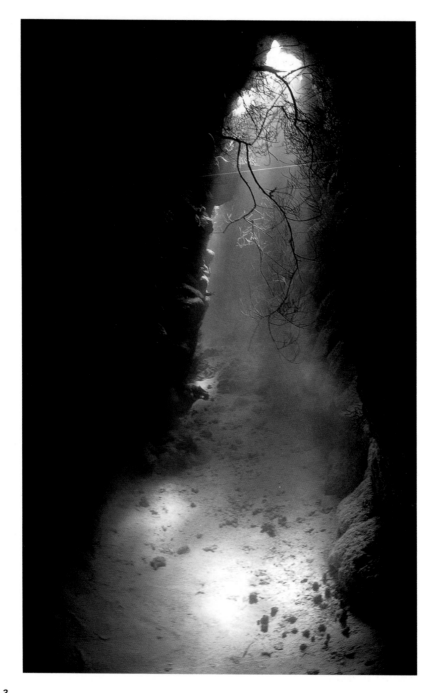

Figure 13.3
I spent one entire afternoon shooting the sunlight within the shallow cave system at St John's reef in the southern Red Sea. I chose to 'preset' my white balance within the camera. I left my flash guns on the boat to make it easier to work my rig without the bulk of lights and flash arms. Using a 10.5-mm fisheye lens, I took a meter reading on the sand illuminated by the sunbeams. I braced my housing against a rock inside the cave, which enabled me to select a slow shutter speed of 1/8 s at f8. The rock acted as a tripod, and I was successful in achieving sharp focus on the majority of opportunities. One bonus was the fan coral, which I found was tinged with red once I had adjusted the exposure in Photoshop CS RAW converter.
 Nikon D70, Subal housing, 200 ISO.

the white balance setting in a RAW converter. The popular consensus, however, is that it is far better to get the colour temperature of the light as accurate as possible in camera at the time.

Personally...

I find that the white balance setting of 'cloudy' consistently produces warm tones that produce realistic and pleasing blue-water backgrounds. It also reduces some of the cyan (blue) cast so often found in underwater digital photography. Currently I shoot RAW for flexibility and adjustment purposes, and I can view my results on a laptop soon after the photo shoot has finished. The current edition of Photoshop CS has a very good RAW converter. After downloading my photo-dive files to laptop I open up my RAW files via the CS converter, where I can adjust my white balance setting to any of the other WB options. The WB converter also facilitates other subtle adjustments, allowing a great deal of control. When shooting in blue water with flash and converting in RAW, I rarely adjust the WB setting to anything other than 'cloudy.' However, with natural light images I do use the white balance colour picker in the RAW converter (which looks like an eye dropper) to sample an area of the image of a neutral tone, such as sand or rocks. This often produces a pleasing white balance snapshot. I would encourage you to try different methods for yourself.

I find it important to reproduce the tones of the blue water displayed in the LCD review monitor as closely as possible to the *actual* blue water colour and tones as they appear to me. The brightness level on my LCD monitor (which can be altered in the custom menu on the camera) is minus 2. This realism gives me excellent feedback and enthusiasm to shoot, quite unlike anything I experience with film, and the pleasing colour of blue water which the 'cloudy' setting captures on my D100 certainly inspires me to shoot wide-angle!

Colour preferences are personal to each and every one of us. You can research all the various white balance settings options on the underwater photographic Internet forums listed in 'Internet resources, equipment suppliers and useful names and addresses' at the back of this book.

Further information

See Chapter 21 for further discussion concerning white balance settings.

14 Workflow and photo trips

Workflow is a necessary requirement in this digital age. In the most simplistic terms, it means helping your work to flow more easily from start to finish – from the photographs which you capture in camera to the finality of printing or publication. For the purpose of this book, there are three parts to take into consideration:

1. Taking the underwater image
2. Downloading images
3. The digital darkroom.

Taking the underwater image

When you take a photograph, your camera writes a file to its memory card. Choose either RAW or JPEG, or a combination of the two. The RAW vs JPEG debate is discussed in detail in Chapter 10.

Downloading images

At some point your memory cards holding your digital pictures will become full and you will need to download them to a computer station, a laptop or portable hard-drive storage. For downloading, I strongly recommend you use a memory card reader. The advantage is that you don't have to remove your camera from the housing – you simply remove the memory card from the camera and place it into the card reader. Card readers hardly need an introduction, but there are several types available and care should be taken in choosing the best one. The things to bear in mind are connectivity and the speed of data transfer. If you

Figure 14.1
Compact flash card reader.

Figure 14.2
Epson FlashTrax storage device.

download from 2-GB or 4-GB memory cards, it's a good idea to choose a high-speed option.

Downloading to a storage device is a similar process. Some come with an LCD display and a video output capability to view your stored images on TV. Others come with a built-in hard disk purely intended as a back-up and mass storage device for digital photographers. The norm is 40 GB plus.

Laptops

It's of little use enhancing the colours on a laptop during a photo trip unless this screen bears some resemblance to your monitor screen at home. If you use the same laptop at home and abroad for all of your workflow, then consider having it calibrated. I carry my laptop to all destinations, and download my memory cards via a card reader. Many underwater photographers use this option (laptops are now treated as free hand luggage by most airline companies). The downside is power, as you need a direct supply for this option to be efficient. However, there are very few photo/dive locations where you cannot charge batteries and dive torches etc.

My own workflow during a photo trip

I carry three 1-GB compact flash cards with me at all times. If I shoot RAW, that's a total of 312 pictures. My downloading workflow is once a day via a compact flash card reader. Next I create Folders on my laptop in 'My Pictures' on Windows XP to copy the image files into. I also create a Word document in which I briefly record underwater photographic information regarding the photo dives made that day – for example:

- Location
- Camera type, lenses, flash guns, length of flash arms
- Flash positioning
- Subject matter
- My own feelings about my performance in terms of creativity, buoyancy, photo technique, mistakes made, etc.

Once I have downloaded from my compact flash card to laptop, I open up Photoshop CS and review the contents of the Folders via the excellent File Browser preview facility. I name Folders and group images either by technique (i.e. wide angle, macro, natural light, etc.) or by subject matter (shrimps, blennies, nudibranchs, etc.). I rarely delete anything in camera via the LCD unless it's appalling! Time permitting, I examine the laptop and delete obvious blunders, including focus and compositional errors. Finally, I burn the files taken that day to one or more CDs, which are labelled with the location so I can find the photo information in the future.

At the start of each day's photography, knowing that my pictures are safely on my laptop and copied to disc, I then delete the files on my compact flash card by using the in-camera 'Format' command.

I review some of my results to determine how they can be improved technically, compositionally or creatively by pursuing new ideas. My laptop images are also made available to other photographers as a part of the photo workshop and learning process. I illustrate to others:

- How an idea may have developed in my mind's eye
- How many shots I took to get the one that worked the best
- How I tried different compositions and lighting angles
- How I may have had the wrong lens on for the subject
- What I intend to do tomorrow to improve on an idea.

Digital darkroom workflow

After returning from a photo expedition, you normally have one of two options:

1. If your laptop containing your pictures also doubles as your home computer, then your pictures are already filed within it and ready placed to begin the digital darkroom process.
2. If, like me, you have a home computer, you now have to transfer your files. This can be done by downloading from your laptop, portable storage device, compact disc or DVDs. I copy my CDs to folders within 'My Pictures' (similar to my laptop workflow when on location). On no account do I delete my CDs; these are my original RAW files, which I retain indefinitely.

At this point I create Folders on my home computer, and try to group them as I copy my CDs over. I name them as, for example, Wrecks, Fish, Macro, Caves, etc.

Adobe Photoshop CS File Browser

A browser is an application that is necessary for you to manage your photographs and the way in which your work flows. There are many image management packages that contain features far more sophisticated than the File Browser built-in to Adobe Photoshop CS; however, I have found this to be the easiest to use.

A distinct advantage of this package is that it allows you to view previews of all of your RAW files and, by the click of a mouse, open up the RAW file into Photoshop CS's own RAW converter.

To open File Browser, go to Photoshop CS File > Browse. Think of the small thumbnails to the right-hand side of the preview as a viewing table, similar to how transparencies are examined and edited on a light-box.

Figure 14.3
Photoshop CS File Browser.

It is best to free-up as much space as possible on the 'light-box' view so you can view your thumbnails and decide on *deletion*, *keepers*, and *best-shots*. The Folders Palette (top left) is used to search for and open up your photographs within a named folder. Once this has been achieved, the size of the Folders Palette can be reduced by clicking your mouse on the horizontal bar and dragging it upwards towards the tab marked 'Folders'.

The Metadata and Keywords tabs can also be moved into the Folders Palette by clicking on the tabs and dragging them each in turn up to where the Folders Palette is.

This has not only left plenty of room for a preview, but also when you click on either of the other three (Folders, Metadata, Keywords) they will be in a larger window and easier to read.

Now, click your mouse on the centre of the vertical divider situated to the left of the thumbnails and drag it over to the left-hand side of the screen so only the thumbnails are visible.

Just above the preview window showing details of the folder, you will see five small menus listed: File, Edit, Automate, Sort and View. Open the View menu and click on Small, Medium, Large or Custom Thumbnail size to understand the viewing options and sizes you have available to you. I tend to opt for Large Thumbnail Size, but it is subjective so choose for yourself.

Rotate

Images that you shot in the vertical format in camera may appear sideways, depending on what model of camera you were using. (The latest digital cameras now have a facility which can automatically rotate your verticals both on your camera's LCD monitor and in File Browser). Simply highlight the thumbnail with your mouse and then click on the Rotate icons situated on the CS

File Browser menu bar – the circular arrows, which can be rotated either clockwise or counterclockwise.

As you work

CS File Browser can also Flag your images. At this stage in the digital workflow, you will have made decisions about those images you like best and ones which you may like to work on in Photoshop to see what can be achieved. You simply highlight the thumbnail and click the Flag icon, which is situated next to Rotate. A small icon of a flag will appear in pink in the bottom right-hand corner of the thumbnail. If I wish to view only those images I have flagged, I select View > Flagged Files from the menu within File Browser. I may want to look at all the images that I have decided not to flag, in which case I go to View > Unflagged Files from the same menu. To view the entire folder, go to View > Flagged and Unflagged Files.

Deletion

At this stage in your workflow you will see images that you now know should be deleted. If the focus is poor or the composition's weak and cannot be corrected by cropping the image, then consider right-clicking the image and choosing Delete. It's hard but necessary!

Large preview

PS File Browser lets you view a large preview of a thumbnail as you scroll through them all. Simply grab the vertical divider which you moved to the left to show all thumbnails, and drag it back to the right and leave enough space for one or two vertical column of thumbnails over on the right-hand side of the screen.

As you continue to consider the strengths and weakness of particular images, you will find yourself switching back and forth between preview and thumbnail views in order to make conscious decisions about those you intend to discard or to retain.

JPEG workflow

If you have chosen JPEG as your in-camera file type, then it is a matter of clicking the selected thumbnail. This opens the picture in Photoshop CS window ready for attention (if necessary).

RAW workflow

If you have chosen RAW as your in-camera file type, you will open the file up into the RAW preview and converter which is integrated within Photoshop CS.

Figure 14.4

Photoshop CS File Preview view.

Figure 14.5

Photoshop CS Metadata view.

This is where you make subtle changes to an image in terms of white balance, exposure, shadows, brightness, contrast and saturation.

Before you get to this RAW converter stage, you have been unable to zoom in on a preview to check for sharp focusing. However, now's your chance – the % view menu is situated beneath the preview in the bottom left-hand corner. Zoom into the preview, and if the centre of interest and the main focal points are un-sharp then once again consider deletion.

The RAW converter has other features and advanced options which are beyond the scope of this chapter.

Make any corrections to the image that you feel are necessary in terms of exposure, white balance adjustment, saturation, etc., and when you are satisfied with your adjustments click on 'Update' and your RAW conversion is now complete.

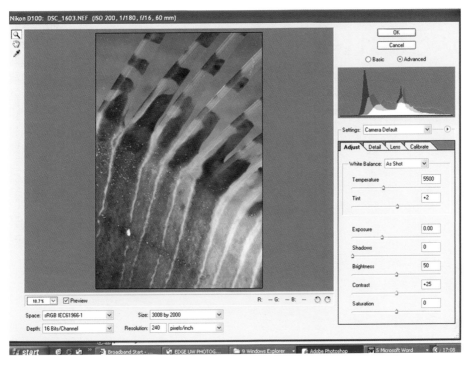

Figure 14.6
Photoshop CS RAW converter window.

Photoshop CS

Your image now appears within Photoshop CS, and you can work on it to your satisfaction. At this point, it is recommended that you save it in the TIFF format.

When processing my JPEGs or RAW files from a photo trip, I set up two folders named 'RAW or JPEGs Pending' and 'RAW or JPEGs Finished', depending on which type of file I am working on at the time.

Conclusion

I cannot emphasise enough that that this is just one method of managing your underwater images. Other popular ones are ACDSee and FotoStation. All digital SLRs and compacts are supplied with a Browser on the CDs. While many of you will have already devised a system appropriate to your way of working, I would encourage you to:

- Keep it as simple as possible
- Enjoy the process – it should be fun!
- Copy your processed enhancements of either your RAW or JPEGs to CD or DVD, and save, protect and archive these for your continued enjoyment.

15 Shutter lag

Shutter lag is the length of time from when you press the shutter release button until the camera actually takes the photograph. There is a combination of two processes at work:

1. Auto focus lag. When you press the shutter button, the camera attempts to search for an appropriate focus point. This auto focus mechanism is often very slow, and causes most of the delay.
2. Shutter release lag. Once the camera has determined the appropriate focus distance, the camera triggers the shutter mechanism. In some cameras this process takes longer than in others, but it is usually not as significant as the auto focus lag.

Shutter lag is one of the biggest complaints from underwater photographers about digital compact cameras. Shutter lag times vary from camera to camera. The majority of new digital compact cameras have improved auto focus, shutter release and write-time, and therefore have little or no shutter lag. With digital SLRs, shutter lag is now a thing of the past. Examples of ways in which you can reduce shutter lag include the following:

- Use fully charged batteries
- Buy a high-speed memory card
- Anticipate the moment. To minimize shutter lag time when taking action shots, try to anticipate the 'peak of the action'. Track the action of a subject with your shutter release button pressed halfway down, using 'continuous focus' mode. You'll hear the camera focusing as it's tracking the subject. Lag time will be greatly reduced when you fully depress the shutter release button.

Buying a digital camera

Before committing yourself to a digital compact camera, test the shutter lag time. If you are buying over the Internet, then go to one of the numerous digital camera Internet review sites. You can easily find the shutter lag times of your intended purchase in this way.

Further information

There is further discussion on this topic in Chapter 19.

At the website www.dcresource.com/forums/archive/index.php/t-2657.html you can obtain information applicable to your own equipment.

16 Understanding histograms: the digital underwater photographer's best friend

The histogram is one of the most valuable tools available in digital underwater photography. It is also the tool that is often the least understood. Digital cameras, from point-and-shoot compacts to digital SLRs, can display a histogram directly upon the image which has just been taken. On most cameras the histogram is displayed on the LCD screen. It can be programmed to do this on the image that is displayed after a picture is taken, or later when frames are being reviewed.

What does it do?

In simple terms, a histogram allows you to check the precise exposure of the picture you have taken. A graph displays the brightness levels of every single pixel value. These levels are found from the darkest to the brightest, and the values are displayed across the bottom of the graph from left (darkest) to right (brightest).

The vertical axis (the height of points on the graph) shows how much of the image is found at any particular brightness level.

Figure 16.1

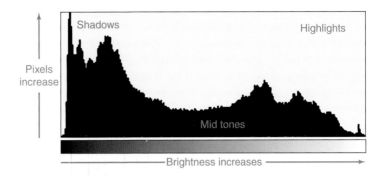

Figure 16.2
This is the shape we are looking for.
Notice that the histogram ends at the
bottom of the graph towards the
right-hand side, which means there
are no pixels that have been 'burnt
out' resulting in lost detail.

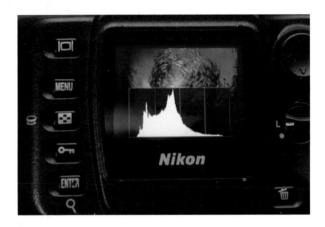

Figure 16.3
The luminosity of histograms which
measures black pixels to white with
lost detail 256 pixels.

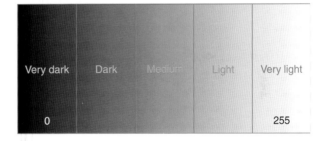

To achieve good exposures in underwater photographs, it is important to check the histogram to ensure that the highlights have not been 'burnt out'. The terms 'burnt out' or 'clipped' mean that the black graph on the right-hand side of the histogram has ended suddenly. A histogram that ends at the bottom of the graph towards the right-hand side means that there are no pixels that have been 'burnt out', thus resulting in lost detail. This is what you're looking for!

Highlights feature

As well as a histogram display, many digital cameras have a 'highlights' feature which can be activated so that areas of lost pixel detail flash on and off repeatedly on the camera's LCD review

Figure 16.4
Take a look at the right side picture. Which pixels look 'burnt out?' Look at the scales of the fish. You can see that they are too bright. How can the exposure on the scales be reduced? The solution is to reduce the flash power and shoot again, recheck the histogram and ensure that the right-hand side does not end suddenly.

screen. To correct the error, simply reduce either the aperture or the shutter speed or the flash power so that the screen no longer indicates lost detail. Making an exposure adjustment will now correct the contours of the histogram to an acceptable exposure.

A digital image can tolerate an amount of underexposure, as detail can often be recovered and then easily and quickly corrected in an imaging program such as Photoshop. However, where the highlights are overexposed and the pixels are bunched up on the right-hand side of the histogram, it cannot be corrected.

Using a histogram underwater

Use the histogram review on your digital camera when you take pictures, although in certain lighting conditions it may be difficult to view the LCD monitor. Some are better than others, but even the top of the range digital SLRs can be frustrating. Confirm your exposure with the histogram – it's significantly more reliable than your eye! You may choose to set your camera to display the histogram after every picture. Get into a routine of checking it for exposure. If you have 'burnt out' the highlights and the opportunity is worth a second attempt, then do it again – but this time consider reducing the exposure.

How to adjust for the correct exposure

If light from your flashgun has 'burnt' the highlights, then reduce the flash power. If it is the natural light that is at fault, adjust either the aperture or the shutter speed.

By using the histogram to determine exposure, you will begin to learn a lot about your images. However, it is important to remember

Figure 16.5
The strength of this image is the sunbeams illuminating the shallow cave system in the Red Sea. The histogram in Photoshop indicates that highlights are 'burnt' on the right-hand side. Sunlight is often recorded in this way. If we underexposed these beams, the atmosphere would be lost.

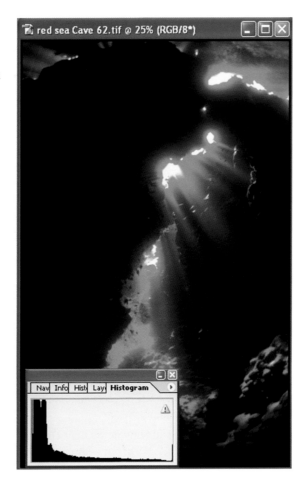

that as long as the highlights are not clipped or burnt out on the right-hand side of the graph, you will have a good histogram.

Wide-angle histograms: there are always exceptions

Some wide-angle compositions and ideas may feature highlight detail within the image which results in a burnt-out histogram. It does not always mean that it's wrong and should be avoided! A diver's torch, sun shafts and clouds visible through the under surface are all typical examples. In these circumstances, it is a judgement call by the photographer – it may be appropriate, given that white is the colour of these elements.

Histogram tips

- Remember to check the histogram whilst underwater, at the time.
- Do not depend on the appearance of the LCD review monitor to determine exposure; instead, use the histogram for accuracy.

Figure 16.6
I cannot imagine a scenario where I would choose to lose highlight detail in an example such as this. In the main, close-up and macro photographs will benefit from a histogram where no highlight detail has been lost.

Nikon D100 in a Subal housing with 60-mm macro lens and two Sea & Sea YS 90-DX placed each side of the port, f16 at 1/125 s. Dominica, Eastern Caribbean.

- If you have 'clipped' the highlights and the histogram ends suddenly at the light end (right-hand side), you have pixels that are burnt out without detail. Think about reducing the exposure.
- In close-up and macro photography where a flash is normally the only light source, a 'clipped' histogram should generally be corrected.
- With wide-angle, if clipped highlights are appropriate to the composition then consider retaining the image as it is.
- Test yourself. It's fun to try and work out what shape the histogram of a photograph might look like. You can do this on land with everyday objects.

17 Capturing sunbursts with digital cameras

Digital cameras are unable to record sunbursts in the same attractive and dynamic way as can transparency and colour negative film. Bright highlights of this nature don't only plague underwater photographers; land photographers also suffer. In response, camera sensors are rapidly improving, particularly with digital SLRs. Some well-known camera manufactures have increased the flash sync speed of the shutter to 1/500 s. This appears to be the key in capturing acceptable sunbursts, as the faster shutter speed freezes the sun's rays. Nikon D70 and Canon 20D digital SLRs are a substantial improvement on digital compacts and my very own Nikon D100 SLR. For my own personal needs, when shooting wide-angle into the light I continue to use transparency film (Ektachrome VS 100 ISO on a Nikon F100).

At the time of writing, towards the end of 2005, both Canon and Nikon have two high-end professional DSLRs on the market. Personal accounts and reviews from underwater photographers using these latest models are very encouraging. Their sunburst examples appear to be no different from a transparency when both are made into prints.

Check out the Nikon D2x and the Canon EOS-1Ds Mark 11.

Figure 17.1
This was taken with a Nikon D100, 10.5-mm fisheye lens at 1/180 s shutter speed on f11. The manner in which the sunburst has recorded is typical of earlier digital SLRs. The sensor in my D100 is unable to hold highlight detail. Recent digital cameras have improved on the quality of sensors and the shutter–flash synchronisation speed. Unfortunately, too many compact digitals still display this weakness in wide-angle underwater photography.

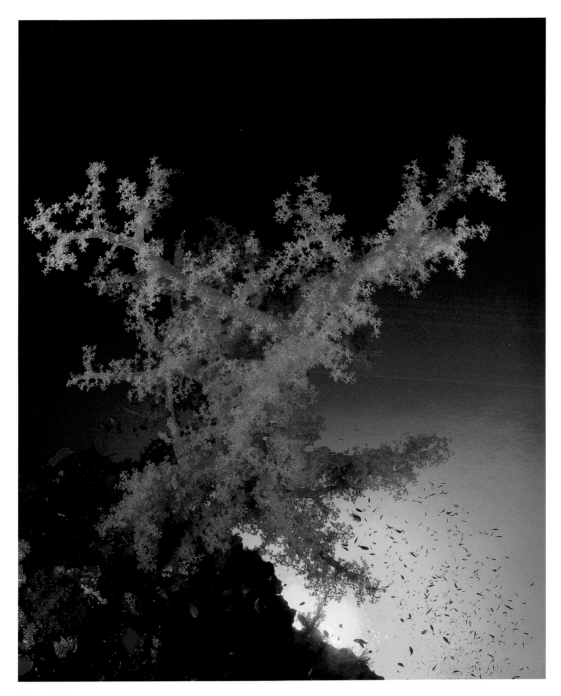

Figure 17.2
It has been found that the best compromise in these circumstances is either to hide the sun ball behind the subject out of view of the camera lens, or to exclude it from the composition altogether. This was taken with the same camera and same lens on the same dive as Figure 17.1, with precisely the same settings. Not only does this technique address the highlight problem, it also often results in a stronger picture by enabling the sun to provide a sparkle without overpowering the primary subject.

18 Using the LCD screen

The LCD is a tremendous source of feedback for the underwater photographer and, from a technical point of view, it works in the same way as a Polaroid print did some years ago.

Digital cameras are better than Polaroids because not only are they far superior in quality but also you can also see everything more quickly, including composition, colour and exposure. In the Polaroid era, it was unusual for outdoor photographers to take a Polaroid snapshot in the field. If ever they did, it was always as a test for the real thing and not the real thing itself. The advantages of the LCD review to the underwater photographer are enormous.

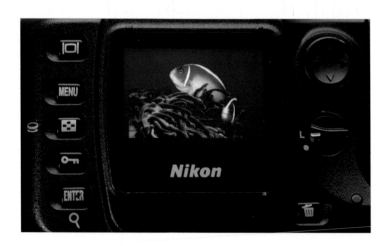

Figure 18.1

Practical uses underwater

Have you ever found yourself shooting something you thought was colourful, only to find that it is really quite bland and insipid? Then take a digital snapshot! Don't worry about composition or focus at this point – just take a shot to test for the colour. If it's too dull for your taste and intentions, then look elsewhere.

In close-up and macro, you should always be looking for areas of outstanding negative space on which to photograph the subject. So, take a digital snapshot simply to determine the colour and quality of negative space.

How many times have you said to yourself, 'I just cannot believe how colourful this has turned out – it was so dull-looking at the time'? Get into the habit whilst underwater of looking for colours with your digital camera by using the LCD review as a tester.

Ever seen a particular underwater technique you like in a book or magazine? Take a snap of it before you get into the water so it is visible on your LCD to remind you of an idea or a technique you might wish to try.

Get your photo buddy to take a snap of your housing, flash set-up, etc., so you can attach it to your own results from that particular photo dive.

The ideas above are not the finished picture itself. The idea is to take the information you obtain from these 'Polaroid snapshots' and immediately apply it to a subject – but this time with thought, concentration and patience.

Underwater photographers who use their LCD screens in this way seem to have more fun than the rest. They climb the boat ladder waxing lyrical about their discoveries.

Learn to use the LCD in bright places by swimming into a shadowed area or your own shade. If you find that your LCD is difficult to see and read, talk to your underwater camera retailer about viewing accessories such as LCD hoods and magnifiers, which can improve your underwater photo experience. Or try contacting Ken Sullivan at ken.sullivan@ntlworld.com – Ken has once again transformed an idea of mine into reality by constructing a LCD viewer that slips into the recess of the LCD compartment on popular makes of digital camera housings. This viewer enables me to check the LCD for precise composition and content underwater, even in bright conditions. I can spot errors and faults in my pictures, which often enables me to reshoot an idea before I return to the surface.

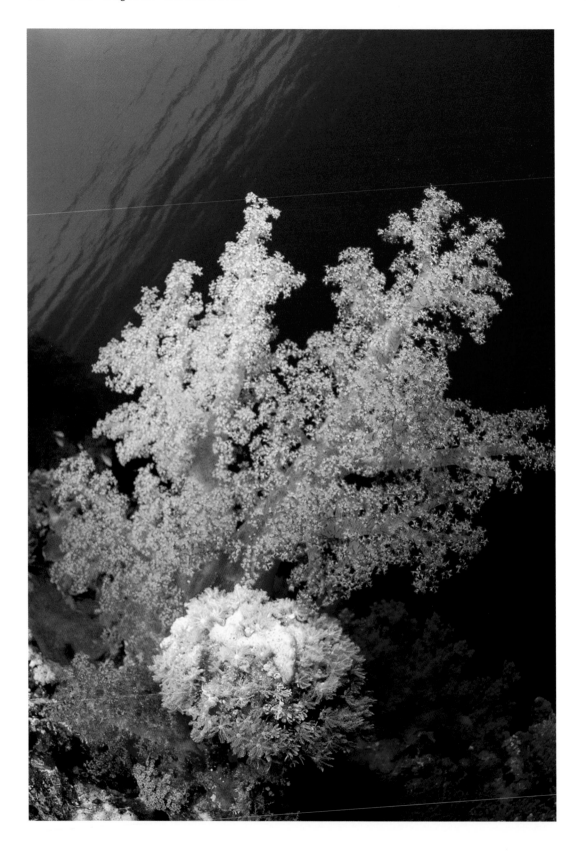

Figure 18.2 (Opposite page)
This image was taken using an Olympus 5060 camera in an Olympus housing with a wide-angle attachment. The flash gun was an external Ikelite 125 with various power settings in order to control the output. Aperture was *f*11 with 1/100 s shutter speed, and the ISO set at 200. I entered the water at the Elphinstone, Red Sea with the intention of shooting wide-angle soft corals. I chose a beautiful pink coral which was accessible to approach, compose and light. It was an easy opportunity. However, I never noticed the circular white piece of hard coral growing on the base. As you can see, the pink soft coral is a splendid specimen, but the image is totally flawed because of the reflective circular rock on the base. I have no excuses! I simply did not view the LCD properly. If I had done so, I would have seen the flaws in the frame and simply selected another branch of coral which was more photogenic and pristine. My attitude has changed since that early experience with digital. I now regularly take digital 'snapshots' just to test for a subject's condition and ask myself the question, will this subject make a pleasing photograph? Whilst underwater, use your LCD review screen in the best possible way. It's the best tool we have.

Figure 18.3
Ken Sullivan-designed LCD viewer of digital SLR housing.

Figure 18.4
Whilst the LCD viewer slots into the compartment, it is not intended that it be attached to the housing through-out the dive. I carry it around my neck on a lanyard. After a photo opportunity, I make every effort to fix the viewer and critically review my efforts. If dissatisfied, and if at all possible, I will return and reshoot before returning to the surface.

Figure 18.5
Photographer reviewing the LCD
before returning to the dive boat.
Image reproduced courtesy of
Shannon Conway.

19 Digital compact cameras

Daniel Beecham

For underwater photographers who do not want to tackle the bulk and expense of a DSLR, there exists a range of cameras that deliver exceptional image quality and flexibility but have much lower starting costs.

The production of polycarbonate housings for consumer-level cameras such as the Olympus C7070, Sony P150 and Canon S70 has made it inexpensive to submerge cameras that offer features which in the past were only available on more expensive SLRs.

Whilst digital compacts have their advantages and disadvantages over SLR systems, many of the photographic techniques – including composition, positioning of strobes, white balance and the use of filters – remain the same and so can be applied to all systems. There are, however, some major differences, and these need to be considered carefully.

A camera and housing on its own can produce impressive results, but you are limited by the flexibility of the built-in lens and flash on the camera. Many manufacturers of underwater photographic equipment produce an impressive range of accessories, including wide-angle lenses, close-up lenses and external flash units, all of which can be added onto a compact camera housing system.

Choosing a camera

As you begin to consider choosing a camera, the massive range of models available on the high street can be bewildering. The choice can be reduced when choosing a camera for underwater use.

From the outset, ascertain which cameras have housings available. It may sound obvious, but many have been caught out buying a camera and assuming that there is a housing available, or expecting the release of one in the near future.

For popular compact cameras, there may be more than one housing available. Many camera manufacturers, including Olympus, Canon, Sony, Nikon, Fuji and Pentax, have produced housings for compact cameras, but there are also housings made by independent manufacturers such as Sea & Sea or Ikelite. Generally these tend to be more expensive than those made by the camera's own manufacturer, but may offer unique features not available on an own-brand housing. At the time of writing, many consider the Olympus range to be the most versatile own-brand housings on the market. Filter threads are a standard feature on the Olympus range, which leaves you much more choice in the range of accessories that you can attach in the future. This also stops you having to use adapters to add accessories, which can be expensive and often introduces many more parts to the system.

Check that the camera and housing combination you plan to use will accept the accessories that you may need for the future. For example, if you plan on exploring wreck photography, then you'll need to make sure that the system you choose will accept a wide-angle lens, otherwise it may not be appropriate for you.

Choosing to select those models that offer you aperture and shutter priority modes can reduce your choice of camera further. Many models of digital compact cameras only have fully automatic exposure systems, which may not offer you sufficient flexibility for use underwater.

Figure 19.1

Disadvantages of compacts

Shutter lag

The main disadvantage of a digital compact is shutter lag – that is, the small time delay between pressing the shutter release button, and the image being recorded. This happens because the camera's on-board computer takes time to adjust its settings, focus and record the new image. With an SLR camera, the only delay that may be experienced is the auto-focus locking onto the subject. When you first use a camera with shutter lag it can be very frustrating and distracting, especially if you're used to the instant shutter release of an SLR. If the camera is too slow, it can stop you getting the picture you intended.

There is no way to eliminate shutter lag completely, but there a few techniques you can use to try to reduce it:

- If you pre-focus on your subject (by half depressing the shutter release), the camera will record the image faster than if you fully depress the button in one movement.
- When using lower-quality settings, the shutter lag will again be less noticeable; this is because the camera has to wipe the previous image from the CCD when taking the next picture. A higher resolution image will take longer to wipe than a low resolution image.
- Shutter lag may often increase when using flash. By using natural light, or a filter, the shutter lag will not be as problematic.

Check out the reviews and shop around before making your choice. The only way to know for sure is to test the camera's shutter lag before you buy. For many subjects shutter lag may not present, but for faster-moving subjects such as fish, turtles and sharks it can be a very frustrating issue. If you choose to use a compact camera, then shutter lag is a problem you will have to face. Carefully consider whether or not the subjects you plan to shoot will be workable. If not, you may be forced into using an SLR.

ISO

Compact cameras have a very limited ISO range, typically from 100 to 400. This can be a problem if you plan on shooting in low light levels. A DSLR normally has a much larger ISO range, typically 200–1600.

Compact cameras also often produce much more noise at higher ISO settings than do SLRs.

Advantages of compacts

Cost

One of the key benefits with compact cameras is the initial start-up cost, which is much lower than that of a digital SLR. With a

Figure 19.2
A typical Olympus dual-flash wide-angle system.

compact you can start with a camera and housing and then build the system as and when you choose, exploring different aspects of underwater photography one at a time. With a DSLR you generally have to invest in a camera, lens, housing, port, flash and flash arm to get a system up and running. If you do not have a particular part of that system, you may not be able to take pictures underwater.

Size and weight
A full DSLR system can be very large and heavy. With most airlines enforcing a hand luggage limit of five kilograms, these systems can be difficult to travel with.

A housing system for a compact camera will be much smaller and lighter, even when using a system with wide-angle lenses and external flash units. Generally, a system like this will be small enough to fit inside a rucksack and be carried onto the plane, avoiding costly excess baggage charges.

Supplementary lenses
One of the nice things about supplementary lenses for compact camera housings is that they are 'wet lenses', and can be removed and replaced underwater to suit your subject. You can also add 'lens caddies' into your system, which attach onto flash arms. A caddy allows you to carry more than one lens on a dive and makes the lenses easily accessible.

Wide-angle lenses and adaptors
The principles of wide-angle lenses on digital compact cameras are the same as on DSLRs. Lenses such as the INON UWL100,

Figure 19.3
Wide-angle lenses and adaptors.

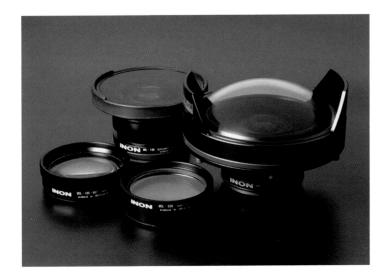

the Epoque DCL-20 or the UN PWC-01 provide around 100 degrees of coverage underwater, equivalent to a 20-mm lens on a 35-mm SLR. There are not many lenses on the market that offer you wider coverage, but the INON UFL165 AD is one of the few that does. A maximum coverage of 165 degrees makes this lens ideal for wreck photography.

An important consideration when choosing a wide-angle lens is how it attaches onto the housing. Some are attached via an adapter and lock on with a 90-degree twist, while others simply screw into place. When using a screw-fit lens you can use colour corrective filters at the same time, which offers you even more flexibility.

It's a good idea to use these lenses at the camera's widest zoom setting, as this tends to yield the sharpest possible image.

Close-up lenses
Most compact cameras have a built-in 'macro' function that typically allows you to get 10–15 cm from your subject, where you will be able to light it evenly using the built-in flash. If, however, you find that you want to gain higher magnification of a small subject, or want to try and capture shy critters that will not allow you to get close, you can add an additional close-up lens onto the outside of your housing.

Close-up lenses are available in both screw and bayonet fittings; these can be stacked together to provide even higher magnification.

Digital compacts and external flash guns

In some situations, the built-in flash on a compact camera will be sufficient to light your subject effectively. There are, however,

Figure 19.4
Two fibre-optic cables from each flash gun slip into a recess near to the camera's built-in flash. This in turn triggers the external flash. Notice the perspex mask, which blocks the extraneous light from the pre-flash.

numerous circumstances where an external flash is required. These include:

- When working in limited visibility
- When using wide-angle lenses
- When attempting creative lighting techniques
- When shooting a shy subject from a distance.

Connections

The principles of flash photography are the same when using either a compact or a DSLR, but there is a significant difference in the way in which a flash unit connects to and communicates with the camera. When the built-in-flash is used on a compact, the camera emits a series of pre-flashes before the main flash fires and the image is recorded. These pre-flashes help the camera to achieve focus and determine camera settings. Because of this built in pre-flash system, we require the external flashgun to ignore the pre-flash and fire simultaneously with the built-in-flash. If you attempt to use an older flash (one designed to be used with a film system), this external flash will fire too early and will not have time to recycle and fire on the main flash.

Most digital compact cameras do not have a flash connector that is accessible through the camera housing. Consequently, external flash units designed for compacts work as a 'slave' which is triggered by the built-in flash on the camera via a fibre-optic cable rather than an electronic sync cord.

The cable mounts onto the housing in front of the built-in flash. When the built-in flash fires, light travels up the cable and hits a slave sensor on the flash unit, telling it when to start and stop firing. Early strobes that were designed for compact cameras used an 'auto' system to control the power output. With an auto system, you selected an appropriate aperture on the camera and set the same aperture by a dial on the flashgun; this gave the correct exposure.

Figure 19.5
A flash gun compatible with compact camera housings. Notice the selection of power settings on the left-hand side.

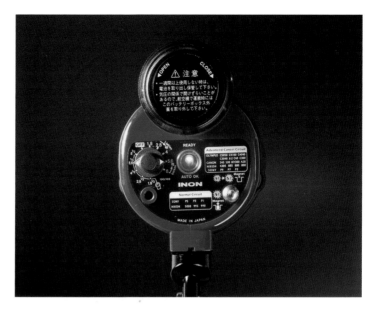

Recent strobe design, such as the INON D2000, now provides a type of 'TTL' system. This has been achieved by building a slave sensor that actually copies everything that the built in flash does, including the pre-flashes. These flash guns also feature exposure compensation controls so that the power output can be easily adjusted to achieve the desired result.

Instead of allowing the built-in flash to fire towards the water column, where it may cause backscatter, it is normally 'masked off' from either the inside or the outside of the housing. A mask is stuck onto the built-in flash which absorbs all visible light, allowing only infra-red light to fire forward, which triggers the slave (external flash unit).

When flash units compatible with compact digital cameras first became available, people cried out for TTL. Many were deterred by the prospect of having to work with manual and auto systems. TTL is now readily available, but many photographers continue to work with manual flash, preferring the amount of control and flexibility it offers the user.

LCD magnifiers

LCD magnifiers are available for some systems. These slide onto a compact camera housing in place of the standard LCD hood, and greatly increase the size of the image being displayed. They are also useful for enlarging the appearance of camera settings that people with poorer eyesight may have difficulty reading.

Summary

Compact cameras meet the needs of most underwater photographers; the vast range of accessories available for these cameras makes them capable of handling many tricky subjects. There are, however, some situations where only an SLR will do the job; superior lens quality, instant shutter release, a wider ISO range and higher resolution makes them essential for many photographers.

The author can be contacted at www.danbeecham.com/ *and* www.wild-productions.com.

All images in this chapter are courtesy of Ocean Optics/INON.

20 Digital SLRs and housings – what's on the market?

Digital SLRs

At the time of writing, the DSLR market for underwater enthusiasts is growing strongly. By the time this book hits the streets in 2006, the popularity of certain models may have diminished and others might have taken their place. Whilst Nikon had the monopoly of the underwater film era, it is encouraging to see how Canon has developed into a predominant force with digital SLRs, providing more than one choice for the user. Here are the current leading contenders, in no particular order.

Canon

The Canon EOS 350D is excellent value for money, and comes with a high-performance 8.2 million pixels and CMOS sensor. It is the lightest digital SLR body on the market at this time; it has an ISO speed of 100–1600, a maximum flash sync speed of 1/200 s, and a 1.8-inch TFT LCD screen with 118 000 pixels. A full review can be seen at www.dpreview.com/reviews/canoneos350d

The Canon EOS 20D has a high performance of 8.2 million pixels. It has an ISO speed of 100–1600 plus Hi (ISO 3200), a maximum flash sync speed of 1/250 s, and a 1.8-inch TFT LCD screen with 118 000 pixels. The viewfinder coverage is 95 per cent. A full review can be seen at www.dpreview.com/news/0408/04081909canon_eos20d.asp

The Canon EOS-1DS Mk11 is a 16.7 million-pixel successor to the Canon EOS-1D Mk11. It has a full-size 35-mm (36 × 24 mm) sensor, which means that a 50-mm lens on this camera will provide the same field of view as it would a 35-mm film camera. The

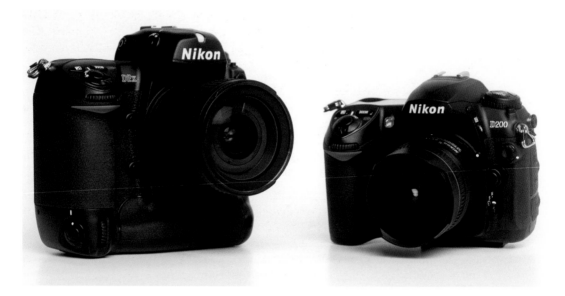

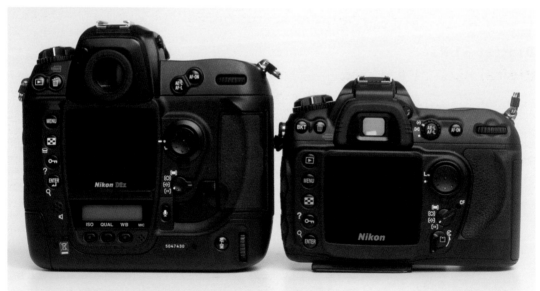

Figures 20.1a and 20.1b

During the production stage of this book, Nikon released the long awaited high-resolution digital SLR to replace the enduring D100. Called the D200, it employs technology from the top of the range D2 series but, as you can clearly see when compared with the Nikon D2x, this model maintains the handy proportions of its predecessor. Its CCD sensor has been up-rated to 10 megapixels and the flash sync speed is now 1/250 s, which provides the extra flexibility in capturing credible sunlight shots that the D100 hardly managed to achieve. The D200 uses a new, more versatile autofocus system, making it much faster and easier to capture moving subjects in low light conditions. A bonus for the underwater photographer is the 2.5-inch LCD, which incorporates a 230 000-pixel monitor with ultra wide-angle visibility. The D200's new viewfinder is big and bright. Its holographic LCD illumination replaces conventional LEDs. This means the autofocus segments are invisible when they are turned off, leaving an impressively clear viewfinder. The D200 retains similar dimensional proportions and weight to those of its predecessor, the D100. Notice the size comparison of the D200 and D2x, both front and rear. It is a huge advantage to us that Nikon has retained the larger LCD of its big brother, the Nikon D2x.

fastest flash sync speed is 1/250 s, with an ISO range of 100–3200. The LCD screen is 2-inch TFT with 230 000 pixels. The viewfinder coverage is an impressive 100 per cent. A full review can be seen at www.dpreview.com/articles/canoneosldsmkii/

Nikon

The Nikon D70s is excellent value for money, with 6.1 million pixels and an impressive fast shutter sync speed of 1/500 s. The ISO range is 200–1600, and it has a 2-inch TFT LCD screen with 130 000 pixels. The viewfinder coverage is 95 per cent. A full review can be seen at www.dpreview.com/reviews/nikond70/

The Nikon D2x has, if one camera has done so, taken the topic of digital underwater photography to another level. It has 12.4 million pixels, a fast shutter sync speed of 1/250 s, and an ISO range of 200–6400. It has a big, 2.5-inch TFT LCD screen with 235 000 pixels. The viewfinder coverage is 100 per cent. A full review can be seen at www.dpreview.com/reviews/nikon2x/

The Nikon D200 has just been released (December 2005). This is the long-awaited high-resolution digital SLR to replace the Nikon D100.

Digital camera housings

There are numerous makes of housings available for those cameras listed above and others not mentioned. It is beyond the scope of this book to discuss the advantages and disadvantages in any detail.

Various manufacturers tend to be popular in different countries throughout the world. In the UK, for instance, two particular housings are popular: Subal, and Sea & Sea. A full list of housings available for DSLRs worldwide follows:

AquaTech	www.aquatech.com
Aquatica	www.aquatica.ca/
Bruder	www.mediasub.com/Montages_e.htm
Fantasea Line	www.fantasea.com
Gates	www.gateshousings.com
Hugyfot	www.hugyfot.com
Inon	www.inon.co.jp
Jonah	www.jonah.co.kr
Light & Motion	www.uwimaging.com
Nexus	www.oceanoptics.co.uk/nexus
Sea & Sea	www.sea-sea.com

Figure 20.2
Sea & Sea housing for Nikon D70
camera together with Sea & Sea
YS 90 auto. Reproduced courtesy
of Sea & Sea.

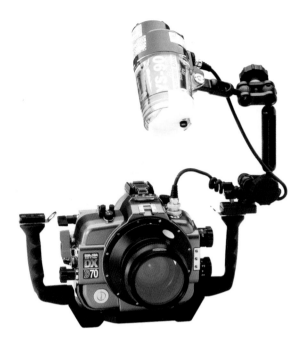

Figure 20.3
Seacam housing with the
changeable viewfinder system.
Reproduced courtesy of Seacam.

Figure 20.4
Nexus housing for Nikon D100.
Reproduced courtesy of Peter
Rowlands.

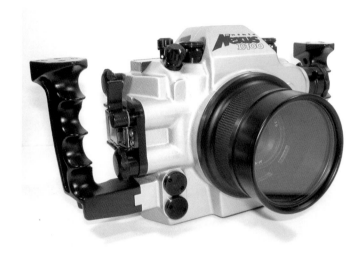

Figure 20.5
Ikelite housing for Nikon D70.
Reproduced courtesy of Gale Livers
Ikelite.

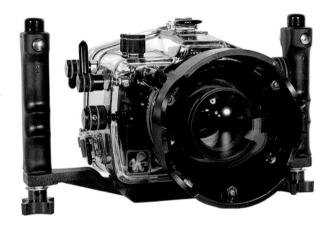

Figure 20.6
Seacam housing for Fuji-S2-Pro.
Reproduced courtesy of Seacam.

Sealux	www.digideep.com/english/ underwater/photo/housing/Sealux/32
Seacam	www.seacamsys.com
Subal	www.subal.com
UK Germany	www.uk-germany.com/english

I would encourage you to visit the pages at www.wetpixel.com and www.digideep.com for extensive reviews and availability of all the above.

21 Digital underwater photography with filters

Dr Alex Mustard

Colour filters are not a new development in underwater still photography, and have been used since at least the 1960s. However, in those early days it seems that filters were only used because flash photography was at best temperamental, and at worst dangerous! Filters have never been the popular choice, and even the most experienced users would rarely be pleased with the muted and inaccurate colours. Digital cameras have changed all of this. These days, filters are more popular than ever before and many new photographers now buy a filter even before an external strobe. Available light photography with filters works with digital simply because the cameras can automatically fine-tune the colour balance of our images to produce accurate and vibrant results.

The theory

Underwater photographers know that as sunlight penetrates the ocean, colours are absorbed at different rates. For example, if we take an available light image at a depth of 10 m (30 ft) in tropical waters it will be almost entirely blue. The warm colours have been absorbed significantly, and the resulting light spectrum is strongly biased towards cooler colours.

We use filters to counteract the filtering effect of seawater by reducing the amount of blue light. Ideally, we want a filter than will exactly redress the balance and produce an even spectrum of light.

The real world

A common misconception is that filters add colour. They do not. Filters work by reducing the colours we do not want, and are most

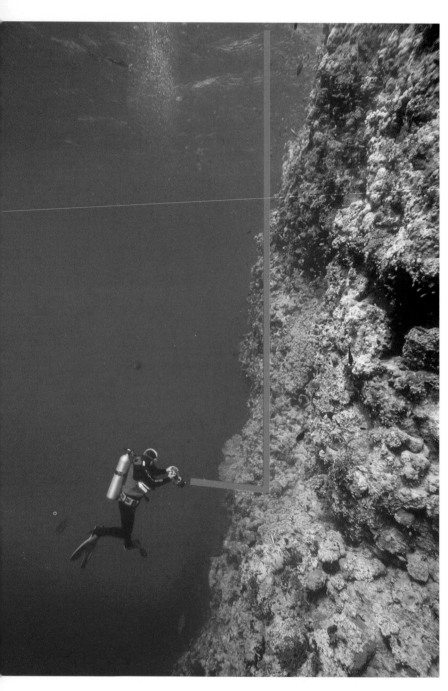

Figure 21.1
The distance that light has travelled through seawater is the most important factor in determining which filter we should use. We can measure this light path underwater by adding our depth (a) to the camera to subject distance (b).

Nikon D100 with 12–24-mm zoom at 12 mm, UR PRO CY filter, f4 at 1/60 s. Ras Mohammed, Egypt.

effective in bright conditions. However, the biggest limitation with filter photography is that each filter has specific filtration characteristics and will only be effective within certain limits. A filter has an optimum working depth range or, more correctly, an optimum light path length determined by how far the light has travelled from the surface to the subject and on to the camera.

Most filters mount directly onto the lens of a housed camera and cannot be changed once we submerge. Other variables also change our filter requirements, such as the colour of the water. Filters' inflexibility to these changes makes them impractical for film but, thankfully for the digital photographer, the camera's image colour processing can overcome most of these problems automatically.

Filters are not suitable on every dive, and ideally we should plan our dive to the filter's requirements. I only use filters when I know the conditions, the dive plan and what I am going to see. Filters produce the best still images in the upper 10 m in sunlit, shallow water close to the middle of the day.

Types of filter

Cast aside your strobes, your strobe arms and your sync cords: filter photography actually simplifies our underwater photography equipment! The most popular filters for colour underwater photography are the UR Pro range of underwater filters and Colour Compensating Wratten gel filters made by Kodak.

UR Pro manufactures filters specifically designed for underwater photography. Their filters use their own secret filtration recipe, and have been widely adopted by videographers and cinematographers for years. Their two blue water filters work over different but overlapping depth ranges: the CY filter is designed to work at 3–18 m and the new SWCY at 0–8 m, although optimum performance can be expected in the middle of these depth ranges.

UR Pro filters produce excellent results underwater, and work remarkably well even with 'auto-everything' compact digital cameras. Unlike gel filters, they do not react to seawater and can be screwed onto the front of the port and then removed during a dive. For example, on an Olympus 5060 a UR Pro filter can be screwed onto the front of the housing between the port and an optional wide-angle lens. The main disadvantage of UR Pro filters is that they are constructed as glass sandwiches in threaded filter mounts and cannot be used with lenses that do not accept threaded filters, such as fisheyes. Most wide rectilinear DSLR lenses (including zooms such as the 12–24-mm) will accept UR Pro filters.

Colour Compensating (CC) Wratten filters, made by Kodak, are a series of optical quality flexible gelatine filters that can be cut and mounted onto lenses. Gel filters must be used inside the housing because they degrade in seawater. CC filters come in specific colours, with red (R) filters being favoured in blue water and magenta (M) in green water. The strength of these filters is stated in CC units – for example, a CC50R is a stronger red than a CC30R. These filters are popular because photographers have already determined an easy to follow relationship to help us choose the right filter. First we must decide at what depth we

Figure 21.2a
A selection of filters used for underwater photography viewed on a light box. The UR PRO filter (the large circular filter) is a good place to start, but if you are adventurous it is worth experimenting with a variety of filters to find out which works best in your local conditions.

want to photograph, and then we can select the appropriate filter. In tropical water we need about 12CC units of red filter for every metre of light path (or 4CC units per foot), so at a depth of 3 m, 0.3 m away from the subject, we need a 40CC red filter (12 × 3.3 = 39.6). In more turbid green water we need about 15CC of magenta for every metre (5CC per foot) because the light actually travels further as it bounces around off the particles in the water.

My recommendation is to start with a CY UR Pro filter – although I should also mention that this is a relatively new field and keen photographers may enjoy testing other filters, which may prove more suitable in your local conditions. Colour Temperature Conversion filters, including Fluorescence Filters, are also well worth experimenting with.

White balance

White balance (WB) is the image processing control that adjusts image colours to compensate for changes in the colour (temperature) of the light illuminating the subject. When white balance is set to auto, the camera measures the colour of the illumination

Figure 21.2b
The UR PRO CY filter designed for use in clear blue water. This filter is an ideal way to start filter photography.

and alters the colours of the final image as it processes the data from the sensor. Our own vision works in a similar way. When we go underwater we see a far more colourful world than is actually there, because our brains react to the predominant blue spectrum and amplify the warmer colours.

Unfortunately, adjustable white balance is not as good as our vision and cannot do everything. Although the camera might be capable of pushing the colours to correct unfiltered underwater light, the processing is so extreme that the image quality will be degraded unacceptably. It is much better to get the colour balance as good as we can before it hits the sensor, using a filter, and then use white balance for fine tuning.

Available light shooting is different to *normal* underwater photography, and I recommend either auto or calibrated white balance (for flash photography other white balance settings are effective, such as cloudy). The simplest way to start is to set WB to auto. Auto WB works particularly well with compact cameras because, in my experience, they make much stronger corrections than digital SLRs, and the results straight from the camera are usually punchy and pleasing. The second approach is to calibrate the white balance ourselves underwater. Most digital cameras offer an option of custom or preset WB that allows us to set the camera's white balance either from a neutral white or grey card or from the environment. We have to be careful when using the environment to choose neutrally coloured objects, such as white coral sand or rubble, and avoid strongly coloured subjects such as blue water or a bright red soft coral. The calibrated WB is depth-specific, and if we change depth then we must recalibrate the WB.

Calibrated white balance is set in different ways on different cameras, and it is best to refer to the instruction manual. With the Nikon D100/D70/D70s/D2x, white balance can be set using a grey card. The camera is programmed to know what colour a

grey card should be, and calculates a white balance by comparing what it sees to what it expects. This setting will then produce correct colours for subsequent shots at this depth.

RAW files

If we shoot RAW files, then it is not necessary to worry about white balance underwater. A RAW file is the camera's unprocessed image file, often referred to as a digital negative. RAW allows us to adjust the white balance after the dive, on our computer. Changes made during RAW conversion are much less detrimental to image quality than are changes made in Photoshop, because we are modifying the original data captured by the sensor before the final image file is created. The only real disadvantages of RAW are that the files take up more storage space and add this extra processing step.

Setting white balance in RAW conversion software can still be tricky. There are no right or wrong settings, and the easiest way to set white balance is with the dropper tool, or grey point tool,

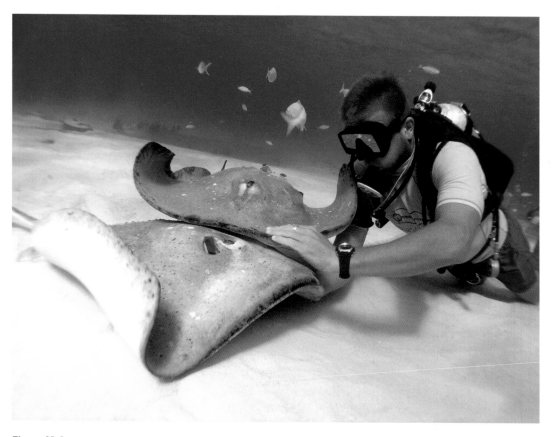

Figure 21.3
UR PRO filters work very well with auto-everything compact cameras. This image was taken with a SWCY UR PRO filter on an Olympus 5060 set simply to aperture priority auto, auto white balance and JPG. Filters can make underwater photography point-and-shoot simple.
 Olympus 5060 + INON UWL, UR PRO SWCY filter, f5.6 at 1/80 s. Stingray City, Grand Cayman.

that is available in most RAW conversion programs. It is worth clicking in several places within the frame with the dropper to find the best setting, although neutral-coloured areas in the foreground tend to be the best place to set white balance. If we set the white balance from a point too deep into the image, the white balance of the foreground tends to be over compensated (e.g. pink sand). Ambient light images are also often improved by increasing image contrast during RAW conversion.

Many photographers prefer to shoot on auto and then fine-tune white balance during post-processing, while not under the influence of compressed air. That said, it can still be worth custom setting white balance underwater so we have this value even though we may make changes later in the RAW converter.

Photographic techniques for filters

When discussing filters and white balance, we can easily get embroiled in the technical issues and not pay enough attention to the shooting techniques. Lighting available light shots underwater is very similar to lighting available light shots on land, and not at all like lighting normal wide-angle underwater photography! It is important to remember that sunlight is our only light source, and the following are my tips for getting the best results when shooting with available light:

- Position yourself so the sun is coming from behind you and illuminating the scene
- A slightly downward camera angle produces the most even lighting on the subject

Figure 21.4
The key to successful filter photography is to make optimum use of your light source. Here, I positioned myself so that the sun was coming over my shoulder and illuminating the reef in front of me. I also selected a slightly downward camera angle to achieve even lighting. It took me a few minutes of searching to find a section of reef at the correct depth for my filter, which was also facing in the right direction, but my persistence paid off in the end.
Nikon D100 with 16-mm lens, CC40 Red Kodak Wratten gel filter, f6.7 at 1/90 s. The Alternatives, Egypt.

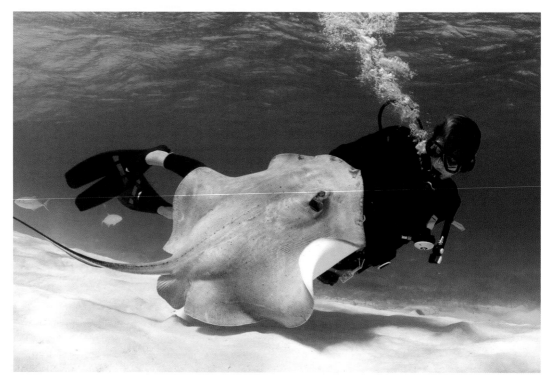

Figure 21.5
Shooting over reflective white sand can help to produce more even illumination on the subject. In available-light photography it is easy to lose a subject in a distracting background, and it is important to compose images to get good subject separation.
Nikon D100 with 16-mm lens, CC50 Red Kodak Wratten gel filter, f9.5 at 1/125 s. East End Lagoon, Grand Cayman.

- Avoid including the surface in the shot, as the water will appear too red
- Photographing over white coral sand will help to fill harsh shadows
- Check your viewfinder/LCD screen for your own shadow in the image
- Compose so you isolate the subject away from the background against open water.

Exploiting filter photography creatively

When I am shooting with filters, I always try and look for images that I could not take with flash photography. Filters allows us to add colour to our images in a completely different way to shooting with strobes. Colour is no longer limited by where we aim our strobes. In filter photography colours penetrate much deeper into our images, away from the camera, and we can exploit this. Filter photography allows us to position a subject much more dynamically in the frame, running from the foreground back into the image, while still photographing it in full colour. A school of

Figure 21.6
Filters allow users to light and colour images free from the constraints of flash photography. In filter photographs, colour extends much further back into the image than in flash images. I could not have lit the snappers further back in this school if I had been shooting with flash.
 Nikon D100 with Nikon 12-mm–24 mm zoom at 12 mm, UR PRO CY filter, f4.8 at 1/40 s. Ras Mohammed, Egypt.

fish provides a good example: now we can photograph the whole school in full colour, and not just the ones close to the camera!

Filters also allow us to photograph large subjects in full colour that we could not hope to light with strobes or to take pictures of in turbid (but bright) conditions where strobes would produce lots of backscatter.

Finally, sometimes an image is made by the colour of light and we should not always try to 'correct' it. The blue or green light in the ocean is very characteristic, and it is not always desirable to white balance it back to white light. Imagine photographing a sunset and correcting the colours so that the sky is blue again! We can make the same mistake underwater – for example, I would never try and white balance silhouette shots, I like them blue!

Conclusion

Filters are not a technique for every dive; we need bright and sunny conditions and appealing subject matter in shallow water. However, when conditions are favourable they are an attractive

prospect for the digital underwater photographer. Certainly it is appealing to be free of the problems of TTL, flash aiming, backscatter, Guide Numbers, sync cords, sync speeds, etc.! But the real promise of this technique is the very different lighting that can be achieved in our shots, allowing us to capture pictures that we just could not produce on a slide.

After years of being limited to the same handful of classic techniques, suddenly filters have given underwater photographers something completely new. These are exciting times, and so far we have only scratched the surface of what is possible with this novel technique. Surely there has never been a better time to be an underwater photographer!

Acknowledgements

I would like to thank Peter Rowlands and Peter Scoones for sharing their experience and for encouraging me with this technique. I am also grateful to the members of the www.wetpixel.com online community, specifically Craig Jones, James Wiseman and Eric Cheng, who have provided an invaluable source of advice and ideas. I would also like to thank Martin for his helpful critique of this article and for allowing me to contribute to this book.

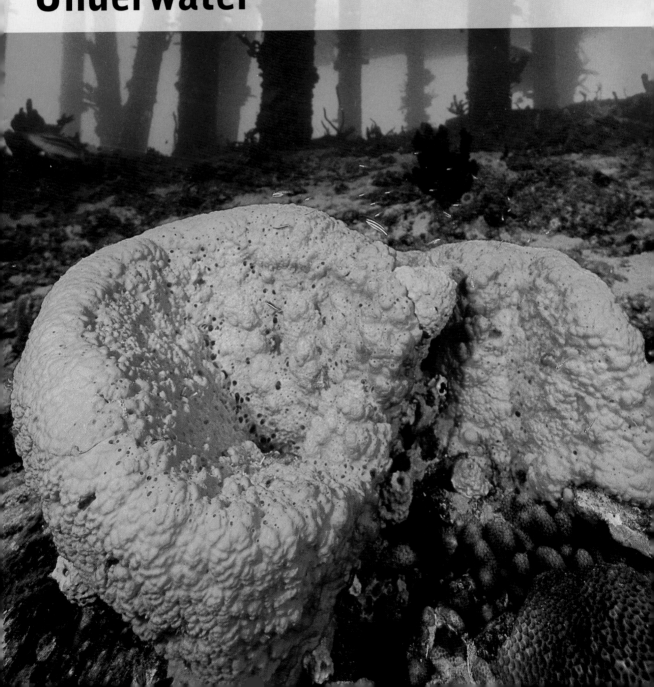

PART 3
Using SLR Cameras and Compact Digitals Underwater

22 Using SLRs and digital compacts: an introduction

Technique is given to you. It's what you do with it that counts.
(Elliott Erwitt)

I am confident that I could take a person who has little knowledge of photography, provide a simple introduction to apertures, shutter speeds and focus, and then let them loose on a subject, assured that they could return with sharp, well-exposed photographs.

It's a fact that billions of people all over the world have no wish to go beyond this basic knowledge of photography. However, underwater photographers are a different breed. Most of those who I meet have aspirations to go beyond snapshots in an effort to take pictures of the highest standards, and of publishable quality. With a love of and passion for diving, an interest in photography, access to

Figure 22.1
SLR housing with a bespoke port for macro use.

photo-friendly and productive dive sites, you have all the essentials to achieve excellent images.

Keen photographers have always read up, digested and self taught on the basics of photography. The abundance of photo technique magazines, books and websites satisfies most appetites for camera knowledge, *BUT* there comes a time to put technique to one side and harness the visual, imaginative and artistic side of the mind to create your pictures. This ethos continues to be the very essence of my approach to teaching underwater photo workshops – providing sufficient technique to control the camera, but with the onus on content and composition of the image when we get below the surface.

We often forget that the quality of the image, and only the image, is how we are judged. Where and when it was shot and how difficult it may have been are of little interest to anyone outside our immediate family.

Some time ago, two guys joined me on a photo workshop in Malaysia. They were using Nikon SLR cameras in housings. One had a good working knowledge of technique and how his camera and housing worked. He displayed good diving skills and had the potential of obtaining some excellent photographs. However, he became totally and unnecessarily (in my opinion) bogged down with the technicalities of the camera he was using, and struggled to focus his mind on the image itself whilst underwater. By his own admission, such was his obsession to have technically correct pictures he found it difficult to consider anything else. His friend was using a similar system but had much less knowledge and experience with it. He had practised auto focusing, and had learnt enough to become competent with flash positioning, TTL and exposures. His results were full of ideas, creative compositions and different lighting techniques. He made his fair share of mistakes, but most importantly he had faith in his equipment despite limited knowledge. This allowed him to concentrate entirely on the photographs he wanted to obtain, and in the process he captured some stunning results. The moral of the tale is this. With a mind uncluttered with the 'bells and whistles' of camera equipment; his mind's eye was free to wander, to make mistakes, to experiment! Unlike his friend, he was able to put all of the technical stuff to the back of his mind when underwater and concentrate on the image itself!

My intention in this section is to discuss those features that I believe you need to understand in order to help you to trust your technique underwater.

Learn it on land – trust it underwater.

23 Exposure modes: aperture, shutter and manual

Most film, digital SLRs and digital compacts have a number of exposure modes. Typical names are:

- Auto, which stands for auto mode
- P, which stands for program auto exposure
- Tv or S, which stands for shutter priority
- Av or A, which stands for aperture priority
- M, which stands for manual exposure.

The default setting for the majority of digital compacts is plain and simple auto mode. The camera makes all the decisions for you, selecting a shutter speed, aperture and even ISO to obtain correct exposure.

Program AE or programmed auto is similar to auto mode in that the camera still determines the shutter speed and aperture for you, but lets you decide on the ISO speed.

Shutter priority mode goes one step further and also allows you to select the shutter speed. For example, to stop action you may want to select a fast shutter speed. The computer in the camera

Figure 23.1
Shutter priority.

Figure 23.2
Aperture priority.

Figure 23.3
Manual exposure.

will then determine the appropriate aperture for correct exposure all on its own.

Aperture priority mode is similar to shutter priority, but you may now select an aperture and the camera will determine the appropriate shutter speed for correct exposure.

In *manual exposure mode*, the camera relegates all decisions to you and allows you to set both the aperture and the shutter speed.

For anyone other than a complete beginner or someone taking underwater photographs for the first time, I would dismiss the notion of using program exposure mode underwater! Whilst aperture, shutter and manual exposure modes all have a place in underwater photography, in my opinion *program* does not. It is accurate and convenient for land use, but it's unreliable underwater. It takes the decision-making away from the photographer. To some this may sound ideal, but trust me. If you wish to achieve more than just a snapshot, you need to develop a basic understanding of how aperture, shutter speed, film speed and depth of field all interrelate. Getting to grips and experimenting with manual exposure mode will help you to achieve this.

Which one to use

Aperture priority, shutter priority or manual – is one better than another? In my experience aperture tends to be more popular with underwater photographers, but there are times when I would be inclined to use shutter priority or manual. Each mode provides the user with an accurate exposure, and I emphasise that in the hands of an experienced photographer any of these modes could be used in any given situation.

Figure 23.4

The snake eel – one of the most ugly creatures I have photographed. This was a simple task for aperture priority; I set *f*16, the shutter speed defaulted to 1/60 s.

Nikon F100 with Nikon 105-mm macro lens, Subal housing, two Sea & Sea YS 30 flash guns set to TTL, Elite 100 ISO.

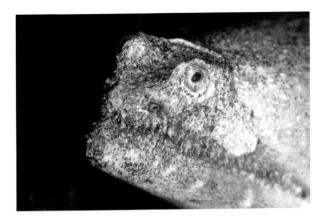

Let us examine them in some detail, and consider the circumstances where one may have an advantage over another.

Aperture priority

This exposure mode is the one that I use around 60 per cent of the time. Many photographers favour it on land and underwater, for the following reasons:

- Stepless shutter speeds can be selected. The shutter is not confined to set increments of 1/60, 1/80, 1/125 s; in aperture priority, the computer selects speeds of 1/95 and 1/145 s, etc. The camera does not display these intermediary speeds, just the ones that we are all accustomed to, and in using stepless shutter speeds we get the optimum accuracy of exposure.
- Regulation of depth of field. In aperture mode we can directly control the aperture, which regulates our depth of field. This is an enormous advantage when shooting both close-up and wide-angle. However, you do have to keep your eye on the viewfinder in aperture mode. If 'HI' appears on the LED display, you need to select a smaller aperture to avoid overexposure of the natural light. Unless we are shooting underwater in very bright sunlight and shallow water, it is not often that we see the 'HI' icon in the LED.
- Aperture priority is easy to use. I select *f*22 or *f*16 for macro work, and when I turn my flash gun on the shutter indicates 1/60 s. SLRs default to 1/60 s whenever the camera detects that a flash unit has been connected.
- With wide-angle I operate around the whole range of apertures, but for a straightforward blue-water reef scene in the tropics I would select *f*8 or *f*5.6, whilst keeping my eye on the electronic analog exposure display in the viewfinder to check that the shutter is not too slow for the task in hand.

Shutter priority

Ask yourself the question once again: What is your priority with a particular photo opportunity? If it is the ability to freeze the

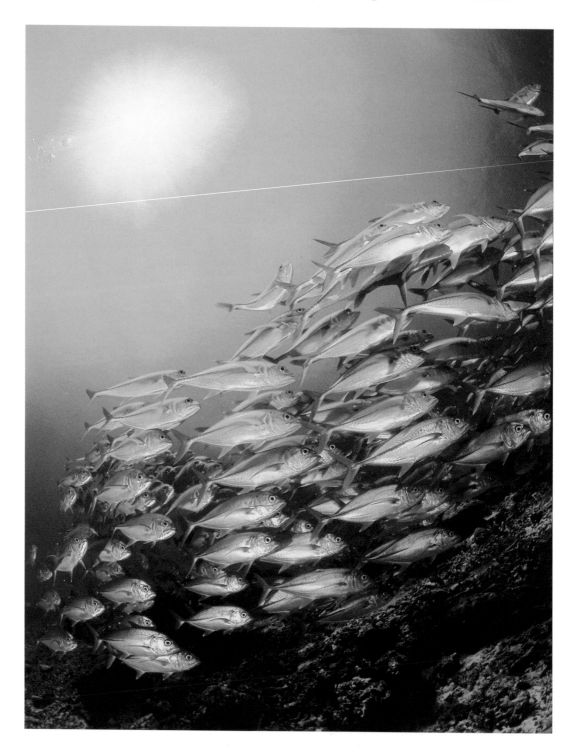

movement of a subject, then shutter priority mode should be considered.

Let us look at some practical examples of moving subjects, such as fish, seals, jacks and barracuda. Using a slow shutter speed could record the subject out of focus. Unless this is the effect we are after, then our priority is to freeze the movement – and the most effective way to do that is to select shutter priority mode.

The next step is to choose a shutter speed on the camera that we feel will adequately meet our needs. A rule of thumb for seals or dolphins is 1/250 s. Slow-moving fish may be in the region of 1/125 s, and other slower-moving subjects may not require a speed that fast. So, let us make the decision and select a speed. In shutter speed priority mode, the camera will select an appropriate aperture for you in whichever direction you point the camera. What is so efficient about this is that the underwater photographer can concentrate totally on the composition through the viewfinder, safe in the knowledge that the computer in the camera is selecting an appropriate aperture in order to record the ambient light.

Manual exposure mode

We all know that both light and colour behave differently underwater. This is where manual exposure mode comes into its own. You can really begin to learn about light in the sea and how it influences your underwater photographs. The concept of manual mode is as follows: you must select the shutter speed, you must select the aperture and, most importantly, you must ensure that the exposure is correct! This may seem obvious to many, but there are some who are accustomed to setting A, S or P and who, when faced with manual, will often set an arbitrary shutter speed and aperture and then shoot, not realising that they have to check

Figure 23.5 (Opposite page)
This image is typical of when I would select shutter priority mode. From experience, I would select no slower than 1/180 s to stop the action of these schooling jacks. My prime concern is to be able to concentrate on the image in the viewfinder and press the shutter whenever I feel the elements of the picture are about to come together. I may take five shots or thirty-five; it all depends on how much potential I feel the opportunity has. I do not want to be stopping in the midst of the action to take meter readings towards the surface when the jacks are swimming overhead.

Some photographers in the middle of the action begin to fiddle with their camera. I ask their reasons for doing this, and often find they are in manual mode with control over both the shutter and the aperture. As their angle of view on the subject changes so to does the internal camera light meter, which may indicate that shooting up towards the surface at the subject requires less ambient light than when the school appears below the photographer, who then needs to shoot towards the deep blue abyss. Hence the need to change settings in mid-flow.

In this case we had been shooting jacks throughout the dive. I selected 1/250 s and followed the action, my eye glued to the viewfinder. The camera was angled in all directions as I tracked the school swimming around us. My film stock was Ecktachrome Elite 100 ISO. I used a Nikon F90x with a 16-mm fisheye lens in Subal housing with a single Sea & Sea YS120 flash gun set to TTL. I took a roll of thirty-six, but only a couple of shots captured the action as I had hoped.

If stopping the action is your priority, then select shutter priority mode on the camera.

the exposure meter on the LCD display in the viewfinder. Don't let this put you off trying manual exposure.

As soon as you have set the control dial to M and depressed the shutter, a small chart will appear on your monitor or viewfinder. This chart is labelled differently on different cameras. *Exposure compensation* is the most popular label in digital compacts, whilst in digital SLR cameras it's called the *electronic analog exposure display*. It acts as a light meter, and shows + (plus) or − (minus) to indicate whether the photograph would be under- or overexposed at its current setting. If the analog display indicates exposure towards the + side, then you may need to close the aperture or select a faster shutter speed; likewise, with a minus indication you may need to open the aperture or decrease the shutter speed. Towards the middle of the analog display is a zero, which indicates optimal exposure. By manipulating either shutter or aperture, a series of small black squares appears and moves up and down the grid. The theory is that if the small square is in the middle, you have matched the exposure that the camera is advising. Consequently, if the small square is over to the minus you are underexposing.

Figure 23.6
The analog display indicates one *f*-stop (1 EV) over overexposure.

Figure 23.7
The analog display indicates one *f*-stop (1 EV) under underexposure.

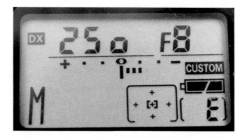

Figure 23.8
The analog display indicates more than two *f*-stops (2 EV) under exposed.

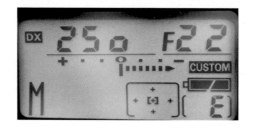

Advantages of manual exposure mode

If you wish to develop your digital underwater photography, then manual mode will help you to understand exposure and how to use it to illuminate the sea. Whilst 'point and shoot' is convenient, you never quite know for sure how you were able to get the result you did. The beauty of using manual is that you have a choice about how the image will appear. It's a win–win situation. Using digital you cannot waste film – if it's wrong, you can correct it, right there and then.

Time is of the essence

To use manual exposure mode with wide-angle, the underwater photographer requires time – time to think and visualise, time to take meter readings, time to adjust the aperture and shutter speed. Manual exposure mode requires a very unhurried, calm, controlled and patient approach to underwater photography. I always try to select a subject that is easily accessible, and without fear of damaging the reef. I consider my intentions and visualise the picture that I'm trying to obtain. I meter the ambient light from both the surface and mid-water. I may select an aperture, which provides the depth of field I require to obtain sharp focus throughout the

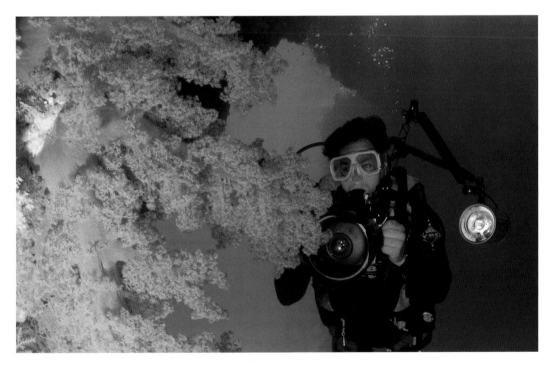

Figure 23.9

I used manual exposure mode on my digital Nikon D100 and 10.5-mm fisheye for the cover shot. It was taken in one of the shallow cave systems at St Johns Reef in the southern Red Sea. I took a meter reading from inside the cave looking out into blue water. For this shot there was little movement, so a fast shutter speed was unnecessary. I set 1/60 s, and the cameras light meter indicated f8. It took a number of shots to capture a pleasing composition in relation to the exposure and my model. I bracketed the aperture between f4 and f8, and picked the best of the bunch. I used twin Sea & Sea YS 90 autos.

composition, and then select a shutter speed, which will balance the natural light of blue water. I may find that I have to refocus on the subject and take into account a small reduction in depth of field. Having chosen the first combination of shutter and aperture, I may bracket the apertures between $f5.6$ and $f11$ and choose which one I prefer at a later date when I see the results. The manipulation of both aperture and shutter speed combined with checking the LCD and histogram display requires a patient, calm, unhurried approach.

Quick start: rule of thumb – close-up

1. With close-up photography, set your exposure mode to M (manual).
2. Select a small shutter speed for maximum depth of field – $f16$ with SLRs and $f7$ with digital compacts.
3. Set a shutter speed close to 1/100s.
4. Choose subjects growing proud of the reef, get close, and use your flash to illuminate the scene. If you have an external flash with variable power settings, then adjust those settings to obtain a pleasing flash exposure.
5. At these settings, your display may indicate a minus exposure. That's acceptable, because your flash gun will provide all the light you require to light your close-up subject. Check your histogram display and LCD review monitor to monitor the result.

Quick start: rule of thumb – wide-angle

1. With wide-angle, use the same shutter speed as above.
2. Try and get the exposure to zero by adjusting the aperture to make it wider to allow more light. Try $f6$, $f5$, $f4$ with a digital compact, and $f5.6–f11$ with an SLR. When you have the small black squares at zero, you have the exposure that the camera is advising.
3. Get close and shoot upwards towards the mid-water background. It is essential to shoot UP!
4. Check the histogram to see how accurate your exposure is.

Knowing how your metering and histogram work, and how to use manual mode underwater, will develop your skills as an underwater photographer.

Conclusion

If you are using digital, have the confidence to experiment with the aperture, shutter and manual exposure modes on your camera. If you get it wrong, you can start over. If you are in a situation where you need to get it correct first time, then ask yourself the question: What is my priority, depth of field, or stopping the action? Set either aperture priority or shutter priority accordingly. If you have plenty of time and have it in mind to experiment, then choose manual.

24 Metering patterns

Today's cameras provide very accurate metering pattern systems. Matrix mode is such an excellent choice that many underwater photographers set their camera to matrix metering, select aperture or shutter priority, and shoot away. This is an excellent way to approach your underwater photography and I would not knock it for one moment. As a rule of thumb, when using a macro lens, a 60-mm or 105-mm, I set the metering to matrix. I also use centre-weighted and spot modes with close-up subjects, and to be honest I have never been able to tell them apart – the reason being that with close-up and macro the primary light source is always a flashgun. However, using matrix metering with wide-angle lenses underwater, this combination may result in exposures that are sometimes inaccurate.

Figure 24.1

Matrix

The computer inside your camera measures a number of segments in the picture (via the viewfinder) – normally ten segments, depending on the model of camera. Matrix works out (very sophisticated, too!) what the photographer is trying to take, and provides an exposure based on information like brightness, contrast and subject distance captured within the segments (this is reliable on land, for which it was designed, but not as much so underwater).

With wide-angle photography in tropical locations, the range of contrast throughout the frame can be so great that it is impossible to handle. Think about it! Shooting wide-angle in the Red Sea in a vertical composition, there will be sunbeams at the top of the frame and a deep-blue colour of water at the bottom. This can give a contrast range of six *f*-stops. How can Fuji Velvia or Elite Chrome transparency handle this range of contrast? Matrix will do its very best and average out the scene, but you may find that the exposure results in a picture that is too bright:

- When you shoot into the sun with matrix, it tends to underexpose because it is adjusting for all the bright light
- When you shoot horizontally, composing a reef wall against the blue, it tends to overexpose the scene because it is compensating for the dark tones of the reef at the bottom of the frame.

When shooting wide-angles, its best to take a light-meter reading from the water column in order to reproduce the most satisfying water colour possible. Centre-weighted or spot metering is preferable, because they measure a smaller area of the frame whilst matrix takes in the entire scene. I find that matrix metering with wide-angle tends to overexpose too much for my taste, and therefore matrix is not a pattern that I am inclined to use that often.

Centre-weighted

The other two options, centre-weighted (CW) and spot, place their emphasis on brightness within the centre of the screen. With CW, it is the 12-mm diameter circle – 75 per cent of the emphasis is in the area of this circle, whilst the remaining 25 per cent is outside the circle. The trick comes from knowing how to meter

Figure 24.2 (Opposite page)
For this wide-angle seascape in PNG, I took a centre-weighted meter reading from the blue-water column in the background, not directly into the sun but just below it. It indicated *f*11 at 1/90 s shutter speed and 100 ISO film. I used two Sea & Sea YS 120 flash guns on manual half and full power. I bracketed the aperture between *f*8 and *f*16, which provided a variation of exposures to choose from. Spot metering would have been just as accurate, but in my view using matrix would have given a wider *f*-stop – *f*5.6 or *f*4 – as it would have compensated for the dark shades of the reef which, without flash fill-in, looked dark and in shadow.
Nikon F90x with Nikon 16-mm fisheye lens, Subal housing.

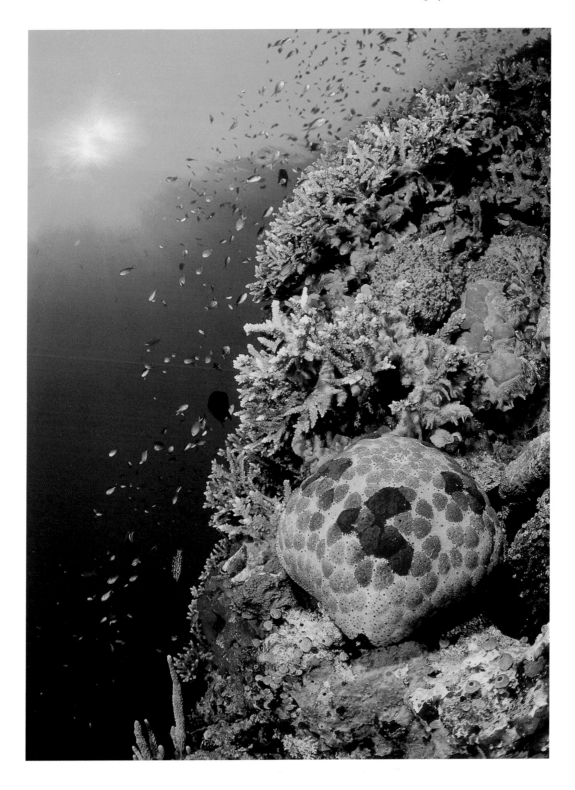

the water column in the background of your wide-angles. Set CW on the camera and point it at the water column. Don't point it directly into the sun – all you will get is underexposure. Choose an area of the water column that you feel will be prominent for that particular composition. As conditions may change and the sun hide behind clouds, you may have to take other meter readings of the ambient light. Centre-weighted is an accurate way of determining the exposure of the water column. It's used by many professionals, and works well.

Spot metering

For ultimate control in your metering of an underwater scene, spot metering is the tool. Spot metering places 95 per cent of its emphasis within the small 2-mm circle in the centre of the film or digital viewfinder. The underwater photographer does, however, need to be confident about exposure and how spot metering works. The most vital element of using spot metering is time! The photographer needs time during the dive to employ this technique, or mistakes can be made. If I find myself rushing my dive, for whatever reason, or perhaps following a guide or following fast action such as schooling fish, etc., I tend to set centre-weighted every time and just shoot, shoot, shoot. If I have time, I go with spot metering and consider the light and dark areas of the frame, colours of blue water and what kind of exposure I am trying to achieve. The advantage is that you can take a reflected light measurement off a very small portion in the frame.

How does it work underwater?

If you intend to use spot metering, the photographer ideally needs to work in manual exposure mode, setting both the aperture and the shutter speed manually. Let's take the example of a wreck dive using a Nikon F100, 16-mm fisheye lens with 100 ISO film. Set spot metering on the camera. If you intend to bring out the texture and detail of a specific part of a sunken shipwreck, by spot metering on a specific area, precise exposure can be achieved. Assume that a spot meter reading indicates 1/30 s at $f4$. Manually set this combination into the camera, compose for this focal point and press the shutter. If using a film camera, bracket around that combination of settings, leaning towards more exposure rather than less in this scenario.

Figure 24.3 (Opposite page)
On the seaward side of Town Pier there are a number of colourful orange sponges. I had the idea to capture their colour with the pier supports in the background. Seventy per cent of the composition contains dark tones, and matrix metering would have overexposed the distant blue water that gives this image its character. I took a spot meter reading on the blue water between the supports. I was holding my housing firm on an old disused tyre in order to select an aperture with enough depth of field to render foreground to background in focus. I set $f11$ and ensured the analog display in the viewfinder was at zero. This gave a shutter speed of 1/15 s. I bracketed the shutter speed, took four identical shots, and chose the one that had pleasing blue water and an evenly lit sponge.

Nikon F90x, two Sea & Sea YS120 flashguns set at full power on ultra-light arms. The flash guns were positioned each side and behind my fisheye dome, angled outwards to cover the entire area of my 16-mm fisheye lens.

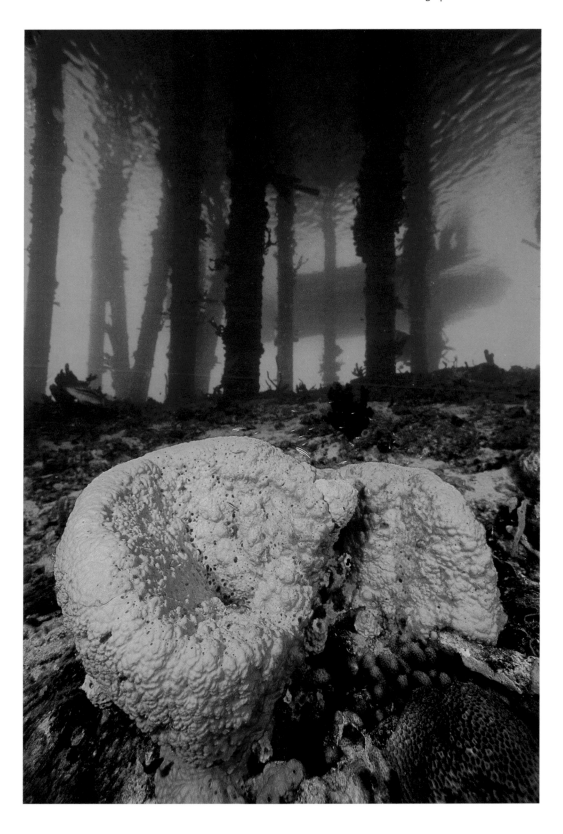

In these situations the photographer is in complete control of the camera, but you do need time.

Digital issues

The more I teach, the more certain I am that digital capture has made everything so much easier. An example of this arose via email following an article I wrote for a UK dive magazine. At the heart of the matter was the following issue:

> What is the purpose of all the choice of metering patterns now I use a digital camera? All I need to do is check the histogram, and if it's too dark or too light I alter my exposure.

I was taken aback! The sender had a point. The difference between matrix, centre-weighted and spot is the pattern of metering used, and nothing more. I gave this matter a great deal of thought, and posted this email advice by way of reply:

> The type of metering pattern chosen with digital capture is less of an issue providing you can critically and carefully evaluate the LCD monitor, the histogram and highlight features at the time of taking the picture to determine if exposure is correct. If not, you can make adjustments and retake the shot. However, you have a much better chance of getting the exposure correct first time if you choose either matrix, CW or spot from the outset. With moving subjects or rare encounters you may only get one opportunity. In the latter situation I would always opt for matrix metering and shoot as may frames as possible.

Summary

- When shooting close-up and macro, I find little difference between matrix, centre-weighted or spot
- When shooting wide-angle, I choose CW or spot
- If it is a rare encounter or I have little time, I will choose matrix
- Using my digital SLR, I am more inclined to review the histogram and adjust the exposure than be concerned which metering mode I have selected at the time.

25 Autofocus

Auto-focusing technology has been a significant advantage to underwater photographers, particularly when shooting close-up and macro. I was a devout manual focus user when the technology first became available in the early 1990s, but soon converted when I saw my focus hit-rate increase considerably.

With close-up and macro, I use autofocus with my 60-mm and 105-mm macro lenses. When using the 200-mm macro lens, I have found manual focusing suits my style of underwater photography due to the reduced speed of autofocus of a 200-mm lens – in my opinion, here focus can be achieved more effectively by focusing the lens manually.

I use other lenses underwater:

- My 10.5-mm fisheye digital lens I focus manually
- My 16-mm fisheye I focus manually
- With my 17-mm–35-mm zoom, I have to use autofocus because of the configuration of my housing; if I could use manual focus I would
- With my 12-mm–24-mm zoom I also have to use autofocus, for the same reasons; again, I would focus manually if I had the choice.

As you can see, my preference is to use manual focusing when using wide-angle lenses. The reason for this is their tendency to 'hunt', particularly when shooting out into blue water. The enormous depth of field, which is a very beneficial characteristic of wide-angle underwater photography, often negates the need for

Figure 25.1
M for manual focus, S for single servo and C for continuous on a typical SLR camera.

precise focusing. For my own underwater photography, I want to be in total control of the shutter release. I have lost count of the times when I have missed a wide-angle opportunity because the lens was hunting for the subject and I missed the shot. When using the 60-mm and 105-mm macros, the autofocus is fast and accurate. The focusing technology of recent SLR cameras used underwater with close-up and macro subjects, even in low light situations, is superb.

Three settings, M, S and C, control the autofocus concept, and there is no doubt that this is where good composition can be won or lost, particularly when it relates to where to place the focal point of the picture.

'S' stands for single servo

Single servo is ideal for shooting still life or very slow-moving subjects. Single servo is often referred to as *shutter priority* for that very reason. Whilst on S you cannot fire the shutter unless you have achieved sharp focus. To activate autofocus detection in the S mode, lightly depress the shutter on your camera housing. The lens begins to focus and locks sharp in the frame. Retaining pressure on the shutter release continues to lock focus. Depressing the shutter fully takes the picture. All popular cameras have at least five focusing areas, which cover the viewfinder frame. By using the 'game pad console' on the back of the camera, you can select between the five areas depending on the subject's position in the viewfinder or your own choice of composition.

Figure 25.2
Whilst damsel fish are colourful and easy to approach, rarely do they ever stay still enough to be photographed. With a wide-angle lens they are easy to capture as part of a reef scene, but to isolate and capture one in close-up is a little more of a challenge.

For this shot I used a Nikon 105-mm macro lens on a Nikon F100 camera. I selected C autofocus. I applied my concentration to just one individual, and tracked its movements in and out of a sea fan. With my trigger finger depressed, the C motor continued to track the damsel as I panned the camera. Remember, I could press the shutter at any time, but because of the speed of the fish it would not guarantee a good composition or a sharp image. Every time the composition looked good to my eye, I pressed the shutter. My shutter was set at 125 s, aperture was f11. My Sea & Sea YS90 flash gun was mounted over the port and set to TTL. Depth of field was good, but I could not be assured that the critical features would be sharp. I took about eight shots. I was looking for placement in the frame and a sharp eye. The action was so fast that it was difficult to react to a sharp image in the viewfinder. In the split second that things looked clear, I popped it. I had about five or six frames that were sharp, but the image shown here was marginally the best of the crop. I spent between ten and fifteen minutes on this opportunity. Something that moves this quickly can rarely be captured in just one single shot. You have to use some film, and the C autofocus mode will certainly improve your chances of success.

My choice
I usually select the focus area situated in the centre of the view-finder as active. My thought process is to consider what I want to be the focal point of the picture. I apply light pressure to the shutter, and lock focus on my choice of focal point. I consider where in the frame to place the focal point and continue to maintain light pressure. I adjust my composition accordingly, and place the focal point elsewhere in the frame than dead centre to improve the composition and impact. When I'm fully satisfied with the

placement and composition of the elements, I fully depress the shutter to expose the picture. On other occasions I may select one of the off-centre focus points in the viewfinder if I believe the subject will remain in this spot. A common fault in all of us is to focus in the middle and press the shutter. The picture is sharp, but the focal point always looks dead centre in the frame.

'C' stands for continuous focus

When the autofocus switch is set to C and the shutter release is lightly depressed, autofocus will 'continue' to focus track a subject, which you have composed between the guidelines, situated in the centre of the camera viewfinder. This makes the C mode ideal for subjects such as small reef fish and other fast-moving subjects. For instance, whilst you are following the subject the fish rushes about its business, C mode continues to focus track the subject as long as the shutter release button remains lightly depressed. Remember! When C mode is set, we can fire the shutter at anytime regardless of the subject being in focus or not!

But why may we want to do that? Remember that C mode is most useful for moving subjects, and because of this movement the subjects can be difficult to compose. If the image in the viewfinder looks good I never hesitate to fire the shutter, confident that on most occasions the depth of field will provide adequate focus throughout the image. In my experience, the subject/focal point is usually sharp in the finished picture. Occasionally the fish will move a split second before you fire the shutter. In these circumstances, C focus may be unable to track the subject quickly enough and the fish may be blurred. I take the view that with modern SLRs the speed of autofocus is much faster than that of human reactions. However, I know of underwater photographers who disagree.

Composition using continuous focus

Efforts to arrange composition with fast-moving subjects in C mode is a challenge. The tendency is to focus on the eye and fire the shutter. This will often locate the focal point/centre of interest in the middle of the picture frame. To avoid locating the eye of the fish in this way, I home in on an area near to the eye – most likely part of the body. The eye will then be off centre. I use a small aperture (f22 or f16) and cross my fingers that depth of field will do the rest. When this is not possible, I focus on the eye and concede to myself that it was a case of either a shot of the subject with a possible static composition or no shot at all!

26 Exposure compensation

When choosing an exposure mode of either P, A or S, the exposures are suggested by the camera. Unlike manual exposure mode, we cannot adjust a shutter or aperture to give a little more or less exposure to our taste. If we attempted this, then the opposite would compensate. This is where exposure compensation comes in.

The exposure compensation feature found on most cameras is quite useful to the underwater photographer. The feature has two main uses:

1. To modify existing exposures suggested by the camera
2. To ensure accurate exposures when a problem arises with the camera or the flash.

These solutions are worthy of discussion (time to check your camera manual!). For ease of explanation, I will relate the following to a typical film or digital SLR camera.

By pressing down on the $+/-$ button and turning the command dial, you can modify the meter reading by as much as -5 EV to $+5$ EV. Think in terms of one EV being the equivalent of one f-stop. Most SLRs can enable 1, 1/2 or 1/3 f-stop increments.

In what circumstances should exposure compensation be used?

1. In close-up and macro, exposure compensation is ideal to control the exposure of a flashgun which is set to TTL but is inaccurately calibrated and tends to either underexpose or

Figure 26.1

Figure 26.2
Minus 7, equivalent to two-thirds f-stop.

overexpose a subject. In my experience, a flash that is just a tad out with the exposure is usually biased towards giving a little too much light. This is most noticeable on a roll of transparency film, where many of the thirty-six frames are consistently a little too bright. (*Teaching photo courses for the last fifteen years, I have seldom seen a flash that is any more than one f-stop out of calibration.*) A practical example in my own work is my ring-flash, which I use for shooting subjects that are difficult to approach but require the qualities of a 105-mm macro lens. I find that my ring-flash whilst set to TTL is consistently two-thirds of a stop too bright. To hold it back to the correct exposure, I dial into my camera −7 (two-thirds) of an f-stop exposure compensation. This ensures consistent exposures. When I use a different flash-gun, I need to remove the −7 compensation and return the setting to zero.

2. Another example is for subjects that have a tendency to either over- or under-expose when a flashgun is used. I have discovered with experience that dark-coloured moray eels soak up light from a flashgun and can often appear underexposed. In this case, whilst underwater I will dial in +1 stop on the exposure compensation feature to provide more light.

3. For white-coloured leaf fish, I have found that −7 stop under-exposure is preferable.

4. When using a film camera and twin flash guns set to TTL with a wide-angle lens, I find that setting −7 f-stop

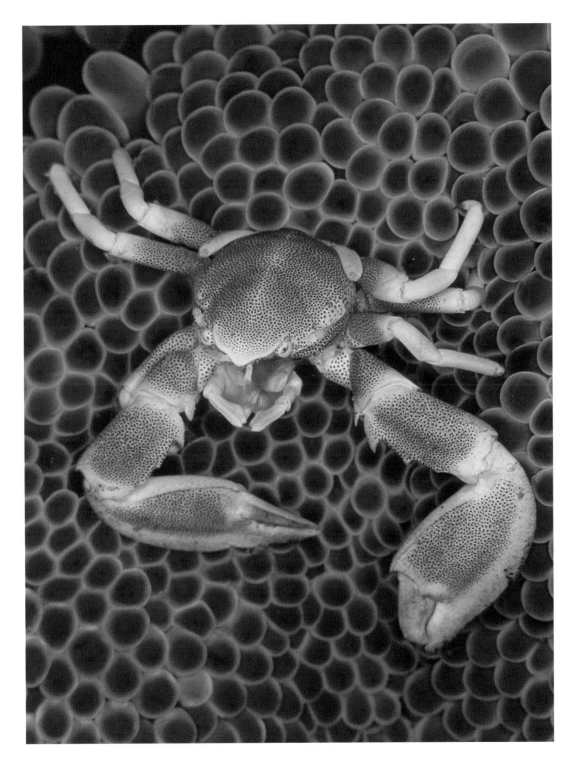

Figure 26.3
This porceline crab was lit by my ring-flash, which requires an exposure compensation of minus 7. This compensates for the TTL function, which has a tendency to overexpose slightly.

underexposure is preferable in order to reduce the combined power of both guns on TTL.

Remember that using exposure compensation affects the entire exposure, both flash and natural light.

Avoid becoming too preoccupied with this topic. My suggestions are just tools in your underwater bag of tricks.

27 Checking TTL is working

If you have doubts that your TTL flash is working properly with a film camera, here is a way to test it without getting wet.

1. Assemble your film camera, housing and flash gun. Ensure you have a lens connected. Don't load film at this time.
2. Turn the flash gun on and set it to TTL.
3. When the flash ready light shows, place your hand over the front of the lens port to block out any extraneous light, then point your flash well away from the lens and press the shutter. The flash should discharge at full power. If it only gives out a small amount of flash, then you have a fault and the first place to look is at the flash lead.
4. Continue and set your lens at its widest aperture – $f4$ or thereabouts.
5. Now point the flash (still set to TTL) into the lens at short range and fire the shutter. This time you should see a small discharge of light because the flash gun is quenching the output by having it pointing into the lens. The ready light on your flash should stay on, or go off for only a second.
6. Without a film in the camera, continue to point the flash from short range into the lens and trigger the shutter four or five times. The flash should fire continually with a small discharge without having to recharge itself.

If the flash gun does not behave in this manner when set to TTL and pointing directly into the camera lens, you may have a fault:

- Check the connector of the flash lead with both the bulk head flash connector on the housing and where the lead is connected

to the flash gun. More often than not, it's a bad connection of the TTL circuitry in the flash lead.

- If possible, test your flash and flash lead on another camera housing. If it works properly, then you know the fault has to be with the flash circuitry on your own housing.
- Check the bulkhead connector once again and ensure the pins are not corroded inside. If they are, then try this tip: take a small (jeweller's) screwdriver and gently press in each pin inside the bulkhead flash connector. These pins can often get stuck. Don't poke, prod or bend them, just press them in. This simple maintenance may be enough for you to finish your photo trip without further problems, but do have your equipment serviced on your return.

It is advisable to carry a spare flash gun lead to avoid frustration on a photo-dive trip.

I would recommend regularly testing your TTL before you load a film into the camera.

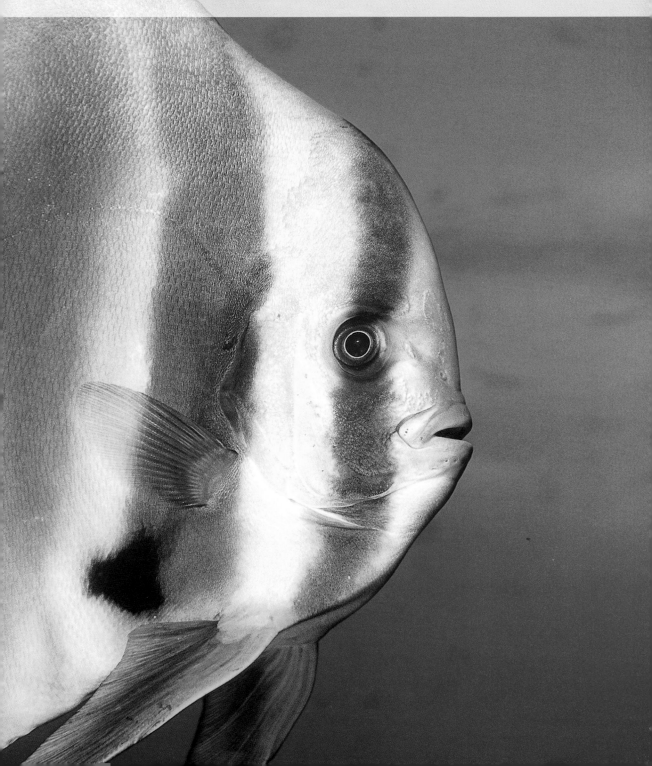

PART 4
The Mindset

28 Our mindset

Achieving a good standard of underwater photography is as much about the state of our mindset when we dive as about theoretical knowledge to do with pixels and points. Our bright ideas can be turned upside down if we have little or no control over our photo dive:

- Dive guides may hurry you around a circuit with little time to stop, concentrate and take photos
- The dive group may constantly switch dive sites, never returning to the same place twice
- Reef dives that start in 20 m or more means little bottom time to find subjects and take pictures!

I'm sure you can all add to this list. This is not the fault of the dive resorts. Whilst many are sympathetic to the needs of photographers, we have to appreciate that they do have an operation to run which caters for the majority, and in many locations that represents newcomers and non-photographers who do not care to stay in one place for a long time or to remain at a particular dive site for the whole day.

If you find yourselves in this situation and have difficulty getting to grips with your underwater photography, then I can offer you the consolation of knowing that it's always difficult to apply your mind to underwater photography in these circumstances. Try not to get too frustrated. If this scenario is your reality, then you may have a few decisions to make. Consider:

- Are you a diver who likes to take a camera along to record what you see? If you are and you choose to continue diving with the

group, then accept the restrictions and enjoy your photography in the best way you can. Appreciate that you may not have the time or opportunity to give a subject the photographic attention it deserves.

- Does the dive leader and rest of the group go a little too fast along the reef for your liking? Do you get left behind by the others, have a pang of guilt, abandon your subject and swim off to catch up with the group?
- Do you think that your penchant is underwater photography, and that is the purpose of your intentions when you dive?

If the latter two strike a chord and you have aspirations to improve your pictures, then you need to consider changing the way in which you dive to a method more suitable for underwater photography. Fundamentally, it is a change of mindset.

All over the world there are numerous diving trips that cater exclusively for the needs of enthusiastic underwater photographers of all standards. The manner in which the diving is conducted, be it shore-based or a live-aboard, provides the conditions, stimulus and environment for photographers to do their thing. Only by creating the right environment will you fulfil your potential and consistently perform at your best. The solution could be nothing more than hiring a boat to visit a particular photogenic dive site, joining an underwater photo group who dive together, or signing up for a dedicated photographic workshop. So many aspects of consistent photography require a state of mind to develop skills so that real improvement can begin.

29 The 'think and consider' (TC) system

The 'think and consider' (TC) system is just a system or structure to be considered in sequence when taking a photograph underwater. It came about as a means of explaining to those who attended my courses how I approach my own underwater photography, and the thought processes that other successful underwater photographers use.

It goes back to 1982, when I was very much a newcomer. I was hungry for knowledge on how the top underwater photographers obtained the stunning shots they did. I quickly identified that it was the person and not the camera equipment that made the image. I set myself the task to ascertain as much as possible about the mindset and methods of those whose work I most admired. Over a period of time I found a commonality in method and mindset of those who I questioned, pestered and badgered into explaining to me how they got the shot. The terms they used to describe their methods differed, but each philosophy had remarkable similarities with others. My thirst for this knowledge has never subsided, and I am still eager to learn more. To this day, I listen to everyone and continue to discard those things I do not feel to be pertinent. The TC system is at the forefront of my whole approach and is fundamental to my teaching, coaching and mentoring philosophy.

As I write this book, I know that the TC system works. In the last fifteen years, I have witnessed hundreds of enthusiastic underwater photographers employ these techniques for themselves. Within a short period of time they have developed from complete beginners to competent, skilful and imaginative photographers.

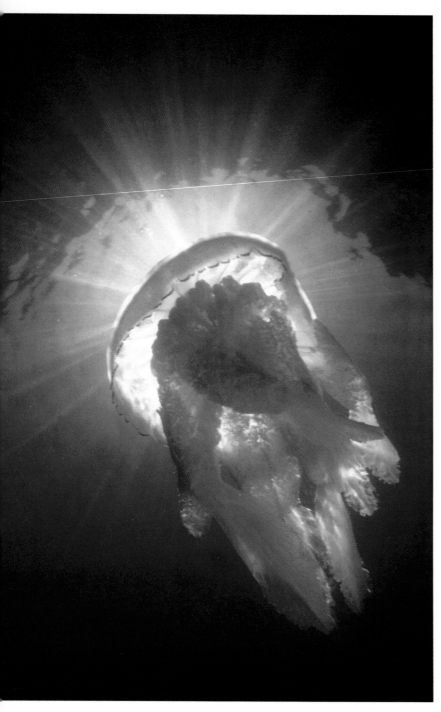

Figure 29.1
Of all the underwater photographs I have taken, this particular shot has the most significance. I could describe it as the moment when, photographically, the 'lights came on' for me. At that time I was a very happy snappy scuba diver, but I knew I wanted more out of my photography. During an Easter weekend dive trip to Cornwall, UK, I came across a jellyfish which had been stranded in a large 1-m deep rock pool. I instinctively knew that the circumstances would provide an opportunity to take a very good picture. I surprised my fellow divers and 'excused myself' from the afternoon boat dive on a well-known wreck. They thought I was crazy to miss a dive in favour of snorkelling in a rock pool. That weekend, jellyfish were in abundance. So, why not shoot one in the sea after the dive? My gut feeling indicated that the rock pool was the right decision. The word that continually came to mind was 'potential' – this opportunity had great potential! My buddy Bob Wrobel and I spent an hour or so in the pool, and I came out with this natural-light shot taken on a Nikonos 111 with 15-mm lens. It was soon after this picture that I first labelled the features of the TC system. It all fell into place, and I never looked back. Shallow water environments have always been a strong feature of my photography since that time.

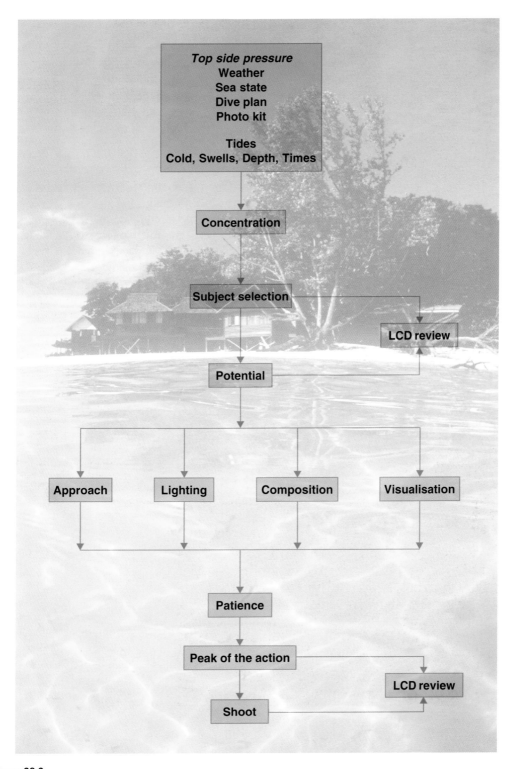

Figure 29.2
Top-side pressure.

Some have become the finest underwater photographers in the UK at this present time.

The digital revolution has made huge advances that benefit the underwater photographer in ways that it was impossible to imagine only a few years ago. I have revisited the structure of the TC system with digital users in mind, and this entire chapter of this book has been developed and rewritten to reflect this.

How do we use the TC System?

Study each feature of the system until you are conversant with it. Relate it to your own photography and previous experiences underwater. The analogy I use to compare the TC system is that of driving a motor car. Throughout the journey we make numerous and often instant decisions – when to pull out, to overtake, to brake and to accelerate. We consider many scenarios and in an instant come to a decision. The TC system is no different. Consider the features, and make decisions based on your experience, intuition and perception of a photo opportunity.

Note that composition and lighting are huge topics, and as such are discussed extensively in Chapters 40 and 41.

30 Camera preparation

The topic of camera preparation belongs at the very beginning of the TC system. If the underwater photographer does not establish a routine or habit of preparing the camera, flash, housing, etc., for a photo dive, then sooner or later problems will arise in one form or another. Technical divers have a rule that 'no one should be distracted by another person whilst they are preparing their equipment'. If we could establish a similar system when preparing cameras for diving, the chances of flooding our equipment would be significantly minimised. In my experience, 95 per cent of floods are caused by human error – and more often than not it is down to rushing to get ready and making simple mistakes. The design of modern camera housings reduces the chance of experiencing a flood. However, mistakes are sometimes made in the preparation stage which result in a flash gun not firing, a lens not focusing and a camera 'packing up' in the first few metres.

In 2004, I was preparing my housing in the camera room at Wakatobi, Sulawesi. I needed to change flash batteries but was running late for an evening drink at the bar. I took the batteries out to charge and left the screw cap off the top, intending to return later. Of course, it never happened. I totally forgot, and the next morning I picked up my housing, took it to the boat – and two miles out to sea discovered that I had left the flash gun caps in the camera room.

How many times have you been in the water and discovered one or more of the following?

- No film in the camera
- No batteries in the flash, or they are flat after two minutes

- The camera will not turn on due to misalignment of the switch
- The autofocus will not work due to a misalignment of gears
- TTL is not working
- The wrong port is fitted for the wrong lens.

The list is endless, and you are not the only ones that suffer from these problems. I will let you into a well-kept secret: underwater photo professionals have as much equipment buggeration factor as anyone. I am not particularly proud of this achievement, but I once neglected to put the camera into my housing!

It's good practice to develop a routine. Ensure that distractions during preparation are minimised. If you feel that you are rushing things, then slow down and retrace your steps. Having experienced all of these errors for myself, I know that distractions lead to floods – not because of faulty equipment, but from a lack of preparation and routine.

31 Top-side pressures

Before we enter the water, we can be carrying around a whole bag of pressures and distractions. I have never completely developed my 'sea legs', and if it's rough I can become nervous at the thought of being seasick. There are numerous reasons why we feel apprehensive at times, and this regularly accounts for why cameras are intentionally left behind before the boat has left the harbour. Have you ever had that instinctive feeling just before you enter the water that maybe you should leave your camera behind?

We are all prone to being apprehensive at times. In these situations, photography will invariably come low in our order of physiological needs and priorities. By instinct, very few of us could abandon these priorities for the sake of a few pictures. An important element of successful and consistent photography is concentration, and we can only begin to concentrate if we identify our own distractions and take steps to minimise them.

Concentration

How efficiently are you able to concentrate on your photography whilst underwater? Do you ever have a photographic task in mind and, as soon as you are breathing from compressed air a couple of metres below the surface, your mind seems to go totally blank? Do you enter the water with a certain shot to take and once there forget how to set your camera up to achieve it? Something stops working on your digital camera. You know for certain that you can fix it, but for some odd reason you seem unable to apply your mind and concentration to the job.

I work with many underwater photographers who have a problem with their ability to concentrate underwater. My first question is this: 'What is distracting?' Often it's hard to put a finger on it, so I give them a slate and ask them to write down (*whilst underwater*) the reasons they find themselves unable to think clearly.

The most common (in no particular order) are:

- Paranoia about cameras and flash guns flooding
- Having a problem in following or losing a speedy dive guide
- The dive mask continually fogging-up
- Feeling the cold
- Being preoccupied with depth and dive profile
- The fear of becoming separated from or holding up the rest of the group
- Lack of confidence with buoyancy control
- Going too slow for their buddy.

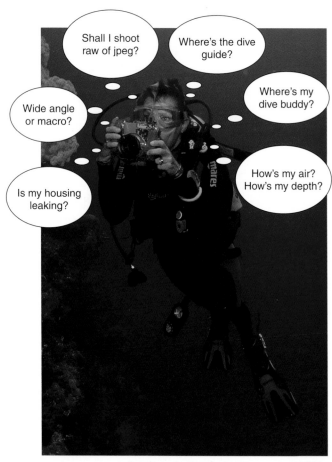

Figure 31.1
Distractions to concentration underwater.

Some of my own distractions and solutions may interest you: I'm sure you will relate to many of them.

- The clarity of my dive mask glass is paramount. A fogged mask is the ultimate annoyance
- I produce little quality work when diving in a strong current. I just go out to enjoy the dive in these circumstances
- Cold, rough seas and sea swell distract me
- I have recently replaced a pair of bootees which rubbed my ankles. This was a painful distraction.

I produce my best work in shallow water, close to shore, whilst diving with a buddy who shares my attitudes. We are able to dive together, but in such a way that allows us to place less emphasis on each other's immediate well-being and more on our photographic aims.

The bottom line

Whilst I believe that our powers of concentration are fundamental to consistent underwater photography, I also appreciate that in a variety of situations underwater photography will come low in the order of our physiological needs and priorities. No one should abandon these priorities for the sake of taking good underwater photographs.

32 Subject selection, negative space and potential

Everything we see underwater is a credible subject. The majority of subjects are quite obvious – dolphins, fish, corals, the list is endless. In certain locations, the less obvious may be in such profusion that we tend to ignore them as quite mundane. The potential of the subjects we choose to stop and photograph is in my opinion one of the main factors that separates the best photographers from the rest. They are skilled at seeing an opportunity which the majority of us swim over without a thought; their inner eye spots a chance and instinct takes over. For some it's an intuitive talent, but I do believe that it is a skill that can be developed with practice.

How can we train our underwater eye to recognise the potential in a commonplace subject? Here are some ideas that may help.

Figure 32.1
The photographer is able to settle on the black volcanic sand to shoot a subject attached to the fan coral.

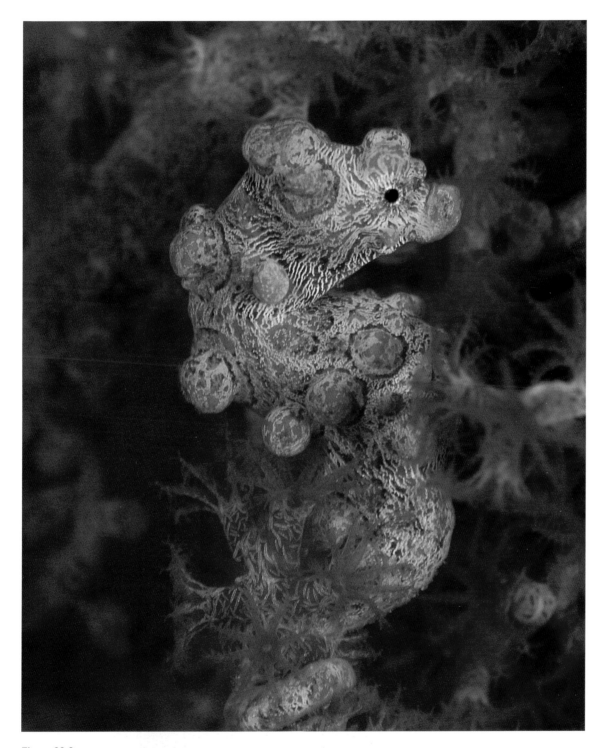

Figure 32.2
Although only 1 cm in height, this pygmy seahorse was situated in an ideal place towards the lower part of a fan coral, which provided accessibility for me to get close without harm to the reef.

Nikon D100 with 105-mm macro lens with Nikon +4 close-up dioptre, single Inon flash gun, f22 at 1/180 s shutter.

Many subjects that live on, in or close to the reef cannot be photographed by virtue of their inaccessibility. We can take a snapshot through branches of coral, but in general it may have little potential by virtue of its location. Reefs that are horizontal, however pristine or attractive they appear, may have little potential for the same reason. It's almost impossible to settle on a horizontal reef. All we can do is to shoot at a downwards angle, which is not the best way to compose subjects.

Lying on the corals to steady ourselves or disregarding the reef in any way is totally unacceptable – period! So how do photographers obtain the shots in the books and magazines which most of us aspire to? This is precisely what subject selection is all about. It's learning where to look and how to find accessible subjects. Accessibility leads to compositional potential; accessibility allows flash gun placement where it will most flatter the subject. It allows us to take our time and work a subject, confident that we can obtain something more than just a snapshot.

Where to look

Look for an overhang or reef wall where it starts to drop away. You have a good chance of placing two fingers on a non-living part of the reef, holding steady and approaching a subject at eye level instead of having a bird's-eye view. From this angle, you have a great opportunity to eliminate a cluttered background.

Shoot a bottom dweller whilst it is resting on plain sand instead of rocks and boulders. It's easier and more effective.

Shooting the strongest features of a photo site

Many good photo dive sites have a feature that is prominent in that particular location. There is a site on Kapali, Malaysia, that has numerous free-swimming lion fish. At Sipadan, it's the abundance of turtles and schooling jacks and barracuda. At St Johns Reef in the Southern Red Sea, it is shallow cave systems with fantastic sunlight. Ascertain the strongest features from other photographers and the locals. Because the feature is common to that site, you will have a far greater chance of finding an opportunity that is situated in the ideal place to make an excellent photograph.

Condition of the subject

By using a digital camera, a proper and critical review of the LCD screen will reveal to you the condition of your chosen subject. If it's a poor specimen of fan coral, you may wish to select another close by. Get into the habit of evaluating the LCD underwater.

Figure 32.3
The blue spotted ray contrasts well against the plain sandy bottom. In my experience this angle of view rarely works, as reflective boulders and rocks are the usual habitat for this subject.
 Olympus 5050, Ikelite 125 flash gun. Wakatobi, Sulawesi.

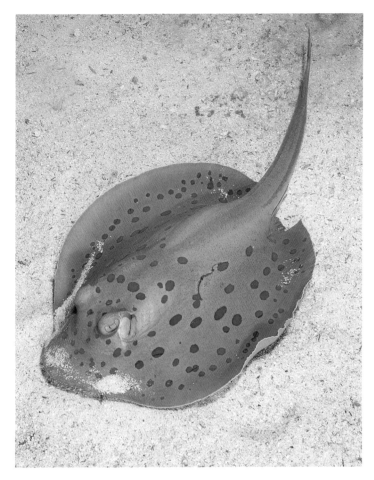

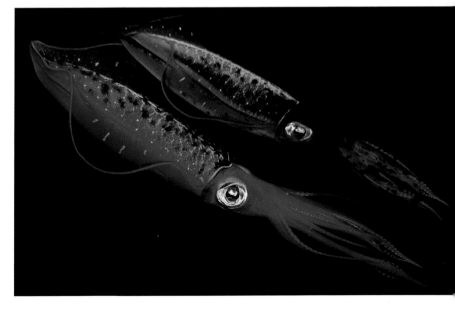

Figure 32.4
In 2001, six Caribbean reef squid were located just off the shore at Capt Dons Habitat in Bonaire. They were easy to approach and very photogenic, providing excellent potential to photograph these creatures successfully in a variety of ways. During the week I shot them at least five times. On this occasion, I entered the water with the intention of shooting two together. I used a 60-mm macro lens on my Nikon F100 film camera with just one Sea & Sea YS 120 flash set to TTL. I took about twenty shots. The dark background is a result of a small aperture – f11 or f16 – and low light conditions at the end of the day.

Negative space around the subject

The phrase 'negative space' was introduced to the world of under-water photography by the excellent American photographer, Howard Hall. In my early days his book *Successful Underwater Photography* was a revelation to me and thousands of others. He defined negative space as being 'Everything in the photograph that is not the subject'.

Negative space has been a significant factor in my own work for many years. My choice of negative space is everything. It determines whether or not I shoot the subject. A fish may be interesting and colourful, but if it's against a poor background the photo will often fail! Successful underwater photography is more often about the negative space than about the subject itself.

Specific types of negative space

A sports photographer will focus on a specific area of a motor-racing circuit, awaiting and anticipating a subject – a racing car – moving into that area so he can press the shutter. Skilful underwater photographers do the same – choose an area of outstanding negative space and wait for something to swim into it before they press the shutter.

A typical example is the photogenic clownfish with anemone, which rarely stay still long enough to focus and compose. I find the best option is to choose an area of the anemone that will make a good background. Pre-focus the lens a few millimetres in-front of the anemone, and lock autofocus to avoid it constantly 'hunting' for sharpness. Concentrate, and wait for the clownfish to swim into your chosen negative space. When it appears, press the shutter. The fish move so quickly that it's difficult to determine whether you have achieved a pleasing composition, so take as many shots as you believe the opportunity deserves. Some compositions will look

Figure 32.5
The negative space around the lion fish was very poor. It was upside down and facing away. I took two shots to record this particular species, which at that time I had not seen before. To me, the opportunity was worth no more.

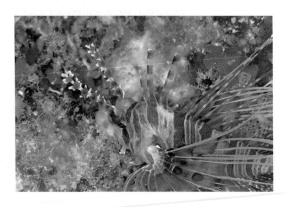

Figure 32.6

The anemone was so colourful and very accessible. I decided to compose a photogenic part of the anemone as my negative space and allow the subject to swim into it. I pre-focused on the tips of the anemone, and every time the clown fish swam into my viewfinder I pressed the shutter. I took eight shots of this action. I retained the same aperture, shutter speed and focal point. In all eight shots, the background is exactly the same; the only thing that differs is the subject. In a couple of frames the fish was out of focus. In three others, the clown fish was facing away from the lens. This one worked well for me.

Nikon F90x with 105-mm macro lens, Subal housing, Edge–Sullivan ring-flash set to TTL, f16 at 1/90 s, Elite 100 ISO.

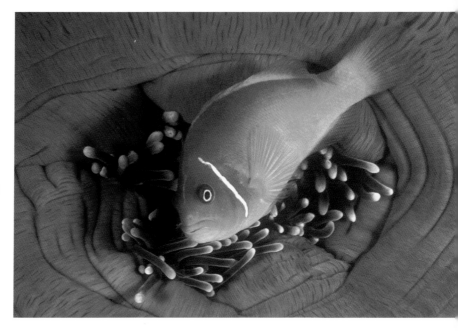

poor, that's a certainty. Other shots may be out of focus due to the depth of field, but you have a great chance of getting shots where the composition of the fish is pleasing and the sharpness and eye contact is just right! What sets this type of technique apart from the rest is that the negative space is simple, uncluttered, and compliments the main subject.

With black and blue backgrounds, using the colour of the water column is one of the easiest of ways to make your subject standout against its background. The technique to achieve this is determined by the exposure in the camera. It's a combination of the shutter and aperture which allows the natural light of the water column to be recorded. By pointing our camera towards the blue or green water column, the internal meter is able to determine the light levels. A typical combination to achieve blue water similar to how our eye sees it with both film and digital using 100 ISO at ten meters in a tropical blue sea would be in the region of $f8$ aperture at 1/90 s shutter speed. If we close down the aperture towards $f22$ or choose a faster shutter speed, we are minimising the light entering the camera and the blue water gradually changes to dark blue, then midnight blue to black as we stop down. This black background is ideal for almost any subject, but some underwater photographers feel that a black background is false and does not represent the blue of the sea.

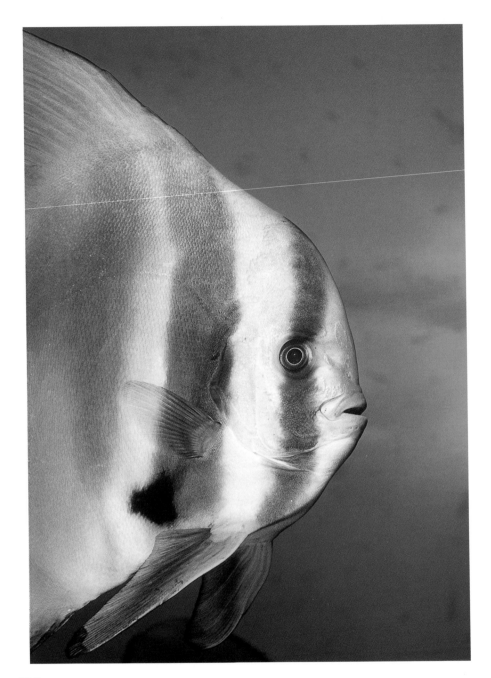

Figure 32.7
I used a Nikon F90x in a Subal housing, 60-mm macro lens, twin Sea & Sea YS 90 flash guns set to TTL and Elite Chrome 100 ISO VS for this shot. The location was Papua New Guinea. One afternoon I had a close encounter with a school of bat fish. Once I realised that the school did not mind my close proximity, I considered the potential of this particular opportunity and decided to open up the water column and achieve a natural blue-water background. I opened my aperture to $f8$ in order to allow my flash to carry a little further, and opened up my shutter speed until my internal camera meter indicated a natural light reading of 1/30 s. I shot another dozen pictures, bracketing between 1/30 s and 1/15 s, until my film ran out. I deliberately placed myself between the reef wall and the fish so I could shoot out into the clear blue water. This is an example of a simple but effective choice of negative space by manipulating the controls of the camera to take advantage of the natural colour of the sea.

Blur

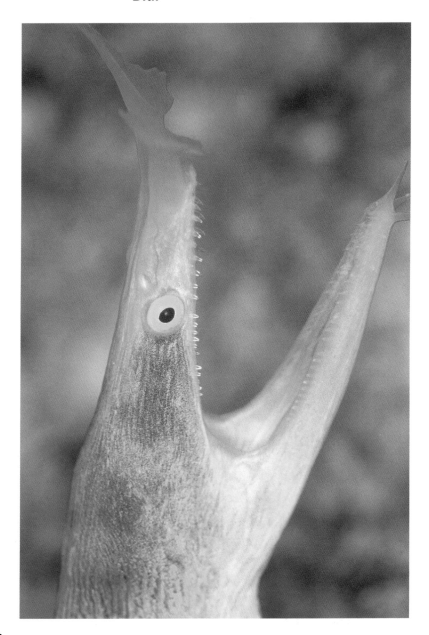

Figure 32.8
A dive guide at KBR, Sulawesi, pointed out a blue ribbon eel. It was close to the seabed, and I decided to shoot tight in on the head. I took three shots at f16, and then opened the aperture to f5.6 to reduce depth of field and create what I hoped would be a very pastel, blurred background. This time I was shooting at a magnification of about 1 : 3 – one-third life-size. I took another four shots, hoping that I would be lucky with at least one in achieving sharp focus on the eye closest to the camera.

I shifted my position in an effort to get the eye and mouth on the same plane of focus as each other. Only two shots were within an acceptable depth of field, which rendered both the eye and mouth in sharp focus.

Nikon F90x with 105-mm macro lens, Subal housing, Edge–Sullivan 'ring of light' ring-flash on TTL, Ecktachrome VS 100. Whilst blurred backgrounds can be obtained quite easily using Photoshop, I myself gain a sense of satisfaction from creating these effects in camera at the time.

Tight compositions

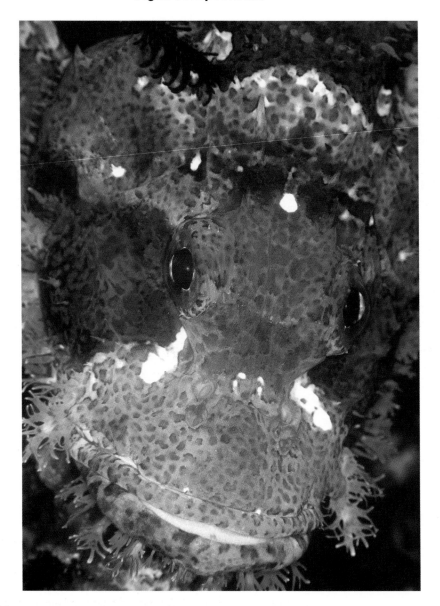

Figure 32.9
A good subject but lying on lousy negative space, this scorpion fish was basking in the sunshine on top of hard corals. I had two choices – not to bother and move on, or shoot him to the best of my ability given the poor background. I chose the latter. I considered my options. I was unable to adopt a lower camera angle because the reef was in the way. On this occasion I was left with no other option than to eliminate the negative space completely. I chose to compose and crop tightly in my camera viewfinder to achieve just a head shot. In effect, the entire subject (the scorpion fish) filled the frame.

Left with such a tight composition, the eyes became the obvious focal point/centre of interest. I had little choice of where to place the eyes within the picture frame; if I had shifted my composition to facilitate this then I would have included clutter. It would have been easy to take the entire scorpion resting on the top and crop the shot later when digitally scanning. However, it helps my own process of composition and concentration to attempt to get it correct first time.

Nikon F100 with Nikon 105-mm macro lens, Subal housing, dual Sea & Sea YS 90 flash guns on TTL, f16 at 1/125 s, Fuji Velvia.

Colour contrast

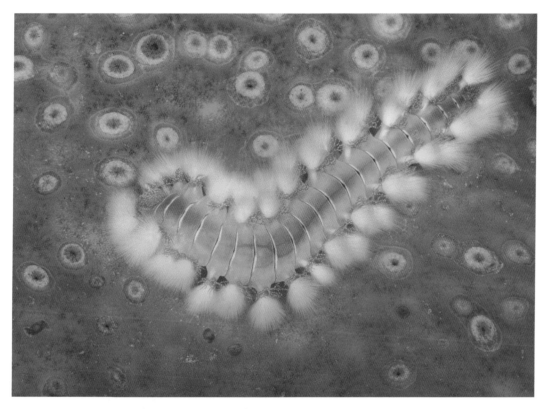

Figure 32.10
I have seen and shot numerous fireworms, but rarely have I see one situated on such excellent negative space. I took several shots before it crawled into a 'Nike' logo shape. The colours of both subject and background are similar; however, it is the texture of the fireworm that helps to contrast against the colourful sponge.
 Nikon D100 with 60-mm macro lens, single Inon flash gun, f32 at 1/180 s.

Potential

You have found a subject with good negative space situated in an ideal position for you to photograph. How many shots are you going to take? How long are you going to stick with this opportunity? Could this be a really good shot? Consideration of the potential is necessary. Ask yourself how good the potential could be. How long should you stay in that spot and shoot? How many shots might it take to get one that really works? Is the potential just OK or excellent? There are no hard and fast rules. Only the photographer can make these decisions.

Practical experience
On a recent photo workshop, I assisted two photographers in their search for potential. They were frustrated, believing they were choosing the wrong subjects. I created an exercise which taught me more than I ever expected.

Figure 32.11
This was taken at Nudi Falls, KBR Sulawesi. At 23 m there is a garden of soft corals growing from the volcanic sand. The potential is colour and accessibility, which makes it a simple matter of hugging the bottom close to your choice of coral. This particular branch was covered with small gobies. I choose an area with a graphic line of an upside down 'V' shape. I composed, hoping that a blenny would occupy the space. After a couple of minutes I had the chance. It moved about the coral branch and I manage to capture it in an ideal composition.

Nikon F90x with 105-mm macro lens, f16 at 1/90 s, Edge–Sullivan ring flash, Elite Chrome 100 ISO.

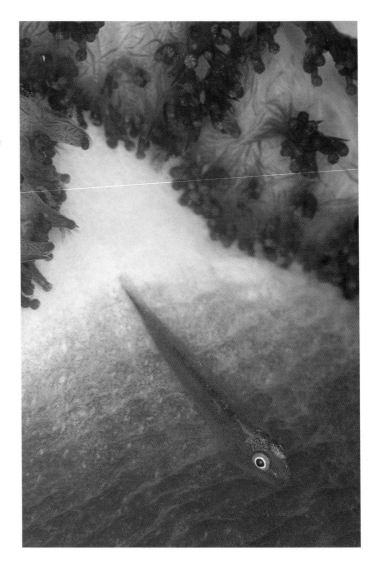

Figure 32.12
Potential! How often do you see leaf fish perched on the top of the reef against clear blue water? Rarely, I would suggest. When an opportunity presents itself, we need to take advantage. In this case I captured it in a variety of ways, in profile, against various tones of blue water. Sipadan, Malaysia.

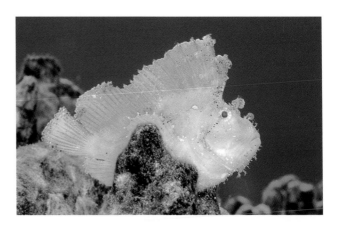

Figure 32.13
As a result of its location, this profile was relatively easy to take. The blue tones around the facial features were recorded on film, perhaps due to the intense blue water in the background.

Nikon F90x with 105-mm macro lens, f16 at 1/90 s.

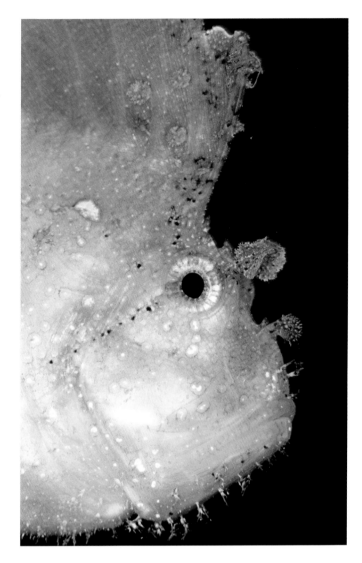

Figure 32.14
Shooting down on this tube worm is the only option in these circumstances; however, the negative space is poor and worth no more than one or two shots.

Figure 32.15
Located on the same boulder no more than 1 m away from the image above, I could get below it and shoot up against blue water – which, at an aperture of *f*16, has recorded black.

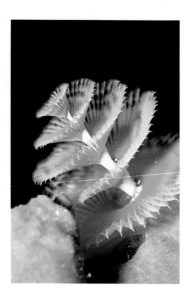

We all used digital. The idea was that for one photo dive the couple would select subjects that they considered had good potential. After their turn, I would attempt the same to see if I could improve on their efforts in any way.

We used a shore photo dive that was familiar to us. They selected between seven and ten subjects. I took my turn after they had concluded. In general I found that I was unable to improve on either the technical or the aesthetic aspects of their attempts. I did all I could to obtain a pleasing shot. What totally thwarted us was the potential of the subjects they had selected. The solution was to select the same type of subjects but situated in alternative locations which provided greater potential to improve.

Digital evaluation of potential
Before the digital age of underwater photography, we were left to ponder the issue of potential in our mind's eye. We anticipated whether it was average or better, but we never knew for sure until we saw our results. Had we got the shot, or did we need to stay longer? The inclination with subjects of good potential was to

Figure 32.16 (Opposite page)
The potential of an opportunity is very subjective. For instance, over the years I have shot numerous images of turtles and schooling fish, which are both in abundance on Sipadan Island. I no longer have the inclination to shoot turtles with the same enthusiasm that others may. During my last trip in 2001, whenever we found the large schools of jacks and barracuda I began to check the reef immediately below them for subjects that I could include in the foreground whilst the schooling fish would occupy the negative space. The image below is one such encounter. I found the schools first, and took advantage of a sleeping turtle which I knew the school would swim over. I only managed to take two shots before the turtle swam away.
 Nikon F90x with 16-mm fisheye lens, two Sea & Sea flash guns set to TTL.

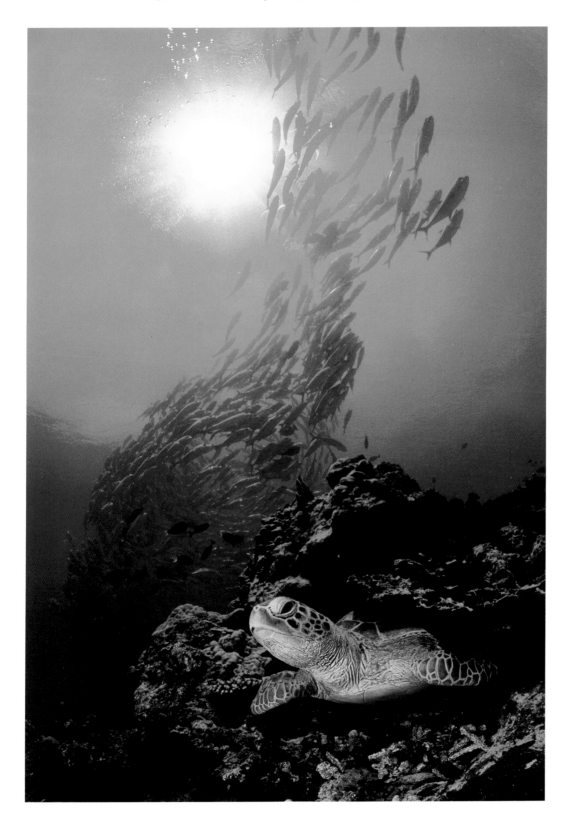

shoot extra just in case. Believing we had an excellent opportunity was the key that spurred us on to shoot additional frames or additional rolls of film. With digital, we can now review and make these decisions underwater before we head back to the boat. If we evaluate the LCD properly, we can see if we need to stay shooting or move on to another subject, safe in the knowledge that we have pleasing images in the camera.

Last thought

Consider your favourite underwater photographer in the world. Doubilet? Newbert? Cathy Church? How do you think your underwater photography would improve if they could choose subjects for you to photograph? Just a thought!

Top tips

1. Shoot the strongest feature of the dive site
2. Consider the accessibility of the subject; if it's tricky, then move on
3. Consider the best place to look on your photo dive
4. Look for subjects against good negative space
5. Check the condition of subjects in the LCD
6. Ask yourself what the potential is of your chosen subject
7. Take a snapshot and look for potential on the LCD review; if it's not as good as you once thought, then move on to something else.

33 Approach

Whenever I present the topic of underwater photography to an audience, one particular question is always popular:

> How do you get close to creatures with a camera without spooking them?

Examples of problems are provided, and go something like this:

> The fish waited until I had ran out of film then began to pose for me.

> When I leave my camera behind on the boat I always seem to be able to get really close to things.

> Whenever I take my camera, things just swim away.

Take heart. You are not alone. The reason for your frustration may have something to do with the feature *Approach*, which I define as:

> The physical means of moving into and getting closer to the subject.

You are diving along a reef with your camera when you spot a creature that you would like to shoot. It could be a fish in the corals, a moray, a scorpion fish. In fact, anything that could potentially disappear is relevant to the technique of approach. You approach, aim the camera, and 'pop' you have the subject on film – or do you? The crucial moments are those between the brain and eye seeing the subject, and making the assessment to shoot it and your finger pressing the shutter. It is within this period of time that the decisions are made, and this is crucial to achieving success.

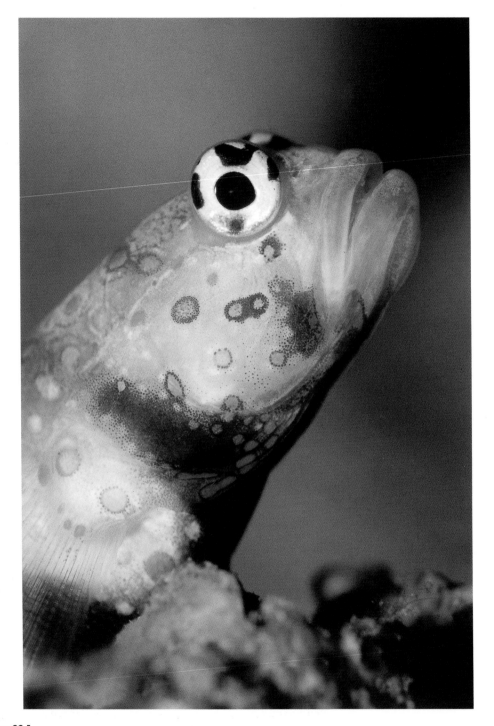

Figure 33.1
Set your aperture, shutter and flash position before you move in. Stay low and move in slowly. Resist the temptation to look at your digital LCD too near to the subject, or else you will spook it and miss the chance of a second go. Give a moment's thought to your intended camera angle so you can approach from this angle.

Nikon D100 with 200-mm macro lens, f16 at 1/180 s, two Inon Z220 flash guns placed each side of the port.

The reality is that the photographer spots the subject and, in the excitement and enthusiasm of the encounter, sometimes:

- Moves straight towards the subject, landing in a cloud of sand and creating backscatter
- Approaches at the wrong angle from which it is impossible to achieve a well-composed image
- Gets to the subject before it's spooked, but needs to alter the camera controls because they weren't set up for the shot before approaching, and then the angle of the flash guns are re-positioned.

More adjustments, more movements and more chance of scatter – ever wonder why subjects swim away?! *Make the adjustments by all means but NOT too close to the subject.*

At the very moment we observe a creature and decide to take a picture, before approaching it, *THINK APPROACH*:

- Look at your surroundings; if you cannot approach without threatening the fragility of the reef, then don't try. Don't take the shot! Back off and find another creature in a location in which you feel comfortable.
- Consider the angle of approach. From which direction does the subject look best? I once spent time moving closer and closer to a resting leopard shark. I did a good job and got to within inches without spooking it. The only problem was, in my eagerness I had moved directly in towards its tail. When I realised this was not the angle I wanted, I attempted to move around to the front end. I spooked it and lost the opportunity for an excellent photographic encounter.
- Backscatter and buoyancy control are fundamentally linked. They can ruin many opportunities.
- Consider the best angle of view.
- Set your aperture before moving in.
- Adjust your flashgun. Does the shot lend itself to a landscape or a portrait composition? Do you need to adjust your flash arms if you shoot it in a certain format?

If you make your adjustments in close proximity to shy and timid creatures, you run the risk of spooking them! Make these decisions before you start your approach. In this way you are prepared to approach slowly, carefully and methodically. Your adjustments will be minimal, and you will have a greater chance of getting close.

Now, back to those problems from the audience:

Why do I always get closer when I have finished my roll of film?

This is because you have now stopped moving your camera from side to side and up and down. You are using your buoyancy to steady yourself, and your eyes to observe. You are stable, quiet and making minimal movements of your body. No doubt your camera is folded away and tucked beneath your arm.

When I leave my camera behind on the boat, I always seem to be able to get really close to things.

You can get closer to things because the camera is not getting in your way. It is the movements and handling of the camera that cause the majority of approach problems.

A word about your flash position

Be aware that if you choose to position your flash gun in front of your housing port, out towards the creature, then you may run the risk of it being spooked – not by your presence or your housing, but by the intrusion of your flash into its comfort zone! The fish swims away, you become frustrated with the fish and you blame your powers of stealth, when all the time it was simply the close proximity of your flash gun to the subject.

My tip: Don't just swim straight in regardless; give it some thought beforehand.

Digital users

Advantages
If you are approaching a shy bottom-dwelling subject, set your flash, exposure and camera orientation. Simulate the opportunity by shooting a test shot along the sand to determine whether your flash guns are placed correctly. Do this a distance away from the subject – it will only take a moment. When you then move in on the real thing, you can be confident that your camera/lighting techniques are sound.

Disadvantages
When you take a digital shot, the anticipation and the need to view the LCD after each frame is overwhelming. It becomes so habitual that even though you may know exactly how the shot will look, curiosity gets the better and you take a peek. I have observed time and time again the camera being lifted from the eye and moved forward a foot or so to take a comfortable look at the LCD. The action of moving the camera in this manner and the direction of movement is thrusting the camera rig directly in the face of the subject. I see so many subjects spooked by this action! Although it has little effect on stationary subjects, there is no doubt that it affects cuttlefish, octopus, etc.

I noticed this in others and scrutinised my own habits. I was the same – I had been doing it for months! I took a shot with my Nikon D100 and had the overwhelming desire to look at my own LCD, even though I knew that my flash guns were correctly positioned, the exposure was correct and the composition pleasing. When I viewed the monitor, I lifted the housing so the LCD was at eye-level and pushed it forward to view – straight into the face of the creature I was trying so hard to get close to. After this had dawned on me I discussed my observations with the group, but having become a habit it was a hard one to break.

The bottom line for me is to be aware of this trait. If you feel like my group and I, you may be susceptible. My advice is to trust your set-up, your lighting and your composition and, if the action is occurring, keep your eye on the viewfinder, trust your trigger finger and resist the temptation to review the LCD after every single shot. You will find that when the action is fast, every other five or six shots for review may suffice and satisfy your curiosity. I fully appreciate this is a very subjective observation, and whilst I do not intend to be prescriptive, it may just give you the edge the next time you are shooting a skittish subject on digital.

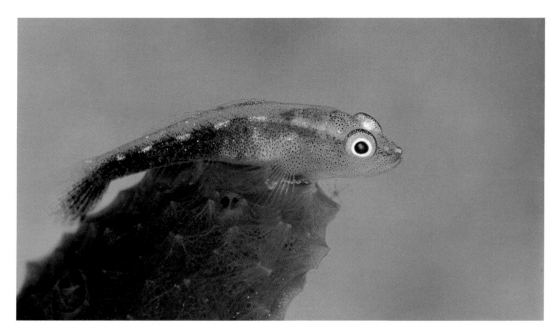

Figure 33.2
This was taken off the island of Mabul, Malaysia. The seabed was interspersed with small coral outcrops. Our dive guide pointed out sponges and coral branches hosting all manner of close-up subjects. I observed a small, colourful finger sponge hosting two colourful gobies. What made this particular spot so easy was the lack of any other corals. I could lie gently on the sand and line up on the sponge. I made all of my adjustments far enough away not to kick up the debris or spook the gobies.

I preset $f11$ at 1/125 s and set TTL on a single Sea & Sea YS 120 flash. I moved-in closer and closer, very slowly, using autofocus on my Nikon F90x and 105-mm macro lens. Over a 5-minute period I popped about six to eight shots without moving a proverbial muscle! I then began to change the composition slightly by moving my body for a face shot. This was okay, but when I moved the flash gun the subject vanished.

34 Lighting for the TC system

I often think back to my early days in underwater photography, when the TC system was just a subconscious contemplation in my mind, swirling around between visions of winning all the best competitions and capturing on film underwater subjects that others had never even seen. How naive I was back then. I remember my first turtle in the Florida Keys in 1982. I sneaked up carefully with my Nikonos 111 at arm's length, and realised I needed a vertical format. Without a second thought I turned my camera and tray anticlockwise, and my long Oceanic aluminium arm holding a heavy Oceanic 2003 flash gun connected with my knees. Clouds of sand and debris billowed out from the reef below. My flash somehow became detached from the arm and began to float upwards like a balloon on a coiled string. Needless to say, I never got the shot of the turtle – but I remembered the embarrassment for some time. One good thing did come out of this: it made me realise that it was too late to start thinking about flash angles when I was on top of a subject and about to press the shutter. That is all the TC system is – just a prompt to consider how you may prefer to light a certain subject:

- Flash or natural light?
- How about a combination of the two?
- My flash gun is over my camera. If I turn it into a vertical format, the flash will illuminate the subject from the side, how will this affect the result?

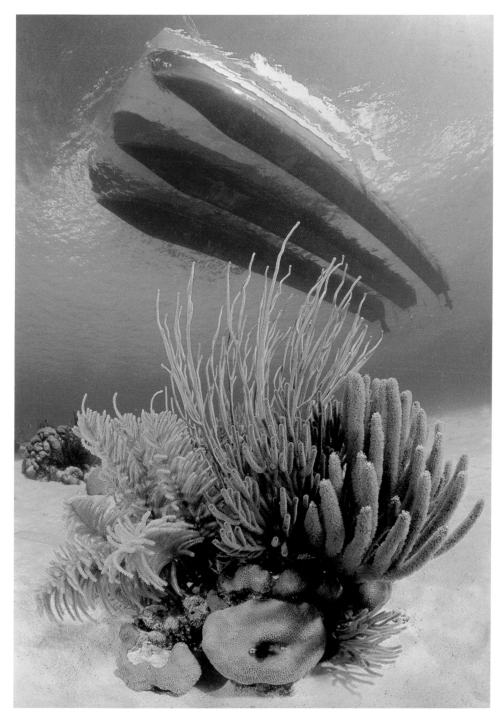

Figure 34.1
A shallow wide-angle opportunity off Klein Bonaire. It took a degree of good fortune and patience to capture the dive boat at a pleasing angle to a small outcrop of hard and soft corals. The foreground is softly lit by the flash gun whilst the ambient light provides the atmosphere. It looks relatively simple, but with the combination of fill flash and composition of the boat it took fifteen frames to get it right. On my roll of film, this shot was number thirty-six!

This is how the topic of lighting with both natural light and flash fits into the TC system. Just give it a thought before you begin. Oh, and by the way, if you are still using one of those big Oceanic 2003 flash guns, be very careful where it lands should you forget where to place it. You have been warned!

The topic of lighting, both natural and flash, close-up and wide-angle, is described extensively in Chapter 41.

35 Composition for the TC system

Some enthusiasts fail to give much thought to composition whilst they are underwater. They know the techniques and compositional guidelines – many are keen land photographers – but underwater the ability to think and consider composition is not as good as it could be.

My suggestion is to consider composition before you press the shutter. Look through the viewfinder to see what is included in the frame. Notice the direction and manner in which your eye travels across the frame as you scan the scene. Look at all four corners. Do you like the way you have placed the subject; is it 'balanced'?

When my concentration is heightened and I am in 'the zone', I am able to imagine that the image is being projected onto a screen in a darkened room. Do I like what I see? If the answer is yes, I press the shutter. I may take a number of shots, depending on the subject, before I make a point of reviewing the LCD on my digital housing. I ask myself, do I like what I have taken? And, more importantly, how can I improve on it? Mindful consideration of composition at the time will improve the chance of getting what you want in camera without extra work in Photoshop.

Composition is discussed extensively in Chapter 40.

Figure 35.1
I had been searching the reefs around Manado, Indonesia, all week for whip corals with a perfect spiral. I took a snapshot with my digital SLR and showed Sylvia, who was happy to model for me. Instinctively she took up a position at the rear of the spiral and pointed a Kowalski dive light towards the camera. I was pleased but very surprised when I viewed the LCD screen to see that two clown fish had swum into a perfect position to balance the entire composition.

Nikon D70 with 10.5-mm fisheye lens, Subal housing, f16 at 1/125 s, two Inon Z220 flash guns placed very close to the dome port just behind the two side shade constructions. The foreground is no more than 8 cm in front of the dome.

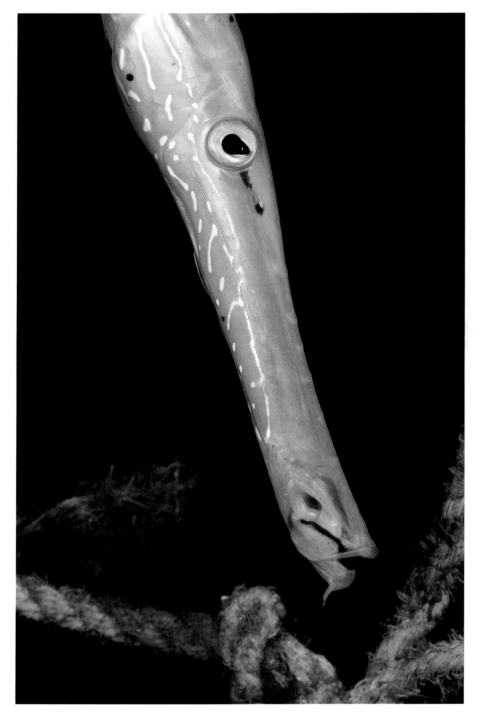

Figure 35.2
So many aspects of composition are present in this image of a trumpet fish: the space above the eye, which looks normal and not 'amputated', the slight diagonal orientation of its snout inside the frame, the position of the eye, the angle of the rope in relation to the fish. This was taken off the beach at Castle Comfort Lodge in Dominica.
 Nikon D100 with 60-mm macro lens, single YS 30 flash on manual full power, f22 at 1/180 s.

36 Visualisation

Visualisation is simply the ability to form a picture in the mind. It is a skill that everyone possesses and exercises on numerous occasions each and every day. We constantly project our mind into the future. We plan our day and visualise a meeting, lunch with a friend, how we intend to spend the evening. We do this subconsciously, and if we stop to think about our plans for tomorrow, we have probably visualised parts of the day already.

Including visualisation as a feature of the TC system, I am encouraging you to:

- Consider the elements that make up the picture opportunity
- Visualise the picture you would like to obtain
- Learn to see the colour that will be recorded
- Attempt to transfer that vision onto film or digital.

On land we can see colour, but underwater it's filtered out at shallow depths. Therefore, it is very important to develop the ability of learning to see in pictures, learning to see in colour, and to take into account the background as well as the subject matter.

Visualisation and the film user

To improve visualisation:

- Carry a dive light, even during the day, to help in identifying the colour of subjects. Before you use the torch, try to visualise the colour you think the subject to be.
- If you have a test facility on your flash gun, use it on a subject; you may get an idea of the true colour of things by flashing it off and using 'test' without taking a shot.

- After a photo dive, draw from memory a simple sketch of a photo opportunity you have just had. Compare the sketch to the picture, when it has been processed.
- Make photo notes in a log after a dive. Describe what you think you have on film, then check it out when processed.

Some of our best images exist only in our mind's eye (these are the ones that failed to ever materialise onto the film or sensor!). We still remember those missed award winners to this day. The power of our mind's eye and the ability to visualise is an awesome tool underwater. Let's use it wherever and whenever we can.

Visualisation and the digital user

When I first embarked on digital, I considered the advantage and practice of visualisation to be unimportant and of no consequence. After all, with digital your visualisation can be confirmed in seconds – the colour of the water, the angle of the lens, composition, lighting angles on the subject, all can be confirmed and vindicated in the time it takes your eye to observe and evaluate the LCD. I have since changed my view. I now firmly believe that the ability to visualise is pertinent to the digital user.

My reasons are these. In digital photography, both above and below water, there is a trend emerging where some users fail to take proper care with framing, composition, lighting, etc. The beauty of instant review and unlimited frames has had a tendency to make some users a little sloppy. Comments often include:

- I'll crop the composition in the computer
- I can adjust the lighting in levels and curves
- I will boost the colour using saturation
- No need to worry about backscatter, I will clone it out in Photoshop.

An experienced photographer approached me to critique his RAW files taken with an SLR. He was proud of the fact that he had filled his entire 1-GB card with 104 pictures in just 30 minutes. I presumed they would consist of several different opportunities which he had worked to the hilt to get the best possible results – but I was wrong. In the 100+ pictures taken, he had over 90 different subjects. They were snaps taken in seconds, without any thought, concentration or intention of any kind whatsoever. I asked him his opinion. He thought he was snapping away, could not seem to settle on a particular subject, was always wondering what was around the next corner. He mentioned that although he had enjoyed the experience of shooting loads of digital pictures on his previous trips, he now seemed unable to break the habit of 'snapping away'.

I have had some experience of this with other digital underwater photographers who seem to find themselves rushing everything

underwater. This may seem a cliché, but it is sensible that digital users take time, thought and patience to get the best possible result, and resist the attitude just to snap away and do all the corrections on the computer at a later date. Digital capture is pushing the boundaries of fresh ideas and new ways at looking at old subjects, but it is still photography at the end of the day. Let's try and get it right first time.

37 Patience

Patience is a fundamental requirement of the TC system – patience in preparing camera and diving equipment, patience in your approach, and patience in waiting for the peak of the action.

To recap. You have selected your subject and positioned the flash. You approach and the subject disappears into a hole! Typical! At this point you need to consider patience. How long do you wait until the subject reappears?

You are diving an excellent macro photo site. Colourful whip corals are growing from the seabed. You find a number of blennies moving up and down the branches. You frame one in your viewfinder, but it moves out of shot. There's another and another! But after a couple of seconds they move again. You need to be patient in these circumstances, but how long for? How long do you persist?

A colourful mantis shrimp disappears into its home in the sand. You have a couple of shots in the bag and they look OK in the LCD, but you feel the composition could be improved. How long should you wait?

In these scenarios, you have a conscious decision to make regarding the amount of time you are prepared to spend in your efforts to take the photograph. Ask yourself, whilst you are there at the time: does the potential of this shot justify the patience and time required to stick around?

Only the photographer can make this decision at the time. Patience is essential within the TC system, not only for shooting marine life but also when you relate it to other features – such as potential, subject selection and peak of the action.

Now is the time for you to retrace a mental path through the features of the TC system and consider the potential of the opportunity. Have you already taken shots like this, or is it a one-off, excellent opportunity?

The TC structure is a means of prompting you to think and consider various options underwater. Once TC is habitual, passing over an opportunity will no longer be because of forgetfulness or the 'I never gave it a thought' attitude. In life, we make hundreds of instant decisions every day. The TC system is no different. Let us think about our photography for a moment before we press the shutter.

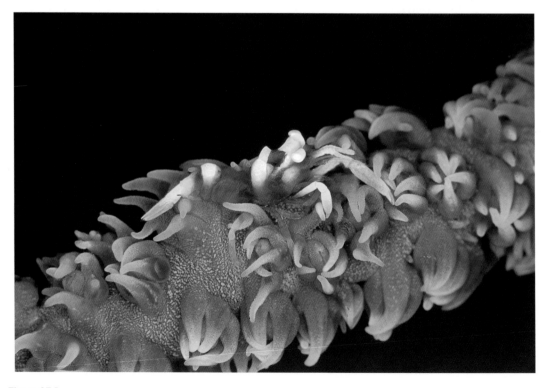

Figure 37.1
How patient are you prepared to be to get this tiny crab on a colourful whip coral? I was after an eye-level shot with a greater than life-size magnification. There was little to occupy me on this particular dive, therefore I was prepared to wait for some time for it to move along the whip coral into my viewfinder.
 Nikon D2x with 105-mm macro lens with +4T Nikon dioptre, twin Inon Z220 flash guns placed each side and close to the port on my Subal housing, f32 at 1/250 s.

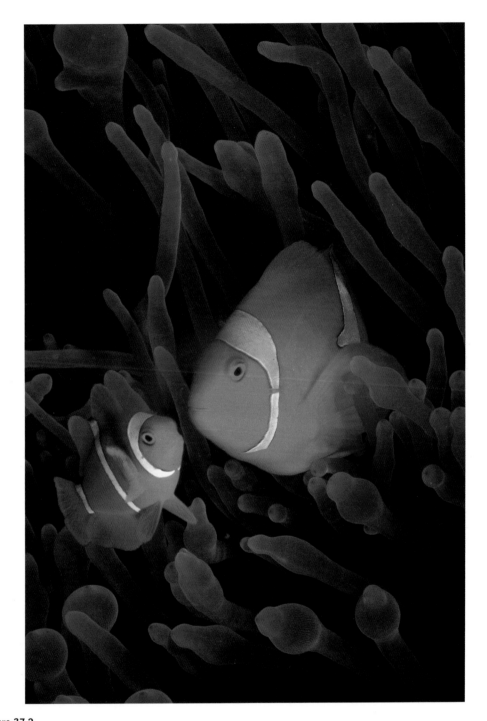

Figure 37.2
Sylvia was intent on capturing this pair of tomato clown fish, side by side, with the anemone as negative space and context for the subjects. She spent at least 15 minutes waiting and anticipating before the opportunity appeared. Even then, it was difficult to view the LCD screen in the shallow water. Wakatobi, Sulawesi.
 Photograph by Sylvia Edge using Olympus 5060 and Ikelite 125 flash gun, f7 at 1/200 s. Equipment courtesy of Cameras Underwater, Devon, UK.

38 Peak of the action

A definitive moment in time when you choose to press the shutter and stop the action of the underwater world in your lens.

To my knowledge, the concept of 'the decisive moment' was first introduced to photography by one of the all-time masters, Henri Cartier-Bresson. His other quotations on this topic are relevant.

To take photographs is to hold one's breath when all faculties converge in the face of fleeting reality. It is at that moment that mastering an image becomes a great physical and intellectual joy. To take photographs means to recognise simultaneously and within a fraction of a second both the fact itself and the rigorous organisation of visually perceived forms that give it meaning. It is putting one's head, eye and hand on the same axis.

There is a definitive moment for a photograph but it is only a fraction of a second and you have to anticipate it.

'Peak of the action' is the bread and butter of sport photographers. The peak is the reason the picture sells. Think of the examples you see from the Olympic Games, tennis, boxing and cricket – moments in time which the photographer has anticipated and frozen on film.

In underwater photography, to capture action and speed of this nature is rare. We recognise the obvious – dolphins swimming in formation, sharks taking a fish, sea-lion pups playing in the waves – but less obvious examples are sometimes neglected.

Consider the word 'action' to be a loose definition, and ask yourself:

- Is the subject capable of moving, or has it any moving parts? For instance, these may be the tentacles of a sea anemone or the polyps of certain corals which open and close to feed.
- If it has moving parts, is there a certain moment in time when pressing the shutter may achieve a better, more pleasing picture?

It does not have to be fast action or any action at all. However, consider the following situations and see the difference that stopping the action at the correct moment in time can make.

- Clown fish in a sea anemone. The tentacles can often sway from side to side. Press at the wrong time and the clown fish can be obscured. If you consider the peak of the action, you can improve the composition by shooting when the tentacles appear balanced in the frame.
- A turtle swimming in blue water. If you neglect to consider the peak of the action, it's easy to obscure its facial features because a fin is in the way.
- Visualise a cleaning station with fish queuing to have parasites removed. As the mouth or gills open and the 'cleaner' pops inside could be the moment in time that will make a better picture.

Where does peak of the action fit into composition? The first thing is not to confuse the two. Composition, in short, is the arrangement of the subject matter in the frame, whilst peak of the action is when to press the shutter and 'stop' the action of the

Figures 38.1 and 38.2
When I settled down to photograph this hawk fish in Sulawesi, my intention was to capture a portrait with good eye contact in order to connect the viewer with the subject. Looking through the viewfinder of a Nikon D100 camera and 200-mm macro lens, I began to notice that the two eyes momentarily disappeared from my view. I watched the fish revolve both eyeballs in various directions. I set to work but found it difficult to anticipate that moment in time when both eyes were looking into the lens. This was the 'peak of action' I wanted to capture, but I had quite a few wasted frames before success. On a digital note, I may not have noticed its eye behaviour if it had not been for the benefit of the LCD review.
 When I show the two examples side by side, viewers often prefer the 'winking one'.
 *f*22 at 1/180 s, twin Inon Z220 flash guns.

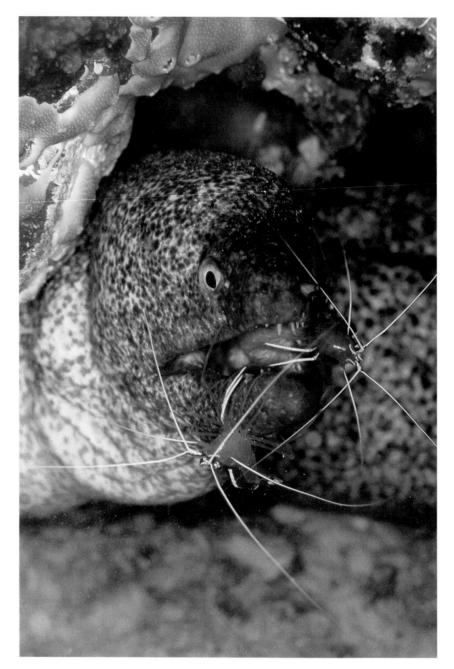

Figure 38.3

A combination of patience and consideration of the peak of the action. At Mabul Island, Malaysia, we found a cleaning station close to the excellent Sipadan Water Village resort. The moray was covered in cleaner shrimps, and after a while they moved down and began work on the teeth. As the moray opened its mouth to allow access, I pressed the shutter.

Nikon F90x with 105-mm macro lens, Subal housing, Edge–Sullivan ring-flash, Fuji Provia 100 ISO.

subject. Composing a distant diver within the frame is an element of composition; however, waiting for the diver to exhale a plume of bubbles may be the peak of action that will enhance the photograph.

Digital evaluation

Review the LCD to determine:

- Have you captured the peak of the action?
- Does it work, is it relevant?
- Can the picture be improved?
- Do I need to shoot more frames or can I move on in search of other things to photograph?

My tip: Before pressing the shutter, look at your subject. If any part is capable of movement, then consider, is there a definitive moment in that movement that will make for a more pleasing picture? If there is, then compose, wait for the peak and press the shutter.

Now may be a good time to revisit Chapter 37, on patience!

39 Shoot and evaluate

Occasional photographic encounters will be spontaneous. Dolphins, sharks and manta rays may only pass by once, and when they do we just shoot from the hip and hope for the best. In a situation such as this, there is very little time to think about anything other than pressing the shutter button before the opportunity disappears into the blue. It's a cliché in photography that 'film is cheap'. That being the case, digital exposures are free of charge! Don't hesitate to shoot, shoot, shoot. Professional photographers may spend the whole day on one subject. Don't limit yourself to five, ten or fifteen shoots; take as many as you feel you need to capture what you are after. You can always edit and delete after the dive is over.

Why take underwater photographs?

It's often worthwhile to consider what stage of the entire underwater photographic experience you like the best – is it actually taking the pictures underwater, or seeing your results on the laptop after the dive? Is it enhancing your endeavours in Photoshop, or perhaps pleasing your friends when you give a picture show? Your answers may surprise you! Have you ever asked yourself who you take photographs for? When you are commissioned for a particular picture or portfolio you must obviously please your employer, and your opinion of the work you have produced for that person comes second. Editors often decide which photographs they wish to publish, regardless of what the photographer may think.

The vast majority of people take underwater photographs for a hobby. They indulge in techniques and methods because they want to, not because they have to. You begin to walk a very fine line when you try to please everyone – yourself, your loved ones, your peers, the public and, in competitions, the judges.

In conclusion ...

Everyone has personal opinions, personal likes and dislikes. I find it very difficult to please everyone with my work. I used to try, but I found frustration would take over, and I soon realised that I was putting myself under unnecessary pressures for no real reason.

I personally have always taken pictures for *me* – no-one else. No-one can take blame for my failures. My attitude has taken away numerous pressures, but I still seek perfection. It's what stops me getting bored. I never seem to get everything right. There's a moment when the film has been developed or the digital file is on the laptop and I can see that things have worked out well. I see a picture that at first glance looks to be 'the one'! However there's usually something wrong. If ever the day came when I was completely satisfied with my work, I would give up!

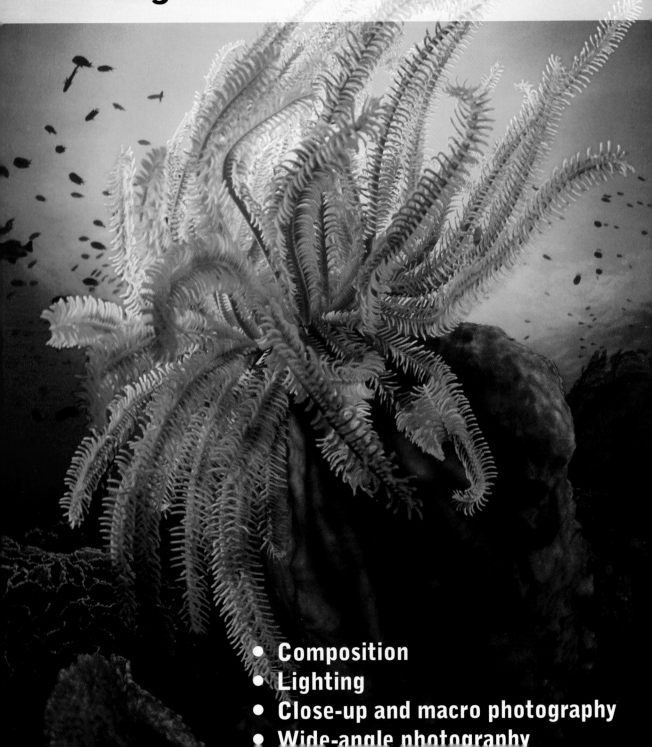

The Big Four

- **Composition**
- **Lighting**
- **Close-up and macro photography**
- **Wide-angle photography**

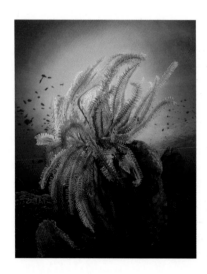

Blue is all around us and the opposites on the colour wheel are orange and yellow. I am always on the lookout for foreground subjects which complement the colour blue – red whip corals, orange soft corals and, in this example, a yellow crinoid. Whenever I see a complementary colour opportunity against the blue water column I pay particular attention to the exposure of the blue background, attempting to blend the two colours together to create the strongest impact on the viewer. In this example I bracketed my exposures between $f5.6$ and $f16$ on Fuji Velvia 100 ISO. To my eye, the blue water exposure of $f11$ created the strongest impact against the crinoid; $f16$ was too dark and at $f5.6$ the blue water was overexposed for my taste. I selected this image as first choice to illustrate the impact of yellow on blue, notwithstanding that the $f5.6$ exposure had a slightly better composition of the crinoid swaying in the current.

Nikon F100 with 16-mm fisheye lens, Subal housing, twin Sea & Sea YS 120 flash guns on TTL, $f11$ at 1/90 s. Manado, Sulawesi.

40 Composition

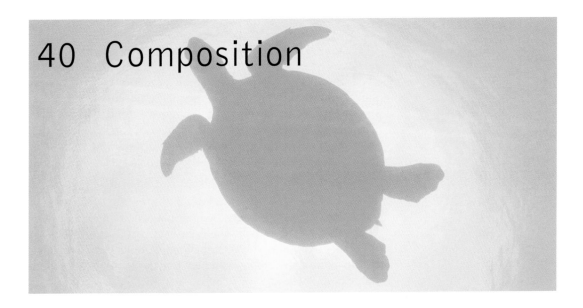

Introduction

Composition is about taking the elements of a scene and arranging them in the viewfinder to make something that is visually interesting – something that will hold the interest of viewers and lead their eyes around the frame on a visual tour.

I am occasionally criticised by a few of my peers for encouraging enthusiasts to follow a system of guidelines on how to compose an underwater picture. I take the view that for photographers to grow and develop, they should learn some basic rules of composition in order to have a solid grounding from which to start. After all, you can only change and experiment with what you know and understand.

When I started underwater photography, I knew nothing about composition. I had to learn, and it was compositional tips and tricks that provided the foundations for me to progress. Great photographers like Chris Newbert and David Doubilet may have a sense of compositional intuition, but for the majority of us advice and guidance is essential for development.

Painters have it easy when it comes to composition! If the elements of a scene are not to their liking, they have the option of moving things around the frame until they are satisfied. If you were to study paintings you admire, you would recognise many compositional guidelines on the canvas.

I dislike the words 'rules' and 'laws'; these are really no more than guidelines that can be used to help us to take better pictures. No composition guideline is universal – no guideline will work for every situation. What works for you may not work for others.

Making decisions

Every time you raise a camera to your eye, you are composing a picture. The process of deciding where to point it is based on decisions about what you want to include. Some photographers don't spend enough time thinking about composition before pressing the shutter, and any form of self-critique only becomes an issue when digital files first appear on the computer. I am convinced that the inability to consider composition underwater is directly connected to the ability to concentrate on topics such as this when diving with a camera (see Chapter 35).

When I teach composition in workshops, my first priority is to encourage decisions on what may or may not work – portrait or landscape format? Where should the centre of interest be? What is the centre of interest? At the beginning it matters not whether it's right or wrong, as long as we get into the habit of considering the options we have.

Since time began, scholars have noticed trends in sculpture, architecture, photography and design that can be summarised as guidelines. Throughout this extended chapter on underwater photo composition, I will summarise some of these guidelines for you.

The picture format

We view a seascape through the viewfinder either horizontally (landscape) or vertically (portrait), but which one do you choose? Often the subject or scene will suggest one or the other. Consider the lines, shapes and orientation of the elements. The format will often jump out at you. If you cannot decide, then shoot both. Many professionals will suggest that, if you shoot for publication purposes, you should develop the habit of shooting both vertical and horizontal so the editor can choose one or the other.

The guidelines say that emphasising vertical lines and height adds tension and excitement to a vertical format, whilst the horizontal format is much more restful to look at because it suggests calm and, in land photography, echoes the horizon – hence it tends to be preferred by landscape photographers.

When shooting wide-angle I believe there are more portrait than landscape opportunities in the sea. The reason for this is limited to the underwater world, and is the colour of blue water as it graduates from the top of the frame to the bottom. A vertical wide-angle blue-water shot can graduate from a very light tone of blue, through the blue spectrum to black. The feeling of depth that this creates is a powerful tool in creating wide-angles with impact.

Figures 40.1 and 40.2
These two imperial shrimps were
moving around a sea cucumber.
The subjects are balanced in either
format, depending on their position
in relation to the camera and each
other. In these circumstances, it is
an advantage that the camera can
be easily alternated between a
landscape and a portrait format.

Nikon D70 with 105-mm lens
with +4 T Nikon close-up dioptre,
twin Inon Z220 flash guns, f22 at
1/180 s.

Figure 40.3
This small homemade bracket at the base of my housing allows flash arms to be attached to the bottom corners. This can be advantage when shooting in the vertical format.

Camera orientation

Hold your camera housing in a landscape format. Now turn it 90 degrees into a portrait. Which way did you turn it? Clockwise or anticlockwise? It matters not, but we all have a preference. I turn my housing anticlockwise most of the time. Why does this matter? Well if you have a flash mounted on the left side of your camera, as with the majority of designs, you will notice the flash is now underneath the camera and knocking against your knees. Orientation of this nature is a personal thing, but you have to consider flash gun placement. If using one flash, I usually have it attached to the right-hand side of my housing so that when I turn into a vertical the flash is still positioned above the camera. For this reason, I have a flash shoe on each of the four corners of my housing to provide flexibility of flash placement in either format.

The preferred compositional format can change in an instant, particularly with a moving subject; that's why it's essential to configure your housing to cope with instant alterations of format. I notice with some the habit to shoot only in landscape format. This occurs because camera housings are comfortable to hold and ergonomically designed to be held in a landscape format.

The focal point or centre of interest

When composing a picture, one of my own priorities is the focal point or centre of interest. The focal point is where the eye of the viewer first lands. The challenge is to unite what I intend to be the focal point and what the viewer is first drawn to! An excellent example is the eye. It's human nature that the viewer will seek out the eye – we do it all the time. We make eye contact with others.

Figure 40.4
When the eyes are visible, they will often be the focal point of the picture. In this case I choose a vertical format with the two eyes occupying the upper thirds.

Nikon D100 with 105-mm macro lens, twin Z220 flash guns, *f*22 at 1/180 s.

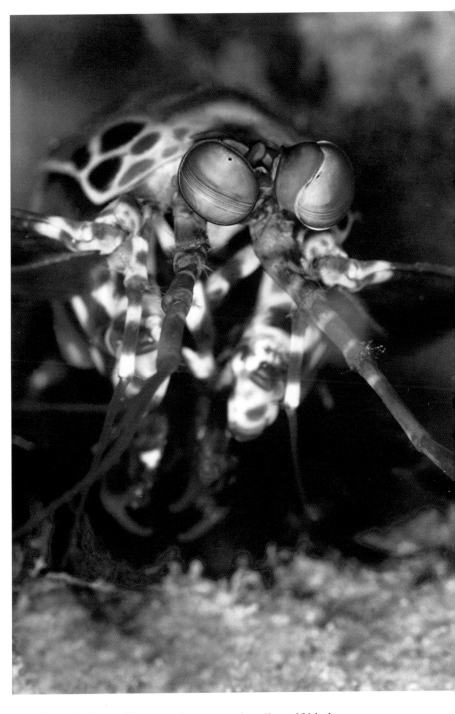

'Look me in the eye' is a popular expression. Even if it's the eye of a fish, the viewer will be drawn to it immediately. For still life, it could be a bright colour that first attracts the viewer. By considering what is likely to be attractive, I can choose where to place this.

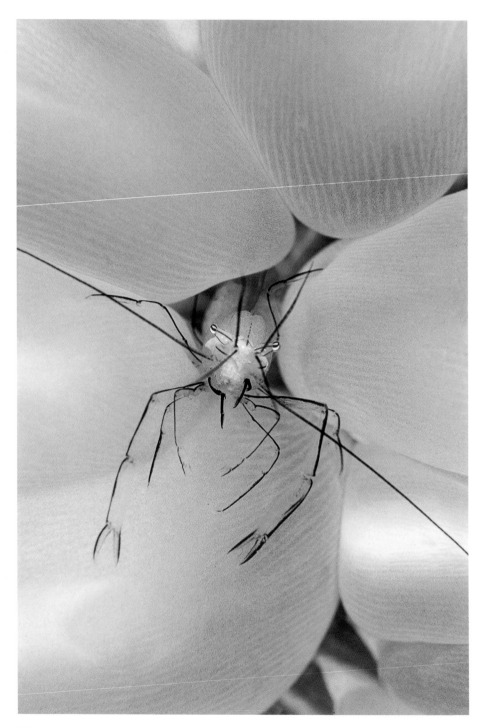

Figure 40.5
When the magnification becomes greater than 1 : 1 (life-size), I tend to place the main focal point in the centre – more because of my eyesight than anything else. In this example, I like the bull's-eye composition of the shrimp. In other circumstances I may crop it in computer.

Nikon F90x with 105-mm lens and +4 T Nikon close-up dioptre, one Sea & Sea flash gun set to TTL, *f*16 at 1/125 s. Sipadan.

Since autofocus cameras have become so popular, the instinct is to use the central focus area in the viewfinder and aim it at the focal point. Usually this reflects what the viewer would seek out. Another golden guideline of composition, and one that I agree with more often than not, is to place the focal point off to one side instead of in the centre of the frame.

A picture will fail if the viewer cannot find anything of interest to look at. Eyes seek a resting place. Try to give the focal point sufficient prominence in the frame.

Bull's-eye composition

There is a well-known guideline that says the centre of interest should not be placed in the middle of the frame unless it enhances the composition. The theory is that the 'bull's-eye' effect can leave it looking flat and boring. The eye will lead into the picture, stay in the centre of the frame looking at the focal point, and will not move around to enjoy other aspects. We want the viewer to look at our pictures, to enjoy them. Whilst I agree with this generalisation, there will be occasions when placing the focal point in the centre is pleasing to the eye.

The law of thirds

A basic guideline of composition, and one that is used to create a visually balanced picture, is the law of thirds. I place significant importance on this technique. It proposes dividing up the viewfinder into an imaginary grid, using two horizontal and two vertical lines, and the focal point is then placed on or near any one of the four intersection points created by the lines. It gives a feeling of balance and harmony, preventing the focal point from occupying the middle of the frame. The majority of film and digital SLRs now have the option to preset a 'thirds grid' in the viewfinder via the custom menu. This grid illustrates the division of horizontal and vertical lines.

This guideline is frequently used by artists. The next time you visit an art gallery, notice the style of compositions. I guarantee that you will find numerous focal points situated on or around these intersection points.

Diagonal lines

There are very few straight lines in nature and even less underwater. Vertical and horizontal lines often cut a picture in half, but the diagonal line is strong and dynamic. It's an excellent tool for the photographer. Diagonal lines contrast strongly with horizontal

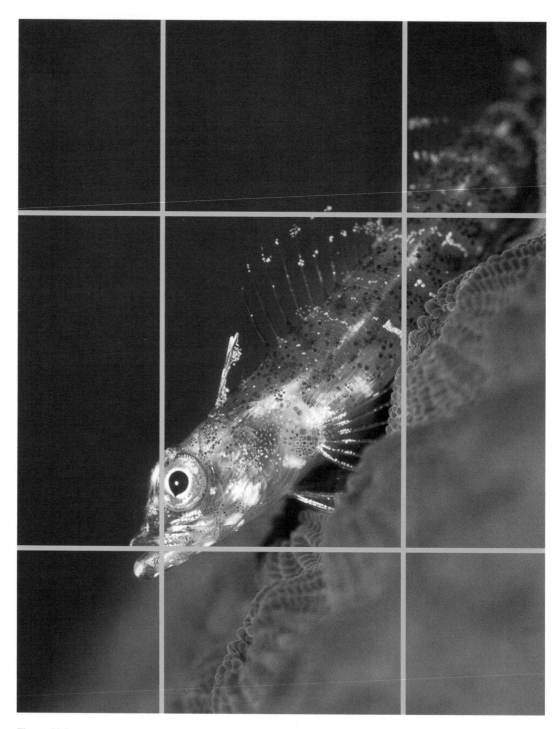

Figure 40.6
I have copied a 'thirds' grid over this particular image to illustrate the concept. Look at the work of other photographers whose work you find pleasing, and notice the positioning of the focal points around the frame. Take a selection of your own favourites and mentally superimpose a grid onto them. I would anticipate that some of your best shots have these 'thirds' characteristics within the composition.

Figure 40.7
This was taken in Papua New Guinea with a 105-mm macro lens on a Nikon F90x in a Subal housing. I used a ring-flash to light it with Kodak Elite Extra Colour 100 ASA film. I composed the red crimson skirt of the anemone diagonally from bottom left to top right, occupying the top left portion of the frame, and waited for the resident clown fish to swim into the frame. I took about six shots. Five were flawed, but this one works so well because of the position and slight curve of the fish. Look at the image closely. Now turn the page 180 degrees. Although it's upside down, this is the way in which it was taken. Which orientation do you prefer? Just because you take a shot in one format does not mean that you cannot project or publish it in another. There are so many examples of composition in this shot – thirds, format, diagonals and focal point.

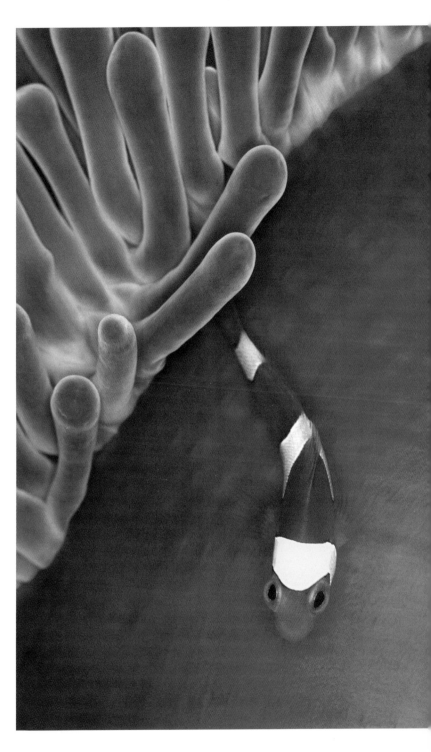

and vertical elements, carrying your eye through the entire scene. By suggesting perspective, they also add depth to a picture. Lines leading from bottom left to top right are considered to work best, because that's the natural way for the eye to travel. This direction happens to be the way in which we read in the Western world. Converging lines created by reef walls, corals and wreckage are ideal for adding a strong sense of depth, scale and perspective, due to the way they rush away to the horizon and seem to move closer together with distance. The dynamic diagonal will often lead the viewer's eye to the focal point.

The diagonal tilt

Would it surprise you to learn that I tilt my camera between portrait and landscape orientation eight times out of ten? It's a technique that would rarely work on land, by virtue of our conditioning to a horizon that is straight. On land, we hold our cameras in either one format or the other because tilting the composition on land would inevitably disturb the eye of the viewer for countless reasons. The horizon is level. Trees, buildings and people stand tall. Land photography is orderly, and the viewer recognises the orientation of subjects. Underwater, the visual clues that determine orientation are not as strong. If there are no visual clues to the horizon, the viewer is unable to determine the original orientation of the subject. The reason for tilting my macro and close-up subjects is to achieve a strong, diagonally-orientated composition in the viewfinder.

Which way to view?

With macro and close-up, there is rarely ever a 'right way up'. Images such as these should be considered and viewed in every format before deciding which orientation is the most flattering. Some of my best images are actually upside down, but underwater there is no horizon to form a perspective of up or down.

There are eight different ways to view a picture. Take a selection of close-up photos and hold each one up in turn. Turn it sideways, upside down and back to front. I'm sure you'll find images that pop out even more when an alternative perspective is considered.

The curve

Lines that curve through a composition lead the eye in a similar way that a shoreline, river or winding road does.

Figure 40.8
The soft focal curves around the centre lead the eye to the sharply focused texture of the clam.

The circle

The circle is made up of a continuous curve, and its movement keeps the eye in the picture frame whilst leading it around the composition. An excellent example of this is 'Snell's window', which is a powerful tool in wide-angle compositions. The circular curve of Snell also makes a soft frame in which to place the main centre of interest.

Simplicity

An element of underwater photography that often separates a beginner from a professional is compositional simplicity. There is no need for the latest equipment or best housing; it's totally unrelated to equipment or technique. It's about the isolation of a subject and providing a simple, single theme to photograph. Simplicity is an area of my own photography that I am very aware of and constantly attempting to develop and improve.

Some years ago a BSOUP (British Society of Underwater Photography) veteran advised me that I had the tendency to include too much subject in the viewfinder. I had to agree – I had the 'bigger is better' approach. If I came upon a school of fish, I tried to include the entire school in the picture. If in doubt, I would cram

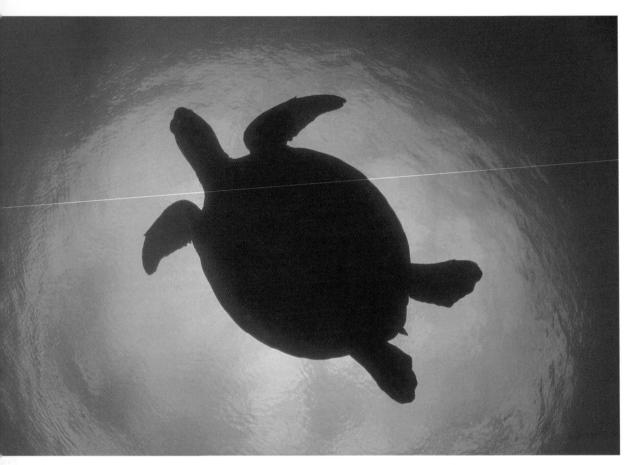

Figure 40.9
The abundance of turtles in Sipadan makes this quite an easy opportunity.
Nikon F100, no flash, f11 at 1/90 s, Elite chrome ISO 100.

everything in. This resulted in poor composition, imbalance, and the clipping of details at the edge of the picture frame. Many of my underwater close-ups were cluttered, distracting and confused. When it was pointed out to me, I immediately recognised my mistake and it was not difficult to rectify. Now it's a matter of remembering to keep the picture simple and uncluttered.

Twenty years on, I find this trait is a common occurrence – a tendency to 'clutter' the composition. My tip is this: Simplicity! Keep the composition simple. Choose a single theme and isolate that theme. The viewer should be in no doubt what the theme of the image is.

Complimentary colours

Different colours produce different emotional responses in a person. Red and orange evoke feelings of enthusiasm, warmth

Figure 40.10
This soft coral still-life study was taken on the house reef of Kungkungan Bay Resort (KBR), Northern Sulawesi, Indonesia. I could have included numerous other elements within the picture, but I chose to 'practise what I preach' and keep it simple. I was attracted to the slight curve, and hoped that my ring-flash would highlight the tips of the feathery feeding polyps. I composed the subject and included a small base, which recorded pink on film. (I had no idea of this when I pressed the shutter.) I would have preferred a dark-blue water negative space background, but this was not possible. The nearest detail to the rear of the subject was at least 1 m away. I visualised that the ring-flash would not affect the background if I selected a small enough aperture. My preference is $f16$ at 1/90 s, and this is what I chose on this occasion. The obvious compositional format was vertical (portrait). I tilted the camera slightly in order to take advantage of the curves and achieve a slight diagonal perspective across the frame. I took three frames and bracketed the composition slightly in each one. The coral pointed from right to left in reality, and this is the way in which it was shot. I have flipped the image 180 degrees so that the curves flow from left to right. This also mimics how the western world reads, from left to right, and it is considered to be more pleasing on the eye.

Nikon F90x with 105-mm macro lens, Subal housing, Edge–Sullivan ring of light ring-flash on TTL, Elite EBX 100 ISO film.

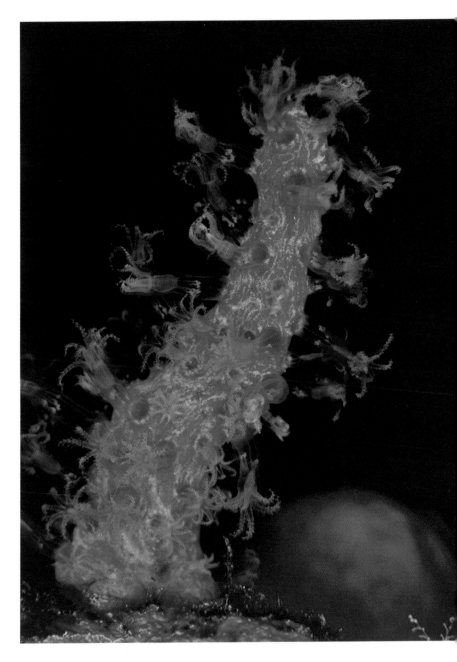

and power. Blue creates a sense of peace, calm and coolness. Underwater we have the primary colour of blue which surrounds us on a tropical dive.

Blue is a colour that signifies the sky, the sea and much more. It represents the world around us from space to the deepest ocean. Physiologists suggest that it is tranquil, self-assured and reliable. It conveys stability, truth, authority and loyalty. I have yet to meet

a diver who is not drawn to the colour blue. Comments abound regarding the colour of the sea. The intense blue! We associate blue with the colour of the sky and fine weather. Blue is one of the primary colours and on a standard colour wheel its opposite numbers are yellow and orange. Underwater, the combinations of these colours work dynamically together. You will see excellent underwater images of yellow schooling fish against an intense blue-water background. In my own photography I am constantly looking to exploit this combination. When I see a yellow or orange subject, I immediately consider how to combine it with a blue-water background.

Figure 40.11
The arrangement of the basic colour wheel illustrates relationships between the complementary colour pairs. These pairs are directly opposite to each other. Red is opposite to cyan, green is opposite to magenta and, perhaps most importantly for the underwater photographer, blue is opposite to and complements yellow.

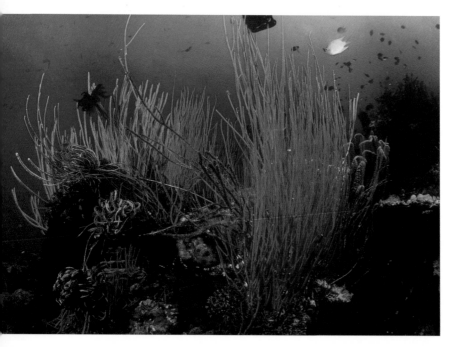

Figure 40.12
There is no better colour to attract the viewer than red. Think of adding a 'splash of red' to jazz up wide-angle seascapes.

Red stands out from all the rest. Go into a newsagent, stand 3 m from the stands and look at the magazines. Which colours do you see? You will find it is the reds. The word 'red' conjures up images of passion, sex, danger and anger. Red is the colour of blood, roses and fast cars. Red is also an excellent colour to combine with blue, and you will see many vibrant photos from the Red Sea in particular where the clear blue sea is mixed with a splash of red from the vibrant soft corals.

Horizon lines

The discussion of horizon lines in underwater photography seems totally irrelevant, but there is a reason. The Collins English Dictionary defines the term 'horizon' as 'the apparent line that divides the earth and the sky'.

Underwater there are numerous examples of what I term 'implied horizons', and we should be aware that the presence of an implied horizon line in seascapes can divide a picture in half, often to the detriment of the composition. On land, there is a guideline that advises against placing the horizon in the middle of the frame for the same reason. The viewer may not always recognise the photographer's intentions. Where we place the implied horizon within the frame helps to define and emphasise the strength of the image.

In the image shown in Figure 40.13, the thin line of water that separates the shallow reef from the reflection in the undersurface is an implied horizon line. In this example it is quite distinct, but less obvious examples may be the top of a coral reef against a blue-water background, or perhaps the line of a sunken wreck silhouetted against the blue.

The old adage and general rule of thumb in land composition is 'avoid placing the horizon across the middle of the frame'. This technique only serves to give equal emphasis to both foreground and background, which can result in a weak and static composition. When I composed the image on page 200, I intended the undersurface reflection to take on a greater significance than the seabed. Consequently, I lowered the implied horizon line and composed it in such a way as to conform to the rule of thirds.

The principle of implied horizon lines is simple to understand once illustrated, but it is a subtlety of underwater composition that often goes unnoticed. The moral is to build this *awareness* into your repertoire and use it to emphasise the content of your pictures.

A photographer who aspires to take more than a casual snapshot cannot hope to produce a standard of excellence without first understanding and seeking to master the art of composition. The rewards for all this endeavour are certainly worthwhile!

Figure 40.13
I spent an hour in shallow water looking for coral reflection opportunities. I chose shallow, hard corals which appeared to have some colour to them. In my viewfinder I composed the horizon line across the middle, knowing that I could accentuate either the reflection or the coral at a later time by making a slight crop. In this example, the reflection is stronger than the coral and deserves prominence.

Nikon D70 with 10.5-mm fisheye lens, Subal housing, natural light, *f*11 at 1/60 s. Batu Angus, KBR, Sulawesi.

Depth perspective

Depth perspective (or image depth, as it is often called) is the technique of creating a sense of depth within a picture. Take the analogy of the paintings inside the tombs of the Ancient Egyptians. For some reason, they had no sense of depth perspective. Their figures were always placed side by side to each other as if everything was the same distance away. They had a sense of height and width, but not of depth; their pictures were two-dimensional, not three. It can be confusing to talk about creating depth or a third dimension, because both mediums (film and the sensor) are flat. The only sense of depth that can be achieved is the perspective which is conjured up for the viewer. This can be achieved by using the foreground, middle ground and background.

Balance

The balance of a composition is more of a feeling than anything else. In my early days, balance in my own work was more 'after the fact' – I only looked for balance after I had taken the shot and viewed the results on a light box. Now I ask myself, before pressing the shutter, 'Does this picture look good? Is it balanced? With the wonders of digital review, I can check for a sense of balance within an instant of pressing the shutter.

Figures 40.14 and 40.15
In the first shot, I have composed the anemone and clown fish against the blue background. Although colourful, the image is two-dimensional. Pink against blue! In the following shot I have readjusted the composition to illustrate the reef in the upper left background. This provides a sense of depth perspective and leads the eye through the picture.

Nikon D100 with 10.5-mm fisheye lens, twin Inon flash guns, *f*11 at 1/180 s. Manado, Sulawesi.

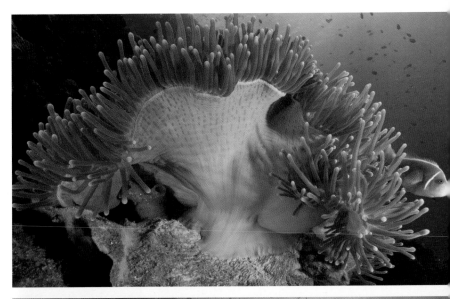

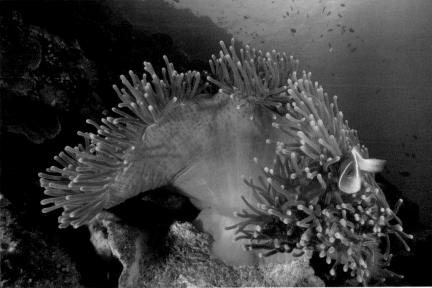

Have you noticed how the majority of us view a photograph that may be 'un-balanced'? We tilt our heads from one side to the other in an effort to view the picture sideways or upside down to see if we prefer it like that. We find it unbalanced; we may be unsure of what we are looking at. It's a method of making some sense out of the content.

Perfect balance in a picture could be described as a symmetrical image perfectly centred. Often this approach fails to draw the eye around the frame, and it may create a rather boring effect. On the other hand, its simplicity can be effective. Composition is like this – there are no right or wrongs.

Consider composition before you press the shutter. Look through the viewfinder to see what is included in the frame. Notice the direction and manner in which your eye travels across the frame as you scan the scene. Look at all four corners. Are there any distractions towards the edges of the frame? Do you like the way you have placed the subject; is it 'balanced'?

When my concentration is heightened and I am 'in the zone', I am able to imagine that the image in the viewfinder is projected onto a screen in a darkened room. Do I like what I see? If the answer is yes, I press the shutter. I may take six or more shots, depending on the subject, before I make a point of reviewing the LCD on my housing. I then ask myself, how can I improve on what I have taken?

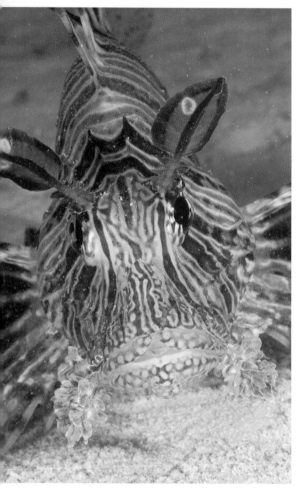
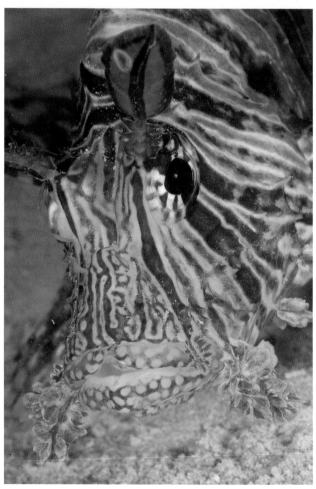

Unbalanced Balanced

Figures 40.16 and 40.17
These photos were taken on one of my first outings with my digital Nikon D100 and 60-mm lens, using twin Sea & Sea YS 90 s. I composed a series of shots close to the sand. On reviewing my LCD monitor, I saw that my attempts on this friendly lion fish were unbalanced and uneven. I went back to the fish and paid more attention to the weight and balance in the frame.

The baseline

This element of composition is about the importance of giving subjects a 'base'. Here, let us think of 'base' as 'the bottom or supporting part of a subject'.

There are many subjects in the sea that are anchored to the reef in some way. How much of the base we include can make or break the composition. If we do not consider the base of the subject before we press the shutter, it can appear that it has been 'cut off'.

Figures 40.18a and 40.18b
These two pictures were discussed in depth on a photo trip to PNG. A number of us had the opportunity to photograph a blue ribbon eel, which was protruding out of a small hole on a shingle bottom. We were using Nikon 105-mm macro lenses in a variety of different housings. The eel allowed us to approach to within 30 cm before it shot back into its hole. The film was exposed and developed, and on viewing several examples it became apparent that some of us (including myself) had chosen to cut the bottom off its slender body from where it protruded from the sand in order to get it into the frame. Our unfamiliarity with the creature and its features left us to contemplate 'where was the rest of it'? I now pay close attention to where along a creature's body I crop and compose.

 Nikon F90x with 105-mm macro lens, Subal housing, Edge–Sullivan ring-flash, *f*11 at 1/125 s, Kodak Elite Chrome 100 ISO film.

Figure 40.19
This colourful sea squirt was no more than 2 cm high. I was attracted by its intense colour. Although I used a 105-mm lens with a Nikon +4 close-up dioptre, I was able to compose the sea squirt with a base supporting part of a subject. I tilted the composition to provide a diagonal orientation to the sea squirt itself. This image is printed in its original shape without a crop. If you were cropping this in computer, would you take a tad off the base or leave it be? I have left it for the reader to decide.

Nikon F90x, one Sea & Sea YS 120 flash gun on TTL, *f*22 at 1/125 s, Fuji Velvia. Sulawesi.

The eye often has a need to see the base of a subject to give it context. With a recognisable subject in land photography, such as a person, animal or a motor car, if part of the subject is cut out of the frame our 'inner eye' subconsciously attempts to complete the part that is missing – we effectively 'fill in' the person's legs or the rear end of the motor car because we know what to expect. Where a subject is not so instantly recognisable, our 'inner eye' has trouble filling in these missing parts.

Amputations

When shooting divers, fish and other identifiable subjects, there is an element to consider that is often labelled 'amputations'. In land photography there are guidelines which advise that you don't

Figure 40.20
I shot this fish over a period of
15 minutes and it provided me with
ample opportunity to achieve a
pleasing composition, but it wasn't
my day. This shot was the best of the
bunch, but whilst the exposure,
lighting and sharpness were correct,
it still fails. It needed to be cropped
to rescue my poor framing and
balance the 'amputation' of its tail
fin. Almost correct but, on this
occasion, not quite!

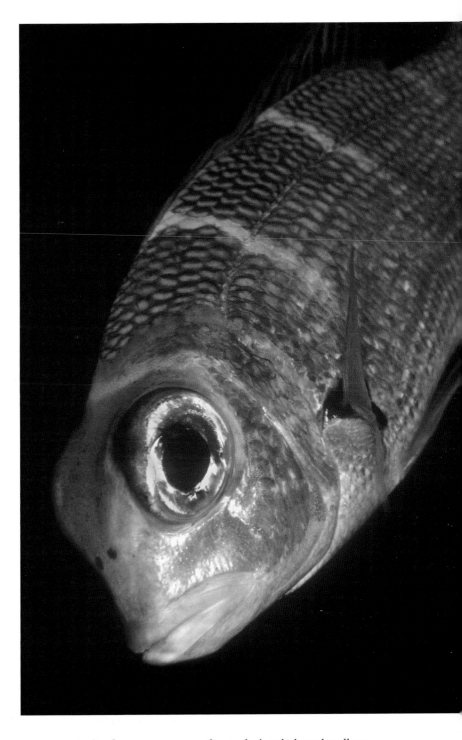

crop a portrait of a person across the neck, just below the elbow
or just above the wrist. If you want an upper body shot, it is usually
best to stop at the waist with the hands and arms included. If you
crop lower, it appears that the subject's legs have been cut off. It's
no different underwater. Just remember the TC system – think

Figures 40.21 and 40.22 (far right)
In the first image, I pressed the shutter whilst the diver's fins are behind the cave entrance. This draws attention to the eye and spoils the overall balance of the composition.

Nikon D70 with Nikon 12-mm–24-mm zoom lens, Subal housing, twin Sea & Sea YS 90 auto flash guns, *f*11 at 1/180 s.

Compare this with the second image on the opposite page. At the same location at the same time, I waited for the outline of the diver to be silhouetted against the blue water. This gives a much more pleasing composition, without the merger in the previous image. Turning my flashguns off and shooting with the natural light has also improved the atmosphere of the situation.

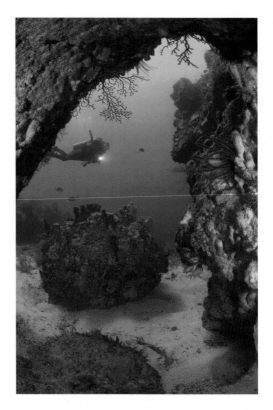

and consider. If you are shooting a fish portrait, consider what to include or to leave out. If in doubt include a little more than you think – it can be cropped later in the computer.

Mergers
I started to consider mergers after reading the early articles by Jim and Cathy Church. A merger is where one subject blends into another. I find them most noticeable when shooting silhouettes. A distant diver can often merge into background and foreground coral. The tip is to ensure the silhouette is completely surrounded by blue water or a colour that will not merge into another shape.

Eye contact

When the viewer looks at a picture of a living human or animal, the focus of their attention will be directed towards the eye. Eye contact from a diver as a subject, for instance, is an excellent tool in order to guide the viewer's eye to the main focal point or, if the diver is the main subject of the picture, to a secondary point of interest. If the diver is looking towards the camera lens with a blank stare, the image says very little other than 'I am a diver'. Even when the main feature of the shot may have been a wreck, reef or coral formation, the eye will always dominate.

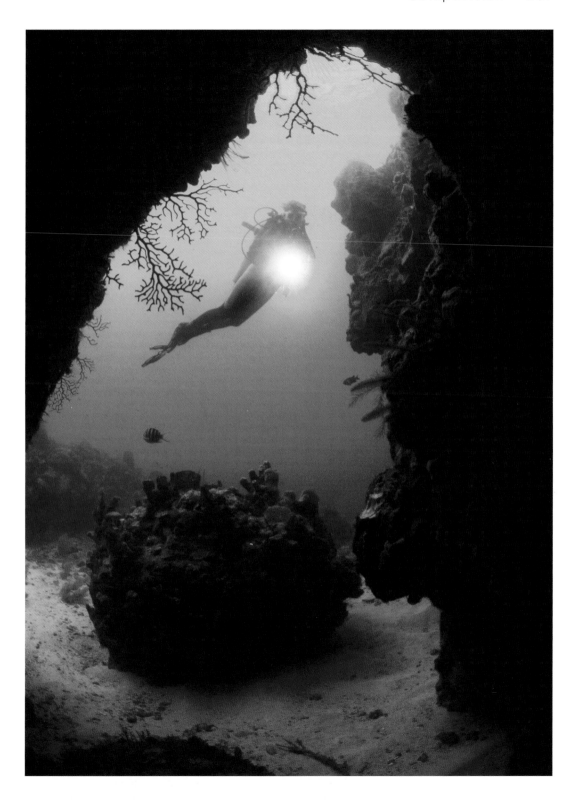

Use the eye of a diver to lead the viewer to the focal point of the picture. If possible, include the subject in the frame. Good communication between the photographer and model is important and necessary. When Sylvia is modelling, I may place her eyes on one of the 'thirds' intersections and the direction of her gaze will direct the viewer to the main focal point.

It can be used just as effectively with fish and other marine creatures that have the appearance of eyes. The viewer will focus their attention on the eye of the fish and with careful composition the direction of the eye may lead the viewer to other parts of the frame.

One thing to bear in mind is that the eye must be in sharp focus, whether it is a diver or a shrimp. If the eye is soft, the picture will fail.

Something to swim into

Another popular topside guideline is to allow space for your subject to swim or move into. A picture of moving subject, a fish or diver just about to swim out of the frame, has the effect of 'leaving the viewer behind'. The effect is unbalanced, and often results in a loss of interest.

Summary

Throughout this chapter I have discussed established compositional principles to assist in the way in which we construct our images. It is our choice to compose in any way we want, and there are no hard and fast rules by which we are bound.

Composition guidelines exist to help us organise the elements of a scene. They are suggestions for predictable results, and should be used with discretion. When we start allowing guidelines to rule our work entirely, both our pictures and our development can become predictable and stilted.

Breaking the rules

Just as there are times when guidelines are helpful, there are times when they can be adapted or ignored altogether. Knowing when to ignore the guidelines requires some experience, but the results can be quite dramatic and cause a particular image to shine above the crowd. Some underwater photographers are able to blend their understanding of composition with personal style, interpretation, and technical experimentation. For others, this can be difficult. There are no formulas for achieving this creative ability; I believe it comes from understanding and practice.

It is up to you to decide when to stick to the guidelines and when to break them. I have always taken the view that you cannot break or follow the guidelines unless you know what they are. There are photographers who do not concern themselves with

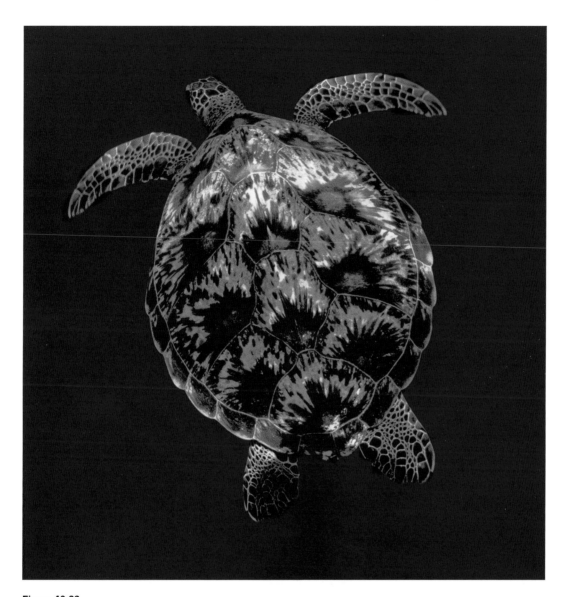

Figure 40.23
Don't shoot down – a golden rule! But there are always exceptions. Turtles work well looking down, and so do other creatures that have strong features on top. I first noticed the pleasing downward angle with turtles in Sipadan in 1995; I took a number of shots that day, but unfortunately the E6 slide processing was compromised when there was a power cut on the island. My film came out with this cyan cast, but I decided to mount this particular picture. Good thing I did – it has been one of my best sellers in the last 10 years, colour cast or not!
 Nikon 801s with Nikon 16-mm fisheye lens, Subal housing, natural light, in the region of f5.6 at 1/60 s, Ektachrome 64.

composition guidelines at all. If they can produce solid images doing so, then so be it. The rest of us often need a little help, and guidelines are like having a photo coach in the water with you. They gently suggest and guide, but they do not and should not rule your photography.

41 Lighting

In underwater photography, the topic of lighting is vast. No matter how thoroughly we try to cover this in words and pictures, it can never be complete. As a fundamental element of photography and an integral part of the TC system, it should be considered as just another feature to think and consider before you press the shutter. You may ponder whether to light a subject with flash, to use natural light only, or to use a combination of the two.

Underwater, there are two types of light; natural light, which comes from the sun, and artificial light, from a flash gun. Natural light is rarely used in close-up and macro because of the necessity to maximise depth of field by using small apertures.

We most often use natural light in shooting wide-angles, either on its own or in combination with flash where the two are blended together. This technique is commonly known as 'fill-in flash' or 'balanced light' (see Chapter 43).

Natural light

Natural light is also referred to as ambient light. On a clear, cloudless day, it is direct and pervades the surface in the form of sun shafts. On a cloudy day, the light is flat and diffused. As the sun arcs across the sky from dawn to dusk, the effects change. The position of the sun in the sky, the time of day, the clarity of water and your depth will vary, and this will affect your results.

Take a look at the wide-angle photographs in your favourite underwater coffee-table book. Look at the number of times in which blue water features in the background.

Look closely at the wide-angle photographs you most admire. What is it about these that attract you? On many occasions, it will be the way in which the photographer has captured and used the available light.

At seminars and presentations, one question that continually arises is: How has the photographer captured the light in this way, is it a special lens or can anyone do it?

Let's take a look at some specific types of light and how anyone (with a wide-angle lens) can achieve the effect.

Blue-water backgrounds

How do you get the water to look so blue in wide angle shots? Another popular question! To record the colour of blue water in the tropics, or green water in more temperate regions, we use combinations of shutter speed and aperture. If we select $1/100\,$s shutter and $f22$ or $f16$ with close-up/macro, and point a camera towards the water column, the outcome is a black or very dark blue background.

Exercise: Blue water

Try this exercise in the sea.

- At a depth of 10 m with the sun high in the sky, using ISO 100 with a wide-angle lens, turn your flash gun off and switch your camera into manual exposure mode so that you can select both aperture and shutter speed value.
- Set the shutter close to 1/100 second (fast enough to stop most subjects).
- Point your camera horizontally towards the blue water column. Conducting this exercise on a drop-off, looking out into clear blue water, is ideal.
- Take a series of shots from your smallest (f22) to your widest (f4) aperture. If you are using a digital compact your smallest aperture is around f8, which is closely equivalent to f22 on an SLR.

The blue water column at f22 will record plain black just like a close-up water background at the same aperture. As you turn the apertures through f16, f11, f8, f5.6, f4, f3.5, etc., the colour of the water column will lighten up and record as midnight blue, dark blue, blue, light blue and so on.

Which shade of blue water is better for your subject? It's your decision! Black or dark blue can enhance the impact when combined with a colourful foreground. On the other hand, exposing for a blue as seen by the human eye gives depth perspective and places a subject in its natural environment.

Rule of thumb: Using film, 100 ISO at 10 m, 1/100 s shutter speed with an aperture of *f*8 in a clear blue sea with the sun high in the sky is a general (and accurate) rule of thumb to record a tropical blue water column as it appears to the human eye at that depth.

Using a digital SLR or a compact in the same circumstances, I have found that a combination of 200 ISO and 1/180 s (or thereabouts) at *f*11 produces a pleasing colour of blue water, realistic to the eye.

Our own preference

Colour preference in relation to the shade in which blue water is recorded is very subjective. With film, you have little choice. Whilst you can scan a transparency and alter the shade on computer, by and large it is the characteristics of the film choice that provide a blue tone to your liking. I have always preferred the shade in which Ecktachrome transparency film records blue water; in my opinion this film version of blue is often superior to the colour we see with our eyes in reality.

Blue is the most prominent colour in the sea, so it is important to record blue to our own individual taste – hence my use of Ektachrome VS with wide-angle.

White balance

Digital white balance settings underwater can be either preset by taking a reading from a grey card or set to one of the default settings. Preset white balance gives the photographer the opportunity

Figure 41.1
By bracketing my apertures but retaining the composition, I had a choice of blue water colour to frame the sunken wreck off Captain Don's, Bonaire.

Nikon F90x with 16-mm fisheye, *f*8 at 1/90 s, natural light. Ektachrome Elite 100 ISO.

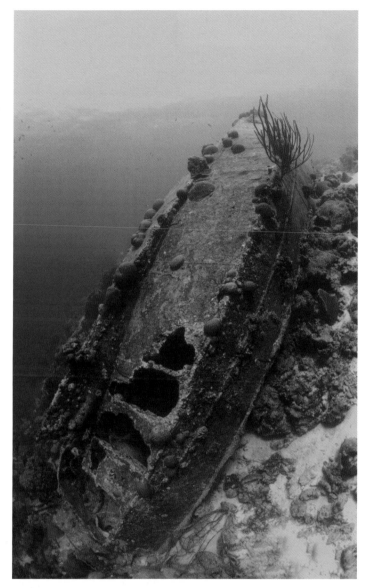

specifically to set a proper white balance under difficult lighting conditions such as blue water.

Other photographers prefer to use one of the default settings. My own default preference is 'cloudy'. It is a setting that is popular amongst some underwater photographers on the various Internet forums, and some like to regard it as the best overall white balance setting, but the subtlety with which a blue water background colour is recorded is personal and subjective. The choice of white balance settings is a matter of preference for each and every one of us.

Go to www.wetpixel.com/forums/index.php?act=ST&f=7&t=2820 for further discussion on this topic.

Digital advantages

By using digital capture, we see the result instantly. If we take the view that the blue water is overexposed, we can adjust the settings to our own individual tastes. Using the manual exposure mode in these circumstances is an advantage, as you begin to understand the way in which light works underwater. Aperture and shutter priority also give you some control, but if you choose to set auto or program mode the camera will remove any control you have and do it all for you. Whilst this can work well at times, we learn little about how to control the natural light. The 'do it all for you' mode does work well with the flexible and versatile modern-day film and digital cameras. The most important thing is that you enjoy your photography, however you choose to set your camera.

Sunbursts

A popular technique is to include the sunburst as a pool of light in the picture. This can add considerable impact to your photographs, but over the years it has become a little clichéd and is often overused.

Exercise: Sunburst

At a depth of 10 m with the sun high in the sky, using ISO 100 on either film or digital with a wide-angle lens (in the 20-mm range is fine), turn your flash gun off and switch your camera into manual exposure mode so that you can choose both the aperture and shutter speed value. Set the shutter close to 1/100 s (fast enough to stop most subjects) Look up into the sunburst and take a series of shots from your smallest (f22) to your widest (f2.5 or thereabouts) aperture. If you are using a digital compact your smallest aperture is around f8, which is closely equivalent to f22 on an SLR.

The pool of light at f22 will record quite small, with a rapid graduation from white close to the centre of the sun burst to midnight blue towards the edge of the frame. As you open the aperture through f16, f11, f8, f5.6, f4, f3.5 (or digital compact equivalents), the pool of light will increase in size and the graduation between the white light of the sun and the blue background diminishes. Apertures of f16 and f22 have a tendency to sharpen the rays of light, but this effect diminishes and at f8 it is hardly noticeable.

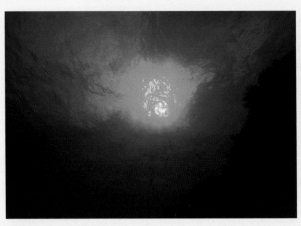

Figure 41.2 f22.

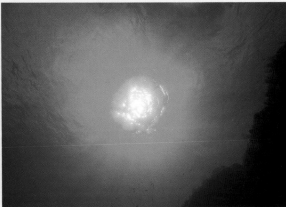

Figure 41.3 f16.

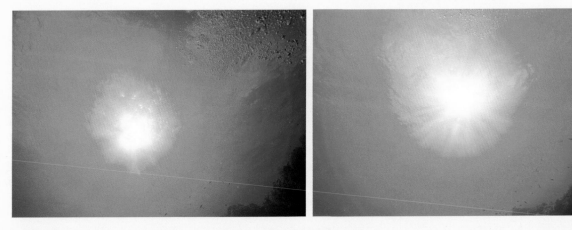

Figure 41.4 *f*11.

Figure 41.5 *f*8.

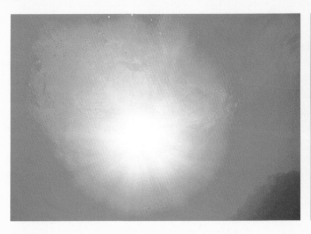

Figure 41.6 *f*5.6.

Figure 41.7 *f*4.

Next, descend to 20 m and repeat the process. If you wish, do the same at 30 m. Examine your results at different depths for acceptability of exposure.

Rule of thumb: As your depth increases, you need to open the aperture or shutter to compensate. A rule of thumb is 1 *f*-stop for every 10 m. The effect is that a pleasing sunburst taken at *f*16 at 10 m will require *f*11 at 20 m and *f*8 at 30 m.

Whilst underexposure has some disadvantages, it can work well in numerous situations. However, overexposure of the sun is distracting to the viewer and unacceptable in the majority of situations. When you choose to include the sunburst in your picture, be minded that if it's too bright or too large it can easily overpower the entire scene. The sunburst remains an excellent tool to give wide-angle photos that 'wow' factor, but if the aperture is too wide it will become the focal point of the viewer's attention instead of what you were seeking to achieve in the first place.

Conducting these exercises with the water column and sunburst is an ideal way to commence a photo trip. From the outset, using either digital or film, you get a feeling of how the water column and sunburst will record at your particular photo destination. This groundwork prepares you for the unexpected. When the manta appears out of the blue you can instantly set $f8$ or $f5.6$, knowing that you will get at least one accurate shot before he disappears into the blue.

Whilst conducting these exercises in the sea, the built-in light meter reading within the camera viewfinder will indicate to you the camera's choice of what the correct exposure should be. If it indicates an aperture of $f5.6$ at $1/100$ s but you choose to set $f8$, it is not wrong – it just means that the blue will record a little darker than it would have and this underexposure may be preferable to you. It's your choice, and in a short space of time you will develop your own taste regarding water colour and make your own decisions.

Digital sunlight

As already mentioned in this book, digital cameras, particularly compacts, do not record highlights that well. Sunbursts and surface highlights are particularly susceptible to overexposure. The key is to increase shutter speeds to freeze the sunbeams, but this is not always possible when the fastest flash sync shutter speed is only $1/180$ s or below. Experiment with your own camera. If sunlight becomes a problem, then leave it out of the frame altogether. If that's not possible because of your angle of view, then try to hide the circular shape of the sun ball behind the reef or the subject – out of sight.

Recent cameras appear to have solved these problems. The Nikon D70s and Canon D20 are two such models. The Nikon D2x and the Canon EOS-1DS Mk11 have vastly improved sensors and, although expensive to purchase at present, are both comparable with film capture when it comes to digital sunlight.

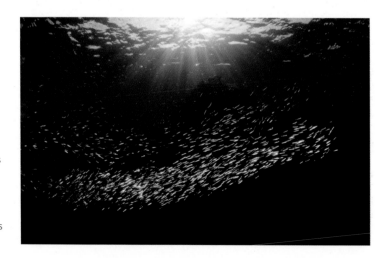

Figure 41.8
This sunburst shot has retained all its highlights and impact. Older SLR cameras cannot capture sunlight in this way.

Image by Shannon Conway, using Nikon D2x with 10.5-mm fisheye lens straight into the sun, $f14$ at $1/250$ s.

Figure 41.9
The sun sets rapidly in tropical locations, and all too soon the effect of the sunbeams vanishes. Close to sunset produces a golden light, and this effect is amplified as the beams pervade the surface. f-stop settings can be tricky; they tend to fool everyone on their first attempt at 'dappled light'. Because of the angle of the sun's penetration, light levels are significantly reduced. Although this effect looks bright to the naked eye, settings with 100 ISO at 1/100 s with f5.6 usually prove successful.

 The quality of this type of light is so strong that often it can stand as a credible theme on its own.

Dappled light

In the early 1980s I attended a presentation by a well-known UK underwater photographer. The topic was all about 'light in the sea'. During the interval I asked him about a particular photograph that had a quality of light which I had never seen before. He called it 'dappled light', and went on to describe how to achieve it. The word 'dappled' is defined as 'covered in patches of light and shadow' – a fitting label for such a quality of light.

As the sun rises at dawn or drops towards the horizon in the late afternoon, the sunbeams that enter the surface of the sea are at their most acute because of the low angle of the sun in relation to the surface of the water. To see and photograph dappled light, you need to ascertain the depth at which the sunbeams are most dramatic. In my experience it is always in shallow water, at a depth of between 1 and 4 m. The trick is quickly to find a subject at that depth to photograph against this outstanding negative space. If you are lucky, it may be a school of fish, shallow soft corals or gorgonian. At other times there maybe nothing to use. The quality of this type of light is so strong that it can often stand alone as a credible theme.

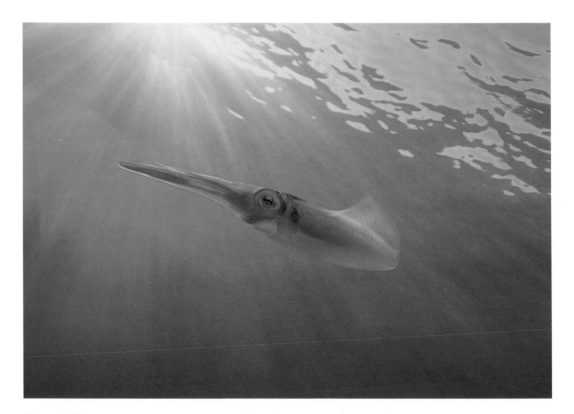

Figure 41.10
It's an excellent opportunity when you can capture an exciting subject in shallow water with dappled light. In reality, the water colour was much darker than portrayed here. I bracketed my apertures throughout this encounter. This shot had the best composition and placement within the frame, with the additional benefit of stunning natural light.
Nikon F90x with 17 mm–35 mm zoom lens set at 24 mm, f4 at 1/125 s.

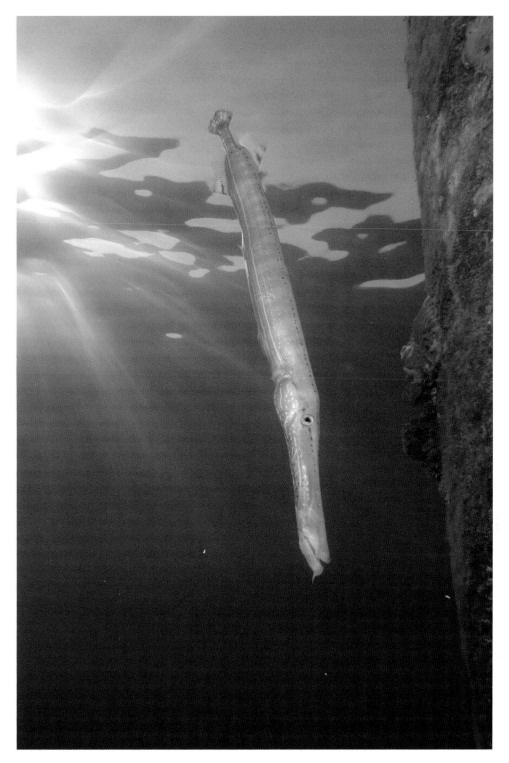

Figure 41.11
My first encounter with dappled light and a digital SLR. I was delighted; my Nikon D100 captured the light particularly well.
 f5.6 at 1/90 s, twin Sea & Sea YS 90s.

Digital and dappled light

Digital cameras handle dappled light quite well because the low angle of the sun is not clearly visible at dusk and dawn. The camera captures the beams without being troubled by the intensity and brightness of the sun ball itself. Faster shutter speeds are preferable once again, having the effect of sharpening the beams.

Cathedral light

Cathedral light and radial light are terms often used to describe the same effect.

Cathedral light takes its name from the effect of sunlight bursting through high stained-glass windows in a diagonal orientation. The camera remains in a shaded area whilst observing the shafts of light from close by. An example of cathedral light is when you see the light penetrate a shallow cave system. The sunbeams contrast dramatically with the dark walls. If you point your camera into the sunbeams towards the surface, you cannot help but include the sun ball. Instead, move out of the light, remain in the shade but aim your camera back towards the sunbeams.

Radial light is when the surface of the water is flat calm and the sun is quite high in the sky. The sunburst effect has tremendous potential because of the way the rays penetrate the water in a spherical pattern. These characteristics of natural light are very much about beams of light as opposed to the large round sun ball in the sky.

Silhouettes

To make a silhouette, you place a subject between the lens and the sunlight. The closer the subject is to the lens, the darker the subject is recorded.

This is a relatively easy shot to take. A wide-angle lens is preferable because it will allow you to get closer to the subject and fill the frame. If you do not place the subject close to the lens, the contrast will not be as effective and the particulates in the water column between lens and subject will diminish the effect.

Exposure for silhouettes

The exposure for this type of light is taken in exactly the same way as you would with the sunburst. Take a light reading to one side of the sun – not directly into it. Ensure that the exposure is not too dark. If the corners of the frame are reduced to dark blue with only the sun's rays in the middle, then the edges of the silhouetted subject will be hardly visible. The water needs to be bright all around the silhouette, but not so bright that it is over exposed and burnt out in the digital histogram.

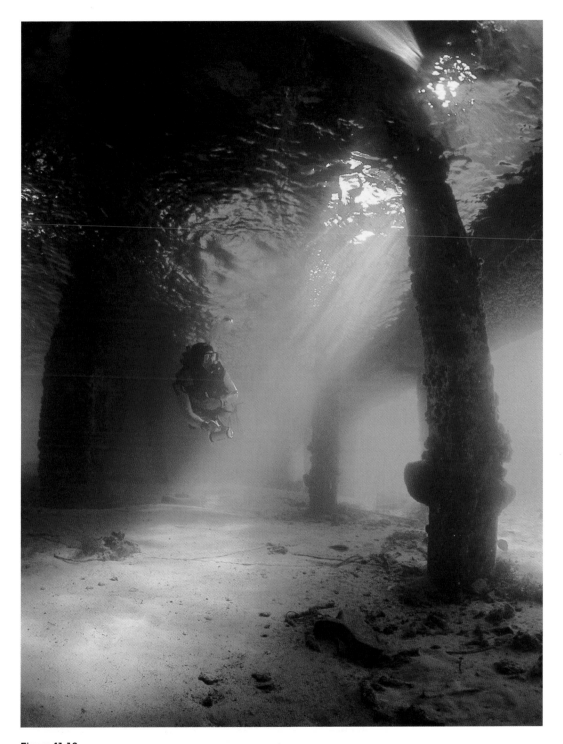

Figure 41.12
On workshops, I often notice that my students will find the light but remain in its beam to shoot either vertically or horizontally. The trick is to move out of the beam into a shaded area and shoot the rays, not the sun ball itself.

Figure 41.13
Although the background behind the model appears to be Snell's window, it is in fact a narrow inlet called Macro City off the beach at Sipadan.

If you are lucky enough to have flat water with clear visibility, then take advantage of these conditions. Shooting silhouettes in this light will result in your subject blocking out the sun, with sharp sunbeams radiating out in all directions. A faster shutter speed in the region of 1/125 to 1/250 s will emphasise these beams to great effect, but again, ensure the corners are not too dark.

Shapes in silhouettes
A silhouette is a subject that is devoid of colour. Visually, in the eyes of the viewer a subject photographed in this way is reduced to a shape. Consider sunset photographs taken on land – trees on the horizon against red skies are recognised only by their outline. It is therefore important, if at all possible, to select subjects with strong and graphic shapes, easily identifiable to the viewer.

Snell's window

'Snell's window' was named after the Dutch mathematician, Willebrod Van Roigen Snell, who lived between 1580 and 1662. A professor of mathematics at Leiden University, he discovered the law of refraction known today as 'Snell's law'.

In underwater photography, Snell's window is portrayed as an arc or half-circle through which the sky is visible. The area around the circle is a reflection of the seascape, and as such is much darker than the sky. Many newcomers often claim never to have noticed it. Here's how you do it: as you descend, look back towards the surface through a wide-angle lens; it's important to keep your vision directed in this way. You will see an arc or, depending on your depth, a half-circle.

This window, arc or circle, call it what you may, is your only visual access to the world above. If the visibility is good and the surface is flat, you will clearly see the sky through the water. You don't need to be in the sea to see Snell's window; it's clearly visible through the surface of a swimming pool.

On 35-mm format a 16-mm fisheye lens will capture the majority of the circle, but not all! I was once under the impression that the deeper you went the more could be included. This is incorrect! To photograph the full circle, you need a fisheye lens equivalent to a 12-mm lens on 35-mm format.

The best conditions are when the surface of the sea is mirror calm and the sky is blue with (to be very pernickety) white fluffy clouds.

Conclusion

Photography is all about light, underwater wide-angle is all about the natural light. Learn to see these qualities, learn to capture them and set about using them to improve your own images.

See the section 'Creative wide-angles just below the surface', in Chapter 43, for further discussion.

Figure 41.14
A diver devoid of colour captured in silhouette. We are able to recognise the subject by the shape. When composed within Snell's Window the impact of the silhouette is advanced. During one late afternoon in Sulawesi I was searching for ideas. The potential was a glass calm sea, the sun was falling towards the horizon. I motioned my buddy, Shannon, to swim through the window. I turned my flash guns off. The image looked promising through my viewfinder and the LCD review confirmed a strong two tone image of blue and black. He made three passes and I took about nine shots in all. The was the strongest by virtue of Shannon's body position within snell.

Nikon D100, 10.5-mm fisheye lens, flash guns turned off, 90th second at f11.

Using flash underwater – a new approach to an old technique

Numerous book and articles have been written about how to use flash guns in underwater photography. By and large, they all emphasise the traditional methods. I have done the same for many years, and it would be safe and easy for me to repeat the advice in this book. However, if I took that stance, it would be artificial and insincere. Why my change of heart? Well, I have completely reassessed my outlook and approach to using flash guns underwater. An explanation of how this came about is significant.

In 1997, Ken Sullivan from Photo Ocean Products produced a prototype ring-flash which contained a 105-mm macro lens. The majority of individuals who were aware of this project thought it would fail to produce acceptable results underwater. Admittedly, I too had grave doubts, but a kind of intuition and 'gut' feeling drove me forward. Against all the theory and rules appertaining to backscatter and underwater flash angles, the ring-flash was a success. At lens to subject distances of 80 cm or less, backscatter was insignificant.

Ring-flash guns became available in the UK and Europe, and Inon from Japan launched a variation of their own. At the same time I began to notice a growing trend in macro photography of placing a couple of small flash guns each side and very close to

the macro port to emulate a similar quality of light to that the ring-flash produced. The small and versatile YS30 flash guns produced by Sea & Sea became popular for this because of their compact size. Whether this trend had anything to do with my introduction of the ring-flash I doubt, but the theory of flash angle placement appeared to be shifting.

Wide-angle work

At this time, for 16-mm fisheye wide-angle work I often used two flash guns on long custom-made tripod arms that could extend to 150 cm (5 feet) on each side of my housing. Whilst these provided even lighting with minimal backscatter, they were cumbersome, awkward and totally impracticable to use underwater.

When fully extended and placed at 45 degrees to the housing, I noticed that flare was often visible in the top left- and right-hand corners of the transparency when composed in a landscape format. I realised that my flash positions were alongside the corner area of my fisheye dome port, which had no port shade construction in place. I experimented and found that flare was more prevalent when the tripod flash arms were fully extended than when the arms were shorter. Fifty centimetres appeared to be the optimal length. As a result, I started to place my two flash guns much closer to the housing than before but with the flash guns angled outwards and away from the subject. I found that the corners appeared cleaner with reduced flare. If I mistakenly placed either of the two guns at 45 degrees above my fisheye dome port (the widest part of the frame with the least shade protection), flare would occasionally feature in the corners. I continued to use this configuration from 1999 to 2002, and with the reduced length of flash tripod arms I found it much easier to use and carry both in and out of the water.

My current views

Since switching to digital, the instant feedback provided by the LCD monitor has allowed me to pursue a greater understanding of the characteristics of light which flash guns produce. As a result, I have radically changed my views since those days of long flash arms.

When a flash gun is triggered underwater, a 'hot-spot' is visible immediately in front of the flash gun. This extends proportionally depending on the power output of the flash (inverse square law). Underwater, this hotspot has the appearance of backscatter. The hotspot cannot be completely eliminated; no matter what angle you place your flash gun.

Exercise: Hotspots

In a swimming pool, with a digital camera (for instant feedback) using the widest angle of lens you have available together with a flash gun on a long flash arm, switch the flash on and position it so it's visible to your eye just inside the viewfinder on your camera. Select f11 on your camera, and a fast shutter speed that will synchronise with the flash. Set the flash to manual full power and take a shot. Now review the LCD. You will see the appearance of snow/backscatter immediately in front of the flash gun. Whilst still leaving your flash gun visible in your viewfinder, position it at an angle at which, in theory, you would not expect to see backscatter. Take another shot and review the LCD. The flash gun must be present in the LCD for you to see the effect clearly. I suspect this hotspot is still visible! Try once again, but change the aperture on your camera to f22 and see how the hotspot diminishes. Now set it to f5.6 and notice the increase.

Figure 41.15
This was taken at f22 at 1/90 s using a Nikon 12-mm–24-mm zoom lens on the 12-mm end and one Inon Z220 on full power. I have placed my flash just inside the viewfinder to illuminate a collection of silk flowers in a swimming pool. In the following examples, notice how the hot spot continues to increase and becomes wider as the aperture is opened.

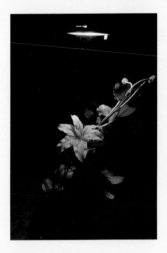

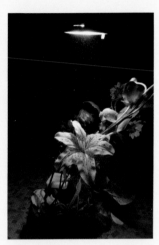

Figure 41.16

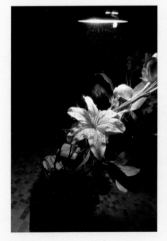

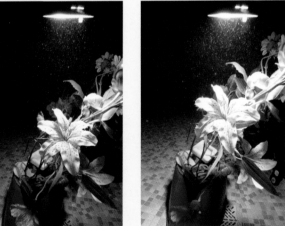

Figure 41.17 **Figure 41.18** **Figure 41.19** At f5.6.

Inverse square law

This hotspot is related to the inverse square law, which states that:

> The intensity of light falls off or diminishes at a rate inversely proportional to the square of the distance it travels from its source.

Figure 41.20
The inverse square law.

| 1 foot | 2 foot | 3 foot |
| 0.3 m | 0.6 m | 0.9 m |

Thus, a subject two feet away from a light source receives one-quarter of the light of a subject at one foot away. At three feet away, the subject receives one-ninth of the light.

This immediate intensity of light in front of a light source is always present. However, underwater, and with all the particulates water contains, when a flash gun is fired the hotspot is clear to see. If you examine the characteristics of the hotspot on a laptop or monitor, you will see that it falls off rapidly and within a few centimetres depending on the power setting on your flash gun or your aperture. It diminishes in relation to the distance it has travelled from its source.

In the past

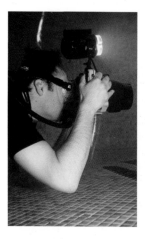

Figure 41.21
A close-up flash position taken in a swimming pool. The flash gun is situated above and behind the port. Notice the immediate hot spot emanating from the flash gun. Keep the flash back and out of the picture area to avoid it being present in your finished photograph.

Relate this to your own experience. How many times in the past have you taken close-up with a black background and found back-scatter at the top or sides of the frame? I know I have on numerous occasions. I remember this as being a common occurrence when I used a Nikonos system with the close-up lens and framer. On occasions I mistakenly placed my flash gun too near to the top frame, and backscatter appeared at the top of the finished picture. I always took the view that I had chosen a poor flash angle, but I now know that this was not the case. My angle was appropriate, but the flash itself was just too close to the picture area – which caused the hotspot from the flash output to encroach into the frame.

Take another look at the characteristics of the hotspot in the example, and notice how narrow it is. The flash gun used for these illustrations was an Inon Z220 with a diffuser, which provides a flash-beam angle close to 100 degrees. Notice how clean the edge of the beam angle is. The characteristics of flash illumination underwater make it beneficial to light subjects for both close-up and wide-angle with the 'edge' of the flash gun beam, as it is commonly known.

Many underwater photographers all over the world call this method of flash illumination 'edge lighting'. I would point out at this stage that, helpful as it is to have my surname connected to

flash techniques, it is purely coincidental that it appears to have been christened in this way!

Personal recommendations

I recommend the following ideas as a foundation for good flash techniques. My suggestions are simply methods that enable you to begin your knowledge and experimentation of flash lighting. I am not advocating that these are the only positions you should use – far from it! Experimentation is essential, but you can always return to these baseline techniques if you become dissatisfied with your own results.

- I no longer believe that long and cumbersome flash arms improve wide-angle lighting.
- With wide-angle, try to position your flash gun(s) so the light emitted comes from behind the dome port where there is some shade construction (if your make of dome or fisheye port has shade constructions).
- In order to prevent the hotspot from becoming visible in the picture area, keep the front of the flash gun well behind the picture area.
- If you only use one flash gun, position it from above in either a landscape or a portrait composition. This simulates the light from the sun, and produces shadows where the human eye is used to seeing them.
- Aim the flash gun(s) above the subject so that the bottom edge of the light beam cuts just in front of the subject and is illuminated with the outer edge of the beam as opposed to the centre. The

16-mm fisheye and wide-angle

Figure 41.22
Illustrations and test examples taken in Wakatobi, Sulawesi. I choose these crinoids on a barrel sponge and purposely placed both flash guns inside the picture area. The flash gun on the right illustrates the concept. The lighting is clean in the middle of the frame once the hot spot is diminished.

Figure 41.23
Note the narrow beam angle associated with the hot spot. It is clear to see that the flash is illuminating the fan coral on the edge of the frame. There is between one-and-a-half and two stops difference between the 'edge light' and main beam.

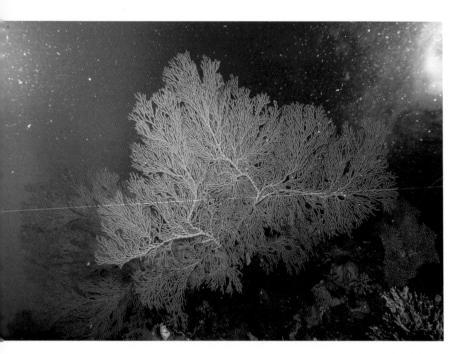

Figure 41.24
During a low-visibility drive in Wakatobi I selected a fan coral, took an exposure on the green-water column behind, and placed my two Inon flash guns just outside the frame at an angle of 45 degrees where I have no shade protection on my Subal fisheye dome port. The backscatter in the water is significant.

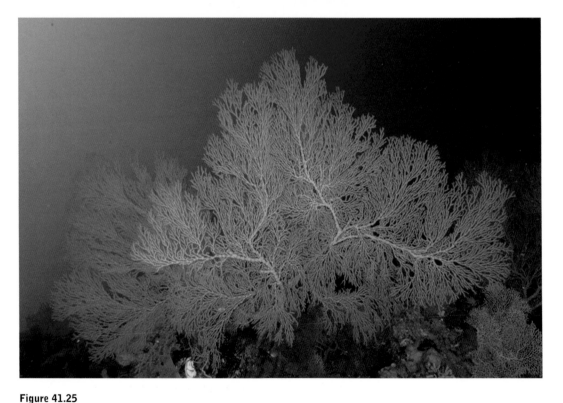

Figure 41.25
This shot follows on from that above. I maintained the composition but repositioned my flashguns several inches behind the dome, alongside the shade on the landscape side, pointing outwards to illuminate the fan with the 'edge' of the light. What a difference! See the following figure.

Figure 41.26
From the position of these flash guns there is a good chance that light will spill into the dome port and, depending on how far away the subject is from the dome, the hotspot could be evident in the top left- and right-hand corners of the frame.

Figure 41.27
The two flash guns are now behind the dome port and replaced behind the side shade constructions. Both guns are pointing out and away from most subjects so as to light them with the clean edge of the beam.

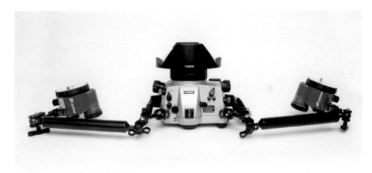

idea is to avoid lighting the water column in between the lens and the subject. This reduces the effects of particles, and creates images that are cleaner, sharper and more colourful.

- I no longer position my flash guns any further than 70 cm from the housing when shooting wide-angle. An exception would be an occasion when I want to fill flash over a larger expanse, such as in wreck photography, when I would place my flash guns about 90 cm away from the housing. This is in order to illuminate quite a large area.
- Trust the width of your flash gun(s) and 'edge light' the subject to reduce the illumination of particulates.

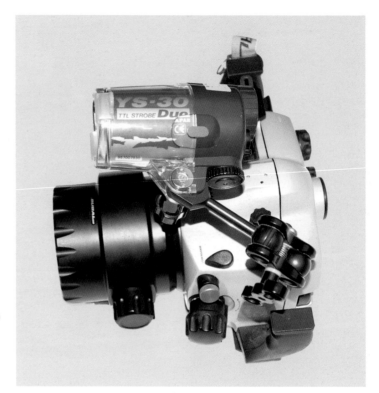

Figure 41.28
My baseline position for one flash when shooting close-up or macro – above and behind the port, pointing up at a slight angle to light the subject with the 'edge' of the beam. This minimises lighting the column of water between the lens and the subject.

Close-up and macro
- With macro, if your flash gun(s) protrudes in front of your housing you run the risk of alarming a timid subject.
- Locate a position for one flash gun which you can always repeat and return to should you feel dissatisfied with the lighting of your close-ups. I recommend 8 cm above the housing, pointing out at an upward angle of about 20 per cent.
- If your flash gun(s) is placed very close to the picture area that you are composing, you run the risk of the hotspot appearing as backscatter.

Figures 41.29 and 41.30
Even though the water was very blue and the visibility limited in both these shots, I held the housing in a vertical orientation and positioned the flashguns on each side of the dome port – one pointing down and the other upwards to light the entire frame.

Nikon D100 with 10.5-mm fisheye lens, twin Inons, f11 at 1/180 s.

Figure 41.30

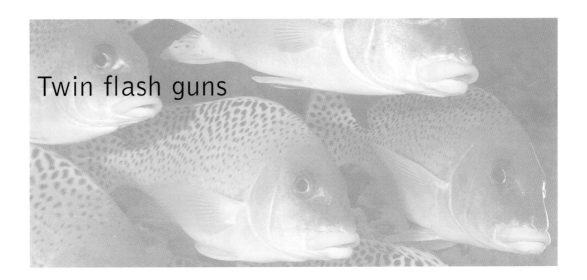

Twin flash guns

Those new to underwater photography tend to start with one flash gun, and for the first few dives even the smallest camera system will feel bulky and awkward as you carry it around trying to remember the advice you've been given. There is so much to think about.

Sooner or later you will consider the question of adding a second flash gun – shall I, shan't I? Are two flash guns better than one?

Dual lighting, as the name implies, is a very popular underwater technique. A second flash is introduced, not to increase the intensity of light as often thought, but rather to:

- Reduce the harsh shadows caused by the use of one flash, particularly when shooting macro and close-up
- Increase and enhance the quality of light and achieve effects that appear to 'wrap around' a subject, making it 'glow' from within
- Increase the area of coverage for wide-angle photography, particularly when using fisheye lens.

The second flash in more detail

The main flash is usually connected to the housing by a sync cord and positioned on the left-hand side. A second flash is then introduced in one of three ways:

1. It is connected to a second flash connector on the housing in the same way as the first flash. This is by far the most reliable and

Figure 41.31
Two flash guns on this school of sweetlips have improved on the quality of one flash and also reduced shadows. On the right of the frame, notice how the fish have been rim-lit by the second flash also positioned on the right.
 Nikon D100 with 12-mm–24-mm lens, Inon Z220s.

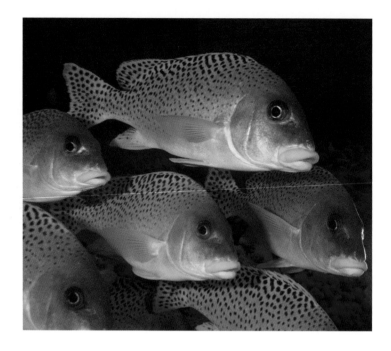

popular method. The majority of housings have the facility. Ensure you check out your options with the retailer before you purchase housing.

2. It is connected to the housing by means of a 'T' connector or a dual cable. This dual cable connector attaches both flash guns directly to the camera, and it ensures that both fire at once.

3. The third option is a slave flash gun, which fires when its sensor detects a burst of light from the first flash. A slave can be unreliable, and the photographer can end up positioning the two flash guns so they 'see' each other instead of positioning them in order to provide the desired quality of light on the subject. The plus side is that a number of flash guns have a slave function which enables dual flash TTL. The effect is that the main flash connected to the housing triggers the cordless slave flash. This is able to quench the amount of light which is emitted, resulting in a TTL type of exposure. The Sea & Sea YS-30 TTL Duo is a reliable example.

Dual flash guns should be positioned on the left- and right-hand sides of the housing by a versatile articulated flash arm. In this way, they can be moved quickly and easily to achieve the angles required.

Balancing exposures
It's often said that the left-sided flash should be the 'main' light and the right-sided flash used as 'fill-in', but I advocate an alternative. The photographer should consider the shape and orientation of the

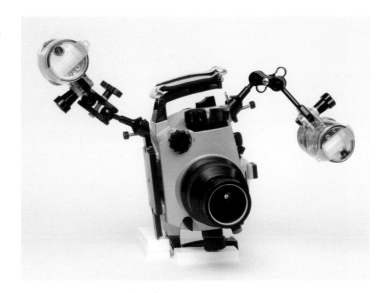

subject and where the shadows will fall in relation to the shooting angle. For instance, if a fish is facing left to right, the flash placed on the right side should be treated as the 'main' light because in all probability it will be illuminating the key features of the subject. The flash on the left will then be the 'fill-in' or second flash, and should be treated as such. It's not the intention to eliminate the shadows completely; just to reduce and soften them.

Another misconception is that the fill-in flash should be positioned several centimetres further away from the subject than the first flash in order to create the softness. This is a very general guideline. It all depends on the make, size and output of the two units. It also depends on your preference as to how you want the shadows to appear.

Hand-held flash techniques

I used to be a fan of this technique, to hold either the 'main' light or the flash 'fill', but of late I have changed my views. Many experienced photographers have superb buoyancy skills and have mastered the art of hand-holding a flash gun; however, since housings became popular I have seen more accidental damage caused to the reef using this technique than by any other element of photography. In the popular days of Nikonos and Sea & Sea cameras, hand-holding was much easier. Film and digital camera housings have, in my opinion, made hand-held techniques problematic, as two hands are often required to hold the housing. Coupled with the variety of flash-arm systems now available, placement can be achieved much more easily than ever before. If

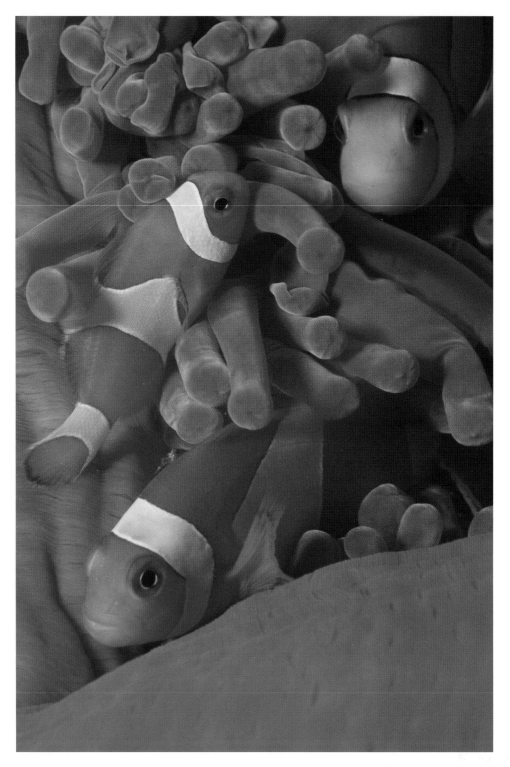

Figure 41.33
To enhance the quality of light and minimise shadows, I would have positioned my flash guns on each side of the housing.

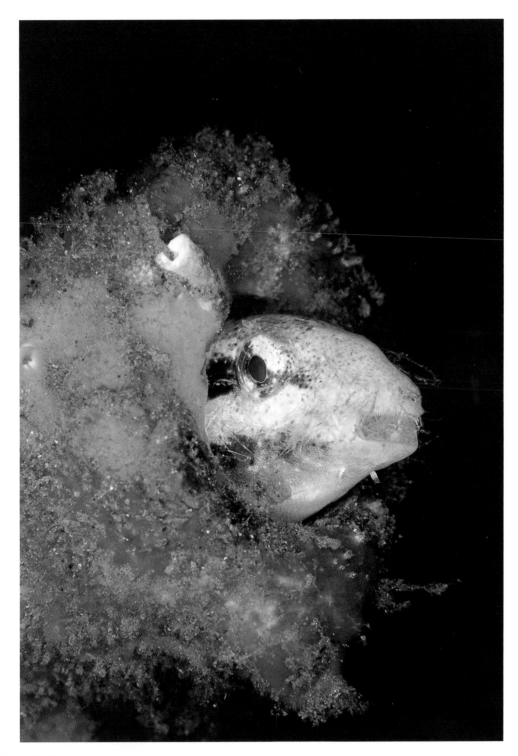

Figure 41.34
For this image I positioned one flash above the housing to light the front of the subject. The other flash was on the right-hand side, pointing out to highlight the facial features with the clean edge of the beam. I used a 105-mm macro lens.

Figure 41.35
Notice how both flash guns are behind the port to avoid scaring away a shy subject.

you are new to photography, I suggest you experiment with hand-held techniques only when there is no likelihood of causing harm to the surroundings.

Types of digital flash guns
It is preferable to twin up two flash guns of the same make and model. Digital users should go for as many manual power settings as possible, which provides infinite control over the quality of light produced.

Practice at home. With digital, you can practice without going anywhere near the water. Place your camera in the housing – remove the port to reduce the weight out of water. Use some realistic silk flowers, during the hours of darkness or in a room with little or no natural light. Set your digital camera to $f22$ or the equivalent on a compact (usually $f8$). Set the fastest shutter speed that the camera will sync with the flash gun. Activate the histogram in the LCD,

and start shooting. Change flash positions, keep notes regarding the positions, and examine the results you prefer and those you don't. If you are shooting at short distances in typical macro and close-up conditions, then the exposures will remain similar when you are in the sea. The purpose of practising in this way is twofold:

1. To get a sense of the quality of light that you prefer and the flash angles needed to produce that light
2. To be able to repeat these angles and the effects when you dive with a camera.

Exercise: Creative flash

Choose a subject that is accessible, and try some of the following combinations:

- Use both guns with extreme side lighting (remember to keep the hotspot out of the picture)
- Underexpose the foreground with one flash and use the second to backlight the subject
- Place a coloured plastic bag over one of the guns to add some alternative colours to the scene
- Choose a translucent subject and try combinations of top, side and back lighting.

The ideas are endless.

The bottom line …

The bottom line for me is this. Many photographers enter the water with two flash guns. It's a misconception to believe that both guns are used for every single shot taken – they're not. One flash may be turned off or pointed away to see how the light affects the subject with a single beam. In my own work I have ruined numerous opportunities because I used two flash guns when one would have been quite adequate.

When selecting a subject that may be new to me, I begin with one flash and then introduce a second to see if I can improve on it. I review my LCD and, if I find that I have illuminated too much of the scene I will often turn one flash off and/or reposition the second. This may be the right or left side, depending on the orientation of the subject. Don't make a hash of a shot with two flash guns when one would have been sufficient.

There is an excellent in-depth article and review of specific flash guns at www.digitaldiver.net/images/strobearticle/strobe-articlescrn2.pdf.

Flash diffusers

A diffuser is an accessory that fits over the front of a flash gun in order to achieve two things:

1. Expansion of the beam angle. This is an advantage when using a wide-angle lens, particularly a fisheye.

Figure 41.36
I leave my flash diffusers in place for the majority of my work.

2. 'Softening' of the light. Many photographers use them as a matter of course because they prefer the quality of light produced. With close-up and macro, some subjects may be highly reflective, which can create a reflection when lit by flash. Diffusers diffuse the light and reduce reflections.

Some feel that a disadvantage of flash diffusers is that they reduce the light output by at least one full f-stop. This is very subjective. There have been times when I too have suffered from this reduction in flash power. However, at other times, in different circumstances, using alternative equipment, I have found flash diffusers helpful in reducing flash output – particularly when using models with limited power settings. Using diffusers in this way is like having extra manual power settings on your gun.

Disadvantages of diffusers
When water conditions are poor, diffusers can be a disadvantage as they can compound the problem of backscatter by increasing the angle of the flash gun. It's a subjective decision whether to use them or not. I strongly favour diffusers and tend to leave them attached, but for the majority of the time I conduct my own photography in clear water.

Flash arms

Flash arms are not just another piece of kit! They are essential prerequisites for producing superior and consistent photographs. The primary requirements are flexibility, strength and lightness. There is a need to be able to move the flash guns to the precise position of choice, easily, quickly and quietly. The most flexible arms I have used are the ball-joint articulated types from Ultralight, Technical Lighting Control, Aquatica and Inon, and the flexible, plastic 'bendy arms' that featured in the first edition of this book.

Underwater housings can be heavy, so consider a flash-arm system that is lightweight as well as versatile. Don't make the mistake of purchasing sections of articulated arms that are too long

for their intended use. Two smaller sections are preferable to one long section, and enable placement to be achieved quickly in any number of positions.

Flash arms for macro and close-up

Whilst it is a personal choice, I have found that for my own style and approach I don't need anything longer than about 45 cm in total. Often I use much less than that, depending on my intended choice of subjects on a given photo dive. The full 45 cm consists of:

- The section that connects to the housing
- The section that connects to the flash gun
- A section in between of about 10 cm
- Two clamps.

Flash arms for wide-angle

I extend the length to about 70 cm, but again I use a smaller arm for smaller wide-angle subjects. For several years now I have developed the habit of using shorter arms but pointing the flash guns 'out' to edge-light the subject (see previous section, 'Using flash underwater').

Experiment underwater with the 'tightness settings' of these arms to allow a firm but adjustable movement when you want to reposition them. Do your research, shop around and purchase wisely. You can acquire sections of varying lengths in order to

Figure 41.37
I have positioned my two buoyancy arms for a vertical shot (see following image), with one flash above the housing when turned into a vertical and the other on the left-hand side.

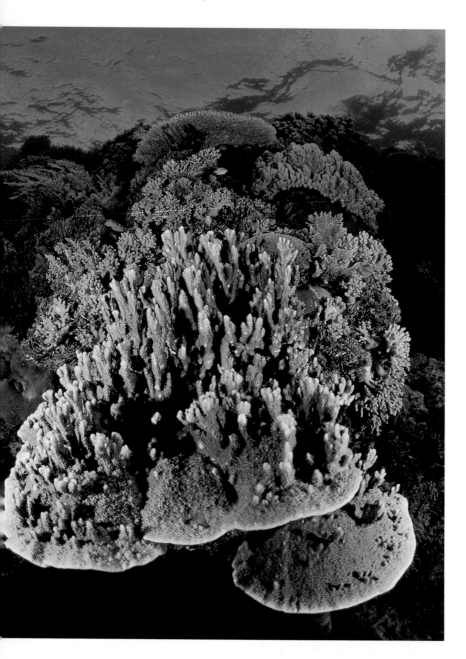

Figure 41.38
A fisheye wide-angle seascape from Wakatobi, Sulawesi. The light is evenly spread over the hard corals.
 Nikon F100, two Sea & Sea flash guns on TTL.

build a flash-arm system that you can mix and match for all your requirements.

My tip: I use one buoyancy arm segment from Ultralight on each side of my housing when shooting wide-angle. These have substantially reduced the strain on my elbow joints and made my wide-angle photography easier and so much more enjoyable since I discovered them. Basically, they each consist of an air-filled segment that has the effect of reducing underwater weight.

Figure 41.39
I would avoid this flash placement!
Both their positions at 45 degrees to
each side of the housing could easily
cause flare in the top right- and left-
hand corners of the picture – the
areas without shade protection.

Figure 41.40
Flash arms from Ultralight. At the top
is a buoyancy segment.

Ultralight claims that a complete double arm system with two
12-inch (30-cm) buoyancy segments weighs only half an ounce
(~15 g) in water, compared with 11.5 ounces (~325 g) when
using standard arms.

Follow this thread at Wetpixel.com digital forum for discussion
on flash arms: http://wetpixel.com/forums/lofiversion/index.php/
t7479.html.

42 Close-up and macro photography

Introduction to close-up and macro

There is nothing quite as fascinating as shooting close-up and macro photography. A world in miniature is all around, with tiny creatures appearing as monsters. An incredible wealth of detail is achievable, and the greater the magnification the more bizarre it all becomes. A great joy is to illustrate to non-diving friends and family a hidden world of wonder, and most people begin with close-up when they take up underwater photography. The reason being is that it is likely to achieve instant success because it tends be easier. You don't need to go to special places; opportunities are all around. So, if you are itching to get going here is a quick-start guide.

Quick-start close-up and macro

1. Use a digital or film SLR camera with a 50-mm or 60-mm macro lens, or a digital compact camera.
2. Select manual mode and, in order to maximise depth of field, set your aperture to f22 or f16 (f8 or f7 if you are using a compact).
3. Select a shutter speed of around 1/125 s.
4. If using a film camera, use 100 ISO film; if using a digital camera, select the lowest ISO.
5. Use an external flash gun and set TTL if using film. If you have a digital camera, select one of the variable power settings on the flash.
6. Position the flash gun about 10 cm above and over the camera housing, pointing out. Do not let the front of the flash protrude beyond the front of the port.
7. Try to position yourself below the subject and shoot upwards towards the water background.
8. Get close, focus your lens and take the picture.

Digital users should review the result via the LCD. If it is too dark, increase the flash power setting or open the aperture by one *f*-stop; if it is too bright, then decrease the flash power setting or the aperture.

The basic instructions that come with your camera housing and the above quick-start guide should be enough to get you started. However, there are many other aspects that will without doubt improve your photographs.

Close-up and macro – the difference

Whilst it's appropriate to discuss close-up and macro in the same context there are some differences, and it's helpful to agree some mutual terms of explanation. The difference is all to do with magnification and scale. Think of magnification as being the actual size of the subject in reality compared to the size at which the subject is recorded on film or sensor.

Macro is when a subject is the same size (or greater) in reality than it appears on the film or sensor. When it is the same size, we often refer to this as being 'life-size', or as having scale 1 : 1 magnification rate (pronounced 1 to 1). A magnification rate of 2 : 1 gives an image twice life-size – i.e. twice as large on the film/sensor as it is in reality.

Anything less than macro is technically called close-up, but both terms are often discussed in the same context. Close-up is when a subject is smaller than life-size. A 1 : 3 magnification rate image appears at one-third of the size on the film/sensor as it is in reality. In my experience, few underwater photographers attempt macro photography that is greater than twice life-size. Those that do rarely exceed three times life-size.

With the assistance of a Japanese photographer in Mabul, Malaysia, I once attempted three times life-size but was totally incapable of spotting anything with my human eye, even when it was pointed out to me!

Digital compact cameras

Although they have fixed lenses, many digital compacts have built into them close-up and macro modes. The minimum focus distances are also significant, and allow the underwater photographer to within a few centimetres of a potential subject. I have found that some of these macro modes are too close, and problems can arise:

- Living subjects will not tolerate such close proximity
- Environmentally, you, your camera and flash are virtually touching the subject
- Shadows can obscure the subject because of the housing port being in the light path from the flash gun.

I have found that one of the best techniques is to forget about the macro mode settings and use the telephoto end of the lens. Get as close as you physically can (without fear of harm to the reef or subject), then use the zoom to compose the frame more to your liking.

Digital and film SLR cameras

For many underwater photographers, close-up and macro can soon become a passion. If this happens to you, your best purchase will be an SLR camera. The advantages are significant:

- Via the viewfinder, you get to see exactly what will be recorded
- They provide the highest quality of image
- Flexibility
- The availability of fast auto-focus systems
- TTL flash metering (film cameras)
- A selection of dedicated macro lenses
- An instant review monitor (on digital cameras).

At the time of writing, I use a Nikon D100 digital camera for close-up and macro work. Above all else it is because of the instant review facility in the LCD monitor, which allows me to correct mistakes instantly and develop ideas.

Maximising depth of field

In close-up and macro, the topics of apertures and f-stops are an important part of the process as they control depth of field. As the magnification of a subject increases, so the depth of field decreases. To enable as much depth of field as possible, apertures that provide the most depth of field (such as $f22$) are recommended; $f22$, being a small aperture, significantly reduces the amount of light that enters the camera. This is why a flash gun is always used, because in the majority of cases natural light has no influence. Whilst there are exceptions to the rule (see the section 'Blue water macro' later in this chapter), everything that is illuminated within the frame is generally lit by the flash gun. If the flash gun fails to fire, then the entire picture area will be black.

Parallel the subject

To create sharp images at high magnifications, it's helpful to understand how to maximise the depth of field you are working with. I call this technique 'paralleling the subject'. I do this underwater by aligning the flat port with the most important part of the subject's plane, so that the camera and the subject are parallel to each other. Selecting the critical part of a subject's plane is your choice entirely. At around half life-size and greater, the importance of precise camera placement is a significant factor.

Figure 42.1

Profile of a hawk fish in Papua New Guinea. I was using a Nikon F90x in a Subal housing with a 105-mm macro lens behind an Edge–Sullivan ring-flash, *f*16 at 1/125 s. My film was Elite VS100. I was practising getting as close as possible to this common but timid fish. I moved in very slowly and took this picture at somewhere between half- and life-size magnification. I was conscious of aligning my housing parallel to its profile; I knew I only had one chance before I spooked it. To illustrate the small depth of field available, notice the two horns which protrude from the front. They are slightly out of parallel, and consequently not as sharp as I would have liked.

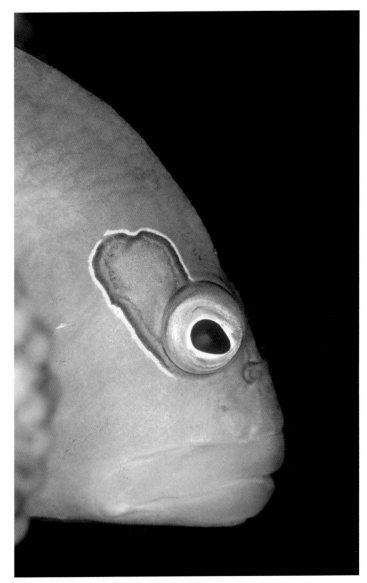

These tips may assist:

- Consider the subject and its orientation within the composition
- Next, consider the parallel plane of most importance
- Using your left hand, reach out and place the open palm parallel to this plane
- Draw your hand back towards the front port of the housing and align the port plane parallel to the angle of your hand
- If you cannot use your hand in this way, just concentrate your eye on adopting a parallel placement.

The shape and nature of some close-up subjects don't always permit this technique, so don't restrict yourself to my advice. Try it when you feel it's appropriate.

Figure 42.2
This stargazer was quite small. I focused between the two eyes and the mouth. Depth of field has rendered both in focus.

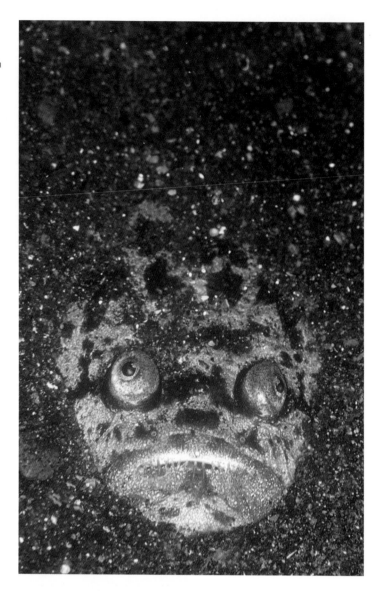

Focusing midway between one focal point (eye) and another (mouth)

Another tip regarding depth of field is useful when shooting fish portraits. If visible, the eye will always be the focal point to the viewer, closely followed by the mouth. Try this:

- Focus the lens between the mouth and eye in order to let the depth of field capture both sharply; a good example is a crocodile fish or scorpion fish taken from the front.
- Use autofocus.
- Compose, but instead of locking onto the eye choose somewhere in between the eye and the mouth.

- Bracket your focus locations and you should achieve a selection where both mouth and eye are sharp because depth of field has covered both.

Important fact

If the aperture and the image size remain the same, all focal length lenses provide the same depth of field. This is significant! If you photograph a subject at life-size on a Nikon 60-mm macro lens, then move back and photograph it with a Nikon 200-mm macro lens at the same magnification ratio using the same *f*-stop, the depth of field will remain the same. The angle of view will look different because of the perspective of each lens, but because the image size and *f*-stop are the same, the depth of field is identical.

Diffraction

SLR macro lenses display a minimum aperture setting of *f*32, which is twice as much depth of field as with *f*22. So why not use it for macro? Many photographers do, but some prefer not to. The reason for this is a physical problem called diffraction.

When light passes through the aperture of a lens, light waves are affected by the edges of the diaphragm blades. If you use a small *f*-top, like *f*32, the more distinct the effect becomes, and as the light spreads out it begins to soften the image. The effect is unnoticeable unless the aperture is very small and the lens is being focused at high magnification. Ratios of 1 : 2 and 1 : 1 are high magnification, so my advice is to avoid *f*32 in these circumstances. The balance is to choose an aperture that provides adequate depth of field without causing noticeable diffraction.

Working with diffraction

In 1989, I upgraded from a Nikonos camera to my first SLR – a Nikon F2 in an Oceanic housing. During my first trip to the Red Sea with this camera, with a 105-mm Micro-Nikkor lens, I used *f*32 for all of my life-size photographs of small creatures. Of all these transparencies, 75 per cent were noticeably soft towards the centre when projected. Ever since then I have avoided using macro lenses at their smallest aperture of *f*32 when shooting high magnification at 1 : 1 or greater. My own choice is to select *f*16 or *f*22.

Effective apertures

When using macro lenses, the optics within the lens casing move further from the film plain in the camera. The consequence of this is the display in your SLR viewfinder of an effective aperture or *f*-stop. An effective *f*-stop is a higher number than the highest *f*-stop marked on the barrel of your lens and displayed in the LCD monitor on film and digital SLRs. I have known some who

are new to underwater photography to become quite panic-stricken when they see *f* numbers of 45 or 64 displayed. This is quite normal when working with a macro lens at a high magnification.

Shutter speeds

Having discussed apertures and the need for good depth of field, let us turn our attention to shutter speeds. Which is best for close up and macro?

On land, the use of a tripod is commonplace in order to keep a camera steady so as to achieve a sharp picture. Unlike the underwater world, land photographers do not need to concern themselves with the loss of colour that we experience underwater because of filtration and depth. Even if it was practical to use an underwater housing on a tripod for long shutter speeds, the results would still lack colour due to filtration. Whilst there are exceptions to the rule (blue-water macro being one exception discussed later in this section), the shutter speed we use underwater for macro is arbitrary, as long as the shutter speed selected does not exceed the flash synchronisation speed of the camera.

Choice of lenses

Macro lenses are optically designed and corrected to provide the very best quality and sharpness in the close-up range. They have the ability to focus close, and the majority provide 1 : 1 (life-size) magnification. The difference between a straight 50-mm lens and a 50-mm macro lens has nothing to do with quality or angle of view; it's simply that the macro version allows high magnification without having to use bellows or a reversing lens.

A popular question is, which focal length macro lens should be purchased for underwater use? There are basically four to choose from:

1. A standard macro lens has a focal length of between 50 mm and 60 mm.
2. The next size up is a portrait macro lens of between 90 mm and 105 mm. Tamron makes an excellent 90-mm lens. Canon makes the 100-mm macro and Nikon makes the 105-mm macro.
3. Zoom macro lenses have become popular, and there is one that is particularly versatile – the Nikon 70-mm–180-mm macro zoom. It is highly corrected for close-up work, and is a popular purchase for beginners.
4. A 200-mm macro lens provides life-size magnification. Whilst it does have its advantages underwater, it's expensive and heavy, and I would not recommend it as a first choice of lens for macro.

A reminder: with the reduced image sensors of digital SLR cameras and the resulting magnification rate of 1.5×, on digital the 60-mm macro becomes a 90-mm macro and the 100-mm macro becomes a 150-mm macro.

The 60-mm macro on a film SLR

This will focus to a life-size magnification rate; however, the distance between the lens and the subject at 1 : 1 is only a few centimetres. Whilst this reduces the column of water between the lens and the subject, it has some disadvantages. The working distance is small, so when trying to fill the frame with a small creature, as you move in to shoot a nudibranch at 1 : 1, your port will be very close to the creature. Timid creatures like blennies and gobies may not tolerate the intrusion at these close distances.

The 50-mm–60-mm range is an ideal lens for angel fish, large cuttlefish and octopus, etc. Subjects the size of a diver's head and shoulders are all credible within this range. If you find yourself shooting with this lens at distances greater than 1 m, then you may be have to re-think your subject selection. Beyond 1 m, the effects of the water column will start to become apparent in the guise of poor contrast and reduced colour saturation and sharpness. At 1.5 m lens to subject distance, either a medium length zoom or a wide-angle lens is preferable.

The 60-mm macro lens on a digital SLR

A 60-mm macro lens with its magnification ratio of 1 : 1 (life-size) becomes a 90-mm with a magnification ratio of 1.5× life-size when attached to a digital SLR. In these circumstances it has become extremely popular for shooting small subjects at life-size, as it is now comparable with the 105-mm macro.

The 105-mm macro on a film SLR

The 105-mm macro has always been the favourite lens for those who like to shoot small subjects, as it offers twice the working distance (lens to subject) as does the 60-mm. It's this comfort distance that allows room to place flash guns around the lens in such a way that the subject is not in the shadow of the port. Also, the 105-mm macro is more environmentally friendly than the shorter 60-mm macro. You do not have to be virtually touching the subject to fill the frame. The disadvantage of the 105-mm macro is that it can be too narrow for larger subjects, which causes the photographer to 'back away' to fit it into the frame.

The 105-mm macro lens on a digital SLR

A 105-mm macro with its magnification ratio of 1 : 1 becomes an equivalent 153-mm macro with a magnification ratio of 1.5× when attached to a digital SLR with a reduced size of sensor.

Figure 42.3

Nikkor 105mm f/2.8 AF Macro

0.129m from lens front

0.314m from film plane

Nikkor 60mm f/2.8 AF Macro

0.064m from lens front

Figure 42.4

Unless you are shooting subjects in the 1 : 2 or 1 : 1 ratio, or a particular creature that is hard to approach, the 60-mm macro (90-mm effective) is preferable on digital.

Zoom lenses: Nikon AF zoom-micro 70mm–180mm
Macro zoom lenses are becoming popular for macro photography, as they take in a number of focal lengths. This model will focus to almost life-size at 180 mm, but only one-third life size at the 70-mm end. It comes with a tripod bracket attached to the base of the lens, which needs to be removed before it can be used in camera housing.

The 200-mm macro lens is used by a minority of photographers for close-up and macro, but it has certain characteristics that I like. It has three distinct benefits, the third being the most significant to me:

1. The long focal length has a considerable amount of working distance, twice that of the 100-mm lens. Small creatures not

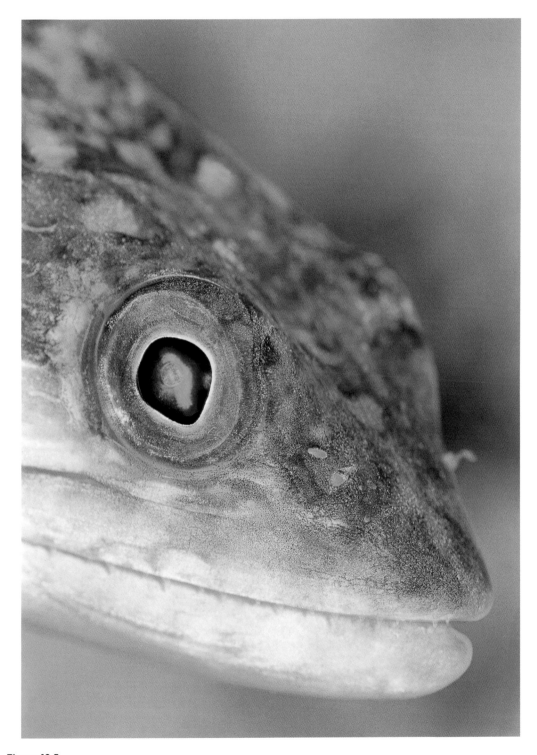

Figure 42.5
Nikon F90x with 200-mm macro lens, f11 at 1/125 s, single Sea & Sea YS 120 on TTL, Ektachrome Elite 100 ISO. Town pier, Bonaire.

only let you into their comfort zone, they don't even know they are being photographed!

2. The narrow angle of view restricts the amount of negative space that is in the frame. This is particularly helpful when the negative space is distracting, cluttered or unattractive.

3. A particular characteristic of the long focal length is that the out-of-focus background appears as a soft pastel-coloured blur, which land wildlife photographers use to such excellent effect in their photographs of birds, flowers and other animals. This quality of blur in topside photography has become known as 'bokeh'.

This lens is also sold with a tripod bracket attached to the base, which needs to be removed before it can be used in camera housing.

Bokeh

Bokeh is a Japanese term used in photography to define the aesthetic quality of out-of-focus areas of a picture. The background is deliberately caused to be out-of-focus to reduce distractions and to emphasize the main subject. Some lenses are thought to produce more pleasing out-of-focus areas that enhance the overall quality. Bokeh is a subjective quality that is often debated.

I discovered the attraction of bokeh (although I did not know it by that term at the time) in 1999, when I used a 200-mm macro lens underwater in Papua New Guinea. I was delighted to get some subjects which up until then I had been unable to get close to. However, it was the soft, blurred pastel colours of the sand in the background that most attracted me to the lens. I went on to develop this technique, and found that I could shoot close-up and macro subjects on sand and rock with potentially poor negative space but still achieve good bokeh with apertures as small as $f11$.

I have experimented with achieving the pastel coloured bokeh backgrounds with a 105-mm macro lens. It may feel uncomfortable to stop down to an aperture of $f4$ or $f5.6$ when we are so practised at achieving the very best depth of field as possible, but at $f4$ we can still obtain a precise point of sharpest focus – only this time with a greatly reduced depth of field. The negative space becomes a blur.

How best can we use the very limited depth of field? The narrow band of focus should be reserved for the main feature. Without doubt, this will be the eye of the creature! If it's a still-life study, then the area that in your view will be the main focal point of the picture is the key.

Digital advantage: when using large apertures, there is a need to control the amount of flash illumination. Use manual flash power settings in combination with the appearance of the histogram

Figure 42.6
Some of the most common corals in the sea can be brought to life with alternative lenses.

display in the LCD review monitor. With TTL flash, overexposure can often occur with larger apertures of $f5.6$ or $f4$.

Which lens is for you?

In my opinion, the 'workhorse' macro lens for either film or digital is in the 50-mm–60-mm range.

If you are using a film camera and feel that it is more your style to shoot quite small creatures (the size of your finger or smaller), then the 105-mm macro is for you.

If your penchant is to shoot reef fish, turtles and soft coral branches, then the 60-mm is the one to go for. If you can afford to purchase both the 105-mm and the 60-mm macros from the outset, then do so. They will both get used, depending on your style of photography and the subjects you wish to capture.

Figure 42.7
A tiny, light-coloured shrimp situated in a small but very accessible hole on white coral sand. I was using a ring-flash, which I knew would illuminate everything in the shot. I set f4 on my 105-mm lens in order to reduce the depth of field to a fraction and create blur. I composed the subject and ensured that the eyes looked sharp in the viewfinder. I set my shutter to an arbitrary 1/125 s and took three shots. I was hopeful that the eyes would be sharp, but I took three shots to make sure, given the minute depth of field. It as well that I did; only one shot out of three had the sharpest point of focus on the eyes! The magnification of the lens was at its maximum.
 Nikon F100 with 105-mm macro lens, Subal housing, Edge–Sullivan ring-flash, TTL. Ecktachrome VS 100.

Autofocusing

See Chapter 25 for information on autofocusing.

Limit switch

Numerous makes of SLR macro lenses (including digital) have a 'Limit' switch situated on the lens barrel. With Nikon macro lenses, this switch is situated in the 10 o'clock position, 1 cm left of the distance scale window. Like me, I am quite sure that many of you have accidentally moved this switch into the 'Limit' setting when handling camera and lens or, even worse, when you have just placed the camera into the housing. What happened next? You tried to focus and found that the lens had a very limited distance of travel. Very frustrating, I know!

The limit switch on macro lenses is a method of presetting the focus range in circumstances where you want to shoot within a specified distance. This enables you to reduce the focusing time it takes for the lens to lock on. The 'full' position allows the lens to focus from infinity to its closest focusing distance. With most macro lenses that is usually 1 : 1 – life-size. When you switch to

Figure 42.8

limit, there are two focus zones. The distance depends on two things:

1. The focal length of the particular lens you have – i.e. 60-mm macro, 105-mm macro or 70-mm–180-mm macro zoom
2. Where the lens is focused to, when you move the switch to 'Limit'.

If you are below the 0.4-m range you will get the near limit, which extends to the minimum focus distance. If you are above it you will get the far limit of infinity.

Whilst this feature has its advantages to topside photographers, who can alternate the switch at ease, does it have any applications for the underwater macro photographer? Is it of any use whatsoever? In my experience, it is a constant source of frustration when you trip the switch by accident. For the most part I tape it into the 'Full' position and leave it. However, on a number of occasions I have used it underwater in specific circumstances – for example, repeat dives on a known dive site when I know that I will be shooting at a specific distance and magnification. The limit switch avoids autofocus hunting. If you find a use for it in your own photography, then don't hesitate to try it. However, if you don't use it and you cannot see yourself using it, then tape it up into the 'Full' position to avoid any frustration!

Greater than life-size

Macro photography can become quite an obsession and, with practice and enthusiasm, there is no reason why you cannot become a skilled exponent in a relatively short time. Once you have mastered this, then why not try your hand at higher magnifications? You don't have to find smaller subjects; you can make portraits and isolate elements to show even more detail. Users with digital SLR cameras will have the capacity for greater magnification by virtue of the reduced sensor. This is an excellent place to start your microscopic adventure.

The methods
There are three methods that I recommend for increased magnification with SLRs:

1. Supplementary lenses (often called close-up filters or dioptres)
2. Wet lenses
3. Teleconverters.

Supplementary lenses screw onto the front of a macro lens, just like a UV filter. They have a positive lens element that acts like a pair of reading glasses. It allows the lens to focus at closer distances, but means that the lens can no longer focus on infinity. They come in a number of strength dioptres and are available in

Figure 42.9
+4 close up dioptre.

Figure 42.10
2× teleconverter.

both single and double element variations, with the double element being better quality. (These can also be purchased for compact cameras, and are ideally suited for digital compacts with enough space in the housing for a filter.)

Nikon and Canon make excellent quality supplementary lenses. The Nikon range is named 3T, 4T, 5T and 6T. They are available in two different powers –1.5 dioptre and 2.9 dioptre – for two different filter thread sizes. The post popular combination for use underwater is the Nikon 4T with a 52-mm filter thread size, which fits the Nikon, Canon and Tamron 90-mm–105-mm macro options. I shoot with this combination quite often, and am always delighted with the results. With a film SLR and 105-mm macro lens focused

on 1 : 1 + 4T dioptre, I can achieve a maximum of 1.4× life-size. It is versatile in that if I want to back off a little I can adjust the AF of the lens and still achieve focus.

Wet lens adaptors can also be used to increase magnification. I recommend the wet lens adaptor from Nexus, which works in the same way as a dioptre. It increases the magnification by 90 per cent, and can be removed and fitted underwater. It fits over the flat port on the housing containing the macro lens. The advantage of this is that you are not restricted to using extra magnification for the entire photo dive; you simply push it onto the port as and

Figure 42.11
Wet lens adapter.

Figure 42.12
Nexus wet lens on a Nexus housing.

Figure 42.13
Nikon F100 with 2× teleconverter, attached to which is a 200-mm macro lens. On film this would achieve a focal length of 400 mm and a magnification rate of 2× (twice) life-size.

when you require it. Whilst it's especially flexible in its use, it does not match the sharpness quality of using a Nikon 4T dioptre.

Teleconverters are optical devices that fit between the camera and the lens to magnify the image in front. They come in various powers, being 1.4× and 2×, and contain glass optics. They are often referred to as 'multipliers', since that is what they do – they multiply whatever lens you put in front of them from the same working distance from the subject. For example, take a 200-mm lens and add a 2× teleconverter and you now have the appearance of a 400-mm lens from the same distance. Whilst a teleconverter doubles the focal length of the lens, it also doubles the magnification. A Nikon 105-mm lens with the addition of a 2× teleconverter provides twice the magnification. Digital capture at 1.5× with a 2× teleconverter would provide 3× life-size! For many, myself included, 3× life-size is extremely difficult to use, though not impossible – I have seen the images to prove it! Unfortunately, I do not possess any myself and I'm never likely to.

Teleconverters do, of course, have disadvantages. Whilst the 2× teleconverter doubles the focal length and magnification, it also reduces the light reaching the film or the sensor and produces a loss of two stops. For example, for a macro opportunity with a Nikon 105-mm lens and a flash gun we would use an aperture of $f22$. If we fit a 2× teleconverter, we immediately lose two stops of light and should adjust the aperture to $f11$ to prevent underexposure. The advantage is a magnified image in the viewfinder at the same distance. The disadvantage is reduced depth of field by virtue of a wider aperture.

Finding life-size and measuring magnification

Parts of my photo courses and workshops are dedicated to macro photography. The terms 'one-to-one', 'life-size' and other magnification terminology are explained and discussed, and I then ask the group to take their cameras with macro lenses and get the lens to focus at its closest and most magnified ratio. I do the same with my own rig – I take my SLR and 105-mm macro lens, and crank it out to its full magnification of 1 : 1. I then pass it around for them to check the magnification that I have achieved and compare it with their own attempts.

A frequent verbal reaction from the group is: 'I never knew my lens could focus that close!'. If you are uncertain about the close focusing abilities of your SLR macro lens, then try this exercise.

Figure 42.14 (Opposite page)

I used a Kenko 2× teleconverter, which maintains full linkages with the camera in terms of autofocus and metering, and a Nikon 105-mm macro lens on a Nikon F90x camera. I needed an extension port to accept the increased length of the lens with the teleconverter attached. I was able to stalk the subject but fill more of the frame. I used *f*8 at 1/90 s, as opposed to my usual *f*16. I took about twenty shots, but at least half were out of focus on the critical features due to the minuscule depth of field. I used a single subtronic flash gun set to TTL with an ultralight arm system. This type of set-up is capable of achieving stunning results with small creatures, but the downside is the reality that when working at high magnification the success rate of usable images can be disappointing.

Exercise: Close focusing

1. Take a metric ruler and place it on a flat surface.
2. Using one of the popular lens models listed above, switch the lens from autofocus (AF) to manual focus.
3. Turn your SLR camera from autofocus to manual focus.
4. Next, rotate the lens by hand so that it is extended to its maximum magnification length – you can determine this by the 1 : 1 markings on the barrel of the lens.
5. View the metric ruler through the viewfinder by slowly moving closer to it. Resist the temptation to refocus the lens! Just move the camera closer and closer until the ruler comes into focus.
6. If you are using the 60-mm or 50-mm macro lens, the closest focusing distance will be about 10 cm. With a 105-mm lens, it will be twice the distance of a 60-mm lens.
7. Place the left-hand side of the image in the viewfinder at the beginning of your metric ruler, indicated 'zero'.

If you are using a film camera, the metric ruler should occupy approximately 35 mm of the viewfinder as long as you have rotated the macro lens to its closest focusing distance/highest magnification. If you are using a digital camera with a magnification rate of 1.5, the ruler should occupy approximately 23 mm of the viewfinder. If your digital camera has a magnification factor of 1.6, then the ruler should occupy approximately 21 mm.

If this magnification is a surprise to you, it's because you have been unable to achieve this close focusing distance whilst using the autofocus feature on the camera. The aim now is to practice focusing (using AF) to this magnification with the camera and lens in the housing. Try around the house or the garden. Leave your lens port off the front; this will reduce the weight and ease the tension in your elbows. You don't even need a film to try; all you need is the practice. Just remember to put the port back on when you get into the sea!

Figure 42.15
At a magnification of 1 : 1 (life-size), the ruler should occupy 35 mm of your film SLR viewfinder.

Figure 42.16
Using a digital SLR camera with a sensor size that provides 1.5 magnification, a metric ruler should occupy 23 mm.

Predictive focusing

'Predictive focusing' is a label I have given to a technique that assists in learning to see close-up and macro subjects in a

different way. It's fun to try and makes a change. This is how it works:

- Rather than looking for subjects and then focusing the camera lens on that subject, predictive focusing is when you pre-set your macro lens to a certain focus ratio – let's say, for example, a ratio of 1 : 2 (half life-size).
- Lock off the focus with the AF lock on the housing or the gears just below the flat port.
- Next, set the flash gun(s) to a position suitable for a subject of this size (e.g. above the camera pointing straight out).
- Now use the viewfinder in the same way you would a magnifying glass to find a small object. Let your eye, via the viewfinder; wander around a subject until you find something that visually attracts you to it. It may be an abstract, or a certain colour. It could be the interplay between two areas of colour contrast, a particular texture or a cluster of shapes. If you are lucky, it may be a small crab or a shrimp!
- If it helps, attach a small spotting torch to the housing and position it to illuminate the frame.

This is another way of 'seeing' subjects. Instead of finding the subject first, you use this magnification to explore and discover image opportunities in your viewfinder which otherwise may have gone unnoticed.

Metering modes for close-up and macro

Having the choice of matrix, centre-weighted and spot metering modes, I tend to leave it set on matrix. I have shot numerous rolls of film and digital files on each of these three options, and to be perfectly honest I cannot see any difference between any of them! With a dedicated manufacturer's flash gun for a particular camera, I would advise the use of matrix metering. However, I prefer to use those flash guns that are specifically designed for and dedicated to underwater use.

Close-up and macro animal behaviour

A large percentage of your photographs will be of commonplace subjects, some living and others still-life. Whilst you may compose and light a beautiful fish portrait which is admired by other photographers, it may not readily attract the attention of publishers and stock libraries unless the fish is displaying some kind of behaviour.

Figure 42.17 (Opposite page)
I stumbled on this technique quite by accident. I was lying on a seabed of black volcanic sand in Lembeh Straits, Sulawesi. Light levels were low, and without a torch I began to use my Nikon D100 SLR with a 105-mm macro lens as a substitute for a magnifying glass. I had locked focus at the highest magnification, and scoured the fronds of this coral for subjects. Through my viewfinder I found this coral crab nestled in the branches. I aimed, fired and obtained this image. I didn't manage a second attempt; it scuttled off out of sight.

Twin Inon Z220 flash guns, *f*22 at 1/180 s.

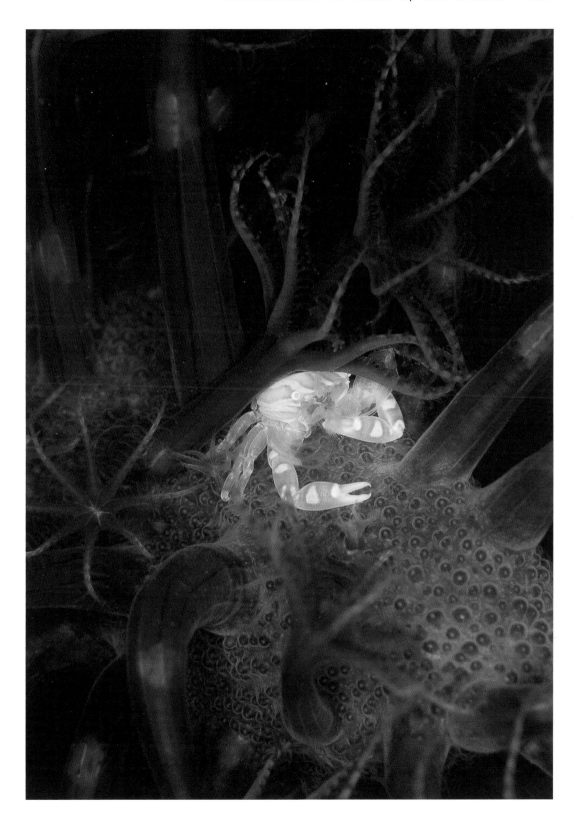

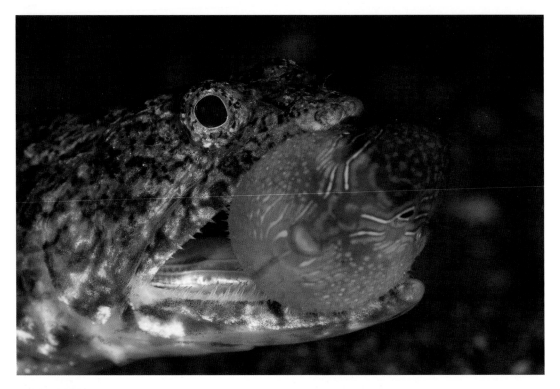

Figure 42.18

Those who are successful in capturing animal behaviour will have a passion for biology and the habits of the creatures themselves. Capturing behaviour requires immense patience and dedication in diving, with the sole purpose of finding and stalking a particular subject or looking for a particular behaviour.

My first port of call on a photo trip is to seek out the dive guides. Many seem to know how to find the interesting creatures, and understand the behaviour they exhibit. I'm sure you have seen the guides swim off to a certain sea fan or coral head. Watch how they approach, where they look.

Another way of improving your behaviour shots is to seek out the photography of others photographers whose work in this genre you admire. An excellent place to start is Dr Alex Mustard, whose work is featured in Chapter 21. See his website at www.amustard.com.

Using flash guns for close-up and macro

The following tips may be useful:

- Given the narrow angle of lenses used, one or two small guns are ideal for the job. The reduction in size and weight will make your camera rig far more easy to use.

Figure 42.19
This jaw fish was known to us throughout the week at Captain Don's, Bonaire. One evening I went to photograph some small creatures with a 200-mm macro lens. I passed the resident jaw fish, and noticed the eggs. I changed my dive plan and spent some time there.

Nikon F90x with 200-mm lens, one Sea & Sea YS 120 flash on TTL, *f*11 at 1/250 s. Ektachrome VS ISO100.

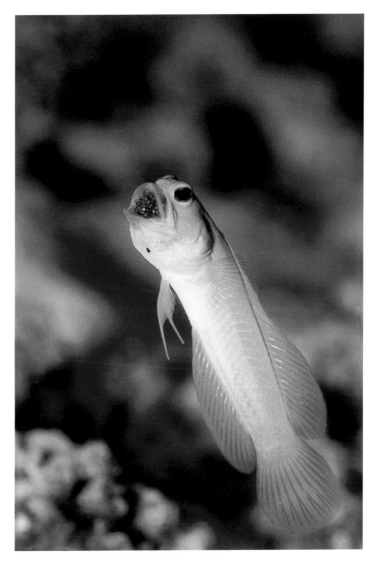

- I advocate the use of short articulated flash arms like those manufactured by TLC (Technical Lighting Company).
- A general concept of close-up flash positions is to try and simulate the light from the sky, clouds and the sun, in the same way that we are used to seeing shadows in our everyday lives.
- A good exercise is to hunt for books, magazines or pictures on the Internet to view examples of close-ups and macro. By examining the shadows, you can often determine the position of the flash gun.
- It's okay to place your flash gun in front of your port, between the lens and the subject, as long as the flash is well away from the picture frame and does not scare the subject away.

If you position your flash gun out in front of the port, you run the risk of invading a creature's comfort zone. If the creature is

Figure 42.20
The position of the flash guns may be appropriate for a still-life subject, but with shy creatures it is likely that they will move away as the photographer approaches.

timid, you may miss the opportunity. So often in these circumstances it is the position of the flash gun, rather than the photographer or the presence of the camera housing, that has spooked it and caused the problem. I always try to ensure that the lens and flat port combination is the closest piece of equipment to the creature. We all spook fish and other creatures at times; if your subject swims away, then at least you know it was the close proximity of the lens port that caused this. Spooking a subject due to the flash being too close is, in my opinion, 'an own goal'.

Baseline position
For practical results in the water, my choice of position with one flash is what I call the 'baseline position'. Keep the flash above the housing and behind the port, pointing slightly upwards regardless of the camera's orientation. You will get good lighting regardless of which way your subject faces, and as a bonus most of the shadows will fall behind the subject. The light will be clean because of the edge-lighting technique.

Two flash guns
When using two flash guns, the orientation of the subject influences the positions of the units. A good 'baseline' starting point is to place them in similar positions to each other but a little above and to each side of the housing, pointing out and away from the subject, so that the edges of both beams cut just in front of the subject.

TTL flash – film cameras and close-ups
Film cameras are best suited to TTL flash guns, and I would go as far as to say that applying TTL flash technology to close-up and macro subjects is almost foolproof!

TTL flash exposure allows the camera to 'talk' to the flash gun. The meter inside the camera reads and interprets the light that has reflected off the subject from the flash. When the camera

Figure 42.21
The baseline position.

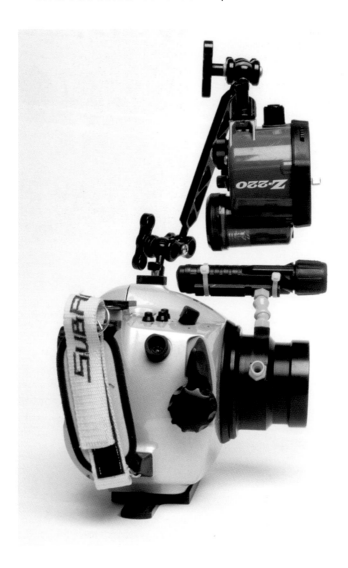

Figure 42.22
Depending on the orientation of the subject, with close-up start by aiming the flash guns outwards so that the 'edge' of the light cuts just in front of the subject.

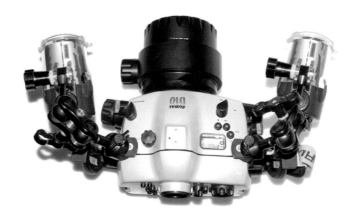

Figure 42.23
With smaller subjects, begin by aiming the two flash guns outwards.

considers it has delivered enough light to the subject to achieve a correct exposure, the camera instructs the flash to switch off.

Using a combination of 50 or 100 film ISO with small apertures of f22 or f16, the consistency of TTL flash exposure eliminates concerns about technical aspects and allows you to concentrate on the subject and how best to capture it in camera. However, you must still be aware that if the flash gun is positioned too far away from the subject with a certain aperture it cannot deliver enough light, and the result will be under-exposed. On the other hand, if the flash is positioned too close to the subject for a certain aperture, then it cannot 'quench' the light enough and the result will be overexposed.

For example, a flash to subject distance of 8 cm with an aperture of f22 could be too close for the flash to quench the light sufficiently, resulting in overexposure. The solution is to close the aperture to f32 or move the flash gun a little further away to about 20 cm.

With a flash to subject distance of 80 cm with an aperture of f22, the flash could be too far away. The TTL technology would deliver a flash at full power, which may still be insufficient to expose correctly at that distance with such a small aperture. The solution would be to open the aperture to f16 or f11, or move the flash closer to the subject.

TTL is reliable as long as the flash is not too far away or too close to the subject. The correct ranges are very lenient, but if in doubt consult the instruction tables that come with most flash guns.

Bracketing TTL flash exposure
If you wish to bracket TTL to achieve frames that are under- and overexposed, you cannot control this by changing the aperture.

Figure 42.24

The flash will automatically compensate. To bracket, you must use the exposure compensation dial on the camera to 'dial in' +1 *f*-stop and −1 *f*-stop accordingly (see Chapter 26).

TTL with digital cameras

If you have become used to relying on a TTL flash system for your film camera, you may be disappointed to find that your new digital SLR will only work with one or two dedicated (own manufacture designed) D-TTL flash guns.

TTL in a film camera works by measuring the light reflected off the film itself. A digital sensor is not film, and behaves completely different. This was a huge issue when digital cameras first became popular in underwater photography. Users who had never been accustomed to using anything other than TTL before were concerned at the thought! Now, it is generally accepted that it's preferable, easy and reliable to use manual flash powers to determine exposure. With just minutes of tuition regarding manual flash powers, histogram interpretation and how to review the LCD monitor, newcomers to this alternative never look back.

This is the most important reason why flash guns with variable power settings are such an advantage when shooting digital close-up or wide-angles. (However, note that the Fuji S2 Pro digital SLR is one exception to this, and provides accurate TTL flash exposures when shooting close-up and macro.)

Shutter speed

The duration of a burst of light from a flash gun is very short – as fast as 1/10 000 (ten-thousandth) of a second. Because the flash is often the only light source when shooting close-up and macro, this short duration has the effect of freezing the motion of a subject. This is the reason why, in close-up and macro, when flash is the only light source, shutter speed is not that critical. Remember that the shutter speed you set does not affect the flash

exposure in anyway whatsoever, as long as it does not exceed the shutter flash synchronisation speed.

Chapter 41 provides an in-depth description of lighting techniques.

Film choice

Fine detail rendition is essential for close-ups, and the majority of photographers use a slow film with ISO values of between 25 and 100. In the 1970s and 1980s, the market for colour transparency film (slides) was dominated by Kodachrome: Kodachrome 25 was very slow but had very fine grain, while Kodachrome 64 was a general-purpose film. There was very little noticeable difference between the two in the grain structure and sharpness. Since the 1990s, the majority of professional underwater photographers have tended to use Fujichrome Velvia 50 ISO. The popularity of Velvia is not confined to the underwater world; it has to be the most popular film for professional photographers throughout the world. Take a look at the annual BBC Wildlife Photographer of the Year competition winners, and you will find that over 75 per cent of them take their winning shots using Fuji Velvia.

Exposure latitude

My own preference has always been inclined to the Ektachrome range from Kodak. For my style, I prefer to use a film with an ISO of 100. Don't get me wrong! I don't think that my film is better than Velvia – I just find it easier to use. Slow film has small exposure latitude, which can be unforgiving. Fuji Velvia has an exposure latitude of less than one stop, and I prefer to use a film that is faster and provides one stop more light, particularly with wide-angle. My current film of choice is Ektachrome E 100 VS (very saturated). It's extremely sharp, produces vibrant colours and records a very vivid blue that is pleasing for my style and taste. I use this film for both close-up and wide-angle (when I'm not using digital). If you opt for Velvia and are concerned about the exposure latitude issue then try exposing it at 40 ISO instead of its recommended 50 ISO, using the manual ISO setting on your SLR. This will provide 0.5 of an f-stop lighter.

Film processing

Except for Kodachrome, the majority of other reversal films can be processed using the E6 system, which some photo/dive resorts and live-aboards offer with a turn-around time of 24 hours. However, the popularity of digital is having an unfortunate effect on E6 availability. Many resorts/boats have converted their processing darkrooms into digital imaging suites with a projector, laptop and download facilities. Because of the relatively short longevity of E6 chemicals and general lack of demand, resorts are beginning to abandon this service. It is worth checking with

your tour operator before you book a photo trip to ascertain the continuing availability of E6 processing.

Depth of field table

The following table gives the depth of field, in millimetres, of reproduction ratios from 1 : 8 to 3 : 1.

Reproduction ratio				Magnification		Aperture	
		f5.6	f8	f11	f16	f22	f32
1 : 8	0.12	27	38	53	77	106	154
1 : 6	0.17	15.7	22	31	45	62	90
1 : 5	0.20	11.2	16	22	32	44	64
1 : 4	0.25	7.5	10.6	14.6	21	29	43
1 : 3	0.33	4.5	7.2	8.8	14.4	17.6	29
1 : 2	0.50	2.25	3.2	4.40	6.4	8.80	12.8
1 : 1	1.00	0.75	1.07	1.47	2.14	2.93	4.27
2 : 1	2.00	0.28	0.4	0.55	0.8	1.10	1.6
3 : 1	3.00	0.16	0.24	0.32	0.47	0.65	0.95

Blue-water close-up and macro techniques

We know that for close-up and macro photography, good depth of field is paramount and apertures of $f22$ and $f16$ are preferable. From previous chapters we also know that when blue or green water is exposed at small apertures, a darker tone of colour or a black background is recorded. This records excellent negative space (everything in the photograph that is not the subject). However, to continue to shoot macro this way can become repetitive and samey. It is also a fact that some viewers, editors and competition judges dislike the technique of illustrating close-up and macro photographs against black backgrounds.

What can we change? One method is to shoot all subjects against the reef, but the majority of your results will look cluttered if you do this.

There are various alternative methods that make it possible to retain a colourful background, but all have disadvantages to some degree:

- Many underwater photographers open the aperture of a traditional macro lens, such as a Nikon AF 60-mm macro lens, from $f22$ to $f5.6$, $f4$ or even larger. This may provide a vivid blue-water background; however, the trade-off is insufficient depth of field, which can be very problematic (unless creative focusing is intended).
- Some photographers use coloured filters which they place behind the subject to create a bespoke negative space (if circumstances allow). I do not encourage this method because of harm to the reef.
- Using a faster ISO speed (digital or film) may provide a blue-water background at $f22$ or $f16$. The disadvantage is an increase in digital noise or film grain.

Figure 42.25
This branch of orange soft coral was situated in an ideal location to compose the water column behind it. I selected manual exposure mode on my Nikon D100 housing and an aperture of f22, but reduced my shutter speed so the analog exposure display inside the viewfinder indicated a zero, which meant correct exposure. I took several shots, checked the histogram and reviewed the result in the LCD monitor.

Nikon D100 with 105-mm macro lens, one Sea & Sea YS 90 auto, f22 at 1/8 s.

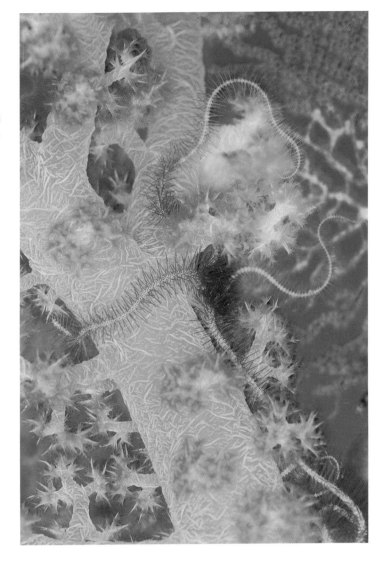

I advocate a technique that is orientated around shutter speed selection. I call this technique 'blue-water macro', and this is how it works. Using the same 60-mm or 105-mm macro lenses, I take time to select a close-up or macro subject which I can shoot against a blue-water background. Appreciate that these situations are not always easy to find, and frequently I can go unrewarded. When I do get lucky, I set a normal aperture for the ISO speed and flash techniques – e.g. f22 or f16. Using my Nikon D100 digital SLR in manual mode, I position the flash for the subject and then adjust the shutter speed so that the camera's meter indicates the correct combination of aperture and shutter speed to record an ambient light exposure – for instance, f16 at one half-second. With my digital SLR, this is very easy. I check

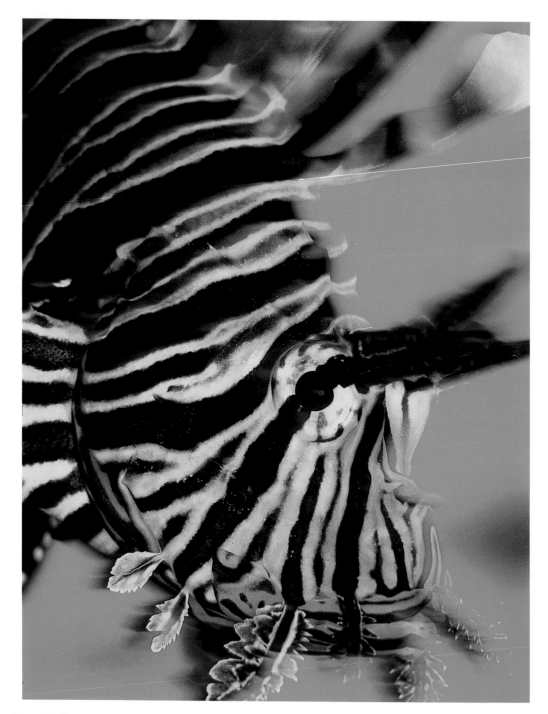

Figure 42.26
I found this lion fish hunting above the reef during the late afternoon. He appeared to be completely unaware of my presence. Coupled with a blue-water background, the potential was good. This was taken with a Nikon F100 film camera beneath Sipadan Water Village jetty on Mabul. The aperture is ƒ16; I bracketed my shutter speeds between 1/8 s and 1/2 s. I used a ring-flash and took about ten shots on Ektachrome VS film.

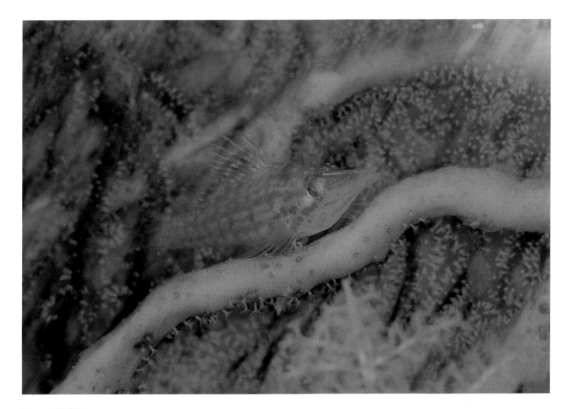

Figure 42.27
This long-nosed hawk fish was amongst a red sea fan growing from a vertical wall in Sipadan. It was easy to photograph against the blue water background behind; however, good buoyancy control was essential in order to suspend in the water column, focus and compose.

Using my Nikon F90x with 105-mm macro lens in a Subal housing, I took a number of shots using f16 at 1/90 s with Ektachrome Elite 100 ISO. They were acceptable, but I had taken hawk fish before and I wanted something different. The following day, I adjusted my 'mind set' to blue-water macro and revisited the hawk fish. I retained the aperture of f16 to provide a good depth of field, but opened the shutter speed from 1/90 s to 1/3 s. I knew that I would be unable to hold the camera still enough to produce a sharp picture, but decided to let things happen and accept the result.

I took about five shots. I often project this image to students on my photo workshops. Some immediately claim it to be fuzzy and out of focus; however, many see something more – a feeling of movement, motion, a blur of unreality.

There is no rule that says everything must be sharp with no sign of motion. Look beyond the technical imperfections of a photographic image in both your work and that of others. You may take a shot that is far from how you expected it to turn out, but ask yourself, do I like what I see? I like what I saw, yet it breaks all the rules of conventional underwater photography.

the LCD monitor to review the colour of blue water which I have obtained, and the camera's histogram to ensure that I have not overexposed the highlights.

Using this technique, I can retain a suitable depth of field at a comfortable flash to subject distance. By bracketing the shutter speed I continue to review the LCD, and by changing shutter speed I choose my preference for the shade of the background water column.

Shutter shake problems with slow shutter speeds

How can you prevent shutter shake at these slow speeds? Well, the truth is you can't. Shutter shake will occur to some degree. However, the duration of light from a flash gun is in the region of $1/10\,000$ s, and this split second burst freezes any movements of the housing so the subject is recorded sharp and in full colour against the blue (or green) background of the sea. The 'fuzzy' areas are recorded much darker owing to the interval between the flash cut-off and the shutter closure. It may take several attempts to achieve one that works, but with immediate digital feedback experimentation is simple.

Abstract images

By its own definition, an abstract photograph is not a true or intended representation of a subject. The underwater photographer, using either a macro or zoom lens, isolates a particular area or portion of the subject. By doing so, they are abstracting and leaving behind what is often a false representation of reality to be recorded on the sensor.

Quite often there is no one centre of interest or focal point. We have all observed people viewing prints, and noticed them leaning over to one side or twisting their heads to view the photograph. In abstract photography, subconscious attempts are being made to relate the image to something that can be recognised. Viewing images in this way can be as unrewarding as it is enjoyable, which in turn is good and bad for the photographer. Some viewers will dislike what they cannot understand and simply dismiss the image at a glance, while others will be intrigued and inspired by the sheer simplicity of the abstract.

In order to provide maximum impact to the viewer, notwithstanding the photographer's own personal preference, it is essential that the image has a strong sense of design. This is because, as already mentioned, there is seldom one centre of interest.

Visual design for the underwater photographer

The visual fundamentals of design that all photographers work with (often without realising it) are:

- Pattern
- Shape
- Texture
- Line
- Colour.

Figure 42.28
Stoplight parrot fish fin – a layer of colour from top to bottom. Brown was the colour of the background, which is a blur due to the lens used. Orange was the colour of the fin and brown was the colour and pattern of the body. I have composed the fin one-third from the top.

Nikon D100 with 200-mm macro lens, twin Z220s, *f*16 at 1/80 s. Image is uncropped. Night dive in Dominica.

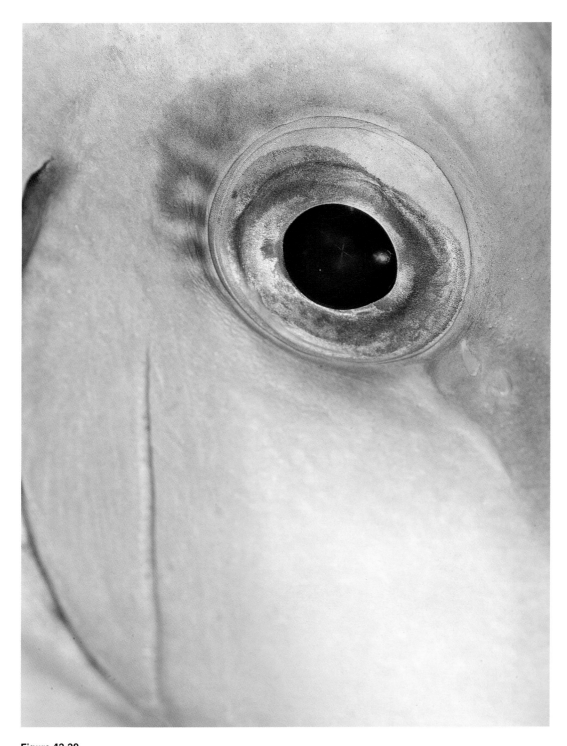

Figure 42.29
This was taken on the same night dive as the image on the page opposite, using the same equipment. I composed the eye off-centre to include the patterns and circular line around the eye. I was going to crop it make the eye stand out more, but decided to retain my original idea.

Figure 42.30
Stoplight parrot fish detail, again taken on the same night dive as the image on page 282, and with the same equipment. There is a combination of shapes and colours, yellow, orange, green and brown. What should I leave in or exclude? How do I arrange the elements? Which format to publish? This is also uncropped, to illustrate my original idea in camera.

Exercise: Heightening design awareness

A land photographer introduced me to a simple exercise to heighten my awareness of the five fundamentals of visual design. The suggestion is to choose about fifty of your own (or friends') photographs, and look at them in no particular order. Take a piece of paper and rule five columns as follows:

Colour	Pattern	Shape	Texture	Line
etc.				

As you look at the photographs, consider which element of design is strongest in each and place a tick in the relevant column. After you've gone through them all, you should have fifty ticks in various columns.

Now see which column has the most and which the least. Doing this will illustrate to you your own personal preferences for the elements of design. Texture may have most ticks and be your favourite, while shape, for instance, may not feature at all. By conducting this exercise you will determine the elements that your mind and eye do not 'see' well. These are the elements that you may like to work and concentrate on in the future.

I have done this exercise frequently on underwater photographic courses using the same set of slides. It's always the case that each individual views the five elements of design differently, each one having their own preferences.

Figure 42.31
Lettuce sea slug detail.
 Nikon F90x with 105-mm lens and 2× teleconverter enabling twice life-size magnification, one Sea & Sea YS 120 flash gun on TTL, f8 at 1/90 s, Ecktachrome VS.

Each of these has a strong symbolic value and creates the designs we see all around us in our everyday lives, whether natural or man-made. The importance of these individual elements in photography cannot be overstated: To create successful abstracts underwater, a good understanding of each is necessary. Let's look at the elements of design in more detail.

Colour
My own preferences have always been for pattern and colour. In the past there was no way of knowing the true colours of what had been photographed other than using a torch. The digital revolution has now provided us with a Polaroid experience in which we can shoot a subject without focus or composition, simply to determine if it appeals to our personal colour palate.

Over the years, I have developed an awareness of colourful subjects underwater. I can now recognise the bright, intense colours of red, orange and purple, though they appear to be very drab and dull. Now, with digital, I will confirm the colour by taking an instant snapshot – a Polaroid – and if I like what I see, I stay and shoot. If I have misread the colour or the condition is poor, I

will move on to something else. This has been made possible by the LCD digital review facility.

Pattern

Patterns are around us constantly in our everyday lives. Visual patterns appear in the clothes we choose to wear, or the ceramic tiles in the bathroom. We see patterns in poetry and music. The patterns and routines of day-to-day life offer us a sense of security. We are creatures of habit, and these habits, by definition, repeat over and over again. No wonder we are attracted to patterns – they are part of us!

Patterns can be found underwater in every conceivable area – fish fins and scales, hard and soft corals, the sand and the reef, the rust-covered chain that secures the anchor, and a host of other patterns that we swim over every time we enter the water.

When you shoot patterns in a subject with the intention of reproducing an abstract image, it is essential that you fill the frame or lens with the pattern. If you are using a macro lens, ensure that it is parallel to the subject. Inconsistency of depth of field of a pattern breaks the momentum and repetition. The pattern is 'broken'.

Shooting a pattern with a wide-angle lens can also prove difficult unless the lens is parallel to the subject. Wide lenses produce a forced perspective and a feeling of depth which, although an advantage in other forms of underwater photography, can decrease the impact of a pattern on the viewer.

Shape

One of the purest and most fundamental shapes is the silhouette. Devoid of light, we use shape to identify the subject. Silhouetted trees on the horizon, a church spire and farm animals backlit by the early morning sunrise are all good examples. Devoid of texture, pattern and colour, we can still quickly make identification as a result of our perception of the shape. It is easy to see why silhouettes are the most frequently photographed shapes, both on land and underwater.

There needs to be strong contrast between the shape or subject and its surroundings, either when backlighting the shape or when choosing to front light. When frontally lit, the viewer experiences the shape for what it is – such as a fish or a diver – and sees just that. What the photographer sees as a graphic shape can be lost when filled with flash.

Texture

Texture, like pattern, has enormous symbolic importance in our lives – the expression 'take the rough with smooth', the soft feeling of silk, the hard impression of gravel and sandpaper. We all have our favourite textures that we love to touch – a baby's skin,

Figure 42.32
I took this close-up of a jelly fish as a snapshot as I was passing. I wished I had taken more; the texture and subtle colours are striking. I have taken many jelly fish abstracts since, and failed to repeat the quality of this shot.

cloth, leather. Even rough textures like broken glass, splintered wood and jagged rocks evoke a response.

Have you every noticed the texture of tree bark and leaves when the sun is low in the sky? Similarly, underwater the acute flash angle of side lighting is the best directional light to bring out such textures as it rakes across the subject creating light and shadow.

Line

Just like the other elements of design, lines are all around. Look up from this book and cast your eyes around. You will see straight, curved and jagged lines, which may be orderly or disorderly.

Lines that lie on the horizontal when photographed evoke tranquillity, rest and relaxation. Vertical lines stand up tall and firm, implying strength and dignity. The world is full of vertical lines.

If a vertical line has a base that is contained within the picture frame, then the directional effect on the viewer is from the bottom to the top. If the vertical line has no base, the effect is quite the opposite – from top to bottom.

You can evoke these feelings in the viewer by shooting vertically or horizontally or both. In abstracts, examine the photograph and turn it 360 degrees to see which perspective provides the greatest impact.

The diagonal line is dynamic and, like the vertical line, provokes a strong feeling of movement. It is at its best when it runs from left to right. To create even more dynamics, compose so that the diagonal line directs the eye from bottom left to top right.

Would it surprise you to learn that the majority of images in this book were deliberately composed on the diagonal? The lines could have been of any orientation but by tilting the angle of the camera a lethargic composition is brought to life. Tilting the camera in this manner will not work with a topside picture – people, buildings and trees composed on a false tilt would be totally unacceptable to the viewer in the majority of cases. But how many horizons and buildings do you see under water? Even the straight, man-made lines of sunken wrecks can be tilted as long as the background surface detail is not disturbing.

Summary

Abstract photography is all about isolating detail and using the appropriate elements of visual design to make the isolation visually stimulating. I have found over the years that it's a genre of underwater photography which people either love or hate.

How to photograph fish

One piece of advice given to me several years ago by a renowned underwater photographer has had a profound influence on my approach to fish portraits:

> You must endeavour to show the animal or character you wish to photograph, you must get personal with your subject, as if to develop an almost silent rapport. Be concerned with making its very essence and personality jump out of the piece of film and on to the printed page.

Over the years, I have come to understand this advice more and more. I can best explain the concept by comparing similarities between land and underwater photography.

Consider a photograph taken for your passport – an unflattering picture taken for identification purposes only. Take a walk down the high street, pop into a photographer's studio and study the portraits displayed. With the advantages of quality optics, studio lighting and so on, the studio photographer has the means to cajole expression and attitude from subjects. Apply this concept underwater. The side view of a fish, though well lit, often looks static and flat, with very little impact. This type of picture is ideal for identification purposes, but not much else.

The alternative is the animal portrait – an image approached and captured in such a way as to breathe life and character into the subject. To appreciate this concept in a positive way is the secret of success. The photographer sees the subject and is able to apply his or her own set of principles. Certain techniques, however, can help you to achieve your goal.

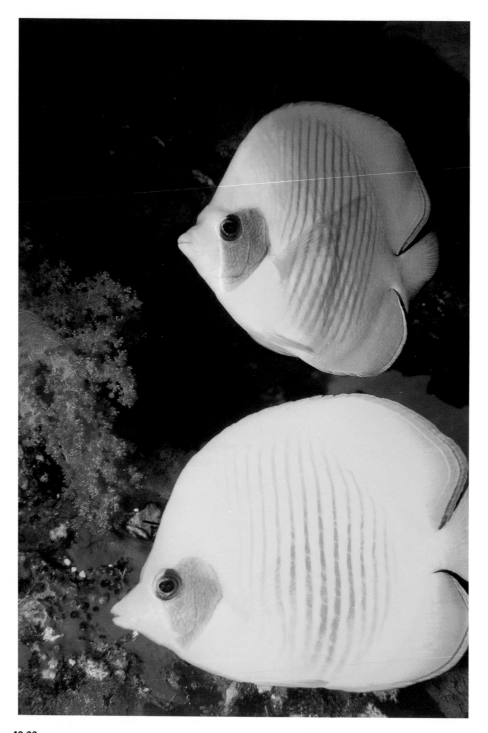

Figure 42.33
This pair of lemon butterfly fish allowed me into close proximity. I was intent to get below and separate their body shapes from each other. I continually moved my housing from one format into another. My Ikelite flash gun was close to the camera housing.

Olympus 5060 compact, f6 at 1/200 s in manual exposure mode.

The approach

Every specialist book, without exception, will strongly advise the underwater photographer not to chase after fish. We all know this advice is sound, but we have all been guilty of it – and often knowingly so. It should be stressed yet again that it serves no purpose whatsoever other than to frustrate and exhaust the photographer – not to mention the subject.

As soon as you see a potential subject (such as a fish), stop and consider the following:

- The location of the subject
- The image you would like to obtain
- Possible lighting angles
- Your angle of approach.

Remember that you are invading the fish's territory, and so your approach should be very gradual. If possible, stand back and observe its routine. To obtain that better picture you need to anticipate behaviour. This can only occur over a period of time and requires a good deal of patience. If a subject does something interesting once, it will do it again provided that it is at ease with your intrusion into its territory. It's this behaviour that will help to capture a creature's personality, and make it stand out as a special picture. The 'peak of the action' may be a fraction of a second, a moment to anticipate that point of interest in order to turn a good picture into a brilliant one.

Where possible, camera and flash adjustments should be made prior to your approach to avoid, as far as possible, frightening the creature away. If this does occur, don't chase it – it's tempting, but it won't work. Given time, the creature will return and, once familiar with your presence, may provide you with the opportunity you require.

Various books describe how fish pictures should 'speak to you'. They should be face to face, close, and looking at the eyes and mouth. Applying the rules of conversation, you don't talk to a person while looking down or looking at the back of their heads. So why do it to a fish?!

The eyes

In any portrait, if the eyes of the subject are visible then that is what the viewer will see first. The eyes must be pin-sharp, or the image will fail. Try to achieve sharpness in features in front of the eyes, such as the mouth. The depth of field usually takes care of this aspect of the picture. It matters not that features behind the eyes are soft, as long as the eye is sharp!

A camera angle of 45 degrees looking towards the face from beneath the subject shooting upwards is often recommended.

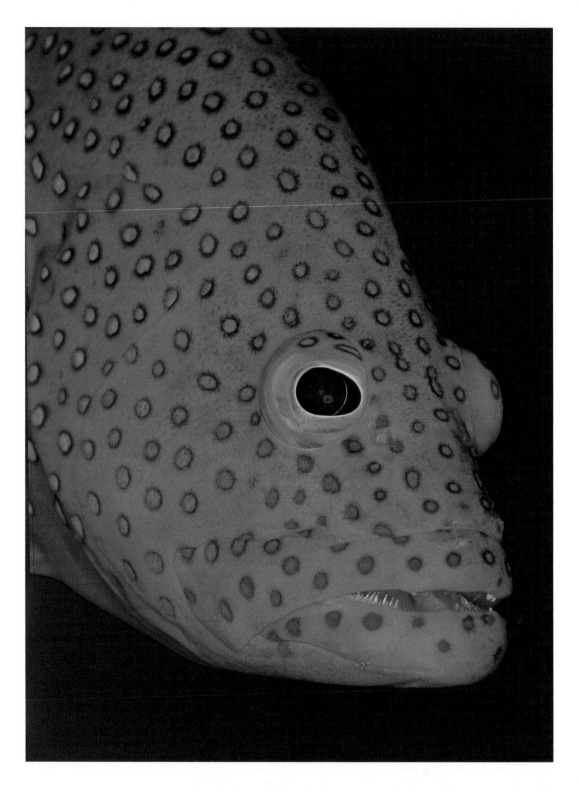

Figure 42.34 (Opposite page)
I used a Nikon F100 with 105-mm macro lens, Fugi Velvia and a Sullivan–Edge ring-flash. I was in manual exposure mode at f16 at 1/125 s. My focus selector was on S (servo). The centre portion of the viewfinder was active. The grouper was hanging about inside a crevice; he appeared very comfortable with my presence and, instead of swimming away like they often do when you get too close, this one seemed curious. I'm sure the unobtrusive presence of the ring-flash allowed me to get this close. I focused midway between the eye and mouth. It's a trick I use often, to maximise the depth of field. My intention was render the mouth sharp with the front portion of my depth of field and the eye with the rear portion. Would f16 provide enough depth of field to get away with this? (You never know until your film is processed.) I took about ten shots, varying the composition and focal point, and my eye never left the viewfinder. I was searching for just a hint of recognition, of personality – a nod of the head, a casual look in my direction. I pressed the shutter each time I sensed a casual rapport with my subject.

Velvia emulsion saturated its colour, my shutter speed of 1/125 s excluded any possibility of natural light, and the f16 aperture provided sufficient depth of field to achieve pin-sharp focus throughout its expression. For every thirty coral groupers that I encounter, I guess that no more than one or two will allow me into their comfort zone in this way. In developing your underwater photography, it's so important to recognise an opportunity when it is presented to you.

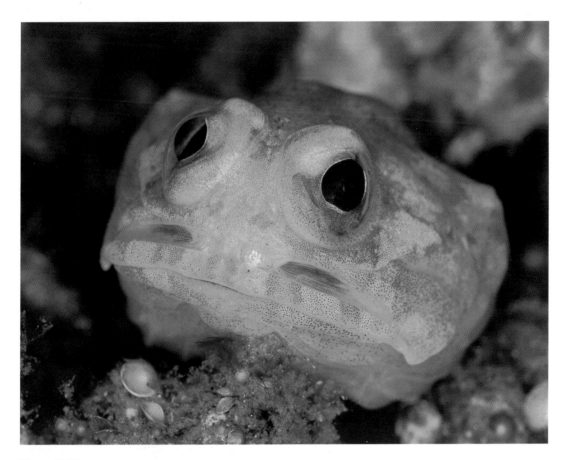

Figure 42.35
On this particular trip I was looking to photograph jaw fish with my 200-mm macro lens to achieve a pastel blurred background. However, I seemed to find them when I was using an alternative lens. In this example, I have positioned my housing as close to the sand as possible to achieve an eye-level composition. I moved around the subject to decide on the profile, and chose head-on or at 45 degrees. It all depends on the position of the eyes.

Nikon F100 with 105-mm macro lens with a +4 Nikon dioptre, f16 at 1/125 s.

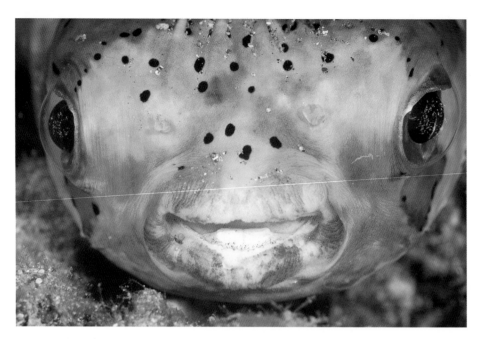

Figure 42.36
Unlike many other fish, if you adopt a frontal angle on puffer you will see that both eyes are visible and pointing forward. The peak of the action is when they revolve their eye sockets and look directly at the camera. This provides strong eye contact and impact. Notice the compositional format and the eye-level angle of view. My housing was on the sand. By using a 200-mm lens (300-mm, taking into account the digital conversion), the puffer fish is unaware of my presence and totally at ease.

Nikon D100 with 200-mm lens, two Inon X220s each side of the macro port pointing outwards towards the side of the puffer fish, *f*11 at 1/180 s.

This is a general rule and works well but, after a fair amount of practice, I believe that every fish has a definitive angle of view that provides the potential for a great shot. Given unlimited time, you could explore these angles to your ultimate satisfaction.

Occasionally, when looking at a co-operative specimen through the viewfinder and thinking that you have obtained the correct angle, a slight deviation or perhaps a movement of its head will jump out as being just right – but actually capturing that moment can be very challenging!

Lighting angles

Most of the time I use two flash guns positioned each side of the camera housing. These angles frequently change, according to the subject's shape and features; however, I always attempt to achieve a catch light in the eye. This can make a tremendous difference in a portrait, as opposed to a lifeless eye which blends into the head. As mentioned already, a fish picture should 'speak to you'. When people speak they open their mouth, and a fish elongating its jaws or opening its mouth (however slight) may be

Figure 42.37
A typical lighting set-up when shooting fish. Two small flash guns are on each side of the port, with a flexible flash arm system which enables alternative positioning in an instant.

that 'peak of the action' that you've been waiting so patiently for. If you can illuminate the mouth, then the picture really begins to talk and you can appreciate the tremendous photographic potential you have before you.

As your photography progresses, you should begin to consider your bracketing technique in relation to the potential of your subject – is it worth three or four shots, or even an entire memory card? The choice is yours. And remember – there are several ways of bracketing, not just by adjusting the flash as many think. You can bracket on the basis of flash distance, flash angle, choice of sharpest focus, angle of view, composition and even in anticipation of the peak of the action. If you are using a film camera with limited exposures, you have to consider whether the subject you have selected is worth it or not.

Moving subjects

Moving subjects, such as sharks, mantas and others like them, are a different consideration. It would be naïve to suggest that you should observe a shark swimming past in the hope that it will turn around and re-perform – it won't! So this type of shot needs to be thought out very quickly – set your aperture, preset your focus and anticipate its direction of travel. If possible, position yourself on line and hope that other divers don't spook it. Panning is a technique that can be employed in these circumstances – following your subject's movement with the camera and pressing the shutter while the camera is still moving. This creates a blurred background, but captures the creature in sharp focus.

Lenses for fish photography

Macro lenses in the 50-mm–60-mm region are ideal for fish, as digitally they equate to 75-mm and 90-mm respectively. This

short telephoto has gained increased popularity over the 105-mm macro. My choice is my Nikon digital SLR in a housing together with a 60-mm macro lens (equates to 90-mm on digital) behind a flat port. My 105-mm macro lens, which converts to 150-mm, is now a little too long for fish pictures and seldom gets used. For larger subjects I use my Nikon 17-mm–35-mm zoom lens, and with digital my Nikon 12-mm–24-mm zoom. This allows me to get as close as physically possible to the subject. If I used an equivalent 90-mm, I would have to back off too far to get a composition with the entire fish in the frame.

Every aspect of fish photography requires persistence and, most of all, a lot of patience. Always consider the potential of the subject, and be prepared to spend time in getting the image you want. It's important that you have your own standard of excellence and an idea of what a good picture should be, and keep trying until your work begins to match up to it.

In conclusion

The American photographer, Avedon, once wrote: 'A portrait is a photograph of a person who knows they are being photographed'. Apply this concept underwater. You will see many stunning fish pictures that reflect this attitude. Catch the mouth open and illuminate the eye with a catch-light, and you could have a winner!

The underwater photographer at night

Night photo dives are popular amongst underwater photographers. The night has its own special appeal, with the creatures that are never seen during daylight and those that are found making their homes for the night after the business of the day.

As the sun gets lower, the water is reduced to shades of blue until it turns to midnight blue and then blackness. We see this darkness much the same as a lens stopped down to $f22$ would record it. Visualisation becomes easier. The need to imagine the clear blue water recorded at $f22$ as black is gone – it's there for us already.

Subjects exactly as you see them

Subjects are found at the end of your torch beam, and for once they are dressed in their true colours of red, orange and green. There is no confusion as to what colour a species of soft coral will record. There's no advantage to looking beyond the length and width of your torch beam in case of sharks parading out in the blue. Subjects at night can be recorded exactly as you perceive them.

A light attached to your flash is essential in modelling the quality of light you wish to achieve on your subject. There is no better place to learn than in the sea at night, experimenting with colourful subjects and various angles of flash.

Keep to one site

Don't be tempted to cover too much ground at night. Become familiar with a particular site and learn to work around a small area. You will soon begin to see the wealth of marine life that

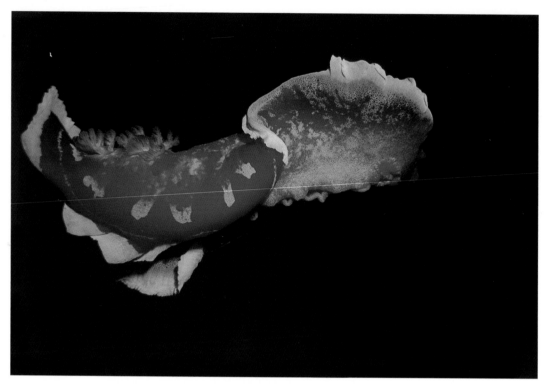

Figure 42.38
During night dives I always try to photograph those creatures not normally seen during the day. This Spanish dancer is an example. I have seen very few in my time, and none during daylight hours.
 Nikon F90x with 60-mm macro lens, one Sea & Sea YS 120 flash gun on TTL, *f*11 at 1/125 s. Sulawesi.

Figure 42.39
There are many torch brackets on the market that are ideal for night-time photography.

abounds. Keep your photography as simple as possible, and remove any unnecessary items of bulky equipment.

Dive with another photographer or a buddy who knows what you're trying to achieve. In a perfect world the ideal photo buddy

is a spotter – one who leads the dive and so manages depths, dive times and direction for both of you, and who swims a little way ahead to find suitable subjects for you to consider.

Use additional signals

It's essential that, whoever you buddy up with, you have a set of hand signals for communication (in addition to standard diving signals). Both of you should also be aware of each other's lens choice and objectives.

Many creatures of the night have photophobia – they retreat from any hint of light. You will learn which species of coral and other marine life are susceptible. I tend to view such subjects with the very outside edge of my modelling light; I also insert a piece of red gel around the bulb in my Q-lite.

Consider the environment

Consideration of the environment continues to be vitally important when taking photographs at night, particularly regarding your own well-being. When you kneel on the sand to adjust your equipment, do look out for urchins – many a photographer has had a spine or two through their knee or backside.

Subjects

I have had a great deal of success with my own night-time photography by working near the surface. Here, numerous creatures are attracted by lights – moonlight, for instance, or dive lights.

Squid, lion fish and cuttlefish are all to be found just beneath the surface of the water. Don't ignore a coral outcrop in an expanse of sand. Creatures will take refuge wherever they choose, so many subjects can be found dozing on the sand.

Good subjects to shoot at night include:

- Parrot fish – close-up and abstract
- Small marine life on corals
- Shrimps
- Small blennies
- Squid
- Crabs
- Fish portraits and profiles
- Other obvious nocturnal subjects that are not usually around in the daytime.

There are so many subjects that can be successfully photographed during the day. The *potential* of night-time photographic opportunities should be saved for those creatures that are too skittish at any other time, and for things that you never see in daylight.

Figure 42.40
Beneath Bonaire's town pier at night,
you can easily find these corals as long
as 4–6 cm. They stand out from the
pillars, and I know of no other place in
the world where they are so intact and
can be photographed so easily. This
was a last-minute idea using the top
off a black bleach bottle as a snoot to
give me a beam of flashlight no wider
than a fifty pence piece. I lit the
background with a second flash on
manual power at a distance from the
corals to underexpose it.

Nikon F90x with a 105-mm macro
lens, Subal housing.

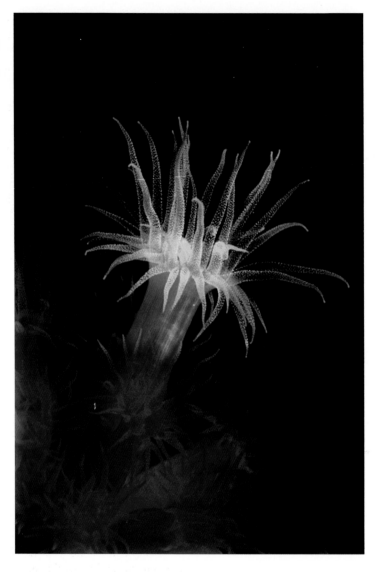

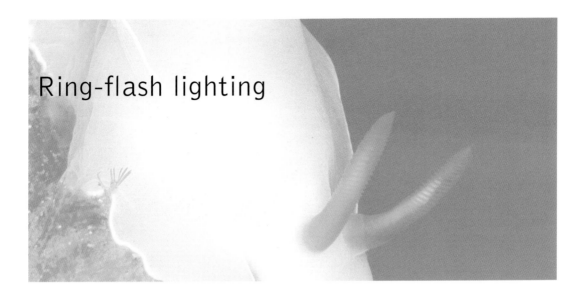

Ring-flash lighting

If you are familiar with my previous books then you will know that I have a liking for ring-flash units when it comes to close-up and macro. They were originally designed for shadow-free shooting of hollows and crevices at close range. Included in that subject matter are medical applications and macro work in nature photography, and to that end ring-flash units have been used in surgical and topside macro photography.

A ring-flash does just what its name implies, encircling the camera lens with a flash tube so that the light is projected forward from the camera. What struck me initially is its ease of use. In the absence of flash arms and flash guns protruding from the housing, it is far easier to approach small marine life. I can honestly say how little I appreciated the impact that attachments to the rig (flash arms and flash guns) have on the photographer's ability to stalk a subject at close range.

With the absence of flash arms and guns it has become a much easier task to get closer to subjects situated in cavities without running the risk of damaging the reef. Before, these cavities placed the subjects in shadow and when using film you never really fully appreciated how hidden in shadows the subjects were until you got to see your developed results.

There are several advantages the ring-flash has over traditional lighting:

- The photographer can rest assured that the light source is not going to miss the subject.

Figure 42.41
The underwater photographer can get so much closer to shy and timid animals when using ring-flash.

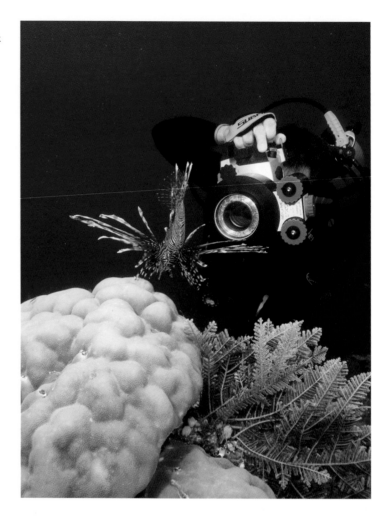

- The flash position remains constant as the magnification of the subjects changes – for example, 1 : 1 ratio (life-size), 1 : 3 ratio (one-third life-size). Choosing the correct aperture for the ring-flash therefore becomes a simple routine.
- The photographer is free to concentrate on composition, secure in the knowledge that flash arms and guns are not damaging the reef.

Exposures

With a digital Nikon SLR D100, I currently use a low-powered ring-flash with just one manual power setting. This provides correct exposures of subjects of 1 : 1 (life-size) at f22. When I need to back off, I open the aperture to compensate for the increase in distance.

Figure 42.42
In recent years I have often attached a small slave to the housing to provide side or top light to the subject.

The disadvantages

The disadvantages of using ring-flash are very subjective. Some photographers dislike the type of light it produces, while others adore it. Ring-flash light tends to shorten and reduce the appearance of shadows. No matter what distance the subject is from the background (if the size of the aperture allows the background to be illuminated), the shadow of the subject falls immediately behind it.

Scatter is a disadvantage, but in my experience it only becomes evident beyond a port to subject distance of approximately 90 cm. This fact astounded me when I first used the technique. I was sure that the ring-flash would be flawed through scatter beyond 30 cm, and it was astonishing that backscatter was absent to this extent.

Conclusion

Shooting a ring-flash port to subject distance of more than 90 cm becomes impractical and the quality of the image becomes inferior.

Figure 42.43
This fire worm has been lit by the ring-flash with an additional degree of back lighting from a small Sea & Sea YS30 slave flash positioned over the subject and outwards.
Nikon D100 with 60-mm macro lens, *f*32 at 1/180 s.

Figure 42.44
The typical lighting effect of ring-flash makes this nudibranch glow from within.
 Nikon F100 with 105-mm macro lens with +4 Nikon 4T dioptre, *f*22 at 1/125 s.

The crucial question you must ask yourself is, do I like the quality of light that a ring-flash produces? If the answer is yes, then consider it for the future.

Author's note: There are numerous images throughout the book taken with ring-flash (see the captions). At the time of writing, details of ring-flash ports can be obtained from Photo Ocean Products (UK), details of which can be found in 'Equipment suppliers and useful addresses' at the back of this book.

43 Wide-angle photography

Introduction to wide-angle photography

Wide angle lenses are capable of focusing very close, but they are not a close-up lens.

It's a toss up between the two most popular topics of underwater photography. On one side there is close-up and macro; on the other side, wide-angle. The memories of being there in the midst of it all can be brought to life even more through wide-angle photography. That may be the reason why wide-angle photography is probably the most popular form of underwater photography today. Images of divers interacting with marine life or entering a huge, intact shipwreck are the stuff dreams are made of.

Why such wide lenses?

Again, it cannot be stressed enough that, to take good underwater pictures, you must eliminate the column of water between the subject and the lens. Wide-angle photography does this to maximum effect. By reducing the distance, you reduce the amount of suspended particles (and other unwanted problems) in the water. The advantage of wide-angle is the lenses themselves. They are all capable of focusing very close. This allows you to get close to the subject and reduce the column of water, but still include much larger subjects within the frame.

Preferable lenses

With the reduced sensor size of digital cameras and the 1.5 magnification factor, up until 2003 we had lost a wide-angle capability. The popular 16-mm fisheye lens and the 20-mm wide-angle became 24-mm and 30-mm lenses respectively, and generally

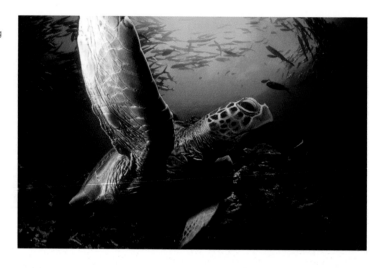

unsuitable to achieve true wide-angles. This has been rectified, and true wide-angle lenses are now available from leading lens manufactures.

For digital SLRs, consider the 10.5-mm fisheye lens and the 12-mm–24-mm wide-angle zoom or other models in that range. For film, the 16-mm fisheye is equivalent to the 10.5-mm, and the 17-mm–35-mm zoom equates to the 12-mm–24-mm range. Nikon, Canon, Sigma and Tamron all produce excellent optics, but before you purchase, satisfy yourself that it is the lens for you. Technical reviews on the Internet can be found at www. wetpixel.com and www.digideep.com.

Also, contact your local underwater photo retail outlet for further advice regarding wide-angle ports, gears, dioptres, and the availability of add-on lenses for digital compacts.

Perspective distortion

When using wide-angle lenses, the relative size of subjects near and far is distorted. Nearer subjects appear to be larger and closer than they really are, and more distant subjects appear to be smaller and much further away. Wide-angle lenses do, in effect, increase the appearance and scale of underwater visibility because the background appears to be more distant. This can be used effectively to create huge fissures in areas where they don't exist – for instance, using a small gap as a surround for a distant diver or seascape gives the impression of a huge hole which frames the distant reef. Again, when photographing divers interacting with marine life, by composing the fish closer to the lens than is the diver you can achieve a dramatic impression of a subject greatly oversized in proportion to the diver in the background.

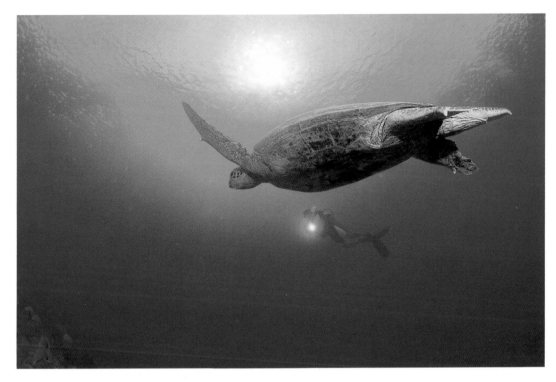

Figure 43.2
The turtle was no more than 0.3 m from the lens. The diver looks to be in the distance, but in reality he was no more than 3 m away.

Depth of field

Apart from the ability to use the above technique to dramatic effect, there is another element of wide-angle underwater photography that offers a tremendous advantage over land photography. This is all to do with depth of field.

The wider the angle of the lens, the greater the depth of field. This increase is so marked that with a full frame fisheye lens of 16 mm or less, when the lens is focused at 1 m, for instance, it will be in focus from 0.5 m to infinity at $f8$. When you shoot up towards the surface, apertures of $f11$ and $f16$ can often be indicated which almost eliminate the need to focus.

Using fisheye lenses

Super fisheye ports are available for all makes of housings, and many underwater photographers use the fisheye as their first wide-angle lens. It does have some disadvantages, and potential buyers should know that a fisheye lens can sometimes be just too wide for many wide-angle subjects. Think of it as a specialist lens that becomes a distinct advantage with certain types of wide-angle

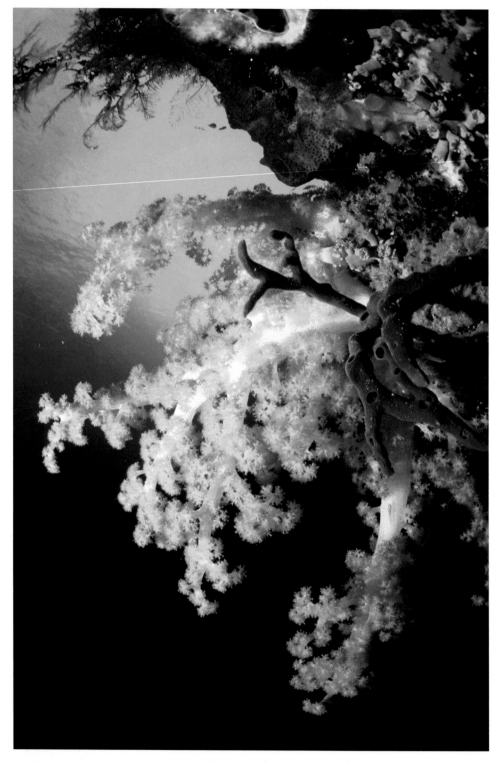

Figure 43.3
Being able to get close to subjects results in vibrant colours that are sharp and clearly defined.

subjects. Wreck photography and seascapes are good examples, together with large schools of fish and other larger creatures that you anticipate being able to get close to. That is the key to choosing to take down a fisheye lens – 'being able to get close to'. If you cannot get physically close, the resulting subject may look very small within the frame.

So why use fisheye lenses at all?
Why not just back off a metre or so and shoot the same scene through the viewfinder of a 12-mm–24-mm zoom?

A fisheye lens reduces this column of water more effectively than does any other wide-angle lens. As a result, the subject is comprehensively saturated with colour and silhouettes are sharper and more clearly defined.

Because of the inherent bending of straight lines, the capability of 'seeing' an amazing 170 degrees and sometimes more makes this lens uniquely artistic and creative. In land photography these gross distortions are a disadvantage because of the many straight lines in man-made structures. Underwater, however, nature has blessed us with curves and spheres. The only straight lines we encounter are generally human intrusions such as shipwrecks and divers. By anticipating the disadvantages and using this lens wisely, the underwater photographer has a uniquely powerful and artistic tool.

Learning to 'see'

For most of the year, the majority of underwater photographers indulge their passion from the comfort of their armchair, enhancing digital files in Photoshop and printing for competitions. We get accustomed to seeing underwater images in a variety of different colours. We all do it; it's human nature! However, the underwater world is not like that in reality. We may see the colour of corals at the end of a torch beam or in the fraction of a second it takes a burst of flash to illuminate a subject, but otherwise we see the underwater world in different shades of blue, grey and green!

I have witnessed some underwater photographers becoming quite depressed during the first few dives of their photo trip when the colour, clarity and saturation of their pictures back home seem just an illusion! When the facemask dips below the surface during the first day's check-out dive, the reality is those familiar shades of blue and grey!

Digital users have a distinct advantage over film users in this respect. They no longer have to imagine the colours of red, orange and purple! It is instant feedback for them – it takes just the time required to write the image to the memory card.

Figure 43.4
Before digital it was so easy to neglect vibrant colours, but with immediate feedback users can take a 'Polaroid snap' to check for colour. At depth, red appears to the eye as a dark, muted green colour.

Looking and seeing

What about learning to anticipate or 'see' what may be recorded on digital in the first place? It is not always easy, given the extreme distortive effect of the fisheye lens. However, successful photographers have developed the ability to 'see in pictures'. They may stop and examine a formation of coral and view the scene with a completely different perspective than their buddy, who may be photographically blind to the creative opportunities that are all around. This type of photographer has all the latest equipment, all the technical 'know-how' and all the enthusiasm, but lacks that underwater inner eye so essential in recognising a subject's potential in the first place.

I have buddied with photographers who swim over glorious opportunities because the corals do not appear to their eye to justify so much as a second glance! I work with them to develop this aspect of their learning more than any other part. If only they could view the scene through the wide-angle viewfinder in their 'inner eye' and take a moment to visualise how things may be recorded, they would discover a wealth of possibilities right under their nose.

Wide-angle lighting

Wide-angles are lit from two sources; natural light, and artificial light from our flash guns. Lighting is a huge subject, and for this reason is discussed extensively in Chapter 41.

Wide-angle tips

- Get close to the subject – this is the most important tip for wide-angle photographers. On your next trip experiment for one day and, no matter what equipment you are using, try to get so close that the subject is bursting out of the viewfinder. When you view your results, you are likely to find that your distance is just right.
- Ensure that you shoot upwards towards the surface. Whilst there are a few exceptions, shooting down on a subject will almost certainly produce a flat result with little contrast.
- When the sun is low on the horizon, try swimming in that direction. It is an effective way to 'see' in pictures more easily, when the spark of sunlight is in view.
- Always fire off a flash exposure before you enter the water. If your flash fails to fire or the camera malfunctions, you have a chance to fix it before you get wet.
- Before you enter the water, set your aperture to ƒ8 and your focus distance to about 1 m. Turn your flash on and position it to strike a subject about 1 m away from the lens. The reason for this is that within seconds of entering the water you will often see opportunities that would make excellent images. Be prepared for them! Being set at ƒ8 at 1 m will provide you with the best possible chance of getting a quick result in a hurry.
- The four corners of a 35-mm photo frame are the widest area of your image. Should you position your flash gun(s) at an angle of 45 degrees, be aware that they may be visible in the photograph. If you use a fisheye dome port without shade construction in the corners, stray light from your flash gun can often invade this space. (*Note:* Shade constructions are absent on the majority of fisheye ports for this reason – that they would show in the finished photograph.)
- Film users should take a dive-light down on photo dives in order to check the true colour of subjects. Play a game, trying to guess the colour, before turning your dive light on. In this way you will begin to sense the colours that to the eye appear drab and muted.
- Digital users should take a Polaroid snap to check out the colour and condition of subjects before they compose for real.
- If you feel a little obsessive in your quest for technical perfection, try to let go of it somewhat. If your results are not to your standard, it may be that your preoccupation with the technical aspects is getting in your way. I often find that this will cloud any artistic ability. Learn it on land and then trust it underwater. This will make room for increasing the amount of thought and creativeness regarding the image itself.
- Digital users should learn to use the histogram to determine correct exposure. If the ambient light is incorrect, then alter the camera settings. If the flash exposure is incorrect, then alter the flash power settings.
- Of all the subjects we see underwater, 70 per cent are unphotographable because of their location on the reef. If you cannot get to it without fear of harm, then move on and find something located in an easier position.

Dome port theory

A misunderstood feature of an underwater camera housing is the lens port. There are two kinds: a flat port often associated with macro and close-up, and a dome port associated with wide-angle and fisheye underwater photography. Both have their place, and it is necessary to know some of the theory and practice of each. For underwater photography with wide lenses, the dome port is the first choice. If you intend to shoot a close-up or macro picture, then a flat port should be used. The cut-off focal length of the lens usable with a dome port is said to be 35 mm (on 35-mm format).

Flat ports

A flat port is unable to correct for the distortion produced by the differences between the indexes of light refraction in air and water. Using a flat port introduces a number of aberrations when used underwater. They are:

- *Refraction*. This is the bending of light waves as they pass through different mediums of optical density (air inside the camera housing and the water outside the lens port). Light is refracted by 25 per cent, causing the lens to undergo the same magnification you would see through a dive mask. Thereby, the focal length of your lens also increases by approximately 25 per cent.
- *Radial distortion*. Flat ports do not distort light rays equally, so they have a progressive radial distortion that becomes more obvious as wider lenses are used. The effect is a progressive

blur, which increases with large apertures on wide lenses. Light rays passing through the centre of the port are not affected because their direction of travel is at right angles to the water–air interface of the port.

- *Chromatic aberration.* White light, when refracted, is separated into the colour spectrum. Colours of white light do not travel at the same speed, and light rays passing from water to glass to air will be unequally bent. When light separates into its component colours the different colours slightly overlap, causing a loss of sharpness and colour saturation, which is more noticeable with wider lenses. In essence, flat ports do not 'do' wide-angle!

Dome ports

The dome port considerably reduces the problems of refraction, radial distortion and chromatic aberrations. A dome port is a concentric lens that in effect acts as an extra optical element to the camera lens. In very simplistic terms, for a dome port to work correctly it has to be positioned precisely in relation to the camera lens. Reputable housing and port manufacturers take the data from lens manufacturers and design the curvature of their dome ports with these data in mind.

Virtual image
A dome port acts as a concave lens, and underwater this produces an effect known as a 'virtual image'. A virtual image is one that has the optical appearance of seeming closer to the lens

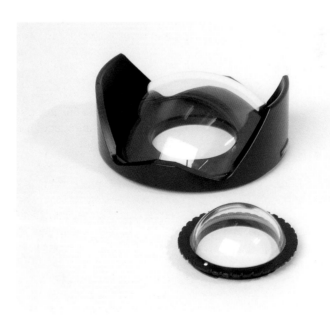

Figure 43.5

than it really is. Consequently, the lens is focused not on the actual subject but on the virtual image – which, depending on the curvature of the dome, will be probably less than 0.5 m from the dome. This water distance of virtual image to dome is treated as though it is an actual lens to subject distance, and it is essential that the lens on the camera is capable of focusing at these short distances.

Dioptres

If the lens is unable to focus at these short distances, the solution is to use a positive close-up filter commonly known as a dioptre. The correct dioptre restores the close focusing capabilities of the wide-angle lens, allowing it to focus on the virtual image. My advice is to consult your underwater photographic retailer, who will advise you on the correct combination of wide-angle dome port and + dioptre to use with a particular make of camera housing and lens focal length.

In summary

- In general, lenses from 35 mm and above can be used with flat ports as the aberrations and distortions are not too much of a problem.
- Lenses from 20 mm–35 mm should be used behind compact dome ports with the use of close-up dioptres.
- Ultra wide-angle lenses require large diameter dome ports in view of their ultra wide angle of view. For sharpness, the fisheye

Figure 43.6

lenses are excellent by virtue of their huge depth of field, which achieve sharpness throughout the picture.

- Zoom lenses can be a problem, as they often span the focal lengths of what is suitable for a flat or dome port. Again, consult your housing retailer on this.

If you would like to investigate the science of dome port theory, I recommend you visit the Wetpixel underwater digital photo website at the following address: www.wetpixel.com/i.php/full/dome-theory.

Balanced-light wide-angle photography

One very effective and popular technique in underwater photography is to balance and blend the natural light falling on a reef with light from a flash gun. You record the background in much the same way that your eye sees it, which gives the picture a tremendous sense of depth in an almost three-dimensional way. Using your flash gun, you simply paint in the foreground colour. Land photographers refer to this technique as 'fill-in flash', but I much preferred Jacques Cousteau's quotation of 'painting with light using kiss of flash'.

Digital cameras and manual multipowered flash guns have simplified the technique no end:

- Choose a foreground subject that has good negative space to include the water column.
- Take an exposure off the water column and set your aperture.
- Take a snap (a Polaroid) and then check your histogram to ensure the natural light exposure of the water colour is correct. If not, you may wish to adjust your combination of aperture and shutter speed.
- Set your flash gun to a power setting that you believe will be correct for the chosen aperture. Focus, compose and shoot. Check the LCD, check the histogram. You may now have some decisions to make.
- If the flash exposure on the subject is too dark or too bright, then increase or decrease the flash power setting first (remember that shutter speed does not affect flash exposure whatsoever).
- If the exposure on the background is incorrect, then increase or decrease your aperture or shutter speed.

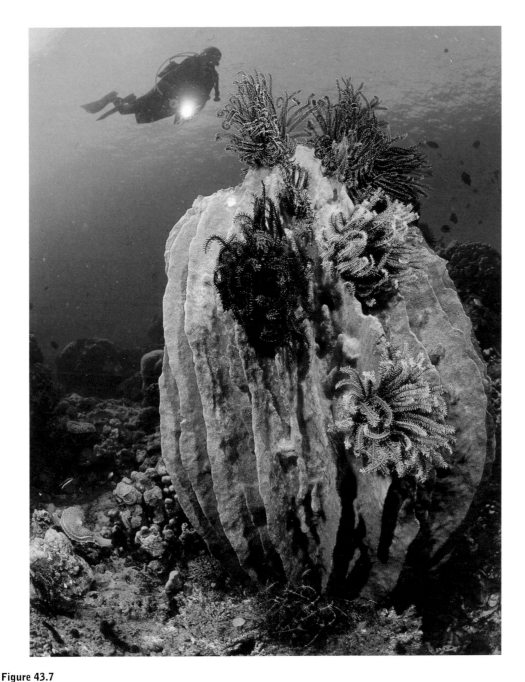

Figure 43.7
This balanced-light seascape was shot on film in PNG for a travel brochure cover. I chose a subject that I believed was colourful and easily accessible. The sun is just out of the frame. This was a conscious decision, with the purpose of decreasing the contrast between the sunlight and the shadow area in the foreground. I took at least twenty frames to get the correct exposure on the barrel sponge along with a pleasing composition of Jacqui, my model. The idea was to fill in the colours with a natural blue-water background.

Nikon F90x with 16-mm fisheye lens, Subal housing, twin Sea & Sea 120YS flash guns, manual full power on long tripod flash arms, in the region of *f*8 at 1/60s, Chrome 100 ISO.

Figure 43.8
We were caught in the act by my buddy Ken Sullivan. Notice in this shot how close Jacqui is to my lens and the small size of the barrel sponge when compared to the finished picture on page 319.

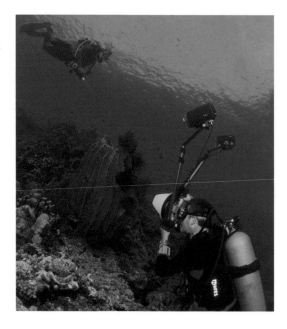

Decision time

Challenges can arise when you become ambitious and choose to include a sunburst or the surface in the background. To expose for the seabed and lower mid-water background at $f5.6$ for instance, may overexpose a large part of the shot if you include a very bright sun, which may only require an exposure of $f16$. A conscious choice is required here. You must either exclude the sunburst and expose at $f5.6$, or include it but reduce your f-stop accordingly. If the background water is reduced to dark blue or black this is no longer balanced natural light, as the flash is the primary source of illumination. With the unlimited frames in a digital camera, try different apertures until you get a compromise that is to your liking.

Digital sunlight

As already mentioned, digital cameras, particularly compacts, do not record highlights that well. Sunbursts and surface highlights are particularly susceptible to overexposure. The key is to increase shutter speeds to freeze the sunbeams, but this is not always possible when the fastest flash sync shutter speed is below 1/250 second. Experiment with your own rig. If it's a problem, then leave the sun out of the frame altogether. If that's not possible because of your angle of view, then try to hide the sun ball out of sight behind the reef or the subject.

Using film and TTL flash

For TTL to work, reflected light from the subject must bounce back to the TTL sensor in the film camera. If you compose a small subject against a blue-water background, the sensor can be fooled into believing that there is nothing reflective within the frame. It will then give out a flash burst at full power in the belief that the subject is far in the distance.

If you have a subject that fills 70 per cent of the frame, TTL is very reliable. If your subject is smaller than that and you have composed it towards the sides of the frame, TTL can be erratic, leading to overexposed images caused by the flash, not the ambient light.

TTL flash distance with film
TTL flash is very consistent, but if it is too close to the subject it cannot quench the light effectively. If the flash is too far away from the subject, it can only provide full output – which may not be enough to achieve correct exposure.

This is consistent with the lenses from 16-mm fisheye range to 28-mm. This distance of latitude is quite forgiving, but if under- or over-flash exposures do occur, be minded that the reason may be simply that your TTL flash was either too close or too far away from your subject.

Rule of thumb for TTL flash distance
Using 100 ISO, a rule of thumb for TTL flash distance is:

- 0.7 m away at $f11$
- 1 m away using $f8$.

These combinations should paint in the colours of the reef quite effectively with most medium-sized flash guns.

I often use Sea & Sea YS 120 flash guns on either TTL or manual. If I select manual half-power setting, it gives accurate exposures at:

- 0.3 m at $f22$
- 0.6 m at $f11$
- 1 m at $f8$
- 1.3 m at $f5.6$
- 1.6 m at $f4$.

Remember that the flash is simply painting in the colours of the reef, whilst our selection of shutter speed and aperture captures the ambient light in the background.

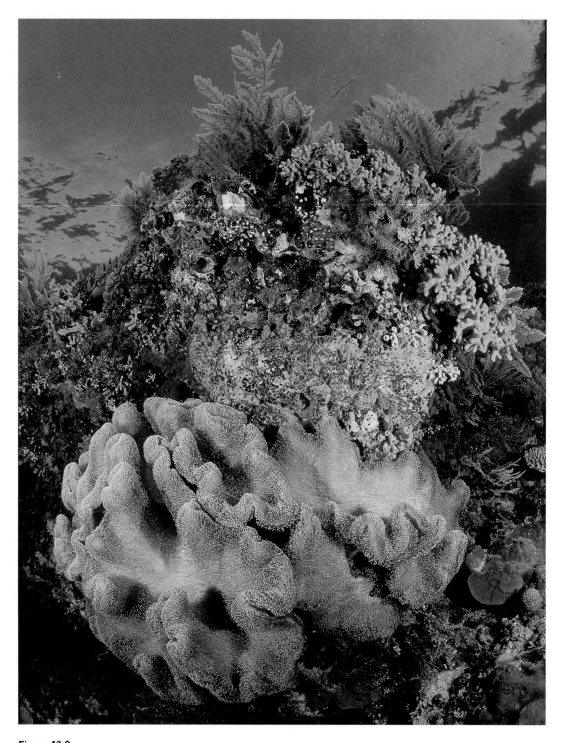

Figure 43.9
This was taken on film in Wakatobi, Sulawesi, very close to the surface. The large coral formation in the foreground is filling the frame, and I chose to use the twin YS 120s on TTL, which provided accurate exposures throughout. I took about four shots, bracketing the aperture to control the colour and exposure of the blue sky visible through the surface.
 Nixon F100 with 16-mm fish eye lens, in the region of f11 at 1/100 s.

Figure 43.10
This was taken in the southern Red Sea with a Nikon D100. I composed the branching soft coral with the sunburst directly behind it to avoid it causing gross overexposure. I chose the colour of blue water by selecting the frame that looked most natural in my LCD review. With those camera settings, I went to work. Using twin Inon flash guns with manual power settings and diffusers, I maintained the same composition but adjusted my flash angles to give an even spread of light. A flash both above and below my dome port, close to the housing but pointing both above and below the coral branch respectively, worked best. f8 at 1/180 s.

Note. For my wide-angle balanced-light shots in blue tropical waters, I consistently find that settings of 1/180 s with f8 or f11 and 200 ISO on my D100 are optimum.

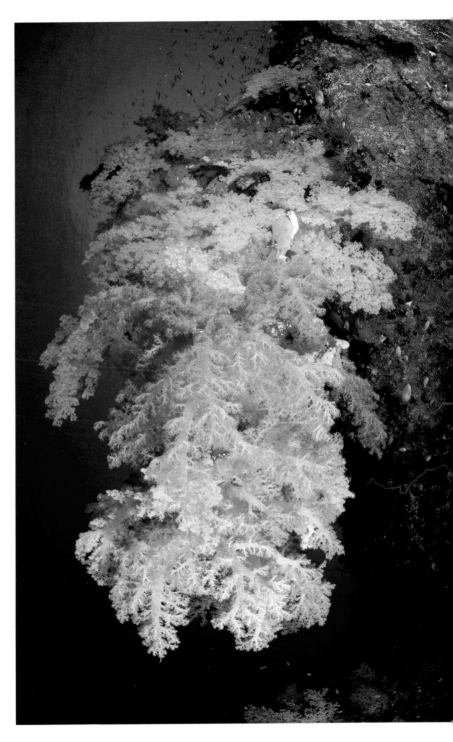

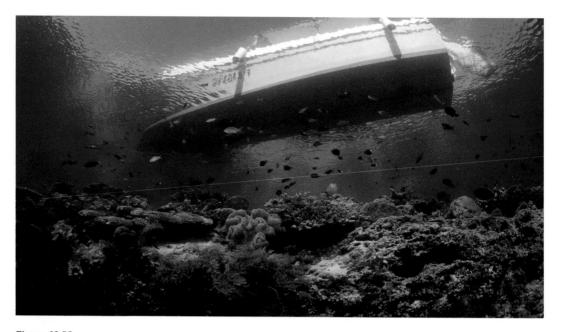

Figure 43.11
'Painting with light using a kiss of flash.' The foreground has had a hint of flash to lift the shadows, whilst the background is made up of the natural light.

Avoid confusion

When using film, be careful not to confuse flash to subject distance with camera to subject distance. Camera to subject distance is irrelevant; it's flash to subject distance that is all important. Adjustable power flash guns can be an advantage, because you adjust your flash power in relation to your chosen distance in the same way a digital user would. However, digital users have the advantage of being able to see instantly if the exposure has worked or not; film users don't.

If you continue to use film, ascertaining your gun's full capabilities and limitations by various tests is by far the most satisfactory method.

As with countless aspects of photography, it is a conscious choice you must make yourself. Give yourself time for these balanced light techniques to sink in. Experiment with them and amend the rules. Once you understand and have mastered the basic concept, it will provide your photographs with much more impact and appeal.

Close-focus wide-angle photography

Close-focus wide-angle photographs seem to be the ones every aspiring photographer wants to take. Images created in this way are perhaps the most dramatic, creative and popular taken underwater.

The secret, as the name suggests, is to select and focus on the foreground subject with perhaps a diver hanging out in the blue water with sunbeams piercing the surface behind. By taking advantage of the extreme depth of field that wide-angle lenses provide, you are able to capture all the elements in focus at the same time.

What is essential is to balance the exposures of the natural light and the light from the flash, then select an aperture of $f11$, $f16$ or $f22$ in order to retain the required depth of field. In order to achieve this small aperture, you simple shoot upwards toward the lighter regions.

To take your picture:

- Select the foreground subject, such as a fan or soft coral, which you can photograph at such an upward angle.
- To achieve the correct exposure with your digital camera and flash, set a shutter speed of between 1/125 and 1/250 second. Point upwards, where you will achieve apertures with the best depth of field.
- With digital SLRs, the aesthetic appearance of the sun can be significantly improved by using faster shutter speeds.
- Position your flash gun(s) and select an appropriate power setting.
- Compose, take the shot, and review the histogram.

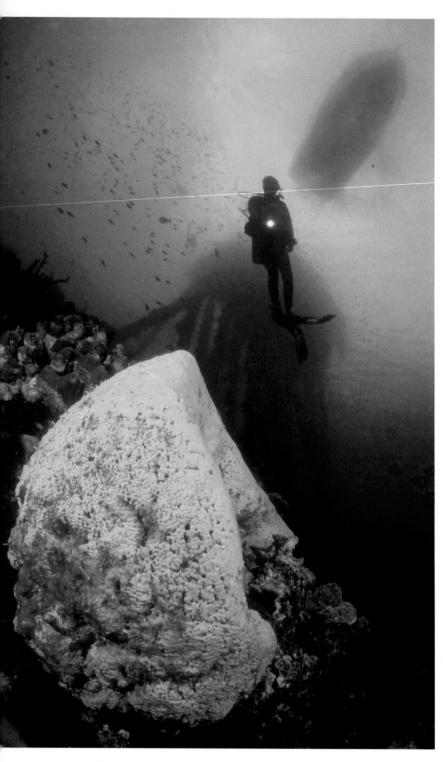

Figure 43.12
This was taken on the seaward side of Salt Pier, Bonaire, looking straight up towards the surface. I found the outstanding negative space earlier in the day, as the dive boat had been fixed to the pier. My search was to find something to put into it. I found the orange sponge quite easily; it was the best sponge of four in the immediate vicinity. I took two spot meter readings, one towards the surface near to where the boat was. This indicated f16 at 1/60 s with 100 ISO slide film. The second reading was towards the structures of the pier, and indicated f8. I chose a shutter speed of 1/60 s because there was nothing moving in the picture that required anything faster. I introduced Sylvia into the frame, equipped with a Kowalski dive light. This added yet another layer. Notice how these layers do not overlap, except for the diver over the background pier. I took about twelve shots, six with the diver and six without. I bracketed my apertures between the light-meter indications of f8 and f11–f16. From my results, I know that the image above was f11 at 1/60 s using full power settings on both Sea & Sea 120 flash guns.
Nikon F90x with 17-mm–35-mm zoom wide-angle lens.

Figure 43.13 (Opposite page)
The red fan coral was meant as the foreground focal point, but when I saw the shot for the first time on the laptop I realised that the yellow hard corals at the bottom added an extra layer of depth perspective (totally accidental – never noticed it at the time!). The eye is drawn to the background, in particular the dive light, which returns the eye back into the foreground. All elements are in sharp focus due to the small aperture of f11 at 1/125 s. Notice the composition. The background reef and diver are strong diagonals. The foreground fan is diagonally orientated in the opposite direction. Squint your eyes and you have an X shape. I intentionally tilted the reef, but I never noticed the diver swimming through the frame until I reviewed the LCD.
Nikon D100 with 10.5-mm fisheye lens, twin Inon Z220s.

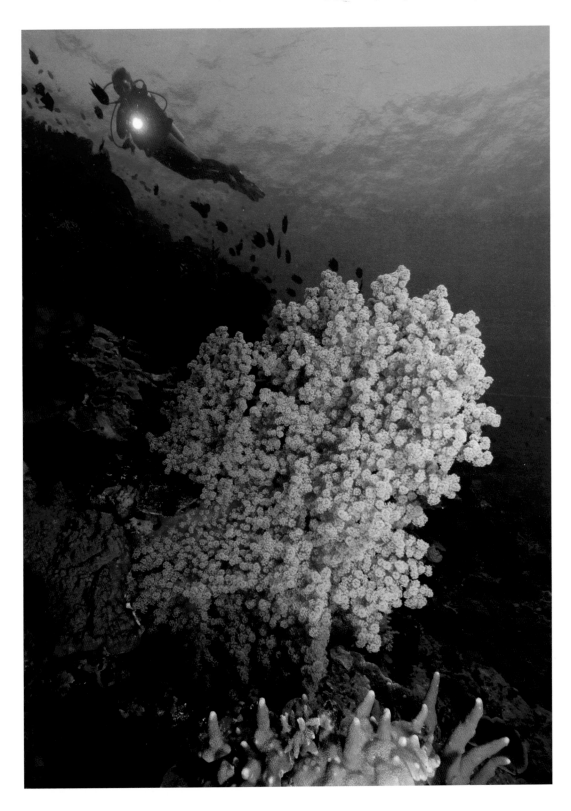

- If the background sea is overexposed, then close the aperture.
- If the foreground subject is incorrectly exposed in any way, then re-select a manual power on your flash gun.

You don't have to include a sunburst within the frame; it's not mandatory.

The critical exposure is the one on the foreground subject. Considerable latitude can be allowed for the distant blue water and the surface.

Tips

- Compose and shoot only when a scene looks good through the viewfinder. Avoid trusting just your eyes — it's the reason your pictures may look so distant!
- With experience, you can learn to 'shoot from the hip' accurately, guessing the angle of coverage of a wide-angle lens and shooting without looking through the viewfinder. This technique is invaluable should an opportunity arise where cameras and diver cannot fit into the same space (such as a small cave).
- Ensure that the lens is capable of doing the job. Anything less than 24-mm film equivalent is not wide enough.
- Shoot upwards towards the surface using small apertures for the greatest depth of field.
- Bracket both apertures and flash positions to give you some variety.
- With digital capture, ensure that overexposure from the undersurface of the water is not excessive.

Photographing people

Photographs of people underwater transport divers or non-divers alike, all over the world, from the comfort and security of their everyday lives to that splendid world beneath the waves, which only a tiny percentage of the world's population ever experience for themselves. They may arouse in so many of us who do dive feelings of hope, aspiration, ambition and memories. The underwater photographer may choose to capture a spouse or buddy on film, or to illustrate interaction with marine life. The inclusion of a model may be used to add impact, drama or scale to an existing scene. However, if you include a model in a seascape that already stands up for itself, it increases the probability of that picture ending up in the bin if the model detracts from the main subject.

For simplicity's sake, different types of people pictures are dealt with separately.

In the distance

An excellent technique for adding scale to an existing scene is to try to separate the model from any cluttered background and surround him or her with water. You can do this by obtaining a low viewpoint, and shooting up into mid-water.

Whether you choose a vertical or horizontal format, remember composition and the rule of thirds. For instance, your model could

Figure 43.14 (Opposite page)
At the rear of the Wakatobi dive resort there are a number of inland caves. I had two willing models, so I used them in the distance to add scale and a feeling of perspective, with the distant one reinforcing the shape and angle of the closer. I directed their movements with a series of hand signals which we had discussed topside. Getting them both into the water column was the most challenging part. You can see in the foreground I have a slight 'merger', with the fins fading into the shadows.
Nikon D100 with 10.5-mm fisheye lens, f11 at 1/200 s.

be placed in one of the thirds, using a hand-light to direct the viewer's attention to the main subject.

As your experience of taking this type of photograph develops, think about pressing the shutter when the model is exhaling. Bubbles create further interest – another plus factor. However, with so many other things to think about it is a feature that is often neglected.

A closer view of your model

As a model swims closer towards the photographer, the objectives may begin to change. At distances of 2 m or less, you should be aware that the light from your flash gun may fall on the model's face – which may prompt you to consider:

- The model's direction of movement
- The appearance of the model
- The position of the facemask in relation to the lens axis
- If using props, the role these props are to play.

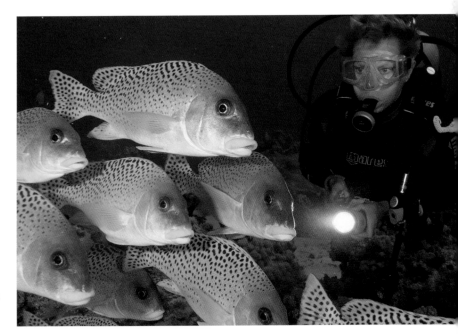

Figure 43.15
As the model gets closer, so light from the flash begins to catch the eyes and facial expression. When interacting with marine life, models should look happy and interested. I'm sure Sylvia felt this way, but as I pressed the shutter I caught her with a plain expression. Other facial shots worked better, but not in relation to the composition and tidy grouping of the school of sweetlips.
Nikon D100, 12-mm–24-mm zoom lens at the 24-mm end, twin Sea & Sea YS 90 DX, f8 at 1/90 s. Red Sea.

Eye contact

Eye contact is a primary consideration whenever a model is close. A mask that allows a clear, undistorted view of the eyes is important. The model should look happy, interested and at one with the subject, whether it be a fish or a still-life study. Eye contact should be directed at the subject, and wherever possible the photographer should endeavour to get light into the mask by means of a flash or natural light. This may necessitate careful consideration of the flash angle required.

Positioning the subject between the camera and the model will make the picture more dramatic, but always take care not to

Figure 43.16
A totally spontaneous shot of Leon the moment he passed his Open Water test. His eyes lit up with delight, and I aimed and fired instinctively. A magic moment for those who happened to be there to share his joy!
 Nikon F90x with 105-mm lens with ring-flash. Settings unknown.

overpower such a photograph by the model's presence. The model should add to the scene and not detract from the main subject. In my view, there are far too many photographs of female models clad in scanty bikinis and gaudy masks and fins which simply detract from the intended theme. This technique is understandable when used to sell a specific brand name or for a particular type of modelling or magazine shot, but otherwise it's overkill.

Advising models

- Have models look to see their own reflection in wide-angle dome ports and use the reflection to position themselves.
- I regularly show my models the view that I am composing, via the camera's viewfinder or LCD. In this way, they have a better idea of what is expected of them.
- Swimming slowly through a seascape tends to be more successful and natural-looking than just hovering. When a model hovers, the fins drop and the suggestion of movement diminishes.
- A strong composition ploy is for models to align themselves at a similar angle to the reef or the main focal point of the picture.
- It is the responsibility of the photographer to direct the movements and body angles of the model – not the other way round.
- Avoid mergers (where a silhouette has a leg or arm, for instance, that merges into the shadows of the reef). This can completely ruin a shot when it appears that they have staghorn coral for legs. We all know that this is not the case, but it will continue to pull the viewer's eye towards these anomalies rather than the intended focal point.

Give your models praise, praise, encouragement and more praise. They need to know that they are appreciated.

Digital advantages

Photographing people is no different with digital than it is with film. However, the instant review of digital capture provides an excellent opportunity to show models what you specifically have in mind. On some frames, the composition or lighting may not be to your liking but the body position is precisely what you are after. In this instance show them the picture in the LCD so they may see what kind of body position you are after and how they should position themselves. Review the LCD for mergers (see above) and body positions. Over the years I have taken some excellent backdrops, only to discover on processing the film that my model was gawking into the lens like a rabbit in car headlights!

Figure 43.17
Photographing people usually means other divers, but recently I had a rare opportunity with two young boys who were fishing from a canoe miles out to sea near Bunaken, Manado. The ambient light near to the surface was intense, so I set 1/350 s at $f11$ and snapped away. Their enthusiasm and excitement was spontaneous and so natural as they took turns to dive down and pose for my camera. It rubbed off on me; I was elated with the interaction.

10.5-mm fisheye lens.

Photographing shipwrecks

Photographing wrecks is a rewarding aspect of underwater photography which can soon become an obsession. It's a theme that often appeals to the general public. Giant, intact sunken ships offer a 'Boy's Own' fantasy that never fails to inspire a feeling of awe. Many non-photographic divers scoff at photographs of fish or coral. However, see the eyes of all those 'wreck ferrets' light up when they view images of wreck exploration! 'Now, that's something worth taking', you often hear them say.

Priorities in wreck photography

A prime consideration of your approach to photographing wrecks is, of course, the depth at which they rest, and the opportunities you have to repeat a particular dive. For example, a wreck of considerable size situated in 45 m of water presents a problem if you are unfamiliar with her and you have only one or two opportunities to dive and photograph her. On such a dive, your priorities are your times, depth and, most importantly, yourself! Can you really give the amount of concentration necessary to photograph the wreck to your satisfaction? I would suggest not; I certainly couldn't. In such circumstances, I would take my camera to record the dive. If I obtained a good shot, I would consider it a bonus and evaluate my results accordingly, bearing in mind the limited time that I could spend diving the wreck. However, if the opportunities to photograph such a wreck were plentiful and I became familiar with it, then the potential for obtaining some exciting images would greatly increase.

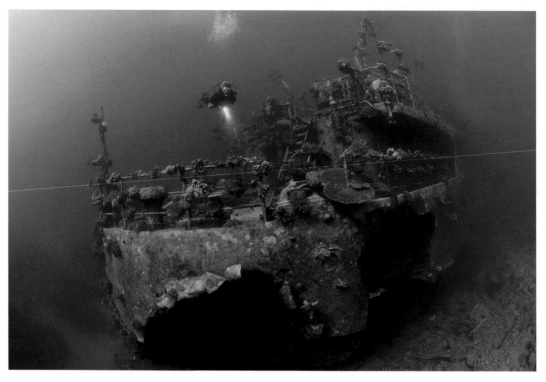

Figure 43.18
This wreck of a Russian cargo boat at Rocky Island in the Red Sea is ideal for photography. We entered the water whilst divers from another boat were beginning their 'deco stop' on the shot line. I took this opportunity to select a strong composition, and a series of natural light 'Polaroids' gave me feedback on the best exposures to bring out detail of the wreck. The divers left the water, and I took a series of shots with and without a model. Compositionally, I chose a landscape format with a diagonal orientation of the stern leading the eye left to right through the frame. Sylvia, my model, swam at various angles over the wreck. I shot 'cloudy' white balance and adjusted it in the RAW converter with the white balance sampler tool.
 Nikon D100 with 10.5-mm fisheye lens, f8 at 1/90 s.

Have a plan

There are various options available in wreck photography. Wrecks that are virtually intact, in shallower waters, offer the greatest potential. Wherever your chosen wreck lies, try to use one dive solely for exploration. A digital camera is ideal for this. You need to consider the most photogenic sections, the existing light levels at your particular depth, locations of the recognisable features of the wreck – winches, masts, rigging, for example – and the photographic potential of those features. You're looking for the very best potential of that particular wreck, and using digital will provide feedback on your initial ideas. Your next photo dive will consist of shooting what you consider to be the best bits. By finding and shooting recognisable features of the wreck, you give the viewer something to relate to. A broken lifeboat hanging from its davit is recognisable to both divers and non-divers;

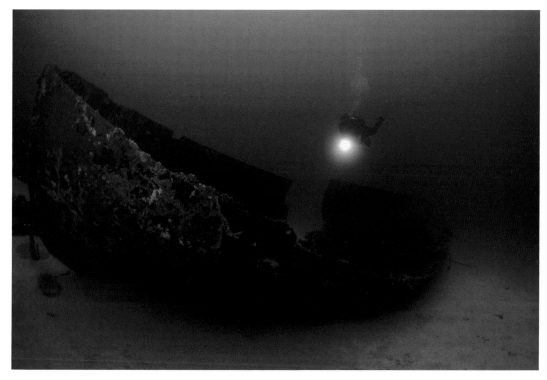

Figure 43.19
Situated in 40 m of water just off the beach at Captain Don's Habitat in Bonaire, I used this shell of a small boat as a workshop practice ground in order to plan, direct models and choose the best angles of composition in the limited time available at this depth. The white sand and almost endless visibility made it particularly photogenic. Notice the composition of the diver and light directing the eye towards the bow. The blue water was much darker in reality; I overexposed it by one or two stop to increase detail in the shadows.
 Nikon F90x with 16-mm fisheye lens, f4 at 1/30 s with manual flash fill from a Sea & Sea YS 120, Elite Chrome 100 ISO.

however, replace this feature with a piece of sheet metal and the viewer could be forgiven for thinking it was taken in a scrap metal yard on a dark night. If possible, give your shots a green or blue water background, which again puts the wreck in its environment, and by including a diver in the scene you can also give the viewer a sense of scale. Be careful not to make the diver too obtrusive, or all the viewer's attention will go that way. Make the wreck the centre of attention, and use the diver to reinforce it.

Equipment for wreck photography

This book constantly refers to the use of wide-angle lenses to allow you to get closer, thereby reducing the column of water between the lens and the subject. In wreck photography, this concept is an absolute necessity. Wide-angle lenses of 20 mm (film equivalent) or even wider are a must. The 35-mm or the

28-mm lens will be quite inadequate for capturing the sheer size of the wreck. Attempting to back off to get it all in will simply reduce clarity and definition. If you do not have use of such a wide-angle facility, then take the shots by all means, but appreciate the limitations when your shot is compared with those of your buddy who was using a true wide-angle.

Lighting

When trying to capture the size and bulk of a wreck the use of a flash is unnecessary and can, on occasions, spoil a picture. After all, a wreck is the biggest object in the sea that you will ever have cause to photograph. When shooting a coral reef you may light a selective area and allow the background to be balanced with natural light, but, even given the size and power of the largest flash guns available today, to illuminate a wreck sitting upright on the seabed with flash is almost impossible. You can use flash to fill in the colour on those recognisable features you have selected to shoot, but use the available light to record the detail of the wreck with a flash to simply fill in shadows.

Available light

In other chapters of this book we discuss opening up f-stops/ apertures to control the colour of the background water. To recap, at 100 ASA on film or digital at $f22$, 1/90 of a second underwater will reduce to black anything that is not lit by flash by virtue of the restricted light that is allowed to enter the camera. As you manipulate the aperture through $f16$, $f11$, $f8$ and $f5.6$, you allow more light to enter and record detail in the column of water, be it green (temperature) or blue (tropics). One technique that I often use is to open up the water column even further, thereby bringing out the natural details in a wreck. For example, the eye sees the dark shape of the wreck in blue water, and by overexposing to a degree the colour of the water we also bring out additional detail of the wreck that was not detected by the human eye.

This deliberate overexposure can be made in one of three ways:

1. By using wider apertures
2. By reducing the shutter speed from 1/60 second through 1/30, 1/15, 1/8, etc.
3. By increasing the digital ISO setting on the camera.

The disadvantage of reduced shutter speed – for example, to 1/15 second – is the greater possibility of blurred pictures because of camera shake. (With housed cameras, the decrease in shutter speed is a good option if you are able to hold the camera firm and steady.) Compromise is the answer! Maintain an adequate depth of field using apertures of $f5.6$ with shutter speeds of 1/30 or 1/15 second. You will often get away with very steady

Figure 43.20
The same wreck as in the image on page 336, but just inside the hold. Using natural light, I braced the housing firmly on a piece of wreckage and composed a series of pipes and railings. The best exposure was f5.6 at ½ s, but it took several minutes of bracketing the settings and checking the histogram to capture the scene without overexposing from the light entering the wreck at the top of the frame. Current camera models from Canon and Nikon can now handle these highlights easily.
 Nikon D100, 10.5-mm fisheye lens in Subal housing. Natural light at ½ s.

Figure 43.21
I used a flash exposure from two Inon Z220s to illuminate this piece of machinery inside a photogenic wreck situated a few hundred yards off Canefield Airport on the island of Dominica. Notice my flash on the right-hand side is visible in the top corner. This is because it was positioned – mistakenly – in the corner where my port has no shade construction. My flash position on the left is behind my dome shade, and as a result the light is cleaner.

Nikon D100 with 10.5-mm fisheye lens, $f8$ at 1/90 s. The machinery is no more than 0.25 m from the lens.

hand-holding. A popular and much-used technique is to brace your camera firmly against a piece of wreckage in a similar fashion to placing your camera on a wall or tripod for land photography.

Increasing the film speed

Another consideration is to increase the digital ISO setting from perhaps 200 to 400 ASA, depending on the conditions. In such circumstances your shutter speeds will not suffer, because the ISO speed will allow you greater latitude.

However, do remember that a faster ISO will produce an increase in grain on film and noise on digital capture, which may not be to your liking. Only you can decide, but grainy images definitely can evoke that mood of wreck exploration that you might be seeking.

Angles of view and composition

I always advocate using upward camera angles underwater to aid separation of the subject and the background. However, I have found (at the expense of numerous wasted films) that this concept of upward angle shooting takes on a different perspective with wrecks. Some years ago I dived on an intact super-tanker in blue tropical water. Applying the normal, well-practised technique, I adopted low angles of view shot upwards the lighter regions of the sea. When my efforts were processed I found silhouettes and outlines of the wreck superstructure, but the essence of the subject (the wreck) was missing. I pondered the problem, and came to the conclusion that the angle of view I had automatically adopted was for most of the time incorrect. How many times on land do you look at a sizeable ship from the hull? In harbours, marinas, rivers and estuaries we are used to viewing decks and the ship's interior from eye level.

In conclusion

Wreck photography is addictive. Apart from the drama of the wreck itself, wrecks also play host to every conceivable creature you may desire to photograph. Dramatic lines and structures will test your compositional skills to the limit. There is scope for everything, from ultra-macro to marine life to diver shots and still-life studies. Find a wreck that suits your needs, is easily accessible and is preferably in shallow water. Explore it, and get to know it and the creatures living around it. Discover its most photogenic aspects and angles, then get to work with your camera.

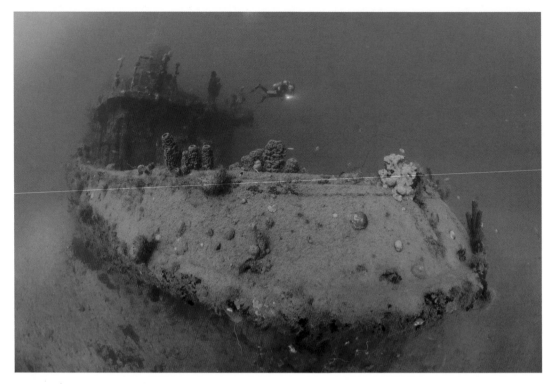

Figure 43.22

The same wreck in Dominica as in the image on page 340. We entered the water 10 minutes before the rest of the group to achieve a wide 'intact' shot without other divers. I knew the best angle from the same dive on the previous day, and I had discussed with Sylvia her angle of 'swim through' topside. I chose a combination of aperture and shutter speed with natural light by taking a Polaroid and checking the LCD. When the histogram was correct, I motioned Sylvia to begin her swim through. I much prefer the model to swim through a seascape, as the motion of the fins looks more natural.

Nikon D100 with 10.5-mm fisheye lens, f8 at 1/60 s, natural light.

Photographing schooling fish

There is no bigger thrill than photographing schools of fish. I have been to many destinations with other keen, passionate underwater photographers, and their enthusiasm jumps into overdrive when they have such an opportunity. They enjoy the chase, the challenges and the spectacle. However, satisfaction with the images obtained does not always live up to aspirations. Why is that? I often feel the same – always believing I should have done better!

I have closely analysed my own techniques and studied many successful images taken by other underwater photographers. As a result, I have developed opinions on which images tend to work and which don't. Here are some of my own tips, ideas and opinions.

T-shirts and posters

Cast your mind back to a dive trade show that you may have recently attended. Consider all the T-shirts on display to the diving public, or perhaps to holiday guests at a tropical dive resort. Visualise the images on the items of clothing that relate to fish. We have probably purchased such a T-shirt as a holiday memento at some time.

An artist has had to consider the design and composition of the group of fish – how many to include in the sketch, how to place one subject so that it balances with the others, whether the eyes are visible or hidden, whether tails overlap, whether the fish are

Figure 43.23
I spotted this poster on the wall of a café in La Paz, Baja. The owner allowed me to take a photograph of it. The freedom of the artist to design the fish in whatever formation provides many visual clues of composition, order, harmony and impact. Take note of these designs in all manners of art. We should learn from artists' talent and the choices they make when we come to consider our own way of photographing marine life. This poster happened to be my best shot of the trip to the Sea of Cortez in 2001. We were hit by Hurricane Juliet, landlocked for six days and never saw a thing underwater!

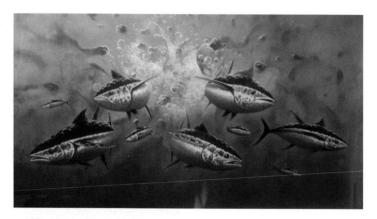

swimming in different directions. The artist/designer is not confined to the reality of a camera – all colours, shapes and sizes of fish can be sketched – but one thing that all artists have in common is a sense of harmony, order and balance in the visual design. Who would buy these designs if they were not pleasing to the eye? There is no better exercise to sharpen your photo perception than to study the design of fish on posters and clothing.

Organised chaos

I use this term to describe the art of shooting schooling fish. Let's face it; for the most part fish swim in a disordered, chaotic and jumbled mass. In my experience, this is why we become dissatisfied with our results. Whilst observing fish over a period of time we perceive an orderly and tidy gathering; however, our camera freezes them in a fraction of a second and the thought of 'chaos' springs to mind. What we have to do is search for an element of organization within the chaos.

My first solution when photographing schooling fish is to have in mind the notion of balance, order and harmony – just like the T-shirts. For me, this way of thinking works really well.

Exercise: Practice makes perfect

I use this exercise on some underwater photo courses, and it really can help. Find some footage of schooling fish on a video or DVD. Concentrate on it, and watch it through several times if it helps (the BBC *Blue Planet* series is excellent for this). Using the remote control handset, watch the footage and, by using the 'pause' button, freeze the action when the school has achieved a sense of balance and order. You will be amazed at the results and at the degree of difficulty to capture a frozen moment in time.

Figure 43.24
I spent the entire dive with these lemon butterfly fish in the southern Red Sea. I took around thirty shots, and found that only six had some order and harmony to the composition.

Nikon D100 with 12-mm–24-mm zoom lens at 24-mm end, twin Sea & Sea YS90 auto flash guns, f11 at 1/90 s.

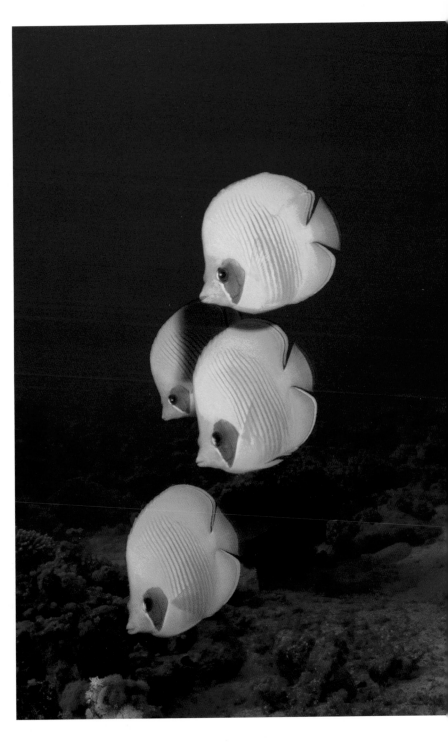

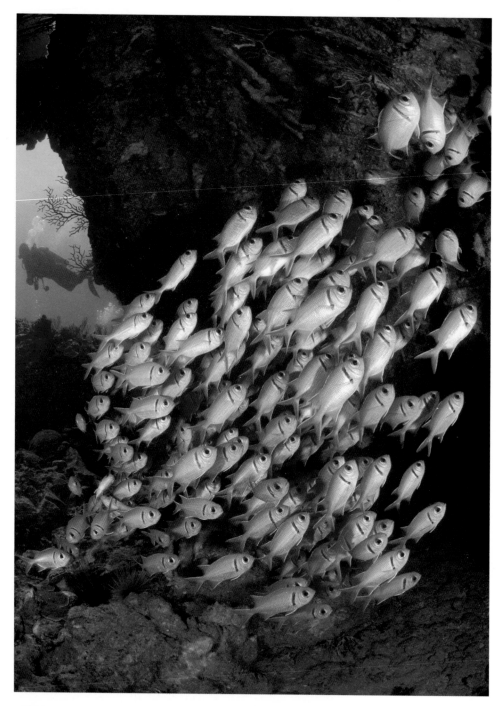

Figure 43.25
Black bar soldier fish in Dominica. The group spent some time over a two-day period shooting this small school in a photogenic cave. I tried to light the fish whilst leaving the cave's wall black for contrast, and also balancing the blue water at the entrance to the cave. It was easy to check the histogram for exposure. I got lucky when the best formation of the fish coincided with a diver swimming past the entrance.
 Nikon D70 with 12-mm–24-mm zoom lens at 12-mm end, twin Inon Z220 flash guns, f11 at 1/180 s.

Equipment

Whilst a 60-mm macro lens can be used to capture small fish in a pair or threesome, the optimum lenses are wide angle. If I anticipate that I can get close to a school, I will use either a 12-mm–24-mm zoom lens on digital or a 17-mm–35-mm zoom on a film camera. If I have photographed the school previously and know the size, I will often choose a 10.5-mm fisheye. I would always choose the digital option to photograph schools by virtue of the limitless number of frames available and the benefit of LCD review and the histogram to check composition and exposure. The one exception that would lead me to choose to use a film camera – Nikon F100 – would be if I was expecting to shoot the school from an upward angle towards the surface and was unable to hide the sun or leave it out of the picture. This is a personal choice. Whilst the recent offering of digital SLRs from Nikon and Canon in the form of the Nikon D70 and D2x, the Canon 20D and EOS-1DS Mark 11 have much improved sensors and flash sync speeds, which record the sunlight more favourably, the truth is that many digital compacts and early SLRs – my Nikon D100 included – do not handle sunlight at all well.

Zoom lenses

From the outset, let us be quite clear about the use of wide-angle zooms on both digital and film cameras. With all subjects in the sea we must endeavour to get close physically, as opposed to using our zoom facility from a distance in order to enlarge the image in the viewfinder or digital LCD. If we simply zoom in, then our pictures will lack colour, contrast and sharpness. Try to move as close to the school as physically possible. Then and only then, when they will not tolerate your intrusion any further, use the zoom facility to compose better.

Panning the camera

Panning is a method to stop motion. It simply means aiming your camera at a moving subject and following its path with the camera matching its rate of travel. As the subject (a fish) moves past you the shutter is triggered, effectively stopping the motion against a blurred background. The finished image gives the impression of movement, and (hopefully) the subject detail will be in crisp focus.

Why not simply use a fast shutter speed, such as 1/250 s, to stop the motion? Well, there are several reasons:

- Some digital cameras will not synchronise with a flash gun at speeds faster than 1/180 s
- Faster shutter speeds require a wider aperture, which may not complement the depth of field required for a particular shot

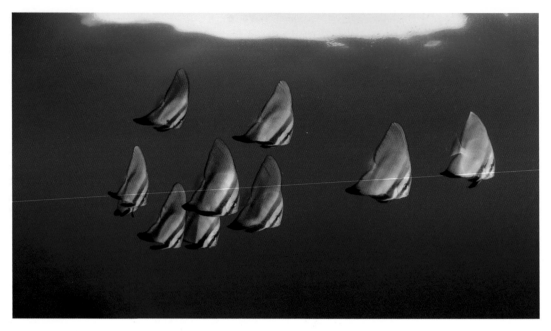

Figure 43.26
This small school of bat fish swam past me once on a particular beach dive at KBR, Sulawesi. I pointed my housing at arm's length and pressed the shutter; there was no composition or selection of aperture or focusing – I had no time. With digital, I usually have my aperture at f11 at 1/180 s when swimming along between opportunities. This time I got lucky and it worked. I could not have hoped for a better formation and balance to the school. Remember the maxim: f11 at 1/180 s and be there! If you are not in the water, you will not get the shot.

- Some digital compact cameras still exhibit shutter lag, and panning can be essential in these circumstances
- The main reason is that fast shutter speeds result in frozen motion, and panning can often improve the artistic qualities of an image.

If the subject is moving towards or away from the camera, there is little movement across the viewfinder and as a result little or no blurring occurs. However, if the subject is moving at an angle across the viewfinder, the technique of panning should be used or else the subject will most likely be blurred. The best option in my opinion is to use a shutter speed of between 1/60 and 1/30 s and *pan* the camera. It creates a more realistic and natural appearance and an illusion of motion. Besides, it's creative and can improve on an otherwise average photograph.

Lighting

In my experience, one of the biggest problems to overcome is how to light such a large area in terms of both natural and flash lighting. Using natural light on wide-angle can be very effective with big schools of fish. If possible, try to shoot the school so that

the sun is positioned behind you and shinning onto it. This will reduce contrast and colour the fish with light so they stand out against blue water. Try to get below the school and shoot upwards if they are swimming above a reef. If the school is situated in open water, then different camera angles can be successful.

Flash

Adding just a hint of flash can lend your pictures a certain verve.

A wide-beamed flash is preferable, attached to a flash arm. Position a single flash so it comes in from the top in both a landscape and a portrait composition. Feel that you are aiming over the top of the school. This will enable the lower edge of the flash beam to cut just in front of the school, lighting the fish and not the column of water between the lens and the fish. This flash angle also simulates the light and shadows from the sky and sun.

Dual flash

Although you have the added burden of weight and drag in the water, the addition of a second flash gun can help to spread a soft, even light at such an angle that it appears to wrap around the fish. Position twin flash guns so they are behind the shades on a wide-angle dome port; this helps to avoid the presence of flare in the top left- and right-hand corners of your picture. Depending on the orientation of the fish school and your composition, you may have one flash coming in from over both shades on the left- and right-hand sides of your dome port.

A lighting tip

When shooting a fish school in mid-water using a slightly upward camera angle, it is not uncommon to achieve natural light exposures of $f16$ and $f11$ with $1/90\,s$ shutter speed. This records the school as a part silhouette against the undersurface of the sea and the sunburst. When you use a flash gun(s), at these small apertures the limitations of the size of the aperture may not allow the light from the flash to carry more than about 1 m through the water and back again into the lens. If your school is keeping the distance from you at 2 m plus, an aperture of $f11$, for instance, may not allow the flash to reach the school to illuminate them!

So what is the answer? Most film and digital cameras have a flash sync shutter speed of up to $1/180\,s$, many are up to $1/250\,s$, and recent digital SLRs are up to $1/500\,s$. Select a faster shutter speed compatible with your flash (e.g. $1/250\,s$), use shutter priority metering mode and point the camera at the wall of blue water behind the school. With $1/250\,s$ selected, the camera's automation will look for a corresponding aperture to provide an accurate exposure. With ambient light levels in the tropics on a typical sunny day, the aperture reverts to the region of $f5.6$ or $f4$. These apertures will now allow the light from the flash gun to travel much further through the water column and paint in a 'kiss

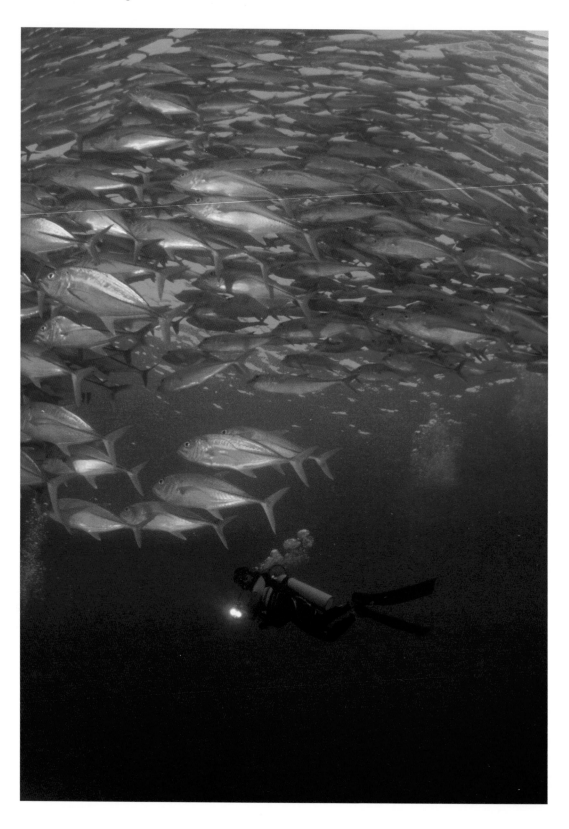

Figure 43.27 (Opposite page)
I try to capture a leading fish and in a perfect world give it a little space to swim into, but often this is just not possible. The schooling jacks in Sipadan often reward the photographer with close and frequent encounters together with excellent formations. When shooting large schools, even with a fisheye lens, the camera to subject distance can be anything from 1.5 m or more away. On these occasions, I recommend the following lighting techniques. Select wider apertures than normal. The reason for this is twofold: f5.6 allows the flash to travel further through the water than f16 and paints the fish with fill-in flash, which creates detail and increases impact; and wider apertures will in turn provide a faster shutter speed. This speed will stop the action and prevent blur, which is also preferable. I see many schooling fish pictures, which to the frustration of the maker are unlit. Their distance is too far for the flash to travel. Try this tip, it works well.

Nikon F90x with 16-mm fisheye lens, Subal housing, dual YS 120 flash guns on manual full power, f5.6 at 1/125 s, Ektachrome VS 100.

of flash' on the fish scales. The faster shutter speed freezes the motion of the school, which is another advantage. One disadvantage is the reduction in aperture, which also reduces the depth of field. However, using wide-angle lenses, which have very good depth of field, this should not be a problem.

Further tips for shooting schooling fish

- Dive key sites repeatedly to acquaint yourself with the habits of the fish.
- If you can repeat these photo sites, so much the better – you will know which lens to choose before you enter the water.
- Using natural light on wide-angle can be very effective with big schools of fish, but adding just a hint of flash can lend your image impact.
- If your flash strikes a reflective fish scale and the fish is situated at an angle to your camera housing so that it is reflecting back into your port, there is little you can do to minimise it. Take plenty of pictures to limit bad luck!

Order, impact and harmony are the key, but have patience. Schooling fish photography can be frustrating!

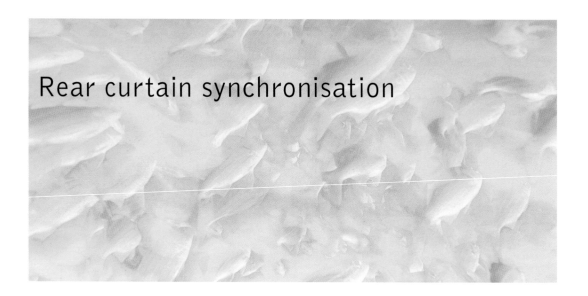

Rear curtain synchronisation

Rear curtain synchronisation is a very popular and creative technique in underwater photography. It has been around for many years, but became prominent in underwater photography in 2001 when Tobias Bernhard won the coveted BBC Wildlife Photographer of the Year Competition with a stunning image of a grey reef shark.

Front curtain flash synchronisation occurs at the beginning of the exposure. For long exposures with flash, the image recorded at the beginning of the exposure will be brightly flash-lit while ambient light continues to record subject motion for the remainder of the exposure. This can result in unnatural looking movement in the image, as light streaks created by the subject moving through ambient light will appear to originate from the subject rather than trailing behind.

Rear curtain sync, or second curtain synchronisation, is the name for a special effect where the flash is triggered near the end of the exposure, just before the shutter closes. In this instance, the ambient light on the moving subject is recorded first and the bright flash-lit moment happens at the end of the exposure, making for more natural-looking movement in the image. This process gets its name from focal plane shutter cameras that generally have two shutters or curtains: the first (front) curtain opens and exposes the film and then the second (rear) curtain closes at the end of the exposure.

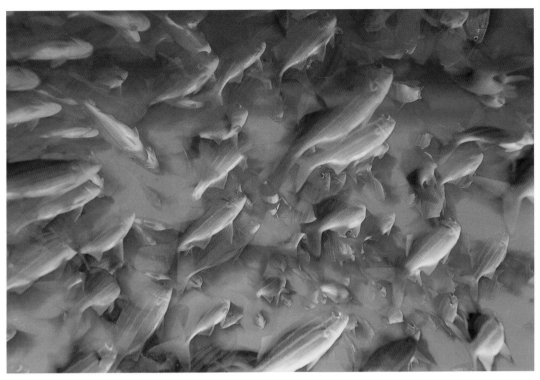

Figure 43.28
One of my first attempts at this technique was beneath Town Pier in Bonaire. A small school of grunts gathered together in a shady area beneath the pier. I used a slow shutter speed of about 1/8 s, and took a whole roll of film in order to experiment and learn more about this method. Six shots worked well; this was the most successful.

Underwater

The majority of film and digital SLRs used in underwater photography have a rear curtain flash sync facility, and many digital compacts are now equipped with this feature. Before underwater digital was available, trial, plenty of error and experimentation was the name of the game. Now, the effects can be viewed in the LCD immediately. However, I have found it difficult to judge the effect of rear curtain sync on the LCD underwater. As soon as pictures are downloaded to laptop or computer, the full effects can be judged. With film, the underwater photographer never knew whether a shot had been obtained that worked. For me, it was always a pleasant surprise when I got one that pleased me. I have used this technique with digital and had loads of fun, but the images you see in this section are from my film attempts. Digital has yet to reward me with anything worth keeping, but my attempts continue.

If you have never set rear curtain sync on your camera, then now may be a good time to see how it works.

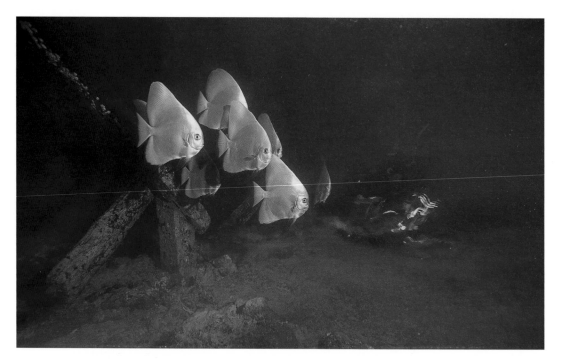

Figure 43.29
I was using my Subal housing with a Nikon F90x, a 16-mm fisheye lens, twin Sea & Sea flash guns on manual half power, and Ektachrome Elite 100 ISO film. I had set the flash function of my camera to rear curtain sync. When I finally settled down to shoot the bat fish, the sun had set over the horizon and the water was very dark. An aperture of f8 was ideal for the half-power setting on my flash guns in relation to the distance of the bat fish. The shutter speed, however, was indicating 1/8 s and falling! How would a slow shutter speed affect the background? What would the image look like? How would the bat fish appear on film? I was about to find out. Over the next 30 minutes I took 20–25 shots at f8 but allowed the shutter speed to become longer and longer until my Nikon F90x indicated the slowest shutter speed possible of 30 seconds. As I pressed the shutter whilst composing the fish the mirror of the camera 'locked up' in position, so I could NOT see the view within the frame. I followed the slow movement by pointing my housing in the general direction. The long shutter speed recorded the natural light, which was virtually black. A fraction of a second before the shutter closed, the flash guns (set to rear curtain sync) fired to illuminate the bat fish. The light on the right of the frame in the background is another diver who was using a small torch to observe our behaviour. This image was a 30-second exposure.

- Set your camera to 'rear curtain'
- Plug your flash into the camera housing
- Set manual mode and adjust the shutter speed. Settings of 1/15 s and below often work best
- Turn the flash on and press the shutter
- The shutter opens, and the flash will fire at the very end of the shutter duration.

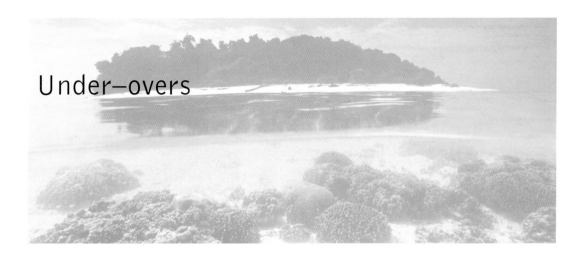

Under–overs

Some people love them, others hate them, but sooner or later it's inevitable that you will try your hand at under–overs.

Under–overs, split-levels, half-in half-outs – call them what you will – are not (and I emphasise this) easy. I have had more failed attempts over the years than in any other area of underwater photography. The concept is quite straightforward, but patience and perseverance is essential.

The technique: camera, lenses and dome ports

An SLR camera housing with a large dome port is preferable to a compact camera with a small port. One particular camera housing by Seacam has a special viewfinder that allows photographers to keep their head above the surface whilst still being able to compose the water portion.

Preferable lenses are the 10.5-mm fisheye and the 12-mm–24-mm wide-angle zoom with digital. I find the easiest lenses to use are the fisheyes. They have a considerable depth of field, which will often overcome any focusing issues. If the underwater and land portions are just too far away from each other, then maintain sharp focusing on the foreground. Another advantage of using a fisheye is the large dome ports associated with this type of lens. The bigger the dome port, the greater the chance of success.

Disadvantages of a fisheye lens
Fisheye lenses can be responsible for unacceptable distortion, and whilst it often goes unnoticed underwater, it is sometimes obvious when composing the topside view. Depending on the

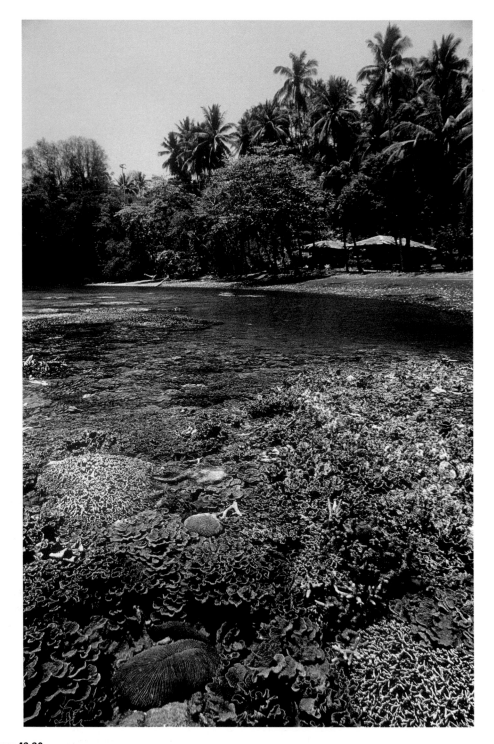

Figure 43.30
Outstanding potential for under–over images. The reef is breaking water at low tide, the sea is calm and the sun is shinning onto the tree-lined shore at Kunkungan Bay Resort, Sulawesi.

Figure 43.31
This dioptre was designed with a +4
optic in the bottom half and a two-
stop neutral density filter in the top
half to equalise the land portion of the
exposure.

Figure 43.31
This dioptre was designed with a +4
optic in the bottom half and a two-
stop neutral density filter in the top
half to equalise the land portion of the
exposure.

size of the topside and water subjects, the fisheye can be a little
too wide at times.

In an ideal underwater world, it is preferable to own a fisheye
lens and a wide-angle zoom that are both compatible behind the
same large dome port.

To prevent water droplets clinging to your dome port use a
motorcar product such as Rain-X™, which is effective on wind-
screens at promoting water dispersal. Another alternative is to
lick your dome! A coating of saliva on the outside of your dome
achieves the same effect. However, I wouldn't recommend that you
start to clean your car windscreen this way! Neither is totally reli-
able, and this is where frustration with these techniques can set in.

Choosing a day when the surface of the water is flat calm is more
likely to result in success. It is easier to control and compose the
water level across the surface of the wide-angle dome port under
these conditions.

Dioptres
There is much talk about the use of dioptres in under–over shots.
In simple terms, the ideal focus on the water portion scene rarely
complements the topside view, which often requires a lens to be
focused towards infinity. The underwater portion is usually in
the close foreground. So how can a compromise be achieved that
will render both in focus? The answer is to use a split-dioptre fil-
ter. When I use a film camera in combination with a Nikon
20-mm wide-angle lens behind a dome port, I attach a +4 split

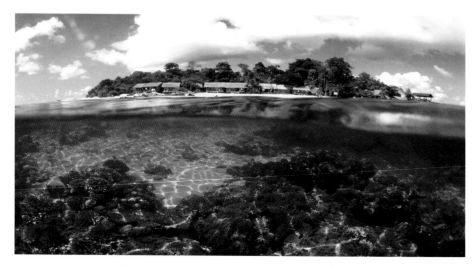

Figure 43.32
This was taken with a 16-mm fisheye lens on a Nikon SLR in a Subal housing, using Ektachrome Elite 100. I chose a day when the surface was mirror calm and the afternoon sun was at my back shining onto Sipadan Island. I waded out far enough to include the width of the landscape in the viewfinder. The hard coral seascape just below me was bright and clear in my viewfinder. My main objective was to select a shutter speed that would freeze the motion of the water and capture the surface cutting across the front of the dome. I used a whole roll to get this result; others were either out of focus or blurred due to my own shutter shake. Some had water drops all over the topside view, others were disappointing compositionally. On this occasion I used neither dioptres nor neutral density filters. I often find that a fisheye lens can provide an adequate depth of field from foreground to background. The shutter and aperture combination were in the region of between 1/100 s and 1/250 s and f5.6 and f11.

dioptre onto the front of the lens. The optical glass is similar to that of a pair of bifocal reading spectacles; it occupies only the bottom half of the filter whilst the top half is clear. This combination has the effect of bringing the focusing closer in the bottom half, where the water portion is to be composed, while the topside view is focused as normal. The photographer can often have both the land and the underwater seascape in focus but, if we have to go with one or the other, always show a sharpness preference to the underwater portion.

Exposure

Once we have solved the focusing problem, the next thing is correct exposure. What may be correct for the topside view is normally too dark for the underwater view. I advocate shooting with the sun behind you. This keeps the exposure differential at a minimum and, by bracketing the combinations of aperture and shutter speed, acceptable exposure can be achieved. Many photographers (myself included) have filters that have a neutral density value in the top half. This decreases the exposure on the landscape by either one or two stops, depending on your choice, but does not affect the seascape portion.

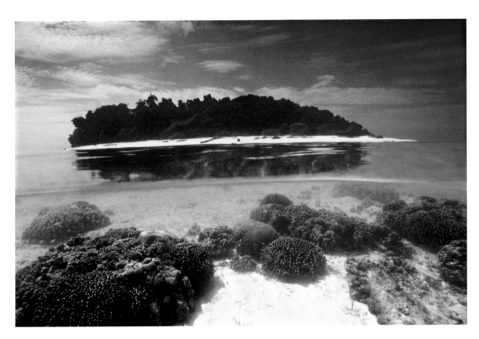

Figure 43.33
This was taken in similar circumstances to the image on page 358. The potential was a mirror calm sea and a blue sky. On this occasion I walked out so I could capture the entire island in my viewfinder; it was then just a matter of finding something of interest to compose in the viewfinder. On this occasion I used a +4 stop dioptre filter for the seascape with a neutral density in the top portion.
 Nikon F90x with 20-mm lens, exposures bracketed around f11 and between 1/100 s and 1/250 s, Ektachrome Elite 100 ISO.

Figure 43.34
I recognised this opportunity as we stopped at Banka Island, Manado, for lunch. The crew moored the dive boats in shallow water above a rocky outcrop of hard corals. I noticed the good visibility, the blue sky and the fact that the sun was shining onto the island. I took 20 shots over a 10-minute period before returning to the beach for dessert.
 Nikon D100 with 10.5-mm fisheye lens, f11 at 1/350 s.

Figure 43.35
Whilst this may look like an under–over, it's not; my housing was completely submerged. I was in very shallow water 1–2 m deep. The surface of the water was flat calm and I had the intention of obtaining this effect before I left the dock earlier that morning. With the sun at my back, I selected several trees growing on the edge of the rock leaning over into the water. I composed the scene through Snell's window.

Nikon D100 with one single flash fill on the foreground coral, f11 at 1/250 s. Notwithstanding that the fastest sync speed of my camera was 1/180 s, the only subject of reflectance was the foreground hard coral. Batu Angus, KBR, Sulawesi.

The perfect filter for my own lens and dome port is one that has a +4 positive dioptre in the bottom half and a two-stop ND filter in the top half.

Fisheye lenses have no filter thread on the front, but they do have the facility to fit a small filter onto the rear of the lens. Speak to your housing manufacture to ascertain whether one is available for your equipment.

Being practical

In an ideal world, you would have:

- An interesting underwater portion in the bottom half
- An interesting topside view
- A flat calm surface
- The sun behind, illuminating both the over and under aspects.

We are not asking for much, are we?! This is where the challenge of underwater photography begins to tease us, and we do need to practise.

You can practise under–over shots in a variety of situations and locations – swimming pools, sandy beaches, mangrove swamps;

the list is endless. The difficulty is finding half a scene that will complement the other half! I am forever finding a colourful, photogenic shallow seascape with nothing on land to complement it. On the other hand, I have walked waist deep around Sipadan Island on numerous occasions with a vision of paradise in the topside view of my viewfinder and nothing but sand in the water portion. When all the elements come together the weather will inevitably intervene, chopping the surface and reducing the visibility. When everything *does* come together, don't hesitate to take advantage of the conditions – don't wait until tomorrow, it never comes!

Creative wide-angles just below the surface

Imagination, creativity and flair as photographic concepts are not that easy to explain, and in my opinion are often avoided. However, time and time again it is these qualities that separate the underwater artists from the accomplished technicians.

Edward Weston, the famous land photographer of the golden era, once said:

> Anything which excites me for any reason, I will photograph, not searching for unusual subject matter, but making the common place unusual.

Let's apply his philosophy to our underwater photography. For most of the time we spend indulging our passion for underwater photography, ordinary and familiar things seldom get noticed. Few think to photograph them in a way that arouses feelings and emotions in the viewer. How many of us have considered an underwater image to be so simple that we would never have thought to take it? Yet, because the idea is so simplistic, the viewer is doubly impressed.

My objective is simply to bring to your attention what you look at every time you go underwater but may not necessarily 'see'.

I believe that we should all learn to see the familiar, and we can train our inner eye on land. Each day we do and see many things almost subconsciously – the actions are routine, the objects are familiar. We travel to work, passing numerous scenes that are so familiar we never give them a second glance. We repeat this scenario in our diving. This is why I have chosen to illustrate the 'familiar' in the latter part of this book.

The most productive of these 'familiars' exist just below the surface. The characteristics of the under-surface have many qualities that have the potential to make beautiful underwater photographs. They are so familiar to photographers, but often neglected. Some of the most well-known wide-angle underwater images of the last two decades possess characteristics of the under-surface somewhere within the composition. We are all familiar with these images, but sometimes fail to identify what gives the composition that 'wow' factor.

Wherever you may be right now, if possible, close your eyes for a few seconds and visualise yourself kneeling on the sand in very shallow water looking up towards the under-surface. What do you see? Look out of the water towards the sky. Visualise the colour of the sky, the shape of the clouds. Can you see the sun, or the palm trees that fringe the beach? Can you see reflections of the shallow sandy bottom, the sunbeams dancing on the sand? Study the wave action and the texture of the under-surface. How still is the surface, how pronounced is Snell's window?

There are no particular tricks of the trade in capturing these shallow-water qualities. Once you know they are present, it's just a matter of remembering that these 'familiars' can be taken advantage of.

Under-surface texture

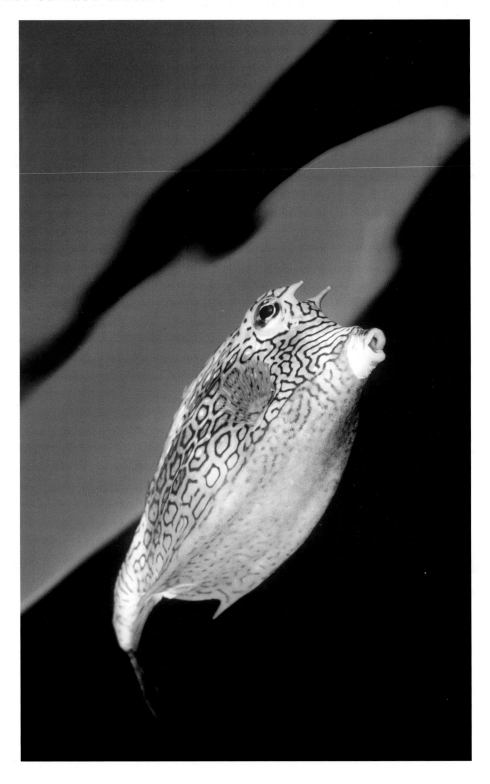

Figure 43.36 (Opposite page)
An example of under-surface texture. The cowfish was taken in no more than 1 m of water below the wall of the restaurant at Captain Dons, Bonaire. At breakfast time the scraps tend to get hurled into the sea, which brings in the resident reef fish. Cowfish are found in abundance at many Caribbean resorts, and can be photographed in numerous ways. It is not the subject (the cowfish) that makes the picture; it is the negative space. I have taken advantage of the surface texture to enhance an otherwise blue or black background. The two-tone texture gives the image an indefinable quality which, I would suggest, sets it apart from the norm.

I am shooting directly up towards the surface. My camera is no more than 0.5 m away. The blue in the background is the colour of the sky through the surface; the dark area is the reflected light. What makes this image is the diagonal angle of the surface details, which compositionally complement the diagonal orientation of the subject. I had no impression of how the surface texture would record on film. However, by working so closely I knew to expect surface detail to play its part in some way in enhancing the negative space.

I shot at least three rolls of Ektachrome Elite film of the early morning fish feeding antics during the week-long photo workshop. This image was taken with a 24-mm lens in a Subal housing, f8 at 1/125 s, on continuous autofocus. On other days I shot the same scenario with a 60-mm macro.

Figure 43.37
There are many mangrove swamps in Sulawesi. I knew of one in shallow water which produced vivid reflections. Equipped with a 10.5-mm fisheye lens, I snorkelled into the inlet with just fins and a mask. I took 40 minutes and composed a number of reflections using tree branches against the backdrop of dark volcanic sand.
 Nikon D100, f4 at 1.30 s, natural light.

Reflections

All manner of things, when photographed at the correct angle in relation to the under-surface, can produce reflections and add impact to a picture – divers, marine life, hard corals in shallow lagoons, jellyfish are all potential subjects. The secret is seeing the

reflection with your own eyes in the first place. Secondly, once you view the scene through your viewfinder, you must visually relocate the reflection and combine the composition of elements, the subject and the reflection.

I am often asked where to aim the flash gun. My tip is to aim your flash at the subject; however, I would encourage you to experiment with different angles of light. In this way you will learn what effect these angles create, and by considering your own preferences you will achieve different effects. For example, try holding your flash gun out of the water or, alternatively, aim it at the reflected image.

Reflections are most prominent when the surface is flat calm, but different and appealing images can be obtained when it is rippled. Remember, if you can see the reflection in the viewfinder, so will the lens. Reflections can often be photographed in areas of trapped air in and around wrecks and caves.

Piers, jetties and other structures

I often notice photographers swimming over unique opportunities in their desire to descend to seemingly more attractive, bigger and more colourful wide-angle subjects. However, working close to the under-surface provides a wealth of opportunities that may have gone unnoticed in the past. Even though the depth below may be 30 m, it does not stop the photographer from working just below the surface with a wide-angle lens in order to exploit the various ways in which surface detail can be recorded on film.

- Who would have thought that rickety old pier could provide a backdrop for excellent wide-angles by the way in which sun shafts burst through the holes in the planking?
- What about the old landing jetty, which is no longer used for boarding your dive/photo boat? It has been broken and dormant for years, and is now colonised by schools of small fish. How does it affect the sunlight that penetrates the shallows?

Figure 43.38 (Opposite page)
This location was beneath the small dive jetty at Sipadan water village on the island of Mabul, Malaysia. From the moment we arrived at the resort, I recognised that the shallow rich water beneath the jetty had enormous potential for dramatic wide angles. The added bonus on this occasion was the location of the setting sun at the end of the day. It danced, sparkled and illuminated the water with a soft orange glow. I swam around the pillars looking for dynamic subjects. Taking into account the evening light I was searching for a simple subject to place within the frame against the graphic, dark structures of the jetty in the background.

In no more than 2 m of water I noticed a sea fan swaying gently in the path of the light. I took a light reading via the camera meter which indicated a natural light reading of f4 at 1/30th of a second. I took a couple of shots with both flash guns and then just one gun. I was mindful that the flash might overpower and spoil the effect of the natural light. I motioned my buddy, Ken Sullivan, to hold my 100-watt Kowalski dive light just out of shot, pointing towards the base of the sea fan. I only had time to shoot five or six frames before the setting sun dropped below the horizon and the shallow water faded into darkness. Those frames lit with flash were too hot and ruined the mood of the natural light. However, by using slow shutter speeds and wide apertures the dive light had cast a lovely glow over the sea fan. The rapport between Ken and I had been essential, as had his assistance.

Nikon F90X, 16-mm fisheye lens in Subal housing. My Sea & Sea flash guns were turned off for this particular shot.

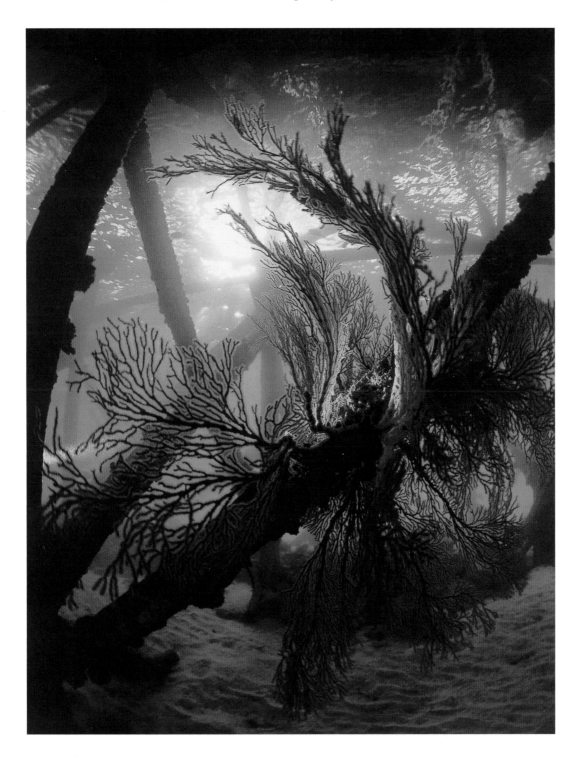

Wave action

Whilst planning this chapter, I identified one topic that I had never taken or for that matter even attempted – wave action! It had never occurred to me that surge or waves breaking on the surface above me could be photogenic!

Figure 43.39

I had watched *Perfect Storm*, starring George Clooney, on the flight over to Bonaire. It must have inspired me to capture waves and rollers. From the outset, I could not find anything around Bonaire that resembled wave action. I'm always preoccupied by safety, and I doubt very much that I would have chosen to dive in such conditions even if they had been available.

I kept things simple, and began to check out shallow areas where surface-swell met harbour walls or rocks. During a glorious photo dive beneath Town Pier early in the week I swam into the shore, towards the steps that lead from the promenade into the sea. The tide was high and a slight surface swell was rolling against the wall. For 30 minutes I wallowed in 2 m of water and took half a film of the swell. Bubbles, surf and spray spewed out of the impact, and my decisions regarding composition and peak of the action were entirely instinctive and spontaneous. I was excited by the subject matter – the more so because I had tried something which, in my own work, was original and innovative. One particular shot caught my eye. It is abstract in nature and does not portray the shallow waters of Bonaire by any stretch of the imagination. To me it has a 'space and planets' feeling to it. One of my friends labelled it 'Heavens'. I used a Nikon F90x and Nikon 17-mm–35-mm zoom lens set at between 20 mm and 24 mm, Subal housing with a 35-mm extension ring and a fisheye dome in view of the length of the lens. It's lit entirely by natural light. The *f*-stop was around *f*11 at 1/250 s. Film stock was Ektachrome Elite 100 ISO. You have probably worked out how the picture was taken by now. When I first saw it, I noticed how effective it was viewed upside down! Turn the page around. That is the way it was shot. The moral is to try new things, have a go at anything that takes your fancy. Look for the familiar, which is there to be photographed every time you take your camera into the sea.

Snell's window in shallow water

Figure 43.40
Those who have visited Captain Don's Habitat on Bonaire may recognise the tree, which is situated alongside dive manager Jack Chalk's office. I shot this picture whilst snorkelling about in a couple of feet of water beneath the wall. My camera was fully submerged. When Jack saw the picture, to his knowledge the tree had never featured in an underwater photograph. I found that hard to believe – to me it was an irresistible subject. It is printed upside down. Flip it to see how it looked to me in the viewfinder.

Nikon F 90x with 16-mm fisheye lens, natural light, Elite Chrome 100.

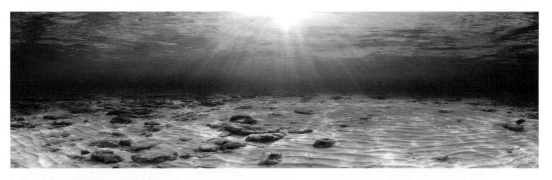

Figure 43.41
This panoramic seascape is the result of my efforts. I took time to consider the characteristic of underwater light which would mostly likely 'stand up for itself'. I chose to capture a simple and shallow sandy bottom at twilight with the effects of dappled light. It was the golden puddles of sunbeams reflecting off the sand, which captivated me that evening in Sipadan. I never moved from the spot. I used all combinations of apertures and shutter speeds in order to capture the light, the shadows and the ripples. Remember to look for the light. Learn how to find the light. The light that pervades is the key to underwater wide-angles.
 Nikon F90x with 16-mm fisheye lens, Subal housing, *f*5.6 at 1/125 s, Ecktachrome VS 100 ISO, natural light.

Light

A final idea when writing this chapter was to indulge my passion for natural light underwater photography. In so doing, I set myself a challenge – to make an image, pleasant and appealing to the eyes of the viewer, where the light totally dominates.

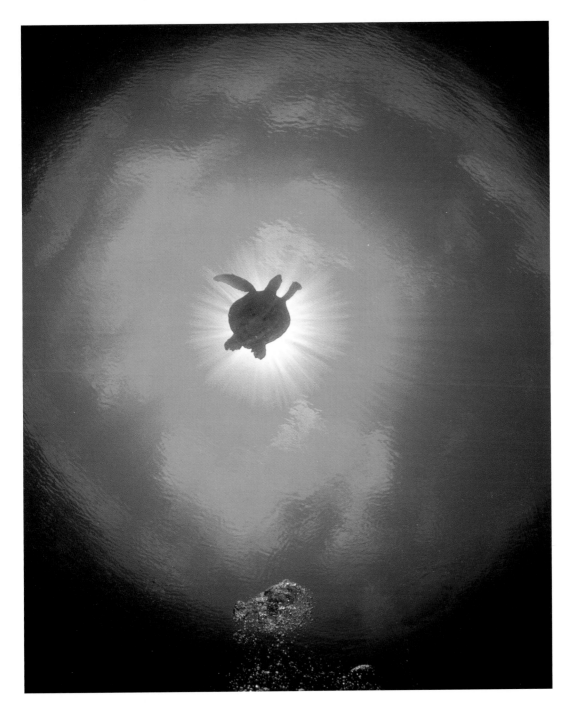

Figure 43.42
Snell's window in this image is at a depth of 20 m. Although the surface sky and clouds are visible at this depth, if you want to capture specific objects (as in the above image) you need to work in very shallow water.
 Nikon F90x with 16-mm fisheye lens.

Internet resources, equipment suppliers and useful names and addresses

Underwater Photography is a free, web-based magazine that can be downloaded at www.uwpmag.com. It is published bi-monthly, and each issue contains new product details, equipment reviews, underwater photo techniques and excellent underwater photos. *Underwater Photography* is a permanent source of information and entertainment for all underwater photographers worldwide.

Wetpixel (www.wetpixel.com) is a website dedicated to providing the latest information on digital underwater photography and imaging. The website contains news, reviews, tutorials and features, but probably the main attraction is the forums, where more than 4500 digital underwater photography enthusiasts chat about all aspects of their passion. Wetpixel.com has won the Website Award at the Antibes Festival, and the Editor's Choice Award from *Scuba Diving Magazine.*

Digideep (www.digideep.com) provides a permanent market overview of the essential equipment for digital underwater photography. When you search the web for the first time to find a suitable underwater housing for your digital camera, this can easily turn out to be a very time-consuming task. Digideep's up-to-date database will help significantly to reduce the time spent searching for this type of information and assist in deciding on the right product for you in a convenient way.

Ken Rockwell (www.kenrockwell.com) is a land-based website dedicated to camera equipment reviews. They are very thorough and in depth. Whatever piece of kit you have purchased or intend to purchase, check out to see if it is reviewed. I have learnt so much about my own cameras from this site.

Alan James Photography UK
8–10 Kellaway Avenue, Redland, Bristol,
BS6 7XR, UK
Tel 0117 944 2102
www.marine-cameras.com

Alex Mustard
www.amustard.com

Berkley White
Backscatter U/W Video & Photo
225 Cannery Row, Monterey, CA 93940
Tel 831-645-1082; email berkley@back
scatter.com

Berkley has designed a filter system to
minimise the overexposure of digital sunlight
with early DSLR cameras. This system allows
the user to mount any type of filter and
control rotation from the focus knob on
housings. For users of the Nikon D100 and
Canon 10D in particular, it is well worth
visiting his web site at www. backscatter.com
for further information on how this filter can
achieve better digital sunburst shots

British Society of Underwater Photographers
(BSOUP)
www.bsoup.org

Cameras Underwater UK
www.camerasunderwater.co.uk

Canon UK
www.canon.co.uk

Dan Beecham
www.danbeecham.com
www.wild-productions.com

Divequest UK (offers tailor-made, long-haul,
dedicated diving holidays for the underwater
photographer)
www.divequest.co.uk

Digital equipment review sites:
www.dpreview.com
www.dcviews.com
www.livingroom.org
www.fredmiranda.com

Fuji cameras
www.fujifilm.co.uk

Ikelite Underwater Systems
www.ikelite.com

Ken Sullivan (for bespoke underwater
housings and other related engineering)
www.pops.co.uk

Nikon UK
www.nikon.co.uk

Ocean Optics and Maverick Diving UK
www.oceanoptics.co.uk

Paul Williams, Professional Photographic
Laboratory Services
www.phonix-imaging.com

Robert White Photography
www.robertwhite.co.uk

Sea & Sea Ltd UK
www.sea-sea.com

Undersea Cameras (www.underseacameras.
com) is a UK based company, specialising in
Seacam housings for Nikon, Canon and the
Fuji S2Pro cameras.

Glossary

Absorption The blue, filtering effect of sunlight. Water absorbs the colours of the spectrum selectively until, at depths of around 20–25 m, only tones of blue and green remain.

AE lock (AE-L, Auto Exposure Lock) This enables you to take a light-meter reading from part of an image and then hold that setting while you compose the picture.

AF lock (AF-L, Auto Focus Lock) This enables you to lock an autofocus lens in its present focus setting and then hold that setting while you recompose the picture.

Ambient light (also referred to as natural light) The light from the sun which is available underwater.

Angle of view The extent of the view taken in by the lens, which varies with focal length for any particular format size. The angle made at the lens across the image diagonal.

Aperture Behind the lens of your digital camera is a circular iris that opens and closes to determine the amount of light falling on the CCD. Altering the aperture also changes the depth of field.

Aperture preview A small button close to the lens on some SLR cameras that allows you to visually check the depth of field in the viewfinder.

Aperture priority A semi-manual exposure mode which allows the user to set the aperture according to the depth of field required, while the internal metering system selects the appropriate shutter speed to obtain the correct exposure.

Apparent distance The distance at which objects appear to be away from the eye/camera. Objects under water appear to be one-quarter closer than they really are.

Artefacts Compressing an image sometimes causes noise to appear as angular blocks or artefacts.

Autofocus (AF) System by which the lens automatically focuses the image of a selected part of your subject.

Automatic An exposure mode found on digital cameras in which all the camera settings, including ISO, white balance, shutter speed and aperture, are chosen by the camera. This is useful for beginners to digital underwater photography.

Av (Aperture value) AE camera metering mode by which you choose the aperture and the metering system sets the shutter speed (also called aperture priority).

Backscatter Light reflected into the camera lens and showing up as snow on the finished photograph, resulting from suspended particles in the water.

Barrel distortion If you take a wide-angle seascape with a wide-angle or fisheye lens and notice that the horizon seems to curve, you are seeing barrel distortion. This is caused by the camera lens distorting an image so it appears spherised.

Beam angle The angle of a flash-gun beam expressed in degrees.

Buffer A buffer is RAM (Random Access Memory) inside a digital camera which can store images before they are written to the memory card. This means you can shoot a number of photographs without having to wait for each to be saved. Shoot too many and you will cause a delay before you can begin to re-shoot.

Bracketing (exposure) Taking several pictures of your subject at different aperture settings, flash distances or flash-power settings, with the objective of obtaining one perfect exposure.

Brightness range The range of brightness between shadow and highlight areas of an image. This is also referred to as 'dynamic range'.

'B' setting Brief or bulb. On this setting, the camera shutter stays open for as long as the release button remains depressed.

Calibration Calibration is altering the settings of a device so it conforms to a standard. You can calibrate the LCD of your camera's viewfinder, a screen monitor, scanner and printer so that what you see is accurate.

CCD (Charge-Coupled Device) The light sensor in a camera that records an image. It consists of millions of tiny light sensors, one for each pixel. The size of a CCD is measured in megapixels.

Centre-weighted metering An auto-exposure system that uses the centre portion of the frame to adjust the overall exposure value.

Close-up attachments Dioptres, teleconverters, wet lenses and other accessories which enable the camera to focus on subjects that are closer than the nearest distance that the lens would normally allow.

Compact flash A popular form of storage media for digital cameras.

Complementary colours A compositional tool for colour balance which indicates the colours that complement each other on the compositional colour wheel.

Composition The activity of positioning subjects within a frame or viewfinder. Photographers often aim to create a visual balance of all the elements within their photographs. They do this via careful composition.

Compression Refers to a process where digital files are made smaller to save on storage space or transmission time. Compression is available in two types: lossy, where parts of the original image are lost at the compression stage, and lossless, where the integrity of the file is maintained during the compression process. JPEG and GIF use lossy compression, whereas TIFF is a lossless format.

Contrast (composition) Photographers who position subjects with different characteristics in the frame together are said to be creating contrast in the composition. Placing a highly textured object against a smooth and even background creates a visual contrast between the two subjects and emphasises the main characteristics of each.

Contrast (exposure and tone) The difference (ratio) between the darkest and brightest parts. In a scene, this depends on lighting and the reflecting properties of objects. In a photograph, there is also the effect of exposure level, degree of development, printing paper, etc.

Cropping Cutting out unwanted (edge) parts of a picture in an imaging program such as Adobe Photoshop, or cropping at the printing or mounting stage.

Depth of field The area that is in focus behind and in front of a subject. Depth of field is controlled by three factors: the focal length of the lens, the size of the aperture and the camera to subject distance.

Diffuse lighting Scattered illumination, the visual result of which is gentle modelling of the subject with mild or non-existent shadows.

Diffuser A circular or rectangular disc placed over a flash gun to widen the beam of light. Diffusers also decreases light intensity from between one and three f-stops.

Digital image A visible image on a computer monitor formed by a stream of electronic data.

Digital zoom Many digital compacts can zoom in on an image by expanding it in-camera. The zoomed area looks bigger but contains the same number of pixels, so will look 'pixelated'. Digital zoom should not be confused with the superior, optical zoom.

Digitise This is the process by which analog images or signals are sampled and changed into digital form.

Dioptre Magnification factor of a supplementary lens. The focal length of such a lens can be calculated by dividing a thousand by the power of the dioptre.

Dome port A semi-spherical piece of glass or plastic used to eliminate the magnifying distortion caused by reflection.

dpi Dots per inch, a term used to indicate the resolution of a scanner or printer.

DX coding Coding printed onto a film cassette denoting the ISO speed. It is read by sensors in the film compartment of most 35-mm cameras.

Dynamic range The measure of the range of brightness levels that can be recorded by a digital sensor.

Effective *f*-stop The actual *f*-stop value when you use a macro lens and focus for extreme close-ups.

Enhancement A term that refers to changes in brightness, colour and contrast that are designed to improve the overall look of a digital image.

EV (Exposure Value) This refers to the amount of shutter speed or aperture adjustment needed to double or halve the amount of light.

EXIF Stands for exchangeable image file. EXIF format enables image data, such as the date and time the shot was taken and exposure, to be stored onto the camera's memory card.

Exposure When you take a picture, the camera's light meter determines how long the shutter should be open for and how wide the aperture should be to gain the correct exposure. If a picture is too dark it's underexposed, and if it's too light then it's overexposed.

Exposure compensation Adjusting the camera or metering system to give a greater or lesser exposure than that which the light meter considers to be correct. Most cameras now have an exposure compensation dial built in.

Exposure latitude (film latitude) The measure of a film's propensity to compensate for over- or under-exposure. Slide film has small latitude. Plus or minus a half *f*-stop is common, therefore exposures have to be very accurate. Print film has much wider latitude.

Exposure mode Camera settings such as M (manual), A (aperture priority) etc. that determine which controls your have to adjust manually for an exposure and which ones the camera does automatically.

Extension tube Used for close-up and macro photography, these rings or short tubes are mounted between the camera body and lens to space the lens further away from the film and so allow the sharp focusing of very close subjects. They were extremely popular with Nikonos cameras users, but are rarely used underwater with digital or film SLRs.

Fast (or high speed) film A film that is very sensitive to light, indicated by a higher ISO rating number of 800, 1200 or 1600 plus.

Fill-in flash This is additional light from a flash gun(s) to enhance colours and lighten shadows when natural light is the primary light source.

Film speed Measure of sensitivity of film to light, which is usually expressed as an ISO figure.

Filter, lens A piece of transparent glass, plastic or gelatine placed over the camera lens to adjust colour in natural light photography or to balance the light when flash is used.

Firewire Faster than USB, this is a type of connection between computers and a range of different equipment, including digital cameras and card readers.

Fisheye lens A lens with a 180-degree field of view across the diagonal. Fisheye lenses offer maximum depth of field.

Fixed focus Non-adjustable camera lens set for a fixed subject distance.

Flare Scattered light that dilutes the image, lowering contrast and seeming to reduce sharpness. Mostly occurs when the subject is backlit or when using wide-angle lenses with flash and extraneous light from the flash strikes the dome port.

Flash contacts Electrical contacts, normally within the mechanism of the camera shutter, which come together at the appropriate moment to trigger the flash unit.

Focal length This describes the magnifying power of a lens. The longer it is, the greater the magnification; conversely, the smaller it is, the wider the angle of the lens.

Focusing Changing the lens to subject distance to achieve a sharp image.

Focus priority (single servo) Autofocus mode by which you cannot release the shutter until the lens has sharply focused your subject.

Format Height and width dimensions of the picture area.

Fractional *f*-stop Any aperture setting which is between the full *f* numbers marked on the camera's aperture control ring. $f19$ is an example, being between $f16$ and $f22$.

Frame One single image on a roll of film or digital sensor.

ƒ-stops The various settings that control the camera lens aperture. The *ƒ*-stop or *ƒ*-number indicates the relationship between the size of the aperture opening and the focal length of the lens, so a setting of *ƒ* 8 means that the diameter of the aperture is one-eighth of the lens focal length.

GIF An image file format designed for display of line art on the Web.

Grain Irregularly shaped, microscopically small clumps of black silver making up the processed photographic silver halide image. It is detectable on enlargements, particularly if the film emulsion was fast.

Grayscale A monochrome digital image containing tones ranging from white through a range of greys to black.

Highlights The brightest parts of a photo.

Histogram A graphic representation of the range of tones from dark to light in a photo. Some digital cameras include a histogram feature that enables a precise check on the exposure of the photo.

Hot shoe Mounting on top of the camera to which the flash is attached.

Image browser An application that enables you to view digital photos. Many browsers also allow you to rename files, convert photos from one file format to another, add text descriptions, and more.

Infinity A distance so great that light from a given point reaches the camera as virtually parallel rays – in practice, distances of about 1000 times the focal length or more. It is written on lens focusing mounts as 'inf' or the symbol 8.

Interchangeable lens A lens that can be removed from a camera to be replaced by another lens.

Interpolation A mathematical method of creating missing data. An image can be increased from 100 pixels to 200 pixels through interpolation. There are many methods of interpolation, but one simple method is to generate a new pixel by using the average of the value of the two pixels on either side of the one to be created.

Inverse square law The physical law that causes light from a flash to fall off in such a way that as flash to subject distance doubles, the light falls off by a factor of four. It forms the basis of flash guide numbers and close-up exposure increases.

ISO (International Standards Organisation) In the ISO film speed system, halving or doubling of speed is denoted by halving or doubling the ISO number. It also incorporates the DIN figure, e.g. ISO 400/27 film is twice as sensitive as ISO 200/24.

JPEG A file format, designed by the Joint Photographic Experts Group, which has inbuilt lossy compression that enables a massive reduction in file sizes for digital images.

Kilobyte 1024 bytes.

Kelvin Measurement unit of lighting and colour temperature.

Landscape An image taken with the camera in its normal horizontal orientation.

Latitude See exposure latitude.

LCD monitor A small LCD liquid crystal display screen on the back of the camera, used to compose or look at photographs.

LED (Light Emitting Diode) Lights and symbols displayed in the camera viewfinder to give exposure data.

Lens speed The widest aperture to which a lens can be opened. The wider the maximum aperture of a lens, the faster it is said to be.

L-ion Lithium-ion is a popular type of rechargeable battery. It holds more power and does not suffer from the 'memory effect', where a battery when recharged only registers the additional charge and not its full capacity.

Line (composition) 'Line' is one of the strongest visual elements that photographers can use to help compose their pictures. Often, line is used to direct the attention of the viewer towards a certain part of the frame or a specific focal point.

Macro lens Intended for close-up photography, able to focus on subjects at close distances. The majority of macro lenses now provide life-size magnification (1 : 1).

Matrix metering An exposure system that breaks the scene up into a grid and evaluates each section to determine the exposure.

Megapixel One million pixels. Used to describe the resolution of digital camera sensors.

Modelling light (aiming light) A small light, often a torch, which is attached to a flash gun and shows the direction in which the flash is pointing and also the effect that the angle of the flash will have on the subject.

Monochrome Single coloured. Usually implies a black and white image, but also applies to one which is toned (e.g. sepia).

Mood The mood of a photograph refers to the emotional content of the picture.

M setting Indicates the cameras is in manual exposure mode.

Negative space Everything in the photograph that is not the subject.

Neutral density filter A filter that reduces the amount of light entering the camera lens.

Ni MH Nickel metal hydride battery. Rechargeable, ecologically safe and very efficient.

Noise Misinterpreted pixels found in a digital image, usually occurring in longer exposures, which can be seen as misplaced or random bright pixels in the picture.

Normal lens Lens that has an angle of view similar to that of the human eye. Underwater, that length is considered to be 35 mm (on film).

Open up To increase the size of the lens aperture. The opposite of stop down.

Optical zoom Digital compacts have optical zoom lenses. This means that they can be adjusted to magnify the scene before you zoom in or, alternatively, zoom out to capture a wide-angle scene.

Orientation sensor A sensor that knows when you turn the digital camera to take a vertical shot and rotates the picture so it won't be displayed on its side when you view it.

Overexposure An image that appears too pale because of too much light reaching the sensor.

Panning Rotating or swinging the camera about a vertical axis to follow the movement of a subject. Carried out correctly with the shutter open, this should produce a sharp subject against a blurred background. Plenty of practice is required to master this technique.

Parallax error Viewpoint difference between the picture seen in the viewfinder and as seen by the camera lens.

Pattern (composition) Repeating subjects that have similar characteristics such as colour, shape and texture create a strong visual element that is often referred to as pattern. Pattern can be used in a similar way to line and colour as a way to balance compositions and direct the viewer's eye throughout the frame.

Pixel Short for picture element, and refers to the smallest image part of a digital photograph.

Pixelisation An effect seen when you enlarge a digital image too much and the pixels become obvious.

Polariser Grey-looking polarising filter, able to darken blue sky when at right angles to the sunlight, and suppress reflections from (non-metallic) surfaces.

Port Glass (or Perspex) window that is attached to the camera housing, through which the lens 'looks' underwater. A flat port is associated with macro lenses, and a dome port with wide-angle lenses.

P (Program) mode Indicates that the camera is in the program exposure mode, in which the camera selects both aperture and shutter speed automatically.

Prosumer A broad term that refers to a digital compact camera with a range of manual controls, many of which can be found on an SLR. They are capable of taking pictures to the very highest standard, and usually have a minimum resolution of five megapixels.

Rear curtain synchronisation Here, the flash fires an instant before the second (rear) curtain of the focal plane shutter begins to move. When slow shutter speeds are used, this feature can create a blur effect from the ambient light – e.g. flowing light patterns following a moving subject with subject movement frozen at the end of the light flow.

Reciprocity law failure The effect of dim light, or small lens aperture, can be counteracted by giving a long exposure time, but this reciprocal relationship (half the brightness, double the exposure time) increasingly breaks down with exposure times beyond 1 s. The film then behaves as if having a lower speed rating. Colour films may also show incorrect balance.

Recycle time The time it takes for a flash gun to recharge between flashes.

'Red eye' The iris of each eye in portraits shows red instead of black; this is caused by using flash directed from close to the lens.

Refraction Change of the direction of a ray of light passing obliquely from one transparent medium into another of different density, e.g. from air into water. Underwater, this causes objects to appear closer and larger than they actually are.

Relative *f*-stops *f*-stops marked on the camera's aperture ring, as opposed to effective *f*-stops.

Reproduction ratio The size of the image on film or sensor compared to its actual 'real-life' size.

Resolution An indication of the sharpness of images on a printout or the display screen. It is based on the number and density of the pixels used – the more pixels used in an image, the more detail can be seen and the higher the image's resolution.

RGB The colour system used in most digital cameras, where red, green and blue light are captured separately and then combined to create a full colour image.

Ring-flash A ring-flash does just what its name implies, encircling the camera lens with a flash tube so that the light is projected forward from the camera.

Scanner An input device that uses light to read printed information, including text, graphics and bar codes, and transfers it into the computer in a digital format.

Short focal-length lens (wide-angle) A lens that provides a wide angle of view of a scene, including more of the subject area than does a lens of normal focal length.

Shutter The device in the camera that opens and closes to let light from the scene strike the image sensor and expose the image.

Shutter speed The length of time for which the shutter is open and light strikes the image sensor.

Shutter lag The time between pressing the shutter release button and the camera actually taking the shot. This delay varies quite a bit between camera models, and used to be the biggest drawback of digital photography. The latest digital cameras, especially the prosumer and professional SLRs, have virtually no lag time.

S (Shutter priority) mode An automatic exposure system in which you set the shutter speed and the camera selects the aperture (*f*-stop) for the correct exposure.

Single lens reflex (SLR) A type of camera with a lens that is used both for viewing and for taking the picture.

Slave flash A flash that is activated by the light from another flash gun. The 'slave' can be turned on or off at the touch of a switch.

Slow film See fast film speed.

Smart media A popular form of flash memory card.

Snell's window The circular arc visible on the under-surface of the water, caused by the effect of refraction.

Spot metering A metering method based on a small circle in the centre of the viewfinder to calculate the best possible exposure.

Stepless shutter speeds Infinite number of shutter speeds available on modern cameras.

Stop An aperture setting that indicates the size of the lens opening.

Stop down To decrease the size of the lens aperture. The opposite of open up.

Teleconverter A device used to increase the effective focal length of a lens that consists of optical glass. It is mounted between the camera and the lens, and usually comes in two different sizes: $1.4\times$ and $2.0\times$. A $1.4\times$ teleconverter increases the focal length by 1.4 times, while a $2.0\times$ increases focal length by 2.0 times.

Telephoto lens A lens that provides a narrow angle of view of a scene, including less of a scene than would a lens of normal focal length, and therefore magnifying objects in the image.

Through-the-lens (TTL) metering Measuring exposure by a meter built into the camera body, which measures the intensity of light passing through the picture-taking lens.

Thumbnail A low-resolution preview version of larger digital image files used to check before opening the full version.

TIFF A popular lossless image format used in digital photography.

Time exposure General term for a long-duration exposure.

Tone (subject matter) Tone can also refer to the mood of a picture. When the tone of a photograph is said to be 'dark', then the subject matter and/or the way that the content is depicted can be emotional, complex, sometimes sad, confrontational and generally thought-provoking.

Translucent Transmitting but at the same time also diffusing light (as with tracing paper).

Transparency Positive-image film, such as Fuji Velvia slide film.

Underexposure Exposing the film or sensor to less light than is needed to render the scene as the eye sees it. This results in too dark a photograph.

Up rating Shooting film at more than the manufacturer's suggested speed rating (e.g. exposing 400 ISO film as if 800 ISO).

Viewpoint The position from which camera and photographer view the subject.

Vignetting Progressively diminished illumination on the film from the centre to the corners. There are two kinds of vignetting: natural vignetting caused by the lens, and vignetting that is caused by improper use of accessories such as a lens hood or filter.

White balance An automatic or manual control that adjusts the brightest part of the scene so it looks white. Cameras have pre-set options, such as sunny, cloudy, flash etc.

Wide-angle lens See short focal-length lens.

Zoom lens A lens that offers several lenses in one by allowing the focal length to be altered at will. The minimum and maximum focal lengths available are made clear by the way in which zoom lenses are described and labelled (e.g. 17-mm–35-mm).

Scene mode icons for digital compact cameras

Auto mode For taking snapshots without worrying about the mechanics of photography. This mode sets all exposure levels automatically and usually locks you out of making any adjustments manually.

M **Manual mode** This mode gives you total control. You set both shutter speed and aperture.

A **Aperture mode** You set the aperture, your camera automatically provides the right shutter speed to deliver a correct exposure. Perhaps the most popular mode for underwater photographers.

S **Shutter mode** This setting is your best option for moving subjects such as seals, mantas and moving fish. Shutter priority allows you to stop the action whilst the camera keeps the exposure matched to the aperture.

P **Program mode** Similar to the auto mode, this mode automatically sets aperture size and shutter speed for a perfect exposure, but it also lets you tweak settings, giving you more creative control. You can change white balance and exposure compensation, for instance, and even alter the shutter speed up or down a bit.

Movie mode Many cameras let you record MPEG or QuickTime videos to the same memory card storing your photos. The videos aren't sharp enough for DVD, but they're good for email.

Macro mode To focus on extremely close subjects, within a few inches of the lens, choose the tulip. You can take life-size pictures of insects, flowers, and other small subjects in this mode, but the focus range at such distances is very narrow.

Landscape mode Your camera picks the best aperture and shutter settings for the depth of field that you want when taking pictures of landscapes and other outdoor scenes.

Brightly coloured or glaring backgrounds can trick the camera into underexposing the subject. This mode overexposes the scene to gain details that would otherwise be lost.

Action Sports mode sets the camera to the highest possible shutter speed to catch fast action normally associated with sport.

Night This mode lets you photograph a night time scene by combining a flash, which freezes people in the foreground, with a slow shutter speed, which allows lights from buildings and other elements to show in the background.

Index